D1376196

PICTURING THE SELF

CHANGING VIEWS OF THE SUBJECT IN VISUAL CULTURE

GEN DOY

I.B. TAURIS

LONDON · NEW YORK

Published in 2005 by I.B.Tauris & Co Ltd
6 Salem Road, London W2 4BU
175 Fifth Avenue, New York NY 10010
www.ibtauris.com

In the United States of America and in Canada distributed by
Palgrave Macmillan, a division of St Martin's Press
175 Fifth Avenue, New York NY 10010

ISBN hardback 1 85043 412 3
ISBN paperback 1 85043 413 1

EAN hardback 978 1 85043 412 2
EAN paperback 978 1 85043 413 9

A full CIP record for this book is available from the British Library
A full CIP record for this book is available from the Library of Congress

Library of Congress catalog card: available

Typeset in Melior LT Std by Steve Tribe, Andover
Printed and bound in Great Britain by TJ International Ltd, Padstow, Cornwall

CONTENTS

LIST OF PLATES

COLOUR PLATES SECTION

1. Sebastien Bourdon (attributed to), *Presumed Portrait of Descartes*, oil on canvas, 87 x 69 cm, late 1640s/early 1650s, Louvre, Paris, photo copyright R.M.N., J.G. Berizzi.

2. Eugene Palmer, *Six of One*, oil on canvas, six paintings each 97 x 100 cm, 2000, courtesy of the artist.

3. Tracey Emin, *I do not expect to be a mother, but I do expect to die alone*, appliqué blanket, 264 x 185 cm, 2002, copyright the artist, courtesy Jay Jopling/White Cube (London), photo Stephen White.

4. Marc Quinn, *Self*, blood, stainless steel, perspex and refrigeration equipment, 208 x 63 x 63 cm, 1991, copyright the artist, courtesy of Jay Jopling/White Cube (London), photo Anthony Oliver.

5. Alexa Wright, *'I' no.1*, digitally manipulated photograph, 105 x 79 cm, 1998–1999, reproduced courtesy of The Art Gallery and Museum, the Royal Pump Rooms, Leamington Spa, Warwick District Council, copyright the artist.

6. Boris Mikhailov, *Untitled, from 'Case History', Karkov, Ukraine*, colour photograph, 127 x 187 cm (edition of 5) or 40 x 60 cm (edition of 10), 1997–1998, courtesy of the artist.

7. Karen Knorr, *Butades' Daughter* (from the series 'Academies'), framed cibachrome print, 101.5 x 101.5 cm, with brass plaque, edition of three, 1994, courtesy of the artist.

HALF-TONE PLATES

ACKNOWLEDGEMENTS

My grateful thanks are due to the Arts and Humanities Research Board for a grant to help with picture and research costs. De Montfort University gave me a most welcome period of research leave during which the book could be completed, and also generously helped to pay for a visit to the College Art Association of America annual conference in New York in 2003 where I gave a paper on some of the material from Chapter Six. The travel to and from the conference was paid for by The British Academy, and I am happy to acknowledge the kind assistance of all these institutions.

I also want to thank all the museum and gallery staff who helped with the research and the illustrations, and the library staff at various institutions including my own. As always, the inter-library loan staff at De Montfort did a great job for me, as did Stuart Wade and Iona Cruikshank in helping me with the plates for this book. I want especially to thank the artists (without whom art historians would not exist) who gave permission for the reproduction of their works here, and also the private collectors who allowed me to see and illustrate works in their collections. In particular, I would like to note the kindness and generosity of Karen Knorr in giving permission to use her work on the cover. Thanks also to Professor Fran Lloyd and Jane Kelly of Kingston University for inviting me to give a lecture on what has become Chapter Six, and to Professor Shearer West who invited me to give a paper at Birmingham University entitled "Questions on the Cartesian Self". Her helpful suggestions on this and other occasions have, I think, greatly improved this book. Professor Thomas Puttfarken very kindly agreed to comment on other parts of the manuscript at a time when he was very busy, and I greatly appreciate this.

Finally a word of sincere thanks to my editor at I.B.Tauris, Philippa Brewster, who has encouraged me at all stages of this project.

Every effort has been made to obtain copyright clearance and permissions for the illustrations. If there are any problems in this respect, please contact me in order to rectify the situation.

This book is dedicated to my father and mother, both now dead, without whom, for various reasons, I would not be myself.

The Writer's Technique in Thirteen Theses

5. Let no thought pass incognito, and keep your notebook as strictly as the authorities keep their register of aliens...

Walter Benjamin, 'Post no bills',
in *Reflections: Essays, Aphorisms, Autobiographical Writings*
(Schocken Books, New York, 1978, pp. 80–81)

INTRODUCTION

I resolved to pretend that nothing which had ever entered my mind was any more true than the illusions of my dreams. But immediately afterwards I became aware that, while I decided thus to think that everything was false, it followed necessarily that I who thought thus must be something; and observing that this truth: *I think therefore I am*, was so certain and so evident that all the most extravagant suppositions of the sceptics were not capable of shaking it, I judged that I could accept it without scruple as the first principle of the philosophy I was seeking.

René Descartes, *Discourse on Method*, 1637[1]

... while little work has been done on what is left behind when the myth of the 'real me' is revealed, deconstructing the 'real me' has involved showing it to be a social and political requirement, a form of enforcement, a means of regulating legitimate ways of being, legitimate ways of understanding the self and the world.

Angela McRobbie, 'Feminism, Postmodernism and the "Real Me", 1985[2]

Her self is just an example of any self, and the work dramatises the general, universal condition of self-centredness, its heavens and hells.

Tom Lubbock, review of Tracey Emin's exhibition at Modern Art, Oxford, 2002[3]

These quotations give some idea of the changing uses of the concept of the self in western culture. For Descartes in the seventeenth century, at the beginning of historical and cultural modernity, the self was a certainty; indeed the self with its accompanying consciousness was the only truth for anyone who wanted to understand the world and his/her place in it. For McRobbie, a feminist academic writing in the period of cultural postmodernity in the latter part of the twentieth and early twenty-first centuries, the self is less a fact than a socially constructed myth. Yet, for Tom Lubbock, the notion of the self reappears as the

essence of human existence – consistently a focus of artistic attention and expression for centuries.

It is the aim of this book to investigate the Cartesian self and its interpretations and legacy in visual representation since the seventeenth century, and in particular in examples of modern and postmodern art.[4]

The French philosopher and mathematician René Descartes (1596–1650) founded his search for knowledge and understanding on a notion of the individual self, or subject, as constituted by rational thought. Descartes concluded that the essence of himself as a human subject was this capacity for thinking, superior to his body and any knowledge about the world perceptible through bodily sensations – smell, sight, touch, and hearing.[5] This dualism, the conceptual separation of mind and body, meant that Descartes formulated a view of a *disembodied self*, rather than an *embodied subjectivity*.[6] In arguing for the primacy of rational thinking over sensation in our understanding of the material world, together with his conviction that his findings could be utilised for the progress of humankind, Descartes has been harshly criticised in recent times. Postmodernist scholars have dismissed the notion of a coherent, individual self, able to position her/himself over and above the material world as a controlling, conscious agent.

Angela McRobbie, quoted above, is but one example of the many writers who have equated the Cartesian notion of the self/subject with eighteenth-century Enlightenment philosophy, also based on the power of rational thought, and then dismissed this amalgam of the Cartesian-Enlightenment subject as oppressive to women and 'non-Europeans'; an essentialist fiction which served 'modern' society as a model for the type of strong, controlling and exploitative subjects increasingly required by a developing capitalist, and later imperialist, economy.[7] McRobbie and others, such as Michel Foucault, Jacques Derrida and Judith Butler, have argued that the concept of a fictional unitary Cartesian/Enlightenment self should be replaced by a notion of the self as fragmented, unstable, decentred and constructed by discourse.[8] By this, they mean that the individual self, subject or just plain person does not really act on the world or construct society as a conscious agent. People may think of themselves as agents, but, these authors argue, the individual subject is formed and constructed by language and social practices which are always already in existence prior to selfhood/subjectivity. Thus the individual is not a centred self, but constructed in the play of social 'texts' – political, religious, legal,

medical, educational and so on. Our gender and sexuality, for example, are considered to be not natural or biological, but a result of discourses of masculinity, femininity and hetero/homosexuality, which engage with and constantly constitute the subordinated self.

For some thinkers, such as Foucault, the result is a pessimistic view of the self as always brought into being by an all-encompassing power, which permeates every aspect of personal and public life. Possibilities to resist are limited. For others, such as the cultural critics Kobena Mercer and Homi K. Bhaba, who theorise 'race' and ethnicity, or feminist philosophers such as Judith Butler, postmodern views of the self and society open up a way of radicalising the experience of subjectivity for oppressed groups marginalised by theories and practices of modernism.[9] While it is not new to suggest that individuals are formed by the values and practices of the societies in which they live, postmodern theorists go further than sociologists, arguing that language is of prime importance, forming the subject even at an unconscious level. Thus a basic tenet of Cartesian and Enlightenment materialism was overturned: language spoke/wrote the self, and not the other way around.[10]

However, as indicated above, postmodernist critiques of the so-called Cartesian/Enlightenment autonomous, essentialist subject, were not universally accepted.[11] Women, black people, lesbians and gay men, to name but a few of the many subjected to oppression and exploitation during the period of 'modernity', were not in a hurry to discard notions of self-consciousness, self-determination, the concept of individual agency and the ability to act on society from a perspective of critical reform or even revolution.

Angela McRobbie, in her essay quoted above, wonders how the postmodern theorist can hold onto the notion that the self can be an agent for progressive change, but at the same time be a 'self' – a fiction. She writes:

At the same time this particular fragmentation of the feminist subject is confirmed through the global and postmodern critique of the European Enlightenment. It is not so much a question of what is left behind, what fragments of the disassembled self can be picked up and put together again, but rather how might the continual process of putting oneself together again be transformed to produce the empowerment of subordinate groups and social categories. This might mean living with fragmentation, with the reality of inventing the self rather than endlessly searching for the self.[12]

In a thought-provoking article in relation to the work of black and Latino artists and writers and the concept of multiculturalism, Ella Shohat and Robert Stam tried to work through some of the problems involved in rethinking the modernist subject, asking, 'How, then, should the struggle to become subjects of history be articulated in an era of "the death of the subject"?'[13] For these authors, the subject as agent was problematic, but not ready for the dustbin of history just yet. I would argue that the state of the debate on the self/subject is now much less polarised than, say, ten to fifteen years ago, when any notion of active selfhood was in danger of being theorised out of existence. Marxist notions of consciousness, agency, the alienation of the self in capital- ist society, were then considered 'unfashionable' at best and laughable at worst by many influential cultural critics. For example, the idea of relating Freudian psychoanalysis to Marxist dialectical and historical materialism in an attempt to integrate social and psychic aspects of the self was dismissed by Kobena Mercer as he mocked approaches 'which previous generations sought in the hyphenation of Freudo-Marxism (a word which today reeks of the funky, musty, smell of hippy kinship arrangements)'.[14] We are invited to relegate such attempts to the cob- web-covered attic of outmoded theories, especially as regards the work of black artists, Mercer's main focus of attention at the time.[15]

David Harvey has demonstrated how postmodern theorists who emphasise the fragmentation of personality, such as Rorty, Lyotard and Deleuze and Guattari, work to undermine Marxist theories of agency and society:

> A number of consequences follow from the domination of this motif in postmod-
> ernist thought. We can no longer conceive of the individual as alienated in the
> classical Marxist sense, because to be alienated presupposes a coherent rather
> than a fragmented sense of self from which to be alienated.[16]

Those who remain committed to Marxism in one form or another disagree with the central postulates of postmodern theory and attempt to understand why and how postmodernism itself (together with its views on the subject) has developed as a cultural phenomenon, rather than accept it as a new 'master narrative', like the older, so- called totalising theories (Freudianism, Marxism, modernism) which, ironically, postmodernism itself sought to replace.[17]

As a writer on visual culture who is committed to Marxist theory, though unfortunately rather less practice in recent years, I am concerned

about the implications of theories arguing for the extreme fragmentation of selfhood and subjectivity. And many other scholars, not necessarily Marxists but unhappy with the direction of postmodern theory, have undertaken measured and thoughtful investigations of subjectivity in the last few years, as researchers from a variety of disciplines and positions seek to grapple with the concept of selfhood, its changing nature and history and problems of consciousness and agency.[18] In my view, the self is a focus where psychoanalysis and Marxism can usefully come together, as subjectivity is situated dialectically in relation to the personal and the political, the private and the public, the social and the psychic. In this book, I want to attend to both Marxist and psychoanalytic approaches to the self and, wherever possible, to integrate them in my study of the self in relation to visual culture, especially the visual arts.[19]

Tensions within, and between, selfhood and society continue to develop despite the 'death of the author' and the decentring theories of subjectivity. Celebrity and status in the art world, as in many other spheres of public life, depend on the notion of an individual self, legally recognised as an owner of property, who can sign and therefore authenticate her/his artworks. This person can then become a 'personality', not just a person, who, in some cases, can form part of a new 'class of celebrities', transcending her/his origins to become a role model who, argues Jeremy Seabrook, plays 'a significant role in reconciling the poor to their status'. In support of this argument, Seabrook points out that the (now-defunct) pop group the Spice Girls, formed when they answered a newspaper advertisement in the early 1990s, had, by 2001, personal fortunes of at least £22 million (US$33 million) each.[20]

Arguably the best-known contemporary artist in Britain today, Tracey Emin (though not in the same financial league as the Spice Girls) is famous both as an individual personality or celebrity and as an artist who represents her subjectivity in her works, which are usually highly 'self-confessional'.[21] To use McRobbie's expression, Tracey Emin shows the art public 'the Real Me'. Tom Lubbock, in the review quoted above, focuses on the self as the essential component of Emin's work, underlining its 'self-centredness', not decentredness, and makes links between the individual self of the artist and wider human experiences of selfhood.

Despite much theorising about the self, its fragmentation and disintegration, it appears that in certain respects postmodern theory has not been totally in tune with developments in contemporary art.

What, then, has happened to the Cartesian, Enlightenment or modernist self? How and why has a notion of the self as agency and conscious subject survived? How do artists represent such a complex notion as the self or human subject? Are questions regarding the subject mainly relevant to portraiture, the most obvious artistic domain for picturing the self, or are we concerned here with something more significant to do with wider aspects of artistic representation?

In this book, I want to look at some of the contradictions and tensions within subjectivity, and in the social life of the self – contradictions that have, I feel, been largely written out of postmodern theory, and supposedly superseded by concepts such as hybridity and in-betweenness. I will look afresh at pictures of the self and their meanings for both artist and spectator; some of these will be familiar, perhaps over-familiar; some less so. Yet, even in the case of well-known examples discussed here, such as Holbein's *The Ambassadors*, our thinking about their picturing of human subjects can be problematised in ways which suggest new avenues through the confusing pathways of the debates on subjectivity in, and after, modernity. My main emphasis will be on the legacy of the Cartesian subject and the persistence of the notion of a coherent yet contradictory self in relation to its embodiment in recent and contemporary art.

THE SELF AND THE SUBJECT

It might be supposed that the relationship between the self/subject and art is so obvious that it needs no further discussion. After all, most artworks and other visual images represent people, are made by people and are looked at and used in various ways by people. However, that is not quite the same as looking at the question of the self, subjectivity and art. When we talk or write about the person or people, there is a tacit assumption that we know what we mean, and that the notion of a person is quite unproblematic.[22] It means an individual who lives in a society, is able to do certain things, and is recognised as having certain rights. A person is also conceptualised differently from an animal, with all that this implies for mental capacities, power relations and diet! When we speak of the self and/or the subject, though, it usually implies an awareness of what constitutes an individual self, how that self relates to society and the various characteristics that are involved in the construction of subjectivity, such as gender, class, ethnicity, sexuality and so on. Ideas of the self are linked to concepts of being,

knowledge and the process of relating to material reality, as in Descartes' writings. While the term self is related to subject/subjectivity, the latter is more associated with structuralist and poststructuralist philosophy and the idea that the subject comes into being through language, even at an unconscious level. While earlier philosophers like Descartes and Kant discussed subjectivity, the term as used currently immediately calls up theoretical positions derived, in the main, from twentieth-century French philosophy and its reworking of the ideas of such earlier thinkers as Hegel and Nietzsche. The psychoanalyst Jacques Lacan was probably the most influential proponent of the subjectivity/language model and, since he occasionally referred to the visual arts in his somewhat obscure writings, he has been the theorist of subjectivity to whom writers on visual culture have most often turned. While I will be discussing Lacan's writings in this book, I will be attempting to offer a more historically situated view of subjectivity than that found in Lacan's application of psychoanalysis. Similarly, in terms of theories of subjectivity, seeing and agency, I will be constantly seeking to ground philosophical ideas both socially and historically.[23]

The term subject, unlike self, also carries connotations of subjection and of being the subject, for example, of a monarch. The self, however, suggests an agent who exists in relation to other selves on a more equal basis. Clearly, there is much more to be said on the use of these two terms.[24] For the moment, we should note the differing connotations of the use of the two terms self and subject, though in practice they can often be used interchangeably, as I will sometimes use them in the course of this book. However, in neither case are they simple, unproblematic terms.

THE SELF/SUBJECT AND THE VISUAL IMAGE

There are various ways in which subjectivity and selfhood relate to visual images. Images may represent people, and thus show us a version of the exterior appearance of the self, either individual, in a social group or as a member of a class. Portraits, for example, carry out this function as one of their *raisons d'être*. Secondly, the ways in which the artwork is made are often read as expressions and traces of the individual subjectivity of the maker. Thus paintings with lively or aggressive markings, like those of Van Gogh or Jackson Pollock, are seen as representations of the artist's subjectivity, among other things. Additionally, we need to consider the viewing subject, her/his positioning and the way in which

the visual image or artwork may address a particular spectator. Meanings are not simply encoded into the image by its maker, but arise from the encounter of individuals or groups of viewers with the work, whether this is an original fine art painting in a gallery, or a film, viewed in a cinema under rather different conditions, and devoid of its 'aura' of uniqueness in time, place and origin, as Walter Benjamin pointed out in his influential essay from the late 1930s, 'The Work of Art in the Age of Mechanical Reproduction'.[25] An original work and a work designed for reproducibility demand, help to create and usually successfully meet with different kinds of viewing subjects. As we can already see, issues of the self and subjectivity in relation to visual imagery go beyond the category of the portrait. However, some of the works illustrated and discussed here will be portraits or self-portraits, and it is notable that this category of artwork has survived throughout the period of the dominance of postmodern theory, from, say, the 1980s until the later 1990s, though in forms which have modulated and sometimes critiqued more traditional portrait representations.

CHAPTER CONTENTS

In order to look at the self in relation to visual representation, it is helpful first of all to know something of Descartes and his view of the self in the context of seventeenth-century European culture. While much of this book is concerned with the legacies of the Cartesian self and aspects of its conceptualisation in relation to later art, I feel it is important to discuss what Descartes actually said, and to situate his views; we can then better understand why and on what grounds the so-called Cartesian subject has been criticised, especially by postmodernists. Given the importance of Descartes' views on the conscious subject, it is also important to ask to what extent this apparently defining concept of the modern self related to the picturing of the self in seventeenth-century art. This will provide a basis for a consideration of later examples in the remainder of the book.

After this, I will discuss in detail three key works which raise important issues about subjectivity and visual culture in relation to notions of portraiture at different periods of European art. These works have been selected in order to discuss the picturing of the self with regard to gender, sexuality, ethnicity and social positioning.

Chapter Three focuses in more detail on discussions of the self/subject and why this continues to be important for visual culture. Artists such

as Marc Quinn, Tracey Emin and Alexa Wright are still concerned with notions of the self and continue to evolve ways of representing subjectivity, whether their own or, in Wright's case, digitally merged with the selves of 'others'. In Chapter Four, I examine the notion of the Cartesian theatre, the fictional place in the mind where our thoughts are performed as if on a stage for a privileged spectator. This metaphorical setting is factually inaccurate, but it provides a highly suggestive framework within which to look at developments in the visual arts and visual culture, whether in the field of 'staged' photography/photo-tableau or in revisiting the positioning of the viewing subject. The way we view the material world, whether directly or through representations, is linked to discussions about subjectivity and ideology, and this topic forms the second part of the fourth chapter, examining not only the notion of the theatre and its spectator, but of viewing devices such as the camera obscura, where light, dark, upside-down and right-side-up are related to the subject's experiences of ideology and consciousness. The camera obscura, with its inverted image, has been famously compared to the self in thrall to ideology, lacking in full consciousness, but the 'dark room' also provides a metaphor for the creative space, mental and physical, where the active photographer makes representations of the material world, including the self. The photographers discussed here are the mid twentieth-century practitioners Mme Yevonde and Cecil Beaton.

Autobiographical turns in recent academic scholarship have become somewhat fashionable, especially as some of the more pioneering women art historians reach middle age and beyond. Looking back on their lives gives female writers and scholars an opportunity to discuss processes of ageing, changing consciousness, the growth of their children to adulthood and consequent separation from the maternal body, as well as to situate themselves and their work within changes in their academic disciplines and a wider, classed and gendered society.[26] I decided that a book on the self was a topic where a 'self-aware' autobiographical contribution was not only justifiable but also necessary. My book is not written by an abstract, neutral, disembodied author, but by a person with a history, living in a particular society, classed, gendered – using language rather than constructed by it. Chapter Five looks at my self in relation to images of my early life in Scotland, while relating this material to the wider debates on subjectivity elsewhere in the book. In particular, I want to emphasise the construction of the self as a site of struggle for the formation of conscious agency within a petty-bourgeois family setting.

The final chapter examines subjectivity in relation to marginalised selves such as the homeless, beggars, refugees and asylum seekers. In this context, the notion of the subject takes on more obviously social resonances as we see the material, legal and financial constraints on agency and selfhood. Contemporary material is discussed here as well as examples of earlier visual imagery, both paintings and photographs, in an attempt to examine how, and whether, representations of marginalised subjects have altered in different phases of European capitalist culture.

In her thoughtful book *Subjectivities*, which examines written representations of the self, Regenia Gagnier observes that 'One of the most interesting contrasts in the following pages is, I believe, that between writers who do claim an autonomous introspective "self" and those who do not – a distinction that appears strongly class-based.'[27] Gagnier is attentive to the inadequacies of Foucault's and Althusser's writings as models of subjectivity and seeks to elaborate 'a more positive version of the death of the Cartesian subject' so as to understand subjectivity from the bottom rather than the top, without reintroducing an autonomous subject or 'retreating to a methodological individualism'.[28] Attention to issues of class, ideology and struggle are crucial in understanding the formation and representation of the self, involving gender, sexuality and other aspects of social and cultural embodiment. Throughout this book, I will be utilising theories drawn from both Marxism and from psychoanalysis in order to investigate the visual representation of subjectivity from its Cartesian formulation to the contested legacy of Descartes in the twentieth century and beyond. I realise that much work remains to be done on a theorisation of the subject that fully integrates individual and social aspects of subjectivity – psychic, ideological, cultural and political. Some years ago, I wrote:

We need a theory of the historically situated subject, individual and at the same time part of a social totality, who consciously and unconsciously engages with a contradictory and changing reality to create new representations, not passive reflections, of her/his material and psychic existence.[29]

Picturing the Self is far from being the final word on the subject (in many senses of this word) but I hope that it will be seen as a useful step forward.

CHAPTER 1

I THINK THEREFORE I LOOK…

I am glad to take this opportunity to ask future generations never to believe that the things people tell them come from me, unless I myself have published them…
Descartes, *Discourse on Method*, 1637[1]

I am a great believer in the idea that if you want to seriously entertain criticisms of particular theories and understand why these criticisms have been made, and by whom, then it is necessary to read the original theories and situate them in the context in which they were written. For the original writings and their critiques can be understood as both embodiments of and interventions in particular social and cultural situations. I therefore want to discuss Descartes' views on the subject, situating these in the context of seventeenth-century European culture and society. It is also worth asking whether Descartes' concepts had much influence on the visual art of his time and shortly after his death, and why his views on the self were the object of so much criticism in the latter part of the twentieth century at the height of postmodernism. Not only specialist books, but also collections of texts as course 'readers' for students of the visual arts and visual culture now routinely include discussions of subjectivity, identity and related concepts. It could be argued that the self/subject and debates surrounding it are of increasing interest to contemporary scholars and artists, despite the rejection of the Cartesian model of subjectivity.[2]

In Descartes' writings, consciousness defines the fact of being human and able to know through reason and radical doubt, as opposed to animals that have no language, reason or soul. Humans and animals are basically seen as living machines, though humans are above animals because of their powers of (self-)consciousness. Subjectivity, in a Cartesian sense, is called into question in the dream state, since

it is based on conscious reason. According to George Steiner, the shift from understanding dreams as prophecy to dreams as (displaced) remembrance takes place from the later seventeenth century onwards in Europe, accompanied by 'a gradual yet observable process' in which 'responsible knowledge is assimilated to daylight' and dreams, sleep and darkness to 'illusion… childishness… pathology'.[3] This is different from Freud's theory of subjectivity (and dreams), which posits the existence of unconscious, preconscious and conscious elements within the psyche while preserving it as a totality, whereas for Descartes the psyche is conceptualised as an active agent at the cost of divorcing it from the body and bodily sensations.[4] However, this is on a *conceptual* level. For most practical everyday purposes, Descartes believed that the mind and body were united in the living human being, and it was precisely only in thought that they could be parted.[5] Yet even Freudian theory depends to some extent on a conceptual focus on the psyche as separate from the body. Freud is not talking about the material brain when he discusses the psyche but of something theoretically separate.

DESCARTES' LANGUAGE AND IMAGERY

Descartes' account of the discovery of his method is narrativised, dramatised, and recounted in the first person. His discovery of the thinking self as the core of his understanding of the world is based on his own experiences, mental and physical. Yet he had to publish the *Discourse* anonymously due to possible persecution by state and religious authorities.

Imagery is important to Descartes, and he states his intention at the beginning of the *Discourse* to 'present my life as in a picture'.[6] At one point, he compares his method to that of a painter, who cannot possibly convey everything in three dimensions, so he lets light fall on one surface of a form to illuminate it. This is how Descartes writes his *Discourse*, focusing on the essentials of his method and findings.[7] In his *Meditations*, Descartes speaks of the images that appear to us in dreams and their similarity to pictures and paintings 'which can only be formed in the likeness of something real'. Even when artists depict fantastic mythological creatures, they compose them from different parts of actual living things, or at least, with real colours. He concludes from this that even medicine and physics, which deal with composite things, can be like pictures and dream images and therefore not always

reliable. But arithmetic and geometry, dealing with simple and general things, must be certain. 'For whether I am awake or sleeping, two and three added together always make five...'[8]

Descartes believed that taste was subjective, and so there is no 'Cartesian aesthetic' as such.[9] Although he said little about the visual art of his day, commenting more on music, he did say enough to show that he viewed images as signs rather than copies of natural objects. It is important, he says, to distinguish between the object and its image. For example, dots of ink in engravings can signify battles or storms. 'So that often, in order to be more perfect as images and to represent an object better, they must not resemble it.'[10]

Given these comments, why have we been encouraged to view Descartes as an inflexible person who evolved a rigid system of mastery over the visual world where objects are geometrically and mathematically placed, and where reason subordinates imagination? Dumont gives us a promising start to finding an answer when he comments that 'a symbolic Cartesianism was substituted for a historical Cartesianism.'[11] So where has this symbolic Cartesianism come from and what does it have to do with my investigation into subjectivity and art?

SYMBOLIC CARTESIANISM AND THE VISUAL

In his influential book *Downcast Eyes*, published in 1994, Martin Jay devotes a section to Descartes as an important founder of what he calls 'modern ocularcentrism'.[12] He remarks that '"Cartesian perspectivalism", in fact, may nicely serve as a short-hand way to characterise the dominant scopic regime of the modern era.'[13] For Descartes, it is the mind, not the eyes, that really sees.[14] Yet, thanks to Cartesian dualism and the conceptual separation of mind and body, Descartes has been seen as the thinker primarily responsible for the concept of the 'disembodied eye', which surveys the material world like a neutral and mastering spectator, where objectivity (matter) and subjectivity (thought) are divorced. This notion of the 'disembodied eye', says Jay, is 'shared by modern science and Albertian art'.[15]

Alberti set out his one-point perspective system in a treatise written in Italy in 1435. This system was devised to help depict three-dimensional reality on a two-dimensional surface. Alberti described lines coming from the viewer's eye as from the top of a pyramid, hitting the picture plane.[16] A cloth or veil-like grid could be used by the artist

to plot the points where the lines from the eye 'hit' the surface and then the design was more easily drawn in the correct perspective. (Actually some of Descartes' diagrams show two eyes, rather than one point of vision.)[17] Alberti also said the picture plane was to be like a window through which the spectator would look to view a narrative history taking place.

In an earlier and, I think, more measured discussion of so-called 'Cartesian perspectivalism', Jay identifies the way in which Descartes treats seeing (as mathematical and geometrical rather than subjective), as the dominant scopic regime of the modern era, but not the only one.[18] Jay argues that within this 'scopic regime of modernity' are a number of conflicting theories and paradigms.[19] He identifies these as: first of all, Cartesianism; second, a less obviously geometrical and mathematical model used in Northern European art, such as Dutch seventeenth-century painting, called 'the art of describing'; and third, the dazzling and sensual visions represented in baroque painting.[20] Jay argues that the baroque regime of vision has enjoyed a new popularity in the late twentieth century, as Cartesian regimes (allegedly) positing the autonomous mastering subject and an ordered 'natural' universe are discredited. The sensuality of the baroque, admittedly enticing, has triumphed over a rational and de-eroticised Cartesianism. I have attempted to explain elsewhere just why the baroque is again popular in the era of postmodernity, as a rejection of so-called Enlightenment values and 'master narratives' results in the valuing of decentredness, and the viewing subject is almost overwhelmed by the seemingly chaotic, the irrational, the vertiginous and the hybrid. The postmodern love of the baroque betrays a yearning, sometimes conscious, sometimes unconscious, to return to a pre-Enlightenment, pre-modern era, where there is no industrialisation, no proletariat, no Third World, no Marxism, no imperialism, no subject of history even – in fact none of the problems or issues that modernist theorists of one sort or another grappled with.[21] Even a leftist theorist such as Fredric Jameson, in his analyses of postmodern culture in the 1980s and 1990s, bemoaned the lack of an individual or collective subject in political terms.[22] Like several other scholars, Jay links, or even conflates, Cartesian perspectivalism and the Albertian system of representing perspective by mathematics and geometry.

These early modern diagrams of vision and spectatorship are indeed more mathematical than those of Lacan in his talk on 'What is a Picture?' of 1964, but in some senses the French philosopher's are

imaginative derivations from them.[23] In Lacan's diagram, the lines connecting viewer and viewed objects come together on a screen/picture surface and are explicitly intended to show us a relationship between the subject and the object in which one constitutes the other in an ongoing process which can never ultimately be totally fulfilling or satisfying for the subject, or indeed for either, if the object is also a living person. While the Albertian and the Lacanian models of picturing involve projections onto a central plane/screen, the earlier is about representing reality for a specific, though universalised, viewing subject with a relatively unproblematic relationship to looking, while the later Lacanian model is about the way in which subjectivity and objectivity endlessly oscillate. In Lacan's theory, the object looks back, so cannot be entirely an object, and the same goes for the subject, which is also an object if seen from the other viewing position. For Lacan, the viewing subject can never be master of the gaze and always struggles against objectification.[24]

Earlier models of looking, including Cartesian perspectivalism, situated the world as an object that has the character of a picture, viewed by a governing subject, and this subject is 'always present in discourse, but merely as an abstraction, and not as an empirical entity'.[25] The same could be said of the Lacanian subject, though not of the Lacanian 'object'.

CRARY'S CRITIQUE

In 1992, Jonathan Crary published another book, which sought to understand the demise of Cartesian subjectivity and its scopic regimes. Crary took a strongly Foucauldian point of view, which conceptualised the observing subject as merely an *effect* of 'an irreducibly heterogeneous system of discursive, social, technological, and institutional relations. There is no observing subject prior to this continually shifting field.'[26] Crary's argument is basically that Cartesian vision, exemplified by the camera obscura (a dark box or room where light enters through a small hole and reflects an upside-down, back-to-front image of the scene outside on the opposite side of the box), was the dominant paradigm for fixed and stable relations of vision in a period dominated by scientific reasoning in the seventeenth and eighteenth centuries. In the early nineteenth century, argues Crary, this was challenged by discoveries that linked seeing to the physical body, rather than technical or scientific machinery, but the development of

photography in the later nineteenth century reinstated paradigms of Cartesian vision. Crary states, 'Photography defeated the stereoscope as a model of visual consumption as well because it recreated and perpetuated the fiction that the 'free' subject of the camera obscura was still viable.'[27] I want to return to the camera obscura and Crary's discussion of it in a later chapter but, for the present, will briefly raise some problems with his argument.

In a perceptive review of Crary's book, Geoffrey Batchen points out that Crary's discussion is based on a kind of 'technological determinism'. It is indeed true that Crary pays a lot of attention to visual aids, tools and toys, tending to neglect wider social and economic factors. Batchen finds Crary's characterisation of Cartesianism as passive, versus modernity as active, rather unconvincing.[28] We should also note that, in Crary's account, the camera obscura and mathematical perspective constructions seem to be conflated, whereas writers such as Alpers see these two tools as corresponding to rather different ways of seeing and producing art images – roughly speaking a kind of 'hard' ordered visual construction (mathematical), or a 'soft' one where the camera obscura and lack of obvious mathematical perspective is involved (for example, Vermeer's and other Dutch seventeenth-century artists' paintings).

In fact, even the better writers on Cartesian perspectivalism fall into the trap of conflating Albertian or Renaissance perspective theories with models that Descartes illustrated hundreds of years later. Admittedly, we could say that one-point perspective was still alive and well in the seventeenth century in both France and Holland, countries in which Descartes lived for years, but it is a truly ahistorical approach to speak as if Alberti and Descartes were living in the same worlds with the same concepts. In any case, as Hubert Damisch points out, subjective space is no less 'constructed' than objective space, though in different ways. Geometrical perspective is not the same as vision.[29] Seeing is about more than geometry and subjectivity is always involved in it, not just because of invented devices like lenses, artist's manuals or cameras, but because of gender, class and ethnicity, through which we consciously and unconsciously situate ourselves. We are also positioned as subjects by wider social factors such as economics, the state and other institutions. Unfortunately, these aspects have been played down in discussions about Cartesian perspectivalism and its demise, since most of the work has been done by scholars who are concerned to distance themselves from modernist master-narratives such as Marxism, which might help to redress the balance.[30]

Cartesianism has its weaknesses, but why is it so insistently seen as the epitome of modernity and all its failings? Why do many present-day critics make Cartesian subjectivity and vision float around in a disembodied way through the centuries in the same way that they accuse Cartesianism itself of conceptualising a disembodied consciousness? Let's briefly look at Descartes' ideas on subjectivity a little more dialectically, and a little more concretely.

THE HISTORICAL DESCARTES

Descartes was born in provincial France in 1596. His father was a landowner who had bought himself membership of the Parlement of Rennes, a strategy typical of the bureaucracy of old regime France. The Parlements were not parliaments in the modern sense but high courts of appeal comprised of wealthy lawyers who were supposed to register the King's edicts, and check them for errors of wording. Gradually, the Parlement of Paris, the most powerful, began to object to aspects of the content of the edicts, especially during the period known as the Fronde in the mid seventeenth century. In addition to their legal functions, they policed public order and supervised the supply of essentials, such as fuel and bread, and the administration of prisons and hospitals.[31] Descartes had a private income and, after a Jesuit education, he enrolled (unpaid) in the forces of Prince Maurice of Nassau to fight against the Protestants. After travelling in Europe, Descartes settled in Holland in the late 1620s, where he spent most of the rest of his life, until moving to Sweden at the request of Queen Christina in 1649. He died there the following year.

Holland seemed a suitable place to live, since it was newly independent from Spain, enjoyed commercial prosperity, and there was a degree of religious toleration.[32] This was significant, for in 1633 Descartes had decided not to publish his newly formulated ideas after learning that the Catholic Church had imprisoned Galileo and condemned his writings, because he had argued that the earth moved round the sun. Despite the fact that Descartes never questioned the existence of God, believing Him to be the guarantor of human reason and creator of the world, he experienced criticism during his lifetime and, in 1663, his works were put on the index of books proscribed by the Catholic Church. In 1671, Louis XIV banned the teaching of Cartesian physics, in the same year that the Sorbonne (University of Paris) tried to ban any philosophical teaching other than that of Aristotle.[33] Marx and

Engels argued that the dissociation of scientific thought and discovery from Church control was an essential factor in contributing to the rise to economic and political power of the bourgeoisie, and Descartes certainly played a part in this process.[34]

The Thirty Years War had ended in 1648, only for France to enter into a period of civil war, known as the Fronde, from 1648 to 1652. Descartes had returned briefly to Paris in 1648 but left due to the unstable political situation. In 1648, the French Academy was established, with the aim of raising the status of fine artists, and lessening the power and influence of the guilds of craftsmen, such as silversmiths, frame-makers, candle-makers and painters.[35]

The Fronde was a civil war in which differing social and political forces entered into conflict, at various times, with the French monarchy. Members of the feudal nobility attempted to regain lost power and, in particular, the magistrates and lawyers, Descartes' father's social caste, mounted a campaign, especially in the Parlement de Paris, of legal obstruction and disobedience to the Crown. The main cause of this was the Crown's attempts to erode the magistrates' political and especially financial privileges.[36] The guilds aligned themselves with the magistrates and their opposition to the Crown, since they resented the way that the monarchy gave privileges to independent artists that enabled them to bypass the guild rules, and even guild membership. Any artist given the seal of royal approval could teach and take on commissions despite what the guild masters said. It is difficult for the modern reader to imagine a group of magistrates doing anything very radical, and indeed these men were always careful to condemn violence by lower-class people. The conflict was essentially kept to the upper classes fighting legally and militarily to limit the extent of royal powers. While in retrospect this seems like the beginnings of the end of feudalism, the contemporary scientists who worked towards the discoveries which underpinned modern Europe were not really concerned to radically change society in political ways, Descartes included. Though Descartes and, for example, the scientist Kepler (1571–1630) wanted their discoveries to be put to practical use for the benefit and progress of society, they accepted social hierarchies as they existed.[37]

However, the mechanical materialism of scientists and philosophers such as Descartes and Newton, which regarded nature as a system of bodies in interaction that could be understood by reason, was bound to come into conflict with feudal social relations and the social and

political power of the Church as an arbiter of knowledge. These early modern materialists wanted to understand *how* the world worked as a machine, but not so much *why*. Social changes could not be explained by these methods of mechanistic materialism.

Descartes wanted his work to be read by all intelligent people, including women. Yet he shared the ideological views of his age and class. He corresponded with, and respected, the aristocratic women of his time, yet wrote that science was like a woman – if she gave herself to everyone she would be degraded.[38] Like many other well-off great men in history, he had sexual relations with his female servant, who bore him a child, yet he did not marry her. The child, Francine, died aged five in 1640, causing Descartes' (and probably the child's mother) great sadness. Of the mother, Helen, we know very little.[39]

EVALUATING DESCARTES' LEGACY

How has the historical Descartes been interpreted in the last years of the twentieth century? As we shall see shortly, several recent books have attempted to relate Descartes' ideas to the visual art of his time. In more general terms, debates about consciousness, how the brain works and the nature of subjectivity have taken place in a climate of scepticism over the validity of so-called 'grand narratives' explaining human society, such as psychoanalysis and Marxism. The apparent triumph of global capitalism, and its continuing exploitation of people and natural resources, as well as newly re-marketised areas such as the former Soviet Union and the shattered fragments of what used to be Yugoslavia, does not provide a central focus of attention for many postmodern theorists, with the partial exception of Slavoj Žižek. Fragmentation, decentralisation and the related demise of the concept of conscious, active subjectivity are valued far more than Descartes' legacy, with all its mechanistic flaws. Most books on consciousness restrict themselves to explaining how the brain works, or how individuals perceive the world and interact with other individuals. Wider social, class and political questions tend to be largely ignored, except in the work of scholars such as Steven Rose.

Antonio Damasio, an expert on neurophysiology, or how the brain works, has argued in his books *Descartes' Error* and *The Feeling of What Happens* that Descartes and later Cartesians emphasised the role of reason in human consciousness at the expense of emotions. At its core, argues Damasio, human consciousness is based on the

feeling, experiencing self.[40] Daniel Dennett, another well-known writer on psychology and neurology, has provided a detailed critique of the so-called Cartesian theatre, that metaphorical place in the mind where the inner self, ego or whatever, sees everything come together and consciousness suddenly 'happens'. He remarks: 'We must stop thinking about the brain as if it had such a single functional summit or central point.'[41] This 'show', which goes on before the eyes of an interior viewing subject, is not actually how the brain works, says Dennett. We need to think of a decentred brain with a multiplicity of contents, constantly editing in various places simultaneously. There is no precise moment at which each conscious event happens, he writes. 'There need be no time and place where "it all comes together" for the benefit of a single, unified discriminator; the discriminations can be accomplished in a distributed, asynchronous, multilevel fashion.'[42] A de-centred brain for a decentred, postmodern subject perhaps?

Steven Rose has also written on issues of the brain and human consciousness and brings an essential social element to his method of study. He locates different types of consciousness – perception or recognition, as well as something more active and aware embodying the possibility of change. This second aspect of consciousness, which includes a heightened self-consciousness, is clearly linked to the possible development of class-consciousness. Dennett and Damasio play down this wider social aspect of consciousness and the self. Rose is careful to stress that consciousness is a process, not a thing or a state.[43] He also stresses that social factors are more significant in the formation of consciousness than 'those of neurobiology or individual behaviour'.[44] Rose proposes that the problem of the infinite regress of 'one thinking about oneself thinking about oneself' and 'How is it possible for one's mind to be *in* one's brain if, at the same time, it can think *about* one's brain?' is a problem which results from a semantic confusion based on a habit of dualistic terminology derived from Descartes. He remarks:

If the conscious 'I' is defined, as has been proposed, as the sum total of the brain activity of an individual from birth (or some other suitable starting point) to the present time, then the 'I thinking about me' and 'I thinking about me thinking about me...' regress is seen as a pattern of events ordered on a time-based sequence. They do not ride on top of one another hierarchically but stretch out in time. Each (and it is questionable that the regress is real, or just linguistic, a pattern of words, after a certain point) description represents a particular brain

state at a particular time in relation to other brain states at times just before or just after.[45]

Basically, Rose is more concerned with social issues than either Dennett or Damasio, and his socialist politics inform his work on genetics, heredity and the self. Dennett and Damasio argue in favour of a decentred brain, without a central 'command point' or central agency, in parallel with postmodern theories of decentred subjectivity, decentred knowledge(s) and for the relativity, indeed sometimes non-existence, of a position from which truth can be perceived.[46]

DESCARTES AND SEVENTEENTH-CENTURY PAINTING

I want now to look briefly at Descartes and his approach to the self in relation to visual imagery in the seventeenth century. As mentioned above, there is little evidence that he was particularly interested in the visual arts. Given that his ideas were so crucial to the development of a modern view of knowledge and self-consciousness, we might expect that this paradigm shift in knowledge would be paralleled by a similar shift in the visual arts, or especially the portrait. William Dunning certainly thinks so. With no ifs or buts or maybes, he writes:

Descartes had succinctly expressed a version of the seventeenth century concept of self, and this sense of self would dominate the point of view of society and its important painters until the middle of the nineteenth century. Italian and French painters during this period were compelled by their assumptions to depict the external world in a manner that accommodated this Cartesian paradigm.[47]

As I noted above when first referring to Dunning's views, the argument that the notion of a Cartesian self really began around the time of Alberti in the early fifteenth century in Italy conflates historical periods and results in problems for the understanding of causation. Though Dunning's position appears seductive, we should be careful. For instance, would discoveries in science and epistemology (the theory of how we know things) necessarily have a noticeable impact on painters, who would be influenced just as much by traditional teaching in their own disciplines as by new discoveries in another sphere? The huge effect on the arts of, say, the French Revolution, a truly massive shift in social and political consciousness which could not avoid having a dramatic influence on the arts, is of a qualitatively different sort than publications by Descartes, which circulated in small numbers and

were actually mentioned by very few artists in his lifetime and the decades after his death. I do, however, accept that art is unquestionably influenced by social, cultural and economic factors and is not totally autonomous. What seems more likely than Cartesianism engendering a paradigm shift in painting, is that both Cartesianism and seventeenth-century art develop out of, and interact with, social and economic factors of their time. Whether a development in science, religion or whatever, greatly influences art or literature is also dependent on foundational and contextual elements of economic and social structures – in what circumstances and why advertising imagery was able to have an impact on Pop Art, or the Counter-Reformation was so significant for baroque style. In addition, influences in the cultural sphere are uneven and complex, and there is no easy way to 'read off' translations of influences from one area to another. So while we may discover a shift in emphasis in the representations of seventeenth-century selves post-Descartes, there is no inevitability about such a change.

Details of a portrait of Descartes illustrate the front covers of many modern editions of his writings, notably the Penguin editions of English translations.[48] In several cases, the image is cropped quite severely from a half-length portrait including the hands, to focus only on the face. The reader of the book is invited to look into Descartes' eyes and scrutinise his face, as a means of gaining an insight into his subjectivity as well as the 'self' expressed in his writings. Portraits of authors are often used on the covers of their works. Our expectation that the portrait shows us the subject, the self, of another person, is actually a historically and socially constructed belief and one which persists in this post-modern period. However, the dualist split between 'body' (external appearance) and 'soul' (interior self) causes problems for both artist and spectator in the sphere of portraiture. The true self of the sitter is ultimately inaccessible through the image, however much the paint surface resembles external appearance. Hence the proliferation, in many portraits from the fifteenth century onwards, of symbols relating to the character and interests of sitters.[49] Alternatively, artists could focus only on the figure, especially the face and hands, which might indicate some rhetorical gesture pertinent to the sitter. However, it might be argued that these two strategies actually intensified the dualist body/mind split as they either showed the sitters as identified by exterior trappings (detailed facial appearance, clothes, attributes etc) or interiority (lack of external trappings, blank background, dull clothing, focus on face). These contradictions are inherent in painted

portraiture in any case, for the portrait is an external object, a surface, an illusion – a fabrication of the artist's skill.

Portrayed faces at this period usually showed no strong emotions, which were transient and merely detracted from the 'essential' character of the sitter. Even specific incidents, such as portraits commemorating naval or military victories, also attempted to refer to general concepts of heroism.[50] Eye contact was often important in addressing the spectator and 'interpellating' the viewing subject, to use Althusser's famous term relating to the drawing in of individuals to make them comfortable and 'belong' in particular cultural/ideological situations.

The one fine artist (as opposed to illustrator) during this period who actually mentions Descartes by name and refers specifically to his writings is Grégoire Huret.[51] Huret was an engraver who published his book *Optique de Portraiture et Peinture* in 1670.[52] Huret's treatise is interesting in the context of seventeenth-century portraiture and subjectivity. In part two of his book, he refers specifically to Descartes' work on Optics (*Discourse* 6, 58, 'de sa Dioptrique').[53]

In Figure 42 (plate 1), Huret shows us various perspectives and anamorphic images, and discusses how it is that painted eyes can look around and seem to see everything, following the viewer as s/he moves around the room. Natural eyes cannot do this and neither can the eyes of sculptures. Even though a number of spectators are in the room, the painted subject can address not only the artist, but also each viewer as an individual, inviting them into an imagined relationship with the absent sitter or the painter whose skill is responsible for this illusion.[54] Huret goes on to discuss how the retinal image is upside-down and then corrected, comparing this to a camera obscura, and how one can produce within the camera's darkened space an inverted image on a card or a piece of white linen. He then concludes that the painted eye, since it is on a flat surface, seems to look everywhere, compared to the real eye, which is convex. The gaze is reciprocated whenever and wherever someone, or even groups of people, looks at the painted portrait where a painted figure has been posed looking at the artist. Huret refers to this as the 'regard universel de l'oeil peint' ('universal gaze of the painted eye'). This can be achieved, says Huret, just by the 'judgement of the painter' without any mathematical knowledge, as long as the sitter is looking at him. Huret advises painters to make the eye, which is slightly further away, a little more open, if the figure is not absolutely full face, to compensate for being more distant. Then the desired effect of the 'universal' gaze will always work.

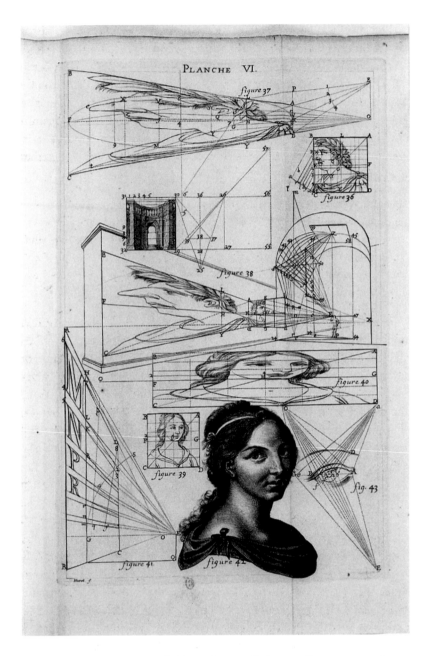

Plate 1. G. Huret, Optique de Portraiture et Peinture, fig. 42, *engraving, Paris 1670, Institut National d'Histoire de l'Art, Paris, Collections Jacques-Doucet.*

Thus portraits reminding us of our absent friends can always address us and their gaze will follow the viewer 'le regarder et le suivre de veuë en tous endroits' ('look at him and follow him everywhere with the eyes').[55] There are many books on portraits, but few really theoretically stimulating ones.[56] Recently, the currency of postmodern theories of subjectivity has prompted some scholars to look again at the portrait and investigate the reasons for its survival and development in contemporary art. In a useful essay Ernst van Alphen concludes that the portrait has not disappeared but that:

Conceptions of subjectivity and identity have been challenged; mimetic conceptions of representation have been undermined in all kinds of ways. This has led to the implausibility of the intertwinement of bourgeois subjectivity with mimetic representation, but not to the death of the genre as such... The project of 'portraying somebody in her/his individual originality or quality of essence' has come to an end.[57]

In Descartes' time, the aim of the portrait was much as van Alphen describes it – to provide a visual representation of the essence of an individual, preferably someone famous for their social, cultural or moral achievements. Originally, the verb 'portraire' described the drawing or tracing of anything, not just a person; however, the use of the word gradually became restricted to the portrait as we understand it today. As early as the sixteenth century, writings on art warned that the portrayal of ordinary, unworthy people would simply degrade the idea of the portrait.[58] Artists and art theorists also worried about the way in which the need to closely reproduce natural appearances in the portrait worked against the aim of differentiating art from nature. Without the perception of this gap between nature and the constructed image, it was argued, art simply does not exist and is not perceived by the viewer. Thus Leonardo thought that a good portrait painter would be a bad history painter, since the two sorts of art required very different approaches.[59] The seventeenth-century portraitist Robert Nanteuil, who produced mainly engraved likenesses, stressed that the portrait should look as if it had been executed quickly, captured in a moment and 'judged in an instant', in comparison to the longer time which was necessitated by history paintings and their visual appreciation.[60] This divergence between the representation of subjects in, and address to subjects by, portraits and history paintings was strengthened by the increasingly codified hierarchy of genres by academies of art, where history painting was most valued.

The aim of most portrait painters in the seventeenth century was to render the surface appearance of the subject/person in a largely naturalistic manner and avoid the expression of strong, distorting or fleeting emotions on the face. Indeed, for Descartes, the inner self would ideally control the passions, so these would not always be obviously mirrored in facial expressions. Some expressions are ambiguous; some are voluntary rather than involuntary. 'And in general all the actions of both the face and the eyes can be changed by the soul, when, willing to conceal its passion, it forcefully imagines one in opposition to it; thus one can use them to dissimulate one's passions as well as to manifest them.'[61] As already noted, the portrait was intended to convey the essential character of the sitter, not some transient mood or feeling. In the mid seventeenth century in France, the emphasis on the expression of passions and drama in history painting was emphasised, especially by Charles Lebrun, in the decades following the foundation of the French Academy in 1648, thus differentiating portraits from history painting even more clearly.[62]

Clearly this essentialist view of the subject is at odds with many present-day theories of subjectivity, including Marxist and sociological approaches (as well as postmodern anti-essentialist theories), which conceive of the self as changing, and in a dialectical relationship with its material and social environment, including other selves. Furthermore, despite group portraits and double-portraits, the overwhelming majority of extant portraits appear to be of single figures; their insistent singularity encouraging a view of subjectivity as individual, almost anti-social. We may think we can see into Descartes' self by looking at his portrait on the front cover of books, but we certainly are not invited to consider his subjectivity in relation to any wider social totality.

SEVENTEENTH-CENTURY SUBJECTS

I want to look briefly now at two portraits from mid seventeenth-century France, one attributed to Sébastien Bourdon (colour plate 1; late 1640s/ early 1650s?) and one by Philippe de Champaigne (1650) (plate 2). If Cartesian subjectivity was so crucially modern and instigated new ways of seeing and knowing, then surely we ought to discern something of this from these images of subjectivity? And if not, why not?

Until recently there was very little scholarly work that looked at Descartes' ideas in relation to the visual arts. Ironically, in part due to postmodern criticism of the concept of the Cartesian subject, more

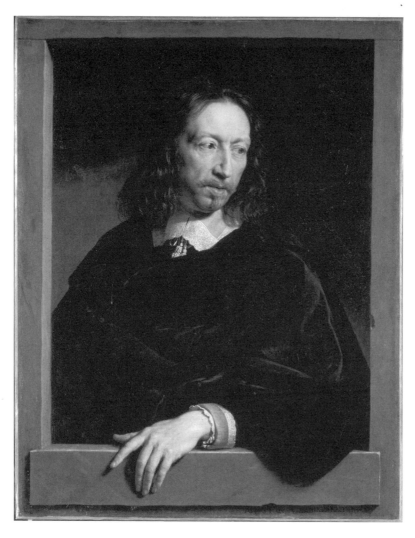

Plate 2. Philippe de Champaigne, Portrait of a Man, *formerly identified as Robert Arnauld d'Andilly, oil on canvas, 91 x 72 cm, 1650, Louvre, Paris; photo copyright R.M.N., J.G. Berizzi.*

discussions of Descartes and visual culture have now appeared in print. This material ranges from arguments in favour of the Cartesianism of specific images to attempts to locate a more general influence of Descartes' ideas on the way spaces are pictured in seventeenth-century paintings. For example, Sawday sees a Cartesian influence in Rembrandt's painting *The Anatomy Lesson of Dr Jan Deijman* (1656) in Amsterdam's Historisch Museum, arguing that the stage of

the dissection indicates that the Doctor is in a hurry to examine the pineal gland, where Descartes located the site of the conscious self.[63] A recent book by B.J. Wolf discusses Descartes' influence on seventeenth-century visual culture in a general way, but also in detailed relation to specific art works, especially works by Pieter de Hooch and Caspar Netscher.[64]

Other writers have made more general comparisons between, say, the work of Poussin and Descartes, or, like Jay and Crary, have commented on Cartesian optics as of 'paradigmatic relevance to the seventeenth-century visual field'.[65] Perhaps the most obvious way in which Descartes can be related to French seventeenth-century art is in theories of the representations of the passions. As noted above, Descartes wrote *The Passions of the Soul*, published in 1649, not long before his death. Charles Lebrun appears to have copied chunks of this (without acknowledgement) to use in his own lecture on the facial expression of passions and the relevance of this to the history painter, first published posthumously in 1696.[66] Given the impact of Descartes' work on seventeenth-century thought, it is surprising that Grégoire Huret seems to be the only artist to refer to him directly.[67]

Most of the attempts to locate a Cartesian influence in specific art works seem unconvincing, because this influence is discerned by art historians centuries later, yet cannot be underpinned by proof that seventeenth-century artists knew much about Descartes' work. Nor did they appear to think that many of his ideas, certainly regarding subjectivity, actually had much to do with their everyday practice and the commissions they executed. His work on the passions and on optics may have been of more interest to artists, but I think it is difficult to link Descartes' notions of the self and the world very directly to artworks. There seems to me to be a disjunction, a time lag, an uneven development, call it what you will, between Descartes' development of a new approach to human consciousness and knowledge, and any embodiment of this view in visual culture. Perhaps all art could be viewed as Cartesian since it involves an active thinking self, working on, and dominating, elements of the material world, wood, canvas, pigments, marble etc – materials which are sensuously appreciated yet ultimately crafted and understood by conscious agency. But this is to have such a broadly defined view of Cartesianism that it is almost meaningless.

It is clearly a good idea to locate and understand specific art works, from the seventeenth century and other periods, in their historical,

social and economic context. Recent work on Poussin, for example, has greatly helped our understanding of the meanings of Poussinism and Poussin's works around the mid seventeenth century at the time of the Fronde.[68] However, the idea that certain art works are near illustrations of Cartesian ideas is dangerous. The concept of Cartesianism and the Cartesian visual paradigm is used in such a general and ahistorical manner by some theorists of visual culture that anything after Alberti in the early fifteenth century could be 'modern' and Cartesian.

So, what of these portraits by Bourdon (attributed) and Champaigne? Do they show an altered post-Cartesian subject? A good many of the paintings produced in seventeenth-century France were portraits. Inventories of the possessions of Parisian financiers show that portraits were the most popular genre of paintings owned, followed by religious works.[69] Later seventeenth-century theoreticians of art, Félibien and de Piles, argued that portraits needed both 'corps' (body) and 'esprit' (soul/spirit), and the ability to rise to this dualist challenge (one facing portrait painters well before Descartes was born) distinguished a successful artist. But as the century progressed, portrait painting became downgraded within the academy at the expense of history painting, and only one of the lectures given by academicians, that of Jean Nocret in November 1668, was devoted to a portrait.[70]

The painting attributed to Bourdon (colour plate 1) has been thought to represent Descartes, but this is probably based on facial resemblance and the fact that Bourdon also visited the Court of Queen Christina, though this was in 1652–1654, after Descartes' death. However, if this is Descartes, it could be a posthumous portrait, which was not unusual.[71] In a very useful article, Paul Barlow discusses the concept of the 'authentic' portrait in relation to 'great men' and national figures in the context of nineteenth-century Britain.[72] The first portrait to be donated to the National Portrait Gallery in London, set up in 1856 as the official commemorative site of British celebrity and greatness, was the so-called 'Chandos' portrait of William Shakespeare, the only portrait known to have been executed of Shakespeare in his lifetime. Like a photograph, but not 'mechanical', the authentic painted portrait seemed to embody a direct link between artist and sitter, a testimony to a meeting between two subjects.

However, Barlow raises some problems. For one thing, the 'Chandos' portrait, like many other portraits of famous people, is, according to Barlow, 'a poor work of art' and 'fails to encode the qualities of Shakespeare into its own pictorial surface'.[73] He asks:

What if the artist did not see Shakespeare? There is no proof of the authenticity of the portrait. It might be that it is a false relic, like many of the dubious saints' bones and pieces of the True Cross held by the Church... Even if it is authentic, what does it tell us? Can we learn anything about Shakespeare by looking at it?[74]

The 'Bourdon' portrait of 'Descartes' is typical of the artist's work, with quite a restricted colour and tonal range, but very soft and warm in its treatment of the figure and face. One hand is raised as if to point to or communicate something, while the other is resting on a stone parapet. The location of the figure is somewhat obscure and vague, neither inside nor outside. The man directs his attention towards the spectator with a fairly expressionless but not unwelcoming look. There is an understandable curiosity to know whether this is Descartes or not represented here, to put a name to a face. Behind this desire are various impulses, for example the ideological notion that someone with interesting ideas should have an interesting appearance and so on. We would consider the painting differently if we knew that it represented a 'somebody' rather than a 'nobody' (note the use of 'body' rather than mind in these terms). Obviously its financial value would change as well. Its significance would be not just personal or familial, but more widely social and cultural. The categories for its study would be different – for example, it would be compared with other portraits of Descartes, rather than just being a good example of seventeenth-century male portraiture. This portrait frustrates many of these impulses of the historian, viewer and possible collector, since it is neither securely documented as *by* Bourdon or *of* Descartes. Thus lack of secure knowledge of subject identity can downgrade the painting artistically and historically. For my purposes, however, these problems actually make it more interesting.

The national borders of seventeenth-century Europe were fairly permeable, and frontiers were regularly crossed by soldiers, artists and other intellectuals, such as Descartes himself, and Philippe de Champaigne, whose *Portrait of a Man* (plate 2) (signed and dated 1650) shows the artist's origins and training in the low countries before his move to Paris. After the end of the wars of religion in 1620, building projects, and art to go with them, flourished in Paris, and from 1630 to 1660, the city became an important focal point for European artists from further north.[75] The Champaigne portrait, the identity of whose sitter is also uncertain, similarly shows a half-length male figure, sombrely dressed, head and hand lit against the dark surroundings, though the

whole figure is in much sharper focus and clearer than in Bourdon's portrait.[76] He wears a dark blue/black velvet cloak. The face is painted in great detail, and the figure is placed within what looks like a window. Yet this is an enclosure made of stone, and does not seem particularly domestic or welcoming. He looks slightly downwards and does not address the spectator.[77] The figure in the window is a common enough motif in art, and functions in a number of ways.[78] The illusionistic skill of the painter is alluded to, along with an invitation to speculate on the nature of the visual. We are shown a place from where to look, to survey or be seen. The window frame is a frame within a frame (of the picture) and the very nature of painting is foregrounded.

In his treatise on painting, Alberti advises the painter to start mapping out his image by thinking of it as a window situated and created within a larger area. The painter must conceive of his painting as a special area conceptually distinct, and of a different nature, from its surroundings – this is what will eventually make it a 'tableau', though Alberti does not use this word. 'First of all, on the surface on which I am going to paint, I draw a rectangle of whatever size I want, which I regard as an open window through which the subject to be painted is seen...'[79] The painting is looked through like a window, and painted subjects can look from 'their' (imaginary) side of the picture plane back towards the spectator. For centuries, this concept of the painting as window was conceived of as a model for the artist, but that does not necessarily make it characteristic of a *Cartesian* framework of vision.

During the period 1643–1661, Champaigne was one of the most important and successful portrait painters in Paris, and his sitters included the rich and powerful. However, by the 1660s, Champaigne's style, which was seen by some academicians as too close to nature, was regarded as old fashioned. The academy wanted to stress the intellect, emphasising art as a process of studied invention rather than 'copying', in order to distance its members totally from the craft-based teaching of the other painters' organisations.[80]

What really is striking about these portraits is the extent to which they relate to previous works in the portrait tradition. They could almost have been done in the Italian Renaissance. The hands on the parapets, the focus on faces and hands are highly reminiscent of, for example, Titian's works.[81] There could be several reasons for this. There may be a definite attempt to relate to earlier works, thereby enhancing the prestige of the sitters and emphasising the knowledge of the artist, or perhaps if something works well, why would artists

necessarily change the format very much? Also, if certain methods of teaching are continually passed on through studio practice, then these will have a certain autonomy regardless of new approaches to the self and subjectivity in other spheres of culture. Indeed, even Mme Vigée-Lebrun's remarks on her portrait painting technique in the eighteenth and nineteenth centuries show the survival of many earlier practices.[82]

Descartes' notion of the dominant, conscious self was not the only one posited by seventeenth-century thinkers of course. Blaise Pascal (1623–1662), who was close to the Jansenist community at Port Royal, turned from 'the sciences of reason' to 'the sciences of authority', i.e. the Bible and theology. Pascal helped to defend the Jansenists and, as in the case of the painter Champaigne, a relative (his niece) was healed by a 'miracle' at the convent.[83] Pascal had different ideas about the self to those of Descartes, and these were clearly influenced by Jansenism. The centrality of the conscious self results in an unjust self, which makes itself the centre of everything, tyrannises the selves of others and wants to subjugate them, writes Pascal. 'The self is hateful.'[84] At other times, Pascal sees the self as a fiction, an imaginary construct that does not really exist. Only abstract qualities (temporarily) embodied in people and their actions are admirable, not the self per se. In *Pensée* no. 688, he writes:

What is the self?

A man goes to the window to see the people passing by; if I pass by, can I say he went there to see me? No, for he is not thinking of me in particular. But what about a person who loves someone for the sake of her beauty; does he love *her*? No, for smallpox, which will destroy beauty without destroying the person, will put an end to his love for her.

And if someone loves me for my judgement or my memory, do they love me? *me, myself*? No, for I could lose these qualities without losing my self. Where then is this self, if it is neither in the body nor the soul? ... Therefore we never love anyone, but only qualities.[85]

This is a very different view of the self from that of Descartes, whose confidence in the power of the thinking subject is far from Jansenism with its ideas of predestination and self-abnegation. Descartes' view of the rational self is progressive and less hide-bound by religious ideologies than that of Pascal.

CONCLUSION

Basically, what seems to have happened is that the Cartesian subject was treated in a symbolic, rather than a historical way by postmodern critics. Then only after the Cartesian subject had been negatively characterised as the epitome of a modern way of seeing and knowing the world, art and cultural historians went to look for Cartesian influences on seventeenth-century art. Most of these influences and parallels I find rather unconvincing, and it is more fruitful to examine what economic, social and political factors helped the development of both Descartes' ideas *and* visual culture in seventeenth-century Europe. We cannot, I believe, expect to find obvious and direct 'reflections' of Cartesian thought in visual art. In the example of portraiture, say, factors such as pre-existing, successful, portrait formulae, patronage, the function of the work, and the place of the portrait in relation to other types of art, for example history painting, are far more significant than the influence of Descartes and his concept of the self. Even in the general sense of a Cartesian way of looking at the world, as posited by Crary and Jay, their arguments are rather ahistorical, conflating the Renaissance and the seventeenth century, and this, I think, is problematic.

So what does all this imply about the Cartesian legacy in the visual arts? I think we need to look for it elsewhere, and not in direct influences and parallels between Cartesian thought and art works. We should look, rather, at ways of thinking about the body and the self, about consciousness and the brain, at ways of picturing the places where thought and representation take place – and this, after all, is what art is about.

CHAPTER 2

SUBJECTS AND PICTURES

Descartes' philosophy posits a rational, conscious subject interacting with, but superior to, both his/her sensations and the material world. This view of subjectivity was formulated in a historical context of scientific discovery, the development of a capitalist economy and the rise of European nations as colonial powers. Consciousness, reason and agency came to be viewed by many as more significant than predestination, fixed social stratification and the Divine Right of Kings. Although not in themselves part of the Enlightenment, the ideas evolved from Descartes' method of radical doubt were further developed by French philosophers of the eighteenth century, such as Voltaire, whose ideas played such an important role in criticising the Old Regime in Europe.

Descartes represents himself in the first person in his *Discourse*, addressing his readers as equals with whom he wants to communicate. He presents himself as a learned but accessible person, someone we can know personally, in addition to reading about his ideas. He tells us of his early life and the personal experiences which led to his decision to work out his particular philosophical approach. The 'symbolic' autonomous, controlling subject is also a person who addresses us, individual to individual – a person with a distinct voice, a specific history and an identity. This interplay of the abstract and the particular, the exemplary and the specific, is a characteristic of human subjectivity and its representations, but in addition needs to be situated within specific historical, cultural and social configurations. Also, the interplay of self and other is, I would argue, a changing relationship rather than a 'given', valid for all historical periods. The self/other relationship might not necessarily be one of conflict and domination, but of mutual respect and cooperation. Perhaps it is only within societies motivated

by exploitation and oppression, resulting in alienated subjectivity, that this model of self/other is emphasised so strongly.

Since this book is concerned with visual, rather than literary, representations of subjectivity, I want to consider different ways of representing the self in three examples of imagery selected from different historical periods. These three examples could all be described as portraits in some sense. Portrait images represent the self for an other of some sort – a lover, a family, a king's/queen's subjects, or members of the same social group (as in Dutch Group portraits of the seventeenth century). Even if the image is for the patron only and kept in a private house, the sitter is confronted by an image which objectifies her/himself and is never identical with the subject/self of the imaged person. The image is an external two-dimensional object and exists independently, even if it is a photograph with a material link to the actual person in the image. Even the self-portrait, while apparently closer to the making subject, cannot avoid this externalisation and objectification of the self, where the self confronts itself as an other while in the process of fabrication. The making self partly constitutes itself through the presence of the image and also through the process of its making. Subjectivity, its construction and agency, as well as the ultimate impossibility of representing subjectivity, are embodied in portraits. For when the portrait is finished, both the artist and sitter are different people. The portrait is (at best only part) of a subjectivity that is in the past. In addition to the artist and the subjects of portrait images, we also need to be aware of the subjectivities of the viewing selves and the modes of address and contexts of viewing in which these works enter into inter-subjective relationships.

The three works I want to look at are chosen from different historical periods in order to investigate changing social notions of the self, its constituents and its visual representation. The three works are Hans Holbein's painting of 1533, *The Ambassadors* (plate 3); Claude Cahun's photograph *Self-portrait with Mirror* (1928; plate 4) and Eugene Palmer's painting *Six of One* (2000; colour plate 2). An examination of these three works will allow us to consider issues of gender, class, ethnicity and sexuality in relation to the subjects depicted and also in relation to the viewing subject(s). In addition, the ways in which the subjects and objects are represented in the works will be discussed in terms of concepts of authorship and self-expression, which can (or more likely cannot) be read from the surface of the images. These three works were also viewed in differing social and cultural locations as well as in different historical

periods. Holbein's painting was exhibited in the home of the patron, a private residence but in a prominent position in a large room where it could be seen by relatives, close friends, visitors and also of course by servants.[1] Cahun's self-portrait photograph, most likely executed in collaboration with her female partner, is a small-scale work, which was not exhibited in public until very recently. It was probably viewed in an intimate context held in the hand of a single person – the subject herself, her partner, or a close friend. Eugene Palmer's paintings, *Six of One*, are intended for exhibition in a public, gallery setting which usually involves single viewers or small groups of acquaintances who may visit the gallery together. It is noticeable how rarely individual visitors communicate with one another in a gallery or museum setting even though they are (partly) sharing a viewing experience.

These images also offer different instances of representing the self. In the Holbein, the subjects are represented by another, the artist; in the Cahun photograph, the image is the result of a collaboration between the sitter and very probably her partner; and in Eugene Palmer's portraits, the subject is his daughter, though he has said that the identity of the subject is irrelevant, since the work is first and foremost a painting, not a representation of anyone.[2]

Roughly speaking, we could situate these works culturally and historically as early modern (Holbein), modern (Cahun) and postmodern (Palmer). Holbein's painting dates from about one hundred years before Descartes' *Discourse on Method* (published 1637), so, in theory, represents pre-Cartesian subjectivity, though as we have seen in Chapter One, visual imagery does not necessarily align itself with developments in philosophy. Cahun's self-portrait dates from a period of European modernism (roughly eighteenth to later twentieth century), which, supposedly, enshrined a controlling, unitary subjectivity and a corresponding mode of vision. Palmer's paintings visually materialise fragmentation and depthlessness, identified by postmodern theorists such as Fredric Jameson as epitomising the postmodern experience of subjectivity in late capitalism and its 'globalising' dominance.

It is my aim in this chapter to investigate notions of Cartesian subjectivity in relation to these three images, but also to problematise Cartesian subjectivity and its legacies in the context of dialectically conceptualised views of modernity and postmodernity. I do not want to suggest that these images are in any way precursors, reflections of, or critiques of, Cartesian thought, as I have pointed to the problems involved with this type of approach in the previous chapter.[3]

THE AMBASSADORS

Hans Holbein the Younger's double portrait, known as *The Ambassadors*, was executed in England in 1533. There is much debate as to the existence and/or nature of subjectivity before the Cartesian 'model'. As David Aers has pointed out, many scholars have dismissed the idea that any notion of interior subjectivity existed in mediaeval times and locate the beginnings of modern, bourgeois subjectivity in Shakespeare's era. This early modern subjectivity, individualistic, interior, self-conscious and incipiently classed as bourgeois, is seen in *Hamlet*, according to such scholars as Catherine Belsey and Terry Eagleton.[4] Stephen Greenblatt argues that 'only in the sixteenth century do we begin to meet self-conscious self-fashioning subjects concerned with an interiority simultaneously "constituted" (in Foucauldian ideology) by the power of the Tudor state.'[5] Catherine Belsey states categorically that the human subject is an invention of the seventeenth century.[6] Aers, however, argues that subjectivity *did* exist in mediaeval times and cites various expressions of this in literature, notably the *Confessions* of Saint Augustine (AD 345–430). He points out that such writings refer to the inwardness of the individual self and that to turn one's thoughts inwards not only interrogates the self and its nature during this period but also initiates a journey to God. Aers maintains that theories of the historical self in the pre-modern and early modern period in Europe must focus on the central role of Christianity in the construction of subjectivity.

It is not easy to relate the emergence of modern subjectivity to economic and social conditions. Developing capitalism is usually linked to the formation of modern subjectivity, but Aers points out that there were commodities and markets by the late thirteenth century, so if these are key factors in the constitution of a version of early modern subjectivity, why have subjectivity and selfhood been denied to mediaeval people?[7] However, Aers fails to point out that capitalism is *generalised* commodity production, including the commodification of labour power and this cannot be said to exist in mediaeval Europe. Marxist theories of alienation as arising due to the commodification of aspects of the self are important for subjectivity and its representations, as we shall see later, but have tended to focus on subjectivity and culture in relation to developed capitalism, not earlier periods.[8] Perhaps we should look to earlier historical periods for positive (self-) constructions of subjectivity rather than more negative ones related

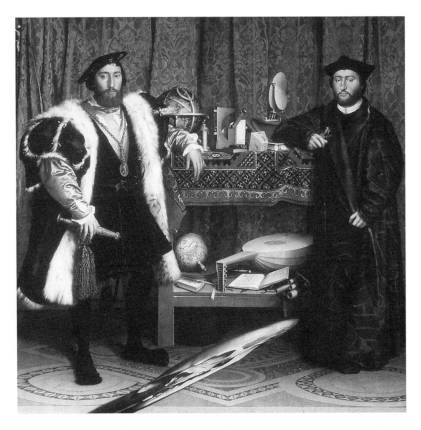

Plate 3. Hans Holbein the Younger, The Ambassadors, *oil on oak panel, 207 x 209 cm, 1533, National Gallery, London; photo National Gallery.*

to alienation. It is also the case in earlier periods of European art that visual representations of subjectivity are more predominantly of the well-off, the cultured and the social elite, in contrast to the present where a far broader range of people has some access to means of self-representation in both visual and other senses of the term, for example political self-representation.[9]

Peter Burke is also suspicious of the traditional argument, famously advanced by the cultural historian Jacob Burckhardt in his book *The Civilisation of the Renaissance in Italy* (1860), that the modern subject was born in Renaissance Italy with the development of portraits and autobiographies. The uses of these images were 'often more institutional than individualistic': hung in family groups, or in categories, such as images of the Doges of Venice.[10] Burke discusses earlier examples of 'ego-documents' such as memoirs and diaries in Japan and India,

denying that the emergence of subjectivity takes place first of all in a European context. He concludes:

In short, we need to free ourselves from the Western, Burckhardtian assumption that self-consciousness arose in a particular place, such as Italy, at a particular time, perhaps the fourteenth century. It is better to think in terms of a variety of categories of the person or conceptions of the self (more or less unified, bounded and so on) in different cultures, categories and conceptions which underlie a variety of styles of self-presentation or self-fashioning.[11]

We should note the debates around the existence of an early form of modern subjectivity which *perhaps* emerges around the time of Holbein's painting. Subjectivity is present in all forms of human society, lived and embodied in different ways throughout differing economic, cultural and social conditions. Human subjectivity should be conceptualised dialectically, neither as passively formed by social and economic conditions, nor as a totally free agent dominating her/his environment and other human subjects. We should also beware of making value judgements on subjectivity based on ideology, class and an assumption that modern is always 'superior'. For example, how could Watt Tyler and the other participants in the famous Peasants' Revolt of 1381 have no subjectivity, or an inferior kind of subjectivity from that of post-Cartesian people?

The rich and powerful have a great deal of control over their own self-images, unlike historical selves who leave 'only' their actions behind, or the millions of whom we know nothing personal whatsoever. Such are the two men in Holbein's picture: Jean de Dinteville on the left and his friend Bishop Georges de Selve, on the right, both Frenchmen. Holbein painted them, commissioned by de Dinteville, during a visit by de Selve to London in the spring and early summer of 1533. Jean is aged twenty-nine and his friend twenty-five.[12] The painting includes wonderfully detailed renderings of scientific and cultural objects, as well as the rich clothing and surroundings of the two men. A crucifix in the upper left corner (Christ's sacrifice brings believers eternal life) counterbalances the connotations of the famous anamorphic form hovering in the illusionistic space in front. When viewed from a narrow angle at the right of the picture, the shape can be read as a skull.

Commenting on early modern subjectivity in England, David Hillman points to the relationship of interiority and exteriority in the construction of a coherent sense of identity. He sees a parallel

between this historical development and psychoanalytic theory, which emphasises interiority and exteriority in the emergence of subjectivity in the human individual.[13] Hillman argues that we should not feel obliged to choose between specifically historical investigations and implicitly transhistorical psychoanalytic ones and such an either/or approach is 'detrimental to a wider understanding both of the historical roots of psychoanalytic conceptions and of the psychological roots of historical processes'.[14] Hillman shares the opinion of those who locate the emergence of the modern subject in the Shakespearian period. He stresses the development of inner/outer binaries in the culture of selfhood in the sixteenth and seventeenth centuries and suggests that concepts of the self and the body parallel developments in other areas such as nation-building, land and property enclosure, architecture, anatomy, medicine and religious and legal discourse.[15] In the sixteenth and seventeenth centuries, according to Hillman and others, architecture changed to provide more kinds of private spaces, closets, cabinets, studies and libraries, rather like the space in which the 'Ambassadors' stand, posed in a staged tableau for the painter. These spaces, argues one scholar, are 'a key location for the emergence of the modern subjectivity'.[16] Thus the emergent forms of early modern subjectivity are heavily influenced by class, if they are nurtured in studies and libraries. We can also locate a move from the situation of learning in monasteries and even, to a lesser extent, nunneries, controlled by the Church, and the emergence of libraries and study resources owned by wealthy individuals, alongside those of universities. During the Renaissance period, the type of image of 'the scholar in his study' is gradually transformed from the image of a saint-scholar to a secular humanist such as Erasmus.[17]

Iconographical details of the cultural and scientific still-life objects in *The Ambassadors* have been interpreted as referring to the situation in Europe in 1533, when Protestant and Catholic countries were in conflict. Both men were diplomats, charged with building alliances within the framework of a united Christian Europe, at a time of disharmony, symbolised by the broken lute-string.[18]

It has been pointed out that it is unusual at this time for double portraits to be made of people who are not in the same family, or betrothed couples.[19] It is tempting to read more than 'homosociality' into the relationship between the two men.[20] Jean de Dinteville died unmarried in 1555. We know from his correspondence that he was not in the best of spirits in England and missed his friends and family. In

a letter he wrote to his brother, he tells the latter that there is no need for the Duc de Montmorency (the second most powerful man in France after the King) to know of the visit of de Selve and presumably the painting.[21] De Dinteville's family fell out of favour, one of the reasons being that a brother of Jean de Dinteville was accused of attempting to have sexual relations with his male cousin, Jean du Plessis. The de Dinteville brother, Gaucher, denied the charges but did not turn up to fight a duel in defence of his honour and fled to Italy to escape the anger of King Francis I. The family did not regain their influential position till the early 1550s.[22] This does not necessarily mean that any of the de Dinteville brothers were homosexuals, and the charge of sodomy could have been made as part of a campaign to discredit them. Yet it is tempting to look for something more than friendship in this image of the two men, if only because we have so little in the way of positive representations of early modern subjectivities which are not heterosexual.

James M. Saslow, in a very useful essay, describes how, in early modern Europe, persecution of 'homosexual acts' varied between different genders, cultures and time periods. A woman was burned at Fontaines, France in about 1535 for attempting to pass as a man and 'counterfeit the office of a husband' with another woman.[23] Saslow suggests that, for many individuals, homosexual relations were only one element of sexual activity among others. Noblemen tended to have homosexual relations with younger men, though not exclusively, whereas same-age, same-sex activity tended to be more common in lower-class relations, suggesting a correlation between social, economic and sexual domination. Saslow also points to an emerging homosexual consciousness discernable in the early modern period, despite the limited historical evidence available in terms of first-person testimony, lack of which poses problems in studying queer self-images. He remarks:

The evidence for this behaviour is selective and sporadic, posing several obstacles to interpretation. Not surprisingly for an illegal activity, little first-person testimony was committed to paper or survived. Most of our knowledge thus derives from hostile outside sources: for the lower classes, from police and court records; for the clergy and aristocracy, from individuals whose opinions may have been colored by personal or political motives.[24]

As Angela McRobbie has remarked: 'The "real", "respectable" me is also the product of a certain kind of psychoanalytical violence, where

desire is also constrained and endlessly defined in culture around the tropes of heterosexuality.'[25] While warning against crude readings of Renaissance images of men which result in the 'collapsing [of] any clear boundaries between an essential "gayness" and a straightforward "heterosexuality"', Patricia Simons nonetheless suggests that 'we should look less hard, less directly and instead, with a historically aware gaze, imitate the slightly averted eyes or return the sidelong glance cast at us by some portraits.'[26] Holbein's painting already invites a sidelong glance to decode its virtuoso perspective – we may as well look for other things while we are at it.

Who is the painting for, apart from the patron? The tour de force anamorphic skull suggests that the picture was going to be shown off to visitors to de Dinteville's home at the Chateau de Polisy as something out of the ordinary – an unusual 'sight'. To appreciate the skill of the painter and to read the anamorphic shape as a skull, the viewer needs to move to the right of the picture near the wall where the painting hangs. Thus the viewing subject is not envisaged as static, but mobile, changing position and perception in the course of viewing the picture in time, not instantaneously. Also a viewer is definitely envisaged during the conception of the image, unlike images which 'pretend' that the scene is just happening without anyone there to see it. The two men fix their eyes on the spectator(s), who may be plural at first as they face the painting, but then become a singular viewing subject if s/he moves round to the side to view the foreground shape as a skull. The presence of two subjects in the image is different from the 'normal' one-to-one relationship set up between the sitter and the viewing subject via the (invisible) artist. The friends are shown as equals in terms of composition and eye contact with the viewer(s) so the much-discussed self/other relation on which 'modern' identity is supposedly posited is complicated here.

The painting is signed in Latin on the floor by Holbein, a personalised trace of his making of the work. Some writers on art have felt uneasy with Holbein's paintings, since they show few such signs of the painter's subjectivity. Ruskin saw Holbein as self-effacing, while a more recent writer commented that Holbein's paintings were all about the physicality of objects, the sitters being no less objectified than the still-life parts of the painting.[27] Thus the manner in which the picture is made works against later cultural and ideological expectations of subjectivity and its traces. Images and writings construct *correspondences* of subjectivity, not actual people. An important aspect of representations of the self is their fetishistic nature, since there will always be something lacking

and the desire for the identification with and/or possession of, the pictured self can never be accomplished. Later in this book, I will look at examples of self-representation where parts of the body are included in self-representations, as if to point to the unsatisfactory and incomplete nature of earlier representations of the human subject.

LACAN AND THE AMBASSADORS

Lacan has been the psychoanalyst of preference for recent writers keen to relate subjectivity to visual art and culture. This is not just because Lacan mentioned visual imagery in his work (so does Freud), but for a number of other reasons. Lacan's work is concerned with the formation of the subject through language. The interest in semiotics and structuralism current in the later 1970s developed into post-structuralism and the related theories of postmodernism. The arbitrariness of language and signs were interpreted in the 1980s and 1990s to mean that there was no truth 'behind' signification. Baudrillard, Deleuze and others stated that contemporary society was fragmented and disorientating and that the experience of postmodernity for human subjects was a schizophrenic one.[28] Lacan's work, though dating from an earlier period (the middle part of the twentieth century), was revisited in the interests of theorising an incurably decentred subjectivity constructed by the play of language – a language abstracted from any social context. My interest in psychoanalysis is not one motivated by a desire to avoid notions of ideology, history and politics, but rather to see whether we can bring together insights from both psychoanalysis and Marxist views of society and focus them on an examination of subjectivity and its visual representation. It is in this spirit that I discuss Lacan to see what he has to offer.

Lacan mentions Holbein's painting in a series of seminars, or public lectures, that he gave in 1964 at the Sainte-Anne psychiatric hospital in Paris. Lacan states that, for Descartes, the subject is a subject of certainty, a point of perspective within a geometric space.[29] Lacan, however, believes that the subject is not self-knowing and self-constituting, but rather the result of processes that construct it through language and through relationships to others and the Other.[30] In his talk 'What is a picture?', Lacan argues that not only are images pictures, but the subject is also constituted as a picture when it is looked at by the other: 'What determines me, at the most profound level, in the visible, is the gaze that is outside.'[31]

In actual paintings, says Lacan, some argue that the artist tries to impose himself on us as subject, as gaze, while other theorists stress the object-like aspect of the artwork. Lacan argues that even in a painting without human figures, such as a Dutch landscape, the viewer will feel the presence of the painter's gaze. For Lacan, it is essential that the other interacts with the self in order for subjectivity to be continually addressed and brought into being. The painting traps the gaze of the spectator by inviting the person to look but also 'to lay down his gaze there as one lays down one's weapons'.[32] A notable exception to this is Expressionist painting (he suggests Munch and Ensor), which offers the gaze some bodily satisfaction of its desires, indicating more physically observable traces of the painter's presence.[33] For Lacan, most paintings appear to offer a lure, enticing the gaze into an ambiguous surface, which is at once illusionistic and a flat screen, a developing film for both the subject and the object perceived.[34]

The gaze is crucial in the experience and construction of subjectivity. Lacan compares the Cartesian notion of thinking about oneself thinking (thought), which for Descartes resulted in certainty, with the idea of 'seeing oneself see oneself' (sight), which is an *illusion* of consciousness. The gaze is 'the underside of consciousness'. Lacan uses a seductive image from the philosopher Merleau-Ponty's writings to convey this:

the turning inside-out of the finger of a glove, in as much as it seems to appear there – note the way in which the leather envelopes the fur in a winter glove – that consciousness, in its illusion of *seeing itself seeing itself*, finds its basis in the inside-out structure of the gaze.[35]

The inside-out glove image appears in the seminar 'Anamorphosis', and Lacan goes on to show his audience a reproduction of Holbein's *The Ambassadors* to demonstrate an example of the distortion of flat images by what he calls 'geometral' or 'flat' perspective. The subject looking at the painting is not the subject 'of the reflexive consciousness, but that of desire'. The viewer's gaze surveys the vanitas objects symbolising the passing of earthly knowledge and pleasures and then changes to focus on the form in the foreground, perceiving it as a skull through which Holbein makes visible 'the subject as annihilated... the imaged embodiment of castration... This picture is simply what any picture is, a trap for the gaze.'[36] Lacan links the concept of castration to the anamorphic form by comparing the way in which the distorted form suddenly extends itself and becomes 'visible', when we perceive it

'correctly', know it for what it is, yet surrender our desiring gaze of subjectivity to it: 'Imagine a tattoo traced on the sexual organ... in the state of repose and assuming its... developed form in another state.'[37] Lacan clearly addresses himself to masculinity here, however symbolically we are intended to read this.

It is not my intention here to imply that Lacan's view of subjectivity is historically viable as applied to the selves of Holbein's sitters and sixteenth-century viewers of the painting. What is significant about his discussion is the fact that he chooses this particular painting as a key focus for discussing Cartesian subjectivity (actually conceptualised about one hundred years after this painting) and comparing that subjectivity of certainty with what we might term a Lacanian subject of uncertainty – a contrast between a subjectivity of knowledge/thought and a subjectivity of desire/sight, between scientific instruments and an anamorphic skull. Yet actually the distorted skull can only accomplish its 'erection' from one perspective position, thus the painting still posits a viewing position based on single-point perspective and geometrical calculation, though the viewer has to physically move around the painting. The viewing subject is invited to change position and not view the picture only from straight in front, which is not the same as becoming a decentred subject in the Lacanian sense. For Lacan, when the viewer (masculine) is teased into changing position and sees the anamorphosis as a skull, this momentarily denies castration/insecurity and offers the lure of a coherent, empowered subjectivity which can never be achieved. It is not clear whether Lacan intends his argument to apply to sixteenth-century as well as twentieth-century subjects.

CLAUDE CAHUN

The second image I want to discuss is a small photograph, a self-portrait made by a female artist working within radical European modernism in the 1920s and 1930s. By studying this image, we can see that the symbolic Cartesian subject of European modernism, supposedly unitary and autonomous, is in fact far more complex than has been suggested.

There are various reasons why artists represent themselves. Sometimes these are concerned with conscious issues of self-interrogation and identity. Sometimes it is easier to use yourself as a model, especially for women artists who want to deal with the naked body. Sometimes you want to make a work together with someone you are personally or professionally close to.

Lucy Schwob, better known by her alias of Claude Cahun, produced this image of herself and her reflection in a mirror in about 1928, probably in collaboration with her partner and step-sister, Suzanne Malherbe, alias Marcel Moore (plate 4). Cahun was born in Nantes in 1894, a member of a family of Jewish intellectuals and publishers.

By the time Claude Cahun was producing her artworks, both Marx and Freud had formulated modernist theories of the human subject in relation to society which were very different from those of early modern European thinkers. Marx, together with Engels, envisaged human subjects as active agents, who, in collaboration with others, could change the world for the better, ridding human society of exploitation based on the ownership of private property. Thus human subjects could cease to experience alienation and estrangement from both the products of their own labour and the unfulfilled experience of selfhood in a capitalist society. Freud, emphasising sexuality and its repression, stressed the role of the unconscious in the human psyche, thus envisaging the human subject not as a coherent, fully conscious entity, able to dominate nature, but as a self ridden with tensions, splits and suppressed desires.

In art, imagery could now be produced in new ways, including film and photography. Most of Cahun's work is photographic imagery, including photomontages. Cahun's self-chosen first name, Claude, can be either masculine or feminine in French, potentially unstable and vacillating between social expectations of masculinity and femininity. Her many photographic self-portraits also construct complex sexual identities which multiply the androgynous-looking artist in both single images and montages produced in collaboration with her partner. Her work is very 'staged': tableaux of herself in disguise, wearing different costumes, hairstyles, masks, make-up and so on. Cahun was also a writer and the author of an essay on art and politics, published in 1934 when she was politically active and close to a group of left-wing surrealists and other artists in Paris.[38]

The interest in Cahun's work paralleled the rise to international celebrity of the American photographer, Cindy Sherman, whose work was seen as characteristic of postmodernism in its reworking of the presentation of the 'author' and refusal of traditional approaches to self-portraiture. Sherman's untitled images of herself as a model, rather than a subject, from the later 1970s on, represented the artist using herself to make images within a discourse of femininity and its (dis)contents. Sherman took on the guise of young women posed in

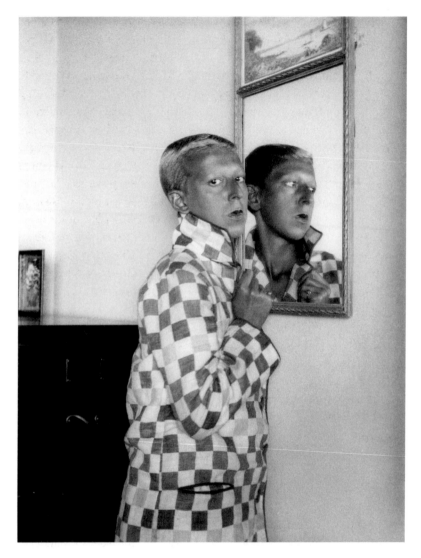

Plate 4. Claude Cahun, Self-Portrait with Mirror, *photograph, gelatin silver print, 9 x 6.5 cm, 1928, courtesy of the Jersey Heritage Trust, Société Jersaise Collection.*

various locations, crying, looking afraid, puzzled, daydreaming and so on. The earlier black and white images were replaced by larger saturated-colour photographs, as Sherman grew both more ambitious and more able to afford such technical experiments and outlay. Feminist and postmodernist critics were delighted to proclaim that there was no 'real' Cindy Sherman behind these simulacral images,

i.e. copies of scenes that never existed in the first place – the so-called *Untitled Film Stills* – were not from any films that were ever made. Obviously though, the scenes fabricated by Sherman had existed in front of her camera. Sherman was perceived to be immanent in the texts (photographs) she reproduced, not standing outside them, observing them like a consciousness anterior to the work.[39] Books were published including essays linking Cahun's and Sherman's works.[40] Despite the apparent similarity between the two photographers' works, though, their approach to subjectivity is rather different and the historical context in which Cahun was working in the inter-war period and during the Second World War in Nazi-occupied Jersey (Channel Islands) involved a more politicised avant-garde. As Abigail Solomon-Godeau has remarked, 'it requires almost more of an effort to re-situate Cahun in her actual time and milieu than it does to consider her work in the context of contemporary theoretical formulations about femininity, identity and representation.'[41] In my view it is a mistake to read Cahun's work as postmodern. Rather, her investigations of subjectivity and desire in collaboration with her co-worker and partner reveal that subjectivity and its representations in the modern period are not just about dominant notions of subjectivity, but also about negotiations of selfhood and identity from various gendered, classed and ethnically constituted subject positions. Approaches which take the interesting bits of modernism like interrogations of sexuality and gender, claiming them for postmodernism, merely try to ensure that the Devil gets all the best tunes, while at the same time impoverishing the achievements of modernist artists. Of course represented subjectivities in modernism will seem monolithic and repressive if we take all their radical and critical elements away and give them to postmodernism.

Cahun's photograph (which exists in several versions) can be discussed in relation to subjectivity, sexuality and representation.[42] The version illustrated here (plate 4) clearly indicates the difference between the figure and the reflection, which is partly why I have chosen it. In these post-Lacanian times, anything with a mirror invites a discussion of Lacan's theory of the formation of a (mistakenly) coherent image of subjectivity and the ego and I am not going to refuse such a temptation. Formulated in 1936, Lacan's theory suggests that the young child glimpses what it takes to be a unified or unitary image of her/himself, probably in the mirror, but perhaps in the loving gaze of the mother. This mistaken identification links the ego to the mirror image, which is a kind of trap for the subject, paralleling the trap

that the picture sets for the subject's gaze. From the beginning, the human subject perceives its identity as outside itself, or as an other. The so-called mirror phase also links this illusory identification with a coherent self-image to narcissism – desire of the self. As Elizabeth Cowie explains: 'We love and desire, in so far as we place the object of our love in the same position as our ideal ego. Thus desire emerges in identification which figures it as fundamentally narcissistic.'[43]

Freud believed that lesbians and homosexuals based their choice of love objects on themselves, thus they did not progress through a 'normal' transference of desire to the 'opposite' sex, away from same-sex models.[44] For Freud and Lacan, the narcissistic ego can take itself or a part of its body as one of its libidinal objects – this ego is not self-contained but depends on the subject's relations with the other, as Cahun's self-constructed images depend on being photographed and observed by the invisible Malherbe (Moore). Instead of being dominated by the demands of reality (as in Freud's more common model of the realist ego), the narcissistic ego 'is governed by fantasy and modes of identification and introjection, which make it amenable to the desire of the other'.[45] Cahun's use of disguises and the deployment of masquerades of femininities/masculinities in her photographic works embody the vacillating nature of subjectivity and socially constituted sexual identity. However, these are produced by a conscious agent in control of her own images in collaboration with the other of her desire. Indeed, as I have written previously, her photographs can be interpreted as realisations of this moment of desire and, perhaps illusory, momentary recognition.[46] Cahun turns from the mirror where illusory self-recognition lies and towards the photographer, perhaps herself with a time-delay or else her partner, Moore, who in turn receives recognition from the narcissistic look.

Cahun's desire for a same-sex love object is one aspect of her subjectivity, but a vitally important one. Sally Munt stresses the importance of writing as a lesbian: 'My thoughts are inscribed upon my butch body and my writing emerges from a commitment to that self; it comes out of the belief that this particular kind of speaking matters.'[47] Taking a distinctly un-postmodernist approach to the self, Munt is one of a number of contemporary scholars and critics who believe that the socially oppressed have little to gain from the notion of a fragmented, decentred self devoid of agency and she argues instead for a critical reappraisal of 'modernist' notions of the self and identity. She stresses the need to move beyond 'self-display into an engaging

personal materialism', seeking to find a way of writing and picturing as a person with an identity, yet at the same time avoiding bourgeois individualism.[48] Cahun managed this, I think, but goes further, combining this with political activism both during the 1930s in Paris and during the Nazi occupation of the Channel Islands during the Second World War. Her subjectivity was elaborated not only through desire but also through politics.

Constructing and deconstructing sexual identities in relation to producing artistic imagery is also of concern to contemporary painter Veronica Slater, who believes that the process of negotiating representation is a self-empowering one. She writes, 'I see sexuality as a fragment of "self" which is constantly re-encoded according to the situation in which it is experienced.'[49] As a student, Slater felt that the traditional narratives of painting's history, as seen in, for example, Sir Ernst Gombrich's *The Story of Art*, excluded her as a lesbian. She felt she had to work hard to reposition herself in relation to an artistic practice which could belong to her. She began to make use of reworked images from the work of male artists such as Francis Bacon and Michelangelo to make visible the position of a different 'self' in relation to various social identities – the artist, the lesbian, the daughter. This is clearly a different strategy from that of Cahun, but nonetheless similarly supposes a conscious agency critical of existing subject-positions and self-images.

MIRRORING THE SELF

We should also note that the mirror in Cahun's photograph functions as a real mirror, not merely a symbolic lure for the desiring subject. Mirrors were rare before about 1630 and were seen mainly in the homes of the rich and those aspiring to the lifestyle of the aristocracy, such as magistrates, merchants and the like. (While acknowledging the symbolic aspects of Lacan's 'mirror-phase', it is interesting to speculate as to what significance the availability of actual mirrors has for the historicity and class-specific applications of Lacanian theories of subjectivity in relation to the pre-modern period.) From the mid seventeenth century, the popularity of glass mirrors grew, despite their expense.[50] Clearly the mirror was of great interest to painters, especially for making self-portraits. Yet, with the development of photography, artists were able to dispense with the mirror in the making of self-portraits. The first photographs were etched by light on mirrors – silver

plates treated with mercury vapour – by the Frenchmen Niepce and Daguerre.[51] The mirror only provides a virtual image, not a real image. A virtual image is a view of something in the 'wrong' place, created by the bending or bouncing back of light. The virtual image in the mirror is different from a real image, projected on a screen, as in the cinema or a slide projection in a lecture.[52] The meaning of Cahun's image in the mirror depends on the presence of another subject. It cannot be seen by Cahun herself. Thus Cahun's image could also be read as a material embodiment of the redundancy of the mirror and the importance of the collaborative photograph in the self-representation process, as well as embodying the differences between virtual and real images.

Sabine Melchior-Bonnet remarks that 'The mirror acts more or less as a theatrical stage on which each person creates himself (sic) from an imaginary projection, from social and aesthetic models and from an appearance that all reciprocally sustain each other.'[53] The mirror facilitates the move from private to public in self-portraiture, as the artist can create the self-image in a fairly intimate setting and then display the work in public as a form of advertisement of portrait-making skills. The crucial role played by the mirror in the development of a professional persona and in negotiating social expectations of female subjectivity is indicated by the title chosen for a recent exhibition of women's self-portraits held at the National Portrait Gallery, London – *Mirror Mirror*.[54] It is, however, unlikely that self-publicity was an issue in Cahun's self-image, since she was financially independent and her photographs of herself were usually shown only to friends.

The relationship of women to mirrors has tended to differ from that of men. When a woman artist looks in a mirror, she encounters not just a technical aid to making a self-portrait, but a whole tradition which invites her to see herself as an object, as sexually attractive (or not), as slender (or not), or as vain and narcissistic (always). John Berger famously drew our attention to the western art tradition of self-appraising women looking in mirrors, which legitimised in a visually seductive way the objectification of women, the alienation and separation of self and image and the power of the male gaze.[55] Simone de Beauvoir, in *The Second Sex* (1946), suggested that 'Man, feeling and wishing himself active, subject, does not see himself in his fixed image; it has little attraction for him since man's body does not seem to him an object of desire; while woman, knowing and making herself object, believes she really sees *herself* in the glass'.[56] However, the conscious activity of the woman artist works against this objectification,

since she is also the creative subject and agent who constructs her own image, rather than reflecting outward appearances, as the mirror does. The mirror becomes a tool for the woman artist, like a brush or a camera. The mirror in itself is neither objectifying nor subjectifying. It is the human social and cultural relations in which it functions that are of prime importance.

Whitney Chadwick, in her discussion of female self-portraits, quotes French psychoanalyst Luce Irigaray who has commented that

The mirror almost always serves to reduce us to a pure exteriority – of a very particular kind. It functions as a possible way to constitute screens between the other and myself. In a way quite different from mucuses or skin, living, porous, fluid differentiations and the possibility of communion, the mirror is a weapon of frozen – and polemical – distancing.[57]

The mirror is thus linked to static images such as paintings or photographs, a surface that is flat, usually polished and not to be touched, since fingerprints will either damage it or trouble the image by foregrounding the material surface of the image and destroying its invisibility and illusionism. We should not forget that the mirror is a material object, not some kind of magical key to subjectivity or selfhood, despite its use as symbol and metaphor. The self/mirror relationship exists in a wider social context, where both objects and aspects of ourselves become commodities.

In her book on women's self-portraiture in the twentieth century, Marsha Meskimmon discusses how some contemporary women artists have subverted the traditional uses of mirrors signifying female vanity.[58] Cahun's image can also be read as a refusal of traditional pictures of female vanity. She looks towards the camera (and perhaps her partner behind the lens) and turns away from the mirror, refusing its confirmation of her appearance, which, in any case, is not particularly 'feminine'. Her hair is cut short and she wears a long jacket or coat with the collar turned up in a mannish way. She does not smile or invite the gaze of a viewer, yet recognises an other returning her look. There is a clear distinction between Cahun and her mirror reflection which seems to look away and is therefore more object than subject. If we reflect on de Beauvoir's comments on gender and mirror images, we can read Cahun's image as one which engages with, and troubles, notions of masculinity and the male gaze, femininity and mirror-images, seeming to oscillate between objectification and subjectification – yet

ultimately subordinating the mirror image within the constructed photograph produced by Cahun very probably in collaboration with her partner, Suzanne Malherbe.

EUGENE PALMER AND THE SUBJECT OF POSTMODERNITY

As already noted, modernist and/or Enlightenment concepts of the self have been discredited as ideological totalisations of white, male and middle-class subject positions, in contrast to a recognition of the subject as contingent, fragmented, decentred and hybrid.[59] I observed previously that some members of socially oppressed groups such as women, lesbians and gays and black people have not welcomed the demise of the supposedly unified and coherent subject without serious reservations. Nancy Hartsock has observed that:

Somehow it seems highly suspicious that it is at the precise moment when so many groups have been engaged in... redefinitions of the marginalised Others that suspicions emerge about the nature of the 'subject', about the possibilities for a general theory which can describe the world, about historical 'progress'. Why is it that just at the moment when so many of us who have been silenced begin to demand the right to name ourselves, to act as subjects rather than objects of history, that just then the concept of subjecthood becomes problematic?[60]

While it is true that many creative artists and writers find the notion of the multiple self a stimulus to the production of imaginative works, many others, including a number of women and black artists, also want to preserve a notion of the self/subject as a conscious agent interacting with a wider social community. Allan de Souza asserted that 'It is the desire for reconstruction of Self, whether as an individual, group or nation, that is the prime condition of the post-colonialist artist.'[61] Theories of the 'death of the author' at their most extreme can almost write the artist out of existence, resulting in the abstraction of a work from its context of production. It could also be argued that the 'death of the author' disadvantages women and black artists disproportionately.[62]

The self/subject continues to figure importantly in works by contemporary artists, as do other important concerns of modernist painting, for example, originality. I have discussed extensively elsewhere the debates over modernity and postmodernity in relation to the work of black artists.[63] What I want to do now is to look at

notions of the artist as a subject and the subject of painting itself, in relation to the work of Eugene Palmer. From different clusters of meanings around concepts of the subject, we can, I think, begin to tease out further implications of the tensions between the painted image as a representation of a subject, an 'expression' of the subject who made it and the embodiment of painting itself as a subject of our contemplation.[64] In addition, I see it as important to attend to the various meanings of self/subject in relation to the lived identities of artists and subjects whose experience is rooted in culturally rich communities, which nonetheless remain socially oppressed. Debates on the decentred subject and the radical potential for 'decentredness' have sometimes been making a virtue out of necessity. Is it not more necessary to assert the right of the socially oppressed to take up the centre, to be at the heart of art, culture and society, rather than on the margins, where black selfhood has often been relegated?[65]

The public perception of the artist's self/subjectivity is complex and necessitates negotiation by the artist with outside agencies such as art galleries and academic institutions, whose concerns for publicity, fundraising and/or the pursuit of knowledge and training will not necessarily facilitate the same constructions of subjectivity as desired by artists themselves. In addition, despite what appears to be an obvious interest in subjects/selves in Eugene Palmer's work (many of his works look like portraits and depict heads and shoulders of individuals), he insists that he is not a portrait painter.[66] Nor are his works self-portraits, though they are very much about him and his own subjectivity. We should be aware that there is a difference between an artist picturing him/herself in the work as a means of linking the self to the subject of (the) painting and the engagement of the self with the work in other ways.

Eugene Palmer was born in Kingston, Jamaica in 1955 and arrived in Britain as a teenager, going on to train as an artist. The figure and the face are central focal points of his work, yet, as noted above, he resists the designation of portrait painter (colour plate 2). Facial images are powerful in his work, yet the old term of 'face painter' (by which portrait painters were known in previous centuries) is not applicable here, though he tantalisingly almost dares you to call him one. Although Palmer paints his family and friends, he does so by choice, not because they are patrons and commission works from him. His independence is important to him, as he sees this as a major difference between portrait painters and the kind of painter he seeks to be.

Leaving college in the 1970s as a non-figurative painter, Palmer wanted to bring tangible contact with the real world into his work and for this reason he turned to the painting of people. However, he feels there is little interaction between himself and his models and he generally uses photographs to paint from. He claims that there is no sitter in his work and though his works happen to depict people, they are primarily paintings. We might be tempted to read this as the disappearance of the modern subject/self. But this process is accompanied by the artist's stated aim of returning to the world of material reality, rejecting non-figurative art, so Palmer's development is a complex process. His paintings are images of black people, but refuse the designation of individual portrait identities and they are not Black Art, in the sense of being 'about' black issues. Also the works intentionally emphasise a split between external appearance and 'interior' of the painted and painting subject.

In an earlier work from 1993, *Index*, Palmer represented his mother dressed in a short, fashionable frock next to draped curtains and broken architectural and sculptural relics of the European classical past, reminiscent of 'grand manner' portraits.[67] Successful though this work is, inserting the artist's Caribbean mother in the elite tradition of European aristocratic 'Grand Tour' portraits, Palmer felt that the expansive brushwork and 'painterly' style necessitated by this type of work with its references to eighteenth-century portraiture was culturally coded as too emotional for his liking. The artist now feels that the expressive and fluid brushwork of his earlier canvases was open to interpretation as too revelatory of his own feelings and involvement. He has stated that he did not wish to show so much of himself in the painterly language that has become a sign for self-expression. His more recent works, therefore, are painted in a much cooler, seemingly detached way, in order to signify a self which is controlled, thoughtful and cerebral. The artist took this decision partly in order to counter stereotypes of black artists, particularly young males, as emotional and given to outpourings of uncontrolled feeling.

Palmer's more recent works can be read as an attempt to minimise the presence of the artist's self, through a 'neutral' manner of painting, or, as a strategy of painting images which signify a different kind of subjectivity on the part of the artist. Paradoxically, the recent works focus on large painted images of a subject/self, at the same time as minimising the expression of the artist's self. The paintings now work as if they were linguistic signs – as the artist puts it, 'The way it's said is important but not who said it.'[68]

EXPRESSIVE PAINTING

The critic Hal Foster has written that expressionism in art has become a kind of language which functions as an ideological sign of creativity and individualism.[69] Writing in the mid 1980s, Foster argued that the artist is the effect or function of his expression, not the originator. The artworks 'speak him rather more than he expresses them'.[70] I am not particularly convinced by this argument, especially his view that expressionism in art originally carried little ideological baggage. However, he does provide a useful critique of a powerful, but flawed, argument within art history and criticism, namely that the self of the artist is directly expressed through particular kinds of art-making, for example, garish, unnatural colours, thick paint and apparently violent manipulations of the materials used. Eugene Palmer clearly shared this view of 'expressionistic' paint handling and its connotations, when he decided to change his technique.

The artist and writer Terry Atkinson has also produced an extensive critique of the ways in which art teaching contributes to the persistence of ideological myths of the subject and his/her expression in art. He criticises the notion of the artist as 'an ideologically unyoked, centred subject' and the approach to art which seeks to read the artistic text using a theory of 'expressive realism', i.e. the artist reflects the reality of experience in his work, which is then recognised as profound and true by other individuals.[71] Atkinson has also put his theories into practice by making works designed to critique notions of the centred subject and its manifestation in art. In *Work by Split-Brain Artist* (1994) and *Cartesian Double-Sided 'I' – Inner/Outer – The authenticity of Signature Expression* (also 1994), Atkinson sought to provide antidotes to what he saw as 'the Cartesian model of the artist'. By using slide projectors, a video player and a printer with large Styrofoam panels, distorting mirror mechanisms and an audiotape, the artist himself questioned the *author*ity of the *author*ial voice of the artist (something of a contradiction, I feel). Discussing these works, David Green comments on Atkinson's interrogation of the artist's signature:

For if the signature is essentially unique and inimitable it is also, paradoxically, necessarily imitative, repetitive and citational. Thus the signature always involves the doubling of an act, a positioning of the self, as it were, in quotation marks. Rather like the enunciative 'I' filled by the subject who speaks and who, in so doing, calls his or her person into being, the signature is a matter of re-

enacting the self, in the sense of playing out, or impersonating. In this sense, the signature is always counterfeit.[72]

These works by Atkinson do not offer the viewer much in the way of sensual pleasure (the materials are cold, hard and unwelcoming), presumably to avoid drawing the spectator into a particular 'subjective' relationship with the work. They remain somewhat cerebral and I feel that there remains much to be done in terms of combining Atkinson's brand of demanding critical theory with seductive artistic practice – the latter need not necessarily be ideologically corrupt(ing).

SIX OF ONE

Six of One, made in 2000 by Eugene Palmer, is a series of six large oil paintings, each 97 x 100 cm (colour plate 2). Though, once again, these are based on a photograph of a member of the artist's family, Palmer maintains that they are not portraits. So what are these paintings about? Why do the facial images of this human subject engage us at the same time as they question individuality, uniqueness and selfhood?

The title, *Six of One*, refers literally to the six paintings of one photograph. Minute differences can be discerned in each painting as the viewer begins to sense the time and care devoted to the painting of this face, which takes on an increasing intensity accentuated by the scale of the group of images and the literally 'in your face' composition. There is little hair visible and nothing to distract us from the intense contact and confrontation with the subject's features. Even the pleasures of colour are absent, as the paintings are executed tonally in grey, black and white. Yet the title also brings to mind the expression 'six of one, half a dozen of the other', with its meaning of 'it doesn't matter', 'it's all the same really'. This could suggest various connotations – that the pictures are all the same, that black faces are all the same, that black people are 'other', or perhaps that there is no difference after all between the self and its supposed 'other' – between the subject of the paintings and the spectator. Yet the works ironically preserve the 'aura' of originality and authenticity at the same time as they seem to deny it by repetition.[73]

Eugene Palmer's concern for painting works to preserve the authenticity of the picture, while repeating it almost as a celebration, rather than a denial of its presence. His commitment to painting as a medium is apparent in the catalogue of the exhibition in which these

six paintings were shown.[74] While many contemporary artists use new technologies and photographic software, Palmer sees the act of painting as essential to the construction of his subjectivity as an artist.[75]

In his discussion of how ideology interpellates (calls to) individuals, thus bringing them into being as subjects, the French philosopher Louis Althusser argued in 1969 that ideology had no history. By this he meant that all societies need ideology as a kind of glue to hold individuals together.[76] He argues that people are made into subjects by ideology; that it constitutes individual people as subjects: '*all ideology hails or interpellates concrete individuals as concrete subjects*, by the functioning of the category of the subject.'[77] Althusser's notion of interpellation has been utilised for the analysis of advertising images, but less commonly for paintings and the ways they address the viewer as subject.[78]

How then might we understand the interpellation of the viewing subject in these six paintings? The address to the viewer comes not from one, but from six apparently identical sources, which immediately disturbs the notion of the unified subject. The force of the address is there and seems to demand a response from the viewer, but what subjectivity is constituted for the viewer thus addressed? Is the viewer 'called to' as a black viewer, a woman, a man or some other kind of viewer? If there is really nothing present in the images other than painting, it is doubtful that the ideological thrust they embody is particularly strong. Does this then mean that the spectator of these works is not addressed as a subject in the Althusserian sense? I believe the answer is yes. The artist has spoken of addressing his paintings to 'a part of an individual that I'd like to reach – a thoughtful part where the work can test ideas and theories, for myself and my audience'.[79] However, it seems to be that though the artist has changed his mode of painting compared to his earlier works, issues of ethnicity and subjectivity are still crucial elements in his work. Perhaps what he is doing is succeeding in painting subjectivity, including his own, in a way which avoids ideology and obvious ethnic identity and reaches a 'thoughtful part' of each individual viewer.

It is also important that, for Palmer, the ownership and control of the painting process and the image rests with the artist, not the sitter or the patron, though clearly he sells some of his work to make a living. Nonetheless, I feel there remains in Palmer's work a (fruitful) interplay between the picture as a painting (of anything) and the picture as a representation of a person (portrait). For Palmer, the artist needs the freedom to choose how to paint his own subjectivity, even if that

means an effacement of cultural signs of subjectivity from the mode of painting employed, as embodied in the coolness and detachment of *Six of One*.

BLACK SUBJECTS

It is over fifty years since Frantz Fanon published *Black Skin, White Masks*. He analyses how a black person's sense of self becomes distorted and alienated under the social, cultural and economic relations of colonialism. Fanon, as a socialist, believed in the possibility of freedom through political action, accompanied by the bringing into being of a human, non-alienated self, free from racism and oppression. Attempts have been made to recreate Fanon as a postmodernist devoted to the study of fragmented and hybrid selves detached from their social and economic contexts.[80] It is clear, however, from Fanon's comments that he viewed the self as a site of conscious agency and human potential. He writes:

Sealed into that crushing objecthood, I turned beseechingly to others... But just as I reached the other side, I stumbled and the movements, the attitudes, the glances of the other fixed me there, in the sense in which a chemical solution is fixed by a dye. I was indignant. I demanded an explanation. Nothing happened. I burst apart. Now the fragments have been put together again by another self.[81]

Fanon concludes: 'It is through the effort to recapture the self and to scrutinise the self, it is through the lasting tension of their freedom that men will be able to create the ideal conditions of existence for a human world.'[82] A new self is possible once the alienated self has been burst open and reformed.

Jagjit Chuhan emphasises the importance of painting her 'real self'. Discussing her painting *Self Portrait 11: 'Living and Painting'* (1996), which includes an image of the artist when heavily pregnant as well as a representation of her daughter, Chuhan speaks of her concerns at being pigeon-holed as a black artist because of her Indian heritage. This has resulted in her determination to refuse a post-colonial, postmodern subjectivity and construct what she perceives to be a more authentic image of her own selfhood through her painting: 'Now I feel that I am rebelling against a post-modern role which has been placed on me by others... In my self-portraits I am actually showing myself how I really am, not how convention tells you to be.'[83]

However, it is clear that the context in which Fanon was writing (in 1952) has changed. Notions of the self are different in a postmodern (or more correctly late capitalist and imperialist) age, driven by global capitalism and consumerism on a wider and more crisis-ridden scale than in Fanon's day. Radical post-colonialism has changed little of these fundamental conditions of economic exploitation. The validation of subjectivity through the identification with and purchase of, goods, is perhaps more insistently present now. Yet it is evident that for many of us, the self as a site of agency and interaction with others in a non-exploitative way (not the self/other relationship) remains important.[84] Subjectivity and its representations may have altered since Fanon's time – it is clear that with changes in society this is inevitable – but they remain a central focus of artists' concerns. This is especially true, I would argue, of works by black and women artists, who still remain disadvantaged in terms of society in general and the art world in particular.

There is clearly more work to be done on the question of subjectivity in relation to notions of 'race', gender and class. It is important, however, while focusing on the subject/self, that we do not lose sight of the wider context in which subjectivity and its representations exist. In an interview with the artist Sonia Boyce, Manthia Diawara asked about representations of self and identity in Boyce's work and the viewing subject addressed by her images. Boyce replied: 'First and foremost I speak to myself. Which isn't as solipsistic as it sounds: I speak to myself because of what's going on around me.' She then went on to say how important it was for her to move beyond the self:

Am I only able to talk about who I am? … Are we only able to say who we are and not able to say anything else? … I want to find out what other things I can talk about. I no longer want to describe who I am… the arena is much bigger than that.[85]

For many black and women artists, it is impossible to conceive of the self as a concept isolated from a wider context, because that wider context is so significant for the formation of the self and its meanings and because that self acts upon the wider context.

CONCLUSIONS

Whereas modernity in philosophy is variously located in the seven-teenth or eighteenth centuries, modernity in painting is usually said to begin in the nineteenth-century urban centres of capitalist Europe,

especially in the Paris of Edouard Manet and Charles Baudelaire. Now this is not the only approach to locating modernity in painting, but it indicates a disjunction between developments in different spheres of culture. It would be mechanistic to expect all spheres of human activity to simply reflect one another, or ultimately be reflections of a crudely drawn, undialectical relationship between economics and culture.

However, concepts of subjectivity and indeed lived experiences of subjectivity have changed in different historical and social situations, modulated by class, gender, sexuality and ethnicity. Within modernism itself (as in the works of Claude Cahun) differing representations of subjectivity were constructed and interrogated. A Cartesian model was not utilised, consciously or unconsciously, by all artists in the modern period, perhaps not even by a majority of them. If Cartesian subjectivity is equated with the use of one-point perspective, then that generalises the argument and every painting based on this method of representing space can be designated as Cartesian. I do not subscribe to this view. Perspective is not the whole of art, nor is Descartes' *I think therefore I am* the sum total of modern thought on the conscious self.

However, we need to take care not to fall into the trap of relativism here and deny the existence of any coherent explanation for changing views of the subject, or any means of identifying them when they occur. To use some Marxist terminology here, when can we discern a qualitative change in representations of subjectivity and positioning of viewing subjects (e.g. the dominance of one-point perspective) as opposed to a quantitative one (e.g. the increase or decrease of large numbers of realist half-length portraits of individuals)? Ultimately, such changes should be understood in the light of economic, social and ideological factors as well as cultural ones.

Even in early modern times, subjectivity was not a simple issue, nor was its representation, as we have seen in the case of *The Ambassadors*. Periodisation of cultural changes in the representations of selfhood also needs some careful reconsideration. Despite the persistence of aspects of modernism within the so-called postmodern period in the later part of the twentieth century, I do think it is possible to locate a shift in attitudes to the self and its representation in recent decades, as in the work of Eugene Palmer. However, whether this can be described as a decentring of the self or as the demise of the Cartesian modernist self is open to debate. In the following chapter, I want to take up these issues in relation to contemporary artworks.

CHAPTER 3

BODIES AND SELVES

You don't need help from nobody else

All you got to do now

Express yourself

[...]

Some people have everything and other people don't

But everything don't mean a thing when it ain't the thing you want

Express yourself.

Charles Wright and the Watts 103rd Rhythm Band, *Express Yourself* (1972)

In this chapter, I want to consider issues of the body and subjectivity in relation to the work of three contemporary artists working in Britain: Tracey Emin, Marc Quinn and Alexa Wright. During the recent turn to postmodernism in radical culture, the self has been revisited by visual artists, but has not been rejected. Indeed it is possible to argue that artists' sense of selfhood is as strong as ever. Accompanying the persistence of the self in art, consumerism has increasingly been seen as a means of self-validation, at a time when left-wing political activity, a more traditional form of social and self-empowerment, has been in decline.

Exhibitions and published material on visual arts and the self often relate to the body. Numerous books and articles on selfhood and subjectivity written by sociologists, philosophers, psychoanalysts and cultural theorists have been published in the closing decades of the twentieth century.[1] In fact, as N. Mansfield has intelligently remarked:

When trying to see the theorisation of subjectivity as a cultural phenomenon in its own right, what is interesting is something quite different: the *subject has had*

its meaning endlessly theorised and proliferated only after being declared dead.
In other words, the subject has become an absolutely intense focus of theoretical
anxiety at the same time as it is said to be over... everywhere in our art, our
entertainment, our popular psychology and journalism, the self is represented as
absolutely important but somehow insubstantial, even absent.[2]

A number of artistic and cultural projects have examined subjectivity
and the visual arts, from exhibitions to symposia.[3] Publications on
subjectivity and visual culture, though much smaller in number than
those in other disciplines, reflected an interest in this most fashionable
of topics, whether accompanied by bodies or not.[4] However, it was the
body that, ironically, proved to be the most fascinating artistic trace of
the self, despite the ongoing denigration of the Cartesian separation of
mind and body. Just in case any of us felt sympathetic to Cartesianism,
Roy Boyne recently reminded us that the bogey-(wo)man Cartesian
subject is 'a creature of instrumental reason. He or she is a construction
well known to economists, military commanders, works managers and
police forces, to name just some of the more obvious instances.'![5]

The interest in exhibitions about the body (usually divorced from the
mind) in recent years has been analysed in various ways. In 1995, art
critic Andrew Wilson interpreted body art, for example the mannequins
of Jake and Dinos Chapman, as a self-defeating reaction to postmodern
theories which argue that the pursuit of self-knowledge has been
displaced by the superficial circulation of images. However, this turn
to body art merely produces 'an illusion of enquiry and communication
rather than the real thing', thereby leaving issues of meaningful
knowledge and communication as elusive as ever.[6] Other body images
in art are not three-dimensional forms or based on body casts, but are
two-dimensional images, often representing body parts or close-ups
of corpses, as in the photographic works of Joel-Peter Witkin, or the
'morgue' series by Andres Serrano. In this kind of 'post-mortem' body
imagery, argues Rachelle Dermer, we are 'protected' from interaction
with other subjects. Viewing these images, we enjoy 'satiating our
appetites for bodies without the burden of intersubjectivity'. Yet, adds
Dermer, our own sense of self is heightened, contrasted with the non-
being of the dead and objectified.[7]

A major exhibition on the body at the Hayward Gallery, London in
2000–2001 included paintings, anatomical illustrations, wax models
of dissected bodies and various works by contemporary artists which
responded to historical material.[8] Again, one critic felt that the

contemporary body art, in this case a model of a partially dissected corpse by John Isaacs, was 'mere spectacle'. 'It is grisly, but not so grisly as a photo of a hacked-up corpse from a war zone.'[9] It is not surprising that exhibiting objects makes them into a spectacle, but a major issue here is that these 'body' artworks are not people. There is indeed no 'intersubjectivity' between the viewer and the work, since the artwork is always a made object. Probably the continual search for the subjectivity of the maker buried somewhere in the work is an attempt to invest the art-object with a communicative potential with which we can interact.

Concerns have been voiced over the moral issues raised when contemporary artists plunder their own bodies to seduce the contemporary art market: 'In this business, the viewer, the critic and the curator claim the body in a sinister way,' stated one academic. She asked 'What happens when the distinction between the body of art and the art of the body is eroded – and where are we going?' Despite the sensual attraction of many artworks based on, or composed of, bodies, this currency of the artists' bodies in 'a climate of exchange' may be problematic.[10]

Writings and artworks dealing with the body are often made with a specific person's body in mind, not just an abstract notion of the body. This can be especially important for groups that have been culturally and economically objectified and denied subjectivity in the past. The following extract from an interview between Jaki Irvine and Turner prizewinner and film-maker Steve McQueen makes this point clearly:

JI I am thinking about this idea of the body. I could be wrong... but when I am thinking about a body I am thinking about somebody.

SM (applauds) Absolutely, cut all the other shit out and just put that in.[11]

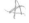

Michel Foucault's view of bodies as always constructed by regimes of power and social discipline, ultimately offers us abstract bodies, not embodied agents or subjects.[12] According to post-structuralist theories, socialised bodies are disciplined, conceptualised as clean, with integral boundaries to separate off our subjectivity from the rest of the material world. There is a continual dialectic not only between subject and object, but also between subject and *abject*, Kristeva's term for the materials and processes which threaten to invade or breach the boundaries of our bodily selves, like vomit, blood or semen. For Kristeva, the socialised and culturalised subject is continually

producing itself in a clearly bounded envelope: 'There is no selfhood without a simultaneous abjection.'[13]

The decision to represent people as bodies is part of a process of objectification. I remember being at the funeral of a dear friend years ago when my elder son, then very young, asked me where Derek was. I replied that his body was over there in the coffin. My son then asked, 'Where is his head?' Without the head and brain, we are not conceived of as subjects, but as just bodies, just matter, which is assumed to be inert. This conception is part of most people's everyday, 'common-sense' assumptions. The problem with a Cartesian conceptualisation of the mind and body as separable is that it can lead to the view that the mind is not part of the (brain) matter of the body, but some kind of abstractable essence, with which God has endowed us.

QUESTIONING THE POSTMODERN BODY

Fascination with bodies is not a new phenomenon in human culture, so what makes the postmodern interest in the body so different – so appealing, at least in countries where capitalism is highly developed? In an excellent discussion of subjectivity, Terry Eagleton comments that the vogue for the body, though highly visible, is a partial and ideological cultural phenomenon:

The postmodern subject, unlike its Cartesian ancestor, is one whose body is integral to its identity. Indeed from Bakhtin to the Body Shop, Lyotard to leotards, the body has become one of the most recurrent preoccupations of postmodern thought. Mangled members, tormented torsos, bodies emblazoned or incarcerated, disciplined or desirous: the bookshops are strewn with such phenomena and it is worth asking ourselves why.

Some bodies are trendy, some are not. Eagleton continues:

For the new somatics [studies of the body], not any body will do. If the libidinal body is in, the labouring body is out. There are mutilated bodies galore, but few malnourished ones... for the new somatics, the body is where something – gazing, imprinting, regulating – is being done to you. It used to be called alienation, but that implies the existence of an interiority to be alienated, a proposition about which some postmodernism is deeply sceptical.[14]

The rejection of the Marxist view of alienation, the fundamentally dehumanising experience of the subject in a capitalist society, means

that postmodern theories of subjectivity have problems with the relationship of mind and body. At times, the body can almost become fetishised, standing in for an absent subjectivity, an absent agency. The Cartesian subject is condemned, and the Marxist goal of non-alienated subjectivity is dismissed as a myth fabricated by a discredited 'master narrative'. The more thoughtful cultural critics and historians try to theorise an embodied subjectivity and agency which will try to preserve some potentially radical relationship between the two (which still seem to remain two) entities, the subject and the subject's possession, his/her body.

Benjamin Buchloh has also commented on the reasons for these many debates on subjectivity, embodied and otherwise:

> However, before one enters into an eager theoretical embrace of the decentred subject one should also reflect on the external conditions that necessitated the dismantling of the traditional concepts of a humanist bourgeois subjectivity. After all, a complex historical dialectic operates between the then emerging structuralist and socialist models that aimed to dismantle bourgeois subjectivity and an accelerating late-capitalist agenda that aims to systematically foil the formation of subjectivity under the auspices of an emerging and increasingly enforced, consumer culture.[15]

It is probably more accurate to say that a late-capitalist agenda seeks to replace active subjectivity with a more passive, consumerist self-fashioning.

BODY WORLDS

In early 2000, Anthony Noel Kelly exhibited his work at the Anne Faggionato Gallery in central London. Kelly had been jailed in 1998 after he persuaded a trainee lab technician at the Royal College of Surgeons to steal body parts on his behalf. The remains were then buried in the grounds of his ancestral home in Kent (he is a cousin of the Duke of Norfolk) after having been used to make moulds for sculptures and photographs. Kelly, a former butcher and abattoir worker, was later able to reclaim artworks confiscated by the police due to a legal technicality. Kelly claimed that the police had 'basically raped my studio'.[16]

While Kelly's case was of passing interest, a more recent case of exhibiting bodies has resulted in paying crowds flocking to view the show. Over the Christmas period 2002–2003, one of the most popular

attractions in London was the *Body Worlds* show in the Atlantis Gallery in East London, where Professor Gunter Von Hagens organised a show of plastinated corpses cut open and arranged in lifelike poses – for example playing chess or riding a horse. The bodies are permanently preserved when fluids are drained and replaced by plastics making the bodies rigid and odourless. The process is carried out in China by workers trained by Von Hagens. A television programme investigated Von Hagens and his work and newspaper articles have reported on alleged suspicious circumstances pertaining to the origins of the bodies.[17] By having the bodies prepared in China, not only are costs much lower than they would be in Europe, but China has a very poor record as regards human rights and selling human organs. Large numbers of prisoners are executed there, some, allegedly, for their body parts.[18]

Doubts have occasionally been raised as to how bodies from Siberia may have ended up in Von Hagens' show. During a broadcast on Russian television featuring von Hagens' display, tattoos in Cyrillic script were clearly visible on one of the exhibits, according to one report.[19] It is believed that the corpses and limbs may have belonged to homeless and mentally ill Russians whose remains were unclaimed by relatives. Despite many people offering to donate their (dead) bodies to the professor, relatives of dead children whose organs were withheld without permission by British hospitals in Liverpool and Bristol spoke out against the *Body Worlds* show, feeling that the integrity of bodies after death should be respected. The show has been hugely successful financially, earning Von Hagens more than £50 million.[20] One journalist found many interesting comments in the visitors' book and concluded that the most important thing he learned was that the 'mind is much more entertaining than the body'.[21]

This uneasy mixture of showmanship, science and consumerism raises several issues. Firstly that it is still basically the bodies of the poor, the dispossessed and the criminalised that are the raw materials for anatomical displays. Available corpses appear to be easier to find in countries where recent economic and political changes have created more social and economic outcasts, who are viewed as less complete 'subjects' with fewer civil rights than others. Interestingly, the two involved in Von Hagens' case are former Stalinist, post-capitalist, states, newly recolonised by the previously restricted, but now unfettered, market economy of capitalism. Discussions of 'the body' are not terribly helpful in the abstract and the bodies in question need to be materially situated, not just debated 'in theory'. Also, bodies are still commonly

viewed as crucial to the individual rights and integrity of selfhood and identity of the dead. At the same time, however, the bodies are seen as 'just bodies', purely material objects and the mind as something separate and 'more interesting', a seemingly Cartesian approach. Thus in contemporary popular culture, it does not appear that postmodern notions of the body and subjectivity have much relevance in everyday perceptions and usage. In terms of the use of bodies of prisoners and the homeless, for example, we are talking about traditional ways of procuring bodies current in the eighteenth and nineteenth centuries, if not even earlier. Regardless of motives, Von Hagens' exhibition has raised important questions about subjectivity and the body in contemporary culture.

BODY AND SURFACE

As mentioned above, the provenance of one of Von Hagens' corpses was traced through the presence of a tattoo. The tattoo, whether freely selected by individuals, or forcibly marked on the body, has increased in popularity in recent years and is no longer a mark of the traditional 'outsider', signifying criminality, 'otherness' and working-class masculinity. Recent work on tattoos has looked at the skin and its role as a kind of boundary of the body and the self. The skin is both outside and inside the body, a sort of envelope for it, an interface between the self and others, private and public sensations. The main writings on skin (though not, interestingly, those on tattoos) utilise the work of Didier Anzieu and his influential book *The Skin Ego*.[22] Anzieu develops Freud's view in the 1923 essay 'The Ego and the Id' that 'The ego is ultimately derived from bodily sensations, chiefly from those springing from the surface of the body. It may thus be regarded as a mental projection of the surface of the body, besides as we have seen above, representing the superficies of the mental apparatus.'[23] The ego is thus formed by both the interior and the exterior of the material self.

Basing his model of subjectivity on the body as opposed to language, Anzieu's view of the subject differs importantly from that of Lacan. Rather than being structured like a language, the self is seen as structured like a body.[24] Anzieu argues that the child must gradually separate him/herself from the common skin shared with the mother in order to develop an independent ego, 'a recognition of which does not come about without resistance and pain. It is at this point that phantasies of the flayed skin, the stolen skin, the bruised

or murderous skin exert their influence.'[25] However, Anzieu speaks
in rather universalist terms and care needs to be taken to ask, 'what
the specific historical situations are in which skin comes to matter'.[26]
I find Anzieu's theories useful in that they relate the skin directly to
subjectivity and do not view skin simply as an exterior surface of the
body which can be decorated by, say, cosmetics. This is why Anzieu's
theories are useful for the consideration of tattoos, since they are part of
the skin, not just a temporary decoration on its surface and are normally
selected through conscious planning on the part of the subject.[27]

Susan Benson points out 'it can only be through the body that the
individual can understand her or himself to be a self. Identities may be
fluid but the too, too solid flesh of the 1990s is definitely *not* melting:
indeed much work has gone into ensuring that it should not.'[28] For
some, expensive tattoos are forms of consumerism, like designer suits
and Rolex watches.[29] At the other end of the scale, Benson comments
on the 'haphazard and incoherent nature of early twentieth-century
tattoos', a result of lives that were often similarly unplanned and
fragmented.[30] This absence of a 'master narrative' of the self on the
skin is not an early form of postmodern subjectivity, but rather the
result of not having enough money, or the desire or possibility to
conceive an overall plan for the future, hence tattoos are obtained
and added in a piecemeal way, filling up different spaces on the body
when the opportunity arises. Linked to the tattoo is a strong feeling
of *individuation* – as one person put it, 'a declaration of me-ness'.[31]
Tattoos can act as a private narrative: signs of remembered events
– internalised/externalised as a mark on the subject's skin. Benson
comments that tattoos can be linked to the over-valuation of certain
aspects of contemporary western ideas of the self, autonomy, self-
fashioning, consumerist customisation, but also to their transgression.
The permanence of tattoos and scars is fundamentally anti-fashion and
its valuation of transience:

Now none of this looks much like the flexible, mutable personhood celebrated in
so many post-modern texts; on the contrary what seems to be central is the fear of
fragmentation, anxiety about boundaries and about the relationship between will
and self; the body is the battleground in which such anxieties are played out.[32]

Benson distinguishes between the tattoos of the middle class and
those of the marginalised and disempowered, which she correctly sees
as different in quality – written and pictured on subjects whose world

is confined more closely to the capacities of their bodies, subjected to the disciplinary gaze of others. In the latter case, argues Benson, the tattoos indicate that the fantasies of permanence and autonomy implicit in western ideas about subjectivity are impossible.

In Anzieu's view of the skin ego, it is crucial to separate (perhaps painfully) your skin from that of the (m)other in order for the autonomous ego to be formed. With tattooing, piercing and scarification, various degrees of pain from the barely noticeable to the awful, mimic that heightened awareness of self-construction. The very skin which contains and proclaims subjectivity becomes consciously marked with its traces, not just unconsciously present as its silent witness.

TRACEY EMIN

Despite the so-called 'death of the author', it seems that the self is alive and well in the world of art. The young British artists (yBas) in particular have been associated with autobiographical self-promotion. One critic, Jonathan Jones, called on British artists to shun the 'glamorous narrative of the naughty self' and 'take the ego out of art' with a view to emulating the 'self-effacing seriousness' of European modernist artists.[33] Another stated that ever since Romanticism we have known that 'Art is about the Self.'[34]

Tracey Emin is perhaps the most famous example of a contemporary artist whose work and persona seem in total contradiction to the supposed demise of subjectivity in contemporary culture. Her celebrity status and the commodification of her 'self' and her works merit consideration in any book dealing with the self and art.[35] What kind of self is represented by Tracey Emin and her art? If this subjectivity is not postmodern, then what might it be?

In 1991, Linda Klinger wrote an article articulating her concerns about authorship and feminist art practice. Klinger argued that works by such artists as Clarissa Sligh interrogated selfhood and identity, as well as the institutional conditions that produced models of authorship, thus paralleling some of the concerns of post-structuralist and postmodern theory. However, she also felt it was crucial that 'no artist should be begrudged her identity – an identity which is rooted in social reality and the *politics* of authorship.'[36] Tracey Emin's work clearly relates to authorial identity and related social and cultural issues. While some critics dismiss her work as simply the unmediated outpourings of someone seeking publicity at all costs, others admire her honesty, at

the same time as recognising that there exists a gap between the author of the artwork and the self of Tracey Emin.[37]

Yet Emin herself has a somewhat contradictory attitude towards the relationship between her own subjectivity and her art. She insists that her art *is* constructed, sometimes painstakingly, as in the appliquéd blankets for example, and at the same time that she *is* her artwork. Part of her struggle as a creative artist, she has stated, was to solve the problem of 'why isn't my art like me?' and to raise the level of her art to an equal level with herself, as she put it in a radio interview.[38] In another interview for television, she returned to this issue and the moment when she realised that 'I was much better than anything I'd ever made' and that 'I was my work.' For this reason, 'After I'm dead my art isn't going to be half as good… It's impossible.'[39] By this, I think she means that she won't be there to talk about her art, to be a living part of it, to represent her art in the sphere of broadcast culture and thus a crucial part of the art will be gone forever. Emin thus sees her art in a very different way from the usual approach to, say, looking at a Titian painting or a Rembrandt, or even one of Emin's favourite works, *The Scream* by Edvard Munch, where we still think the isolated paintings are great works and we have completely accepted that the authors' deaths have not changed that. Indeed physical authorial death almost inevitably enhances the monetary value of the work and often its cultural prestige as well. Emin also speaks of 'the essence of the way I am' and at the age of fifteen 'stopping shagging' as she reached what she calls 'the age of reasoning', though she maintains she still thought with her body.[40] Her shows are reviewed as if they epitomise notions of a modernist, rather than a postmodernist self. Samples of review article titles include 'The Story of I' and 'Me, me, me, me, me'.[41] The artist herself referred to an installation from 1996 where she lived naked for a fortnight, as being 'about the ego and the strength of the ego'.[42]

Some of her video works have shown split subjectivities, as for example in *Interview* (1999), where a sexy Emin in a black petticoat smokes while being interrogated by a more responsible Emin wearing a zip-up hooded sports top and jeans. *The Bailiff* (2001) shows a leather-jacketed and tough Emin banging on the door threatening the Emin inside, who cowers behind the door and puts the safety-chain on. Her self-portraits have included *My Bed* (1999): 'It's a self-portrait, but not one that people would like to see'; and a wooden construction of a helter-skelter with a stuffed sparrow about to fly away, entitled *Self-Portrait* (2001).[43]

At the same time, however, the self-confessional aspect of her work has its limits. She stated, 'I don't really want anyone to come in here – to come inside of me – to be inside my mind.'[44] Art and life are not necessarily the same, she says, pointing out the need to 'draw a line between what works as a metaphor and what doesn't, what is actually real and what isn't...'[45] Despite trying to get her work to coalesce with herself, perhaps Emin realises that this is an impossible project and that when anyone constructs something, it can never be equated with subjectivity since it is something other, outside of and apart from, the maker. In art, the possibility for this coming together of self and work is a tantalising one, sometimes apparently and temporarily realised, though never totally fulfilled. As regards the more usual commodities made in capitalist societies, such as loaves of bread or cars, the promise of becoming one with the products of your own labour really is never on. This contradiction is at the heart of Emin's work, indeed of almost all art. She speaks of her freedom and financial security with pleasure, while accepting that her dealer, Jay Jopling, takes a huge cut from the sales of her work, as all dealers do.[46] It is clear that the supposedly direct autobiographical outpourings of Emin, which imply a simple model of subjectivity, are not as straightforwardly readable as we might suppose. Yet, while Rosemary Betterton has pointed to the 'contradictory and ambiguous sense of self' which is mobilised by Emin's work and persona, she is also acute in drawing our attention to the positioning of this sense of self in a commodity culture, where, as Jane Beckett notes, the work of young contemporary artists makes visible 'a cult of subjectivity, the cultivation of the self and its public identities, which has much in common with contemporary advertising and media strategies for representations of masculinities and femininities'.[47]

PREGNANT WITH MEANINGS

Emin's work deals with the subjects of pregnancy and abortion, in written, pictorial and three-dimensional forms. She is not shy of mentioning her abortions in interviews, not least because they are such an important part of her sense of selfhood – its assertion and its transcendence/incorporation of pain and loss. In her 2002 show at Modern Art Oxford, *This is another place*, one of the rooms contained pieces concerned with abortions, pregnancy and her childlessness. One written work, *Feeling Pregnant*, set out her thoughts on perhaps

being pregnant and then finding out that she was not, after all. The writing is suffused with contradictory and ambivalent feelings about the possibility of another self developing inside the artist's body. She writes, 'Is this normal?' and feels 'not my usual self'. Near this exhibit on the wall was one of Emin's appliquéd blankets or quilts, entitled *I do not expect to be a mother, but I do expect to die alone* (colour plate 3). The poignancy of the statement of the solitary self is intensified by the use of textiles and sewing as a medium and the way Emin's use of textiles is so careful and painstaking, yet so totally at odds with the domestic, self-sacrificing connotations of women's 'homemaking' crafts. The large scale of her appliquéd blankets contrasts with the small blankets on a baby's cot, or the blankets used as 'transitional objects' in the absence of the mother.

The psychoanalyst D.W. Winnicott, an 'object relations' theorist, viewed the Self as a complex entity composed of many parts, but simply expressed as 'the person who is me'.[48] For Winnicott, the transitional object bridges the gap between the infant self and the surrounding world in the process of their separation from one another and the formation of independent selfhood. This separation, which includes splitting from the mother, can be painful. Winnicott, unlike Lacan with his notion of the other or *l'objet à*, insists on the material nature of the transitional object as equally important as its symbolic value:

It is true that the piece of blanket (or whatever it is) is symbolic of some part-object, such as the breast. Nevertheless, the point of it is not its symbolic value so much as its actuality. Its not being the breast (or the mother) is as important as the fact that it stands for the breast (or mother).[49]

The blanket as transitional object is thus linked to the process of subject-development and the crucial nature of the mother-child relationship in this process. As such, the blanket is a particularly appropriate medium for Emin to use to communicate her writings on her childless state and her ambiguous feelings in relation to pregnancy, abortion and childbirth.

In her video *Conversation with my Mum* (2001), the artist speaks with her mother about the fact that her mother considered aborting Tracey and her twin brother before eventually deciding against it. It is also clear from the video that the artist's mother feels it would be a big mistake for Emin to have children, and the reasons for this remain unclear, though the artist probes her mother for answers. Perhaps

Emin's mother is trying to protect her daughter from further disruption, now that her life is relatively stable and prosperous, or perhaps her mother remembers the difficulties of bringing up young children with little help from an unfaithful partner, who fathered another (estimated) twenty-one children in addition to Tracey Emin and her twin brother. Emin states: 'My mum has never wanted me to have children. She thinks I would be destroying my life, even now.'[50] Emin also seems to have a somewhat traditional view of becoming pregnant and the possibility of rearing children as a creative act easily on a par with the act of making art. After becoming pregnant for the first time and having an abortion, she saw paintings as less creative and basically gave up painting to work in a variety of other media.[51]

Women artists relate differently to pregnancy. Some see it as an empowering state which spurs them on to produce more, or different, kinds of work. Others, like US photographer Sandra Adams, fear that 'impending motherhood would swallow up the woman and the artist she knew to be herself'.[52] Pregnant women disturb notions of autonomous subjectivity and also single-sex subjecthood, since they involve male sperm and possibly the embryo of another being of a different gender.[53] The pregnant subject 'experiences her body as herself and not herself'.[54] Clearly the pregnant body complicates Cartesian notions of the self but also the theories of existential phenomenologists such as the French philosopher Merleau-Ponty, who locates a unified consciousness and subjectivity in the body itself.[55]

Tracey Emin's works dealing with maternal subjectivity are very different from those of, say, Mary Kelly and her Lacanian *Post-Partum Document* (begun 1973), despite both artists making extensive use of writing and mark making. While Kelly emphasises the role of language and its acquisition in the construction of a social, gendered self, Emin's works are more comfortable with the idea of language being used by the artist as an agent – language and words are a set of tools among others. Hence Emin's works are more sensual, more visually pleasurable than the austere text-centred *Post-Partum Document*. Pregnant subjectivity is not abstract, but situated and particularised in specific social and historical contexts. Also, agency is crucial. Intentional pregnancies are different from unwanted ones and the mother's decisions about this clearly indicate conscious selfhood and agency, albeit within a rather restricted legal framework. And whatever else we may perceive in Emin's work, there is certainly no shortage of traces of an active agent/subject.

TRACEY/TRACES

Writing is a very important part of Tracey Emin's art. She has empha-
sised this aspect of her work, stating: 'I don't think I'm visually the best
artist in the world, right? I've got to be honest about this. But when
it comes to words, I have a uniqueness that I find almost impossible
in terms of art – and it's my *words* that actually make my art quite
unique.'[56] Words appear in her blankets, in neon signs, in monoprints
and written on sheets of paper.

The spoken word is also important for Emin's art and persona and,
in the pieces written on paper that she exhibits, part of the impression
of the coming together of the psyche and the art is the way that her
written words convey direct speech, speech patterns and her authorial
voice. However, there is always a slight gap, since many readers pick
up the spelling mistakes and the crossings out, which she intentionally
leaves uncorrected for artistic and personal reasons. Asked why she
left words 'uncorrected' on a recent appliqué piece, she explained
that she had spent a long time on it already, and Mat (Collishaw) 'says
my spelling is an endearing thing to me – and it also looks like I don't
give a fuck.'[57] Her spelling also relates to her desire for her work to be
accessible to audiences in a non-elitist way.[58]

It is tempting to see Emin's use of language, both written and
spoken, as an example of the so-called 'écriture féminine' theorised
by such French cultural critics as Hélène Cixous and Luce Irigaray.
This women's script, repressed by the masculine symbolic order, it
is claimed, writes that for which there is no equivalent expression in
phallocentric language. It is certainly possible to see Emin's forceful
writing on sex as an example of this, yet she still uses phallocentric
terms, as for example in a written piece about masculinity where she
decides that to have spunk and balls (like herself) you don't need to
be a man.[59] Underlying the theory and practice of 'écriture féminine'
is 'the assumption that the text and the psyche are isomorphic'.[60] The
closeness of the woman's writing and her bodily desires are emphasised
by Cixous in her essay 'The Laugh of the Medusa', where she argues
that, through writing her self, woman ('a universal woman subject')
will return to her body which has been taken from her and turned into
an alienated stranger on display. Women's writing is closely linked to
eroticism and desire. Cixous explains: 'Time and again I, too, have felt
so full of luminous torrents [of desire] that I could burst – burst with
forms much more beautiful than those which are put up in frames
and sold for a stinking fortune.'[61] Emin's work is not actually selling

for a fortune, but one could argue that she has successfully managed to combine the public display of women's writing and commercial success in her career so far.

The closeness of the writing and the self is emphasised in Emin's work by the way her own handwriting is almost always used, rather than typescript – in the neon pieces, the written texts and in the way her drawing lines look like writing. An interesting variation on this occurs in the cut-out letters and time-consuming process which transforms writing in the appliqué blanket works and in the monoprints, where the slight distancing of the subject from the finished writing gives pleasure:

I started with monoprints, also woodcuts and screenprints... I love the magic of doing everything in reverse and the viscosity of the ink, getting it right and the fact that it takes me two minutes to do a drawing. It's exciting. It's not laboured and I never know what it's going to look like until I turn the page over. What people don't understand is that I have to do the writing backwards.[62]

This can be seen in *I didn't do anything wrong* (monoprint on calico with stitching, 1998; plate 5). I was struck when I saw some of the monoprints, especially those printed from glass onto cloth, at how similar they were to writing and designs on and under the skin. The scratchy lines look similar to cut designs on the body and the way that the edges bleed and become, paradoxically, less sharp.[63] The places where the edges of the lines bleed into the surrounding cloth or paper in the monoprints look similar to tattoo designs after they have been transferred onto the skin. I find this link to the surface of the body and the skin ego in Emin's work most interesting. Emin herself has at least one tattoo – an anchor on her right arm.

Now it is not clear whether or not Emin is aware of theories of 'écriture féminine', but in any case it does not matter particularly. What is significant, though, is the way some critics speak about her writing as if it were indeed women's writing, bursting almost incoherently through the constrictions of patriarchal language and the symbolic order of subjectivity it constructs. Consider, for example, Adrian Searle's words:

To say that these wall-hangings and half-begun paintings and drawings and confessional writings are just so much awful logorrhoea, as indulgent and incoherent as they are heartfelt and soul-bearing, is to state the obvious. There doesn't seem to be any quality control here at all...[64]

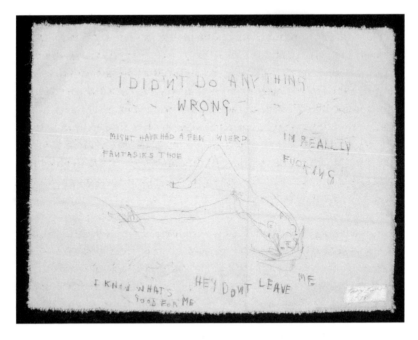

Plate 5. *Tracey Emin,* I didn't do anything wrong, *monoprint on calico with stitching, 38.1 x 55 cm, 1998, copyright the artist, courtesy Jay Jopling/White Cube (London); photo Stephen White.*

Searle, in fact, seems to view *all* the works as examples of what we might term 'écriture féminine', not only the written or drawn pieces. The works, disapproved of by Searle, are like the 'text of her self' spoken of by Cixous.[65]

What troubles some critics (e.g. Searle) about Emin and her work is that she does not seem educated and therefore it is implied that her writing and art works are not 'texts' intentionally subversive of patriarchal or other ideological norms, but are just accidents, the outpourings of a self out of control. Yet at the same time this out-of-control self is savvy enough to have one of the most acute dealers around and make a good living from her art. Not as much though, it must be said, as works by the Chapman Brothers or Damien Hirst, male artists at a similar stage of their careers.[66]

THE SELF OF MARC QUINN

Marc Quinn's sculpture *Self* (1991; colour plate 4) was made with nine pints of the artist's blood, the average present in the adult human

body. The blood was drawn from him over a period of five months, then poured into a mould of his head and frozen to minus seventy degrees centigrade. A barrier of silicone was created around the head to prevent the blood becoming freeze-dried and disintegrating. It is Quinn's intention to recreate a version of *Self* every five years as his appearance changes and the work possibly becomes less stable. In a recent development of his original idea, he has made a sculpture of the head of his newborn baby, Lucas, aged three days, modelled from the placenta. Quinn has explained that the difference between a cast and a model was used to suggest the process of becoming that the self of the baby goes through:

When I made the *Self* sculptures they were life casts and in a sense the life cast is the most photographic way of doing a portrait; it's the least interpretative, it's the blankest way. But with Lucas' head I was interested in the idea of emergence... Who is this baby? He has emerged from his mother's body, but there is also the emergence of his personality. When you first see a baby it becomes itself, but that is not immediate. It's a bit like seeing a flower blossoming. The fact that I modelled the head was really my interpretation of him – of getting to know him.[67]

Quinn seems to locate the beginnings of selfhood very early on, when the baby becomes physically separated from the support system of the mother's body. This more physical notion of selfhood is different from the psychoanalytical theories of subjectivity mentioned so far. These locate the crucial developments in subjectivity at a later stage, from about ten to eighteen months. The idea of making representations of the self from actual body parts emphasises the physicality of the self, rather than its consciousness. The self is a head but a head lacking a mind.

In other works, Quinn has used segments of DNA to create 'portraits' of selves – in one case, the geneticist Sir John Sulston (2001) and in another, entitled *Self Conscious* (2000), the artist's own DNA suspended in alcohol in a test tube.[68] Quinn's knowledge of art history (which he studied at Cambridge University) means that many cultural allusions resonate within his work. In one piece, *Continuous Present* (2000), the viewer is reflected in a steel cylinder while a skull rotates gently around the cylinder's base, reminiscent of, but reinventing, some of the elements of Holbein's *The Ambassadors*. In Quinn's piece, the skull is material and undistorted, while the reflection of the viewer becomes warped and non-iconic.[69] Another work, *Rubber Soul* (1994), was created by Quinn for the Egyptian Gallery at the British Museum

and based on a Perspex mould of his head. On a platform inside the head, a North American Wood Frog was placed in a state of suspended animation in a cold environment. The frog was positioned in the place of the pineal gland, the part of the head where Descartes located the soul. After the exhibition, the frog was reanimated and given to London Zoo. In fact, the emphasis on the physicality of the self in these projects of Quinn does seem to have echoes of Cartesianism in the (inevitable) separation of mind and body in the making of artworks utilising body parts. Quinn himself has stated that, in its ability to transform food, water, medicines, air and so on, 'The body's a machine that is being transformed as it transforms matter into energy.'[70]

This view of the body as an efficient machine is something that critics of Descartes have commented on. However, art works cannot possess consciousness, though Quinn's works hint at a possible life which persists in the 'dead' body parts as the blood heads are kept in existence by refrigeration technology. When the source of energy is switched off, the blood heads will mutate into liquid pools and the shape of the head will disappear.[71]

Quinn's interest in blood as a material for his sculptures is linked to his concern to investigate the interior and exterior of the body. When we are injured, blood moves from the interior to the exterior, it 'stops being oneself and is changed into an object'.[72] This change from subject to object, embodied in the blood, can be seen in several of Quinn's works. As Julian Stallabrass has pertinently remarked: 'With all this work, the unity of body and thus by implication of the self, is denatured or dissolved... fragments of the body... appear rather as autonomous scraps of living matter.'[73] However, the self is an embodied self and for me a crucial question is: are we looking at this embodied self in a social context or not? As it is, Quinn's works are almost fetishistically presented in the ultimate art display cabinets without which they would cease to exist in their present forms. Their very being is bound up with presentation and enclosure, visible, yet separated from the world 'outside'.

Quinn has spoken of his interest in blood as a material – the frozen blood has a kind of iridescence and sparkly quality: 'It's horrific, but it's also deeply seductive.'[74] The way in which blood transgresses the boundaries of the body, like semen, saliva or shit, is discussed by Julia Kristeva in her essay on the concept of the abject. As noted previously, the abject is what disturbs identity, system and order, rejecting borders, positions and rules and transgressing the discrete, socially acceptable boundaries of the body.[75]

In Quinn's sculptures, however, the blood does not convey the element of visceral disgust associated with the abject, since it is frozen and kept in pristine conditions. In some ways, it represents the abject kept at bay, before the disintegration of the work into formlessness. Whereas blood, as menstrual blood, is associated with femininity, male blood in relation to the concept of abjection tells a different story, as injuries involving blood tend to result from violence and hence connote virility. Blood tests and HIV/AIDS have tended to be associated with illness, frailty and homosexuality, despite the fact that HIV/AIDS is now a major sexual health issue for heterosexuals.

Marc Quinn is not the first artist to have made use of blood in his/her work. Performance artists in the 1970s, in particular, often shed their own blood or else used the blood of animals in their work.[76] Blood, with its connotations of violence, sacrifice and disease, has powerful associations with both life and death. Dynastic and hereditary power was traced through bloodlines until the nineteenth century, when blood and genetics came to be seen as separate.[77] Blood is no longer viewed as a bearer of genetic information, in contrast to DNA. Thus Quinn's works have utilised different historical notions of subjectivity and identity in the blood head of *Self* and in later projects using genetic material taken from the artist's and others' bodies. However, the DNA, while providing a unique individual trace of a person, still remains a body part rather than a subject.

SELVES IN STONE

In another sculptural project relating to subjectivity, Quinn has organised the production of life casts of a number of disabled people, usually sportsmen or women, since he values the importance of a body 'in good shape'. The casts were then used to make marble statues in Italy. In these statues, Quinn sought to further investigate subjectivity in relation to concepts of the inner and outer self. Comparing the limbless or amputee sitters to the classical marble statues in museums, often without arms or even heads, Quinn highlights the lack of visibility of disabled people in art history. Some of his sitters have stopped using their prostheses or artificial limbs because they feel that the devices are partly there to help them 'conform' to social norms of the body. These sitters want to go beyond the sense of lack and loss which has marked their bodies and subjectivity. Quinn comments:

These physically disabled models are not mentally disabled; they are as capable
as you or I of deciding whether to get involved in making the sculptures. The
problem of exploitation does not arise here. Naturally, the important concept is
that these people have a sense of the inner self just like ours and the sculptures
are a celebration of this sense of self.[78]

Thus the statues seek to show the models as bodily lacking in some
way, but with a sense of selfhood which recognises this loss and is thus
capable of overcoming it. There are many complex issues here. Quinn
wants to challenge the prevailing view that the interior is reflected in
the exterior of the body and yet he wants to show the strong sense of
selfhood and 'strength of character' of the sitters. So the statues must
then seek to deny that subjectivity can be read from the body and also
to commemorate a valued subjectivity through presenting us with the
materiality of the body. The blank eyes and expressionless faces of
the marble statues also work against the viewer's ability to 'read' an
interior identity on the surface of the stone. One of the models, Alison
Lapper, is herself an artist and studied at Brighton University.[79] A
photograph of a smiling Lapper and her baby son, Parys, is included
on the leaflet of 'The Mouth and Foot Painting Artists' organisation,
formed in 1956 to enable disabled artists to earn a living from their
work. The photograph gives quite a different impression from Quinn's
statue as Lapper looks happily at the camera with her eyes engaging
the spectator in a direct and forthcoming way.

Though most marble statues appear distant and lacking in expression,
many are commissioned to commemorate the subjectivity and agency
of famous individuals, as for example the statue of Margaret Thatcher,
former British Prime Minister, made in 2002 by Neil Simmons. The
use of a durable material and usual location in a public setting mark
out these particular types of portrait as 'historic' and yet 'distant'. (In
March 2004, it was decided that a 15 feet high version of Quinn's nude,
pregnant Alison Lapper would actually occupy the vacant fourth plinth
in London's Trafalgar Square.)[80] Unlike Alison Lapper's marble features,
the hard face of Thatcher's statue does indeed offer something of an
approximation of the stony features of Britain's famous 'iron lady'.
In July 2002, Paul Kelleher attacked the statue with a metal rod after
the cricket bat he had brought with him to the Guildhall Art Gallery,
London, proved ineffective. He knocked the head off the statue as a
protest against the global capitalism supported by Thatcher and others
like her, and he defended himself in court on the grounds that it was

not a criminal act to protest against the destruction of the world, which had to be preserved for future generations, including his two-year-old son. He stated that 'I haven't really hurt anybody: It's just a statue, an idol we seem to be worshipping.'[81] Kelleher distinguished the statue from a real person, but clearly viewed Thatcher as a personification of right-wing policies. Thatcher herself, unveiling the eight-feet tall, two-ton statue in May, had spoken in a way that almost made the statue at one with herself: 'It's marvellous. But it's a little larger than I expected. Though as the first woman prime minister, I am a little larger than life!' The statue and the woman become one in what one commentator called 'this piece of – literal – self aggrandisement'.[82]

The front-page coverage of Thatcher's statue and its subsequent decapitation continued on 4 July 2002, when photographs of the head of the statue and Marc Quinn's *Self* appeared juxtaposed in *The Guardian*, as rumours circulated that builders had inadvertently switched off the deep freeze in the collector Charles Saatchi's home, thus ruining the artwork.[83] Kelleher became part of a long and effective tradition of iconoclasm and despite his success in splitting the jury in his first trial, causing their dismissal when they failed to reach a verdict, he was eventually found guilty. Various cultural and political commentators wrote on the subject of Thatcher's mutilated statue and Gary Younge, a prominent journalist, used the incident to argue against the commemoration in monuments of any 'great' people: 'Like a tattoo dedicated to a lover, it excludes all possibility of a change of heart. Removing it may leave a scar and there are plenty of other ways of showing undying affection.'[84] The destruction of a representation of someone is equated by the iconoclast as symbolic of the destruction of that person and the values s/he represents. Reproductions of the self represent that self. This is a very old form of political intervention in the art world but it survives in the postmodern art world as a particularly destructive act against the self.[85]

Marc Quinn's art, while appearing totally in tune with current concerns in postmodern art in relation to the body, new technologies and so on, interestingly relates to supposedly outmoded humanist, bourgeois, even Cartesian, notions of the self. Quinn has referred to the body as a machine, plays with notions of inside/outside the body and, in relation to the statues of disabled subjects, mobilises a concept of a conscious, surveying inner self.

ALEXA WRIGHT, 'I'

As in Marc Quinn's marble statues, issues of subjectivity and disability are explored in a series of photographs by Alexa Wright, entitled *'I'* and made in 1998–1999 (colour plate 5). This series of eight digitally produced photographs was made by the artist in collaboration with models/subjects living with disabilities of various kinds. The photographs of the models were taken in the studio and then the images were constructed later on a computer using previously photographed interiors of a preserved house in Arbroath, Scotland. In all of the photographs except one, the face of Alexa Wright herself is superimposed on the body of one of her collaborators. By placing the subjects in the sumptuous interiors, filled with fine furniture, wood panelling, tapestries, paintings, statues, carpets and mirrors, Wright seeks to counter the objectification and medicalisation of disabled people, who were/are often posed in stark and dehumanising surroundings.[86] In these images, with their saturated colour and richness, the subjects are likened to the portraits of upper-class people in baroque or eighteenth-century Grand Tour settings, or perhaps a fashion shoot, where idealised models are posed in settings designed to evoke high culture and classiness.

At first, I felt rather uneasy looking at these images, wondering why the artist had superimposed her own face on the bodies of most of her subjects, apart from the photograph of one sitter, who has Down's syndrome, but is shown with Alexa Wright's fully clothed body sitting elegantly cross-legged on a settee. Some of the sitters are shown partly clothed or even naked. However, I looked on these representations of subjectivity more favourably when I read a conversation between Wright and two of her collaborators/models. They too had been wary at first, but felt very pleased with their participation in the work and with the final images. Catherine Long, an artist and facilitator of creative workshops and an active member of the disability arts movement in London, is shown here wearing the red evening dress next to the naked classical sculpture of a woman. The face (Alexa Wright's) is directed towards the spectator, fixing her/him with an intense gaze.

Long is particularly pleased with the way the reflection (of the statue) in the windowpane was situated between her shoulder and the arm of the statue, ambiguously suggestive of a merging of one body with the other. She also speaks of the veneration accorded to classical sculptures with missing limbs, yet often denied to disabled people. She adds: 'It is important that it is other people's attitude to me that is

an issue in this work; it is not about the way I look, but rather the way the people look at me.' Long found the collaboration with the artist very positive: 'the influence it has had on my self-image and sense of self is immense.'[87]

Alexa Wright used her own face on most of the models with the intention of disrupting the tendency to read the personality and worth of the subject from the exterior of the body. Who is the 'I' that we see represented here and on what grounds do we make assumptions about her subjectivity? The 'I' is normally the enunciation and presentation of the public self, but the 'I' signifies the fabricated nature of the bodily self which needs to be interrogated rather than taken as natural. The constructed nature of the photographic images made by Wright also embodies the notion of disturbing the supposedly 'natural' look of straight photography.

Wright has said that 'For me, there is an interesting contradiction between the belief that the self is located in and expressed by, the body as much as the mind and the observation that the body is not always an adequate representation of the self.'[88] Elsewhere the artist emphasises the complex nature of the relationship of body and self.[89] She feels this is particularly acute in the case of Down's syndrome, 'where particular facial features are seen to represent a certain type of personality and level of mental ability'.[90]

While self and body can be conceptually separated, in reality subjectivity resides in bodily existence. Within the brain is a body map, sometimes so imprinted that even some children born without a limb feel the phantom of the missing part.[91] Alexa Wright agrees with the view put forward by Simon Penny, who writes: 'The mind/body split concept is a key component of the enlightenment world view and structures the way we think about ourselves and the world. Computer discourse is a direct descendant of that world view… Subjecthood is anchored in the body. What we call "the mind" permeates the body and is not located in any organ.'[92] Thus Alexa Wright is also aware that her use of computers and virtual reality images can be seen as perpetuating so-called Cartesian dualism, since the VR (virtual reality) bodies are pure representation, not real bodies, and are a creation of the mind. But we can also say this of straight photographs, for, though they are not digitally manipulated, they are nonetheless images and not the actual subjects. The digitally constructed photographs are simply at a further remove. It could also be argued that the 'I' series images, though critically approaching the relationship of self and body, cannot avoid

the problem of conceptually divorcing the two in quite a violent way, with the merging of heads and bodies of different subjects. Another problem with these images is that, through their very aestheticisation and status as art gallery images, they may reify and fetishise the subjects and their disabilities. If the images were totally everyday and ordinary, few people would look at them. The processes of looking at the images as *Art* and looking at the disabled subjects as out of the ordinary work in parallel, though probably unintended, ways. The viewer begins to gaze, rather than to look, in response to the aesthetic aura surrounding the image. The staged tableaux and *mise-en-scène* of the photographs immediately signal their difference and indeed this is the case for all culturally recognised art objects (note the word objects, rather than subjects here).

Disabled people form a significant minority of British society, an estimated 8.5 million out of a population of 56 million.[93] Disability is therefore actually quite a common or everyday thing, but is not often presented as such. Disability is often not visible in dramatic changes in body image, unlike the prevailing fetishised or objectified images of disabled people. For example, epilepsy, mental disabilities and joint pains causing disabling conditions are largely invisible. As Jessica Evans remarks:

The relationship between the appearance of the body and the 'state of the mind' is absolutely arbitrary but in the naturalistic media images I have discussed [charity fundraising photographs] an inevitable relationship is established, so that the whole character of the disabled subject appears to be manifested in the visual appearance of the body.[94]

She speaks of the charities' 'obsession with the bodily mark'. Regarding the low self-image of disabled people and lack of self-worth, Rhian Davies, herself disabled, remarks, 'Disability is rarely seen as an ordinary condition affecting one in ten of the population and disabled people are never regarded as ordinary citizens getting on with life.'[95] In a collaborative photographic project between disabled and non-disabled subjects and photographers, in which Davies participated, many of those involved spoke of their subjectivity, or 'the need to develop a greater sense of who I was', linked to a feeling of independence.[96] The whole aim of the photographic project as summarised in one paragraph on the back of the catalogue mentions various aspects of self-discovery, self-image, self-awareness and sense of self.

CONCLUSIONS

Clearly there are many unresolved (and probably irresolvable) issues concerning the notion of real or inner selves (as well as constructed selves) and disabled subjects. Postmodern theories of hybrid or multiple selves do not seem to hold much emancipatory attraction for disabled subjects, though the postmodern concept of discourse could usefully be applied to discourses of disability, charity and caring. These involve texts and practices of dealing with disability and the positioning of disabled people both socially and ideologically. It is not clear, however, what additional benefits accrue from the use of the concept of discourse as opposed to that of ideology. In both cases, a deconstructive process interrogates existing concepts which position disabled people in particular ways. However, an ideological deconstruction implies that we can replace the rejected images and texts with something better, whereas discourse theory does not necessarily entail such a position, since for many discourse theorists, there is nothing that is not constructed by discourse.

Also, subjectivity is denied to disabled people not only by their representation in images, but their 'representation' politically and socially by campaigns and charities led by non-disabled people who try to speak for them, thus tending to disempower them. Sonia Barnes remarks how the disabled person is 'seen as unable to make their own decisions. It is very interesting that people want to give you equal rights, but they don't want to give you the power to make decisions about your own body.'[97] Rhian Davies echoes this in a tone of heavy irony: 'I must accept that (able-bodied) people who run the said organisations and statutory services know what's best for me. I must not have an opinion and must not interfere in what is clearly not my concern.'[98]

The photographic representation of disability is also problematic. If, on the one hand, we are presented with documentary-type 'straight' photography, then this can associate disability with social reformism and charity fundraising images – all the historical baggage that comes with the documentary image. On the other, if the image of the disabled person is aestheticised, reified in some way, this works to objectify the subject in a different way. Perhaps some way forward lies in incorporating the voice of the pictured subject. I read the Alexa Wright images in a different way as soon as I was aware of the spoken comments of the disabled people themselves. Only then, for me, did they really become subjects rather than objects. I think it is questionable to what extent any images on their own, whether digital or ordinary

photographic images, can guarantee subjectivity for socially oppressed groups of people. The same can probably be said of statues, so mute and frozen in their total object-based identity.

Alexa Wright's photographs and Marc Quinn's marble statues of disabled people raise a number of issues of subjectivity and the body, which are different from those encountered when we consider works by Tracey Emin and Marc Quinn in which they themselves are both the subjects and objects of their work. However tempting it may be, though, to see the self-identity of artist and model as superseding the subject/object divide, this is not in fact the case. The making of a photograph, blanket, or statue results in the production of an object to be viewed, whether it contains traces of the artist's physical presence or even parts of her/his body. The self can never *be* the artwork, even when it is treated as its representative, as in the case of Margaret Thatcher's statue.

CHAPTER 4

FOCUSING ON THE SELF

Emotions play out in the theatre of the body. Feelings play out in the theatre of the mind... Could it be that while emotion and feeling were twins, emotion was born first and feeling second, with feeling forever following emotion like a shadow?
Antonio Damasio, 'Mind over Matter'[1]

For centuries, scholars have been curious about what goes on in the mind, suggesting images for what happens in the tissue and matter of our bodies. Among the most interesting of these are the mind as so-called 'Cartesian theatre' and the mind as camera obscura. These two 'models' of the mind offer analogies, generally regarded nowadays as false, but which nonetheless still exert a powerful attraction. Both involve the centrality of looking and spectacle, questions of illusion and reality, pleasure and knowledge, and thus both offer ways of approaching strategies of presenting the self and also of thinking about consciousness, subjectivity and imagery, in particular the staged photograph. These aspects of the Cartesian legacy have contributed to culture in an imaginative, rather than a scientific, way.

I look first at the notion of the Cartesian theatre in relation to the staged photograph and some of its practitioners – Boris Mikhailov, Karen Knorr and Jeff Wall. Then I discuss the camera obscura in relation to self-portrait photographs by Cecil Beaton and Mme Yevonde. In each case, I look for the connections between representation, subjectivity and ideology, seeing the Cartesian theatre and, especially, the camera obscura as sites where psychoanalytic and Marxist theories converge.

THE CARTESIAN THEATRE

Some contemporary scientists believe that there is no one central part of the brain where consciousness happens and is then perceived by the

subject, but a network of impulses and responses constantly in play. Dennett comments on:

a sort of theoretical myopia that prevents theorists from seeing that their models still presuppose that somewhere, conveniently hidden in the obscure 'centre' of the mind/brain, there is a Cartesian Theater, a place where 'it all comes together' and consciousness happens. This may seem like a good idea, an inevitable idea, but until we see, in some detail why it is not, the Cartesian Theater will continue to attract crowds of theorists transfixed by an illusion.[2]

The idea of a theatre, or even cinema, in the brain, where an interior eye, 'the mind's eye' or an internal spectator perceives and understands images, has been generally dismissed. It was never even suggested by Descartes, though it has ended up being named after him. As Dennett says, 'we exposed the persistently seductive bad idea of the Cartesian Theater, where a sound-and-light show is presented to a solitary but powerful audience, the Ego or Central Executive.'[3] Damasio agrees: 'The usual metaphor has something to do with a large CinemaScope screen equipped for glorious Technicolor projection, stereophonic sound and perhaps a track for smell too.'[4] However, he also stresses the importance of images (not only visual but also related to sound and smell) in forming an important element of subjectivity. But images in themselves are not the self. The images which are neural representations from early sensory cortices of the brain must be correlated with those which, moment by moment, 'constitute the neural basis for the self... It is... a perpetually re-created neurobiological state.'[5]

Models of the mind as theatre pre-date Descartes. In her fascinating book on memory and Renaissance thought, Frances Yates discusses the memory theatre of Guilio Camillo, as described in a letter written in Italy in about 1532 from Viglius Zuichemus to his friend Erasmus. This, says Yates, brought together two rather different aspects of Renaissance thought concerning the mind and memory – the rational/humanist (Erasmus and Viglius) and the irrationalist (Camillo).[6] Camillo's memory theatre, visited by Viglius in Venice, was to be 'a constructed mind and soul':

He calls this theatre of his by many names, saying now that it is a built or constructed mind and soul and now that it is a windowed one. He pretends that all things that the human mind can conceive and which we cannot see with the corporeal eye, after being collected together by diligent meditation may be

expressed by certain corporeal signs in such a way that the beholder may at once perceive with his eyes everything that is otherwise hidden in the depths of the human mind. And it is because of this corporeal looking that he calls it a theatre.[7]

This material construction of a memory system based on Hermetic philosophy was also intended to embody man's position in the world. The 'spectator'/subject stood on the stage and looked outwards, unlike a conventional theatre. The construction included images with, probably, small drawers underneath containing speeches, in order to help develop powers of oratory in the person using the theatre. The theatre is a memory place, stocked with images.[8] However, Viglius seems to interpret the structure, which could be entered by at least two people, as a materially constructed analogy for the thinking mind. Yates observed that the art of memory changed from the concept of memorising all knowledge due to the growth of scientific method in the work of scholars like Descartes, Bacon and Leibniz, after which the function of memory became allied to the search for knowledge about the world.

Writing in 1980, the US art historian Michael Fried discussed post-Cartesian French eighteenth-century painting in relation to the viewing subject using two key concepts – absorption and theatricality.[9] Fried was not interested in the theatre of memory, however. He argued that absorption is the process whereby the viewer enters into the picture, is drawn in and forgets him/herself. Absorption is a kind of abandonment of self and of consciousness.[10] Figures in the paintings can also be absorbed in their own activities, seemingly unaware of being looked at. Theatricality, less approved of by the critic Diderot in his contemporary comments on eighteenth-century art, occurs when the spectator is always conscious of being a spectator and of the painting as being presented to him as a 'tableau'. This position is more Cartesian and recalls Descartes' statement of his wish to be 'a spectator rather than an actor' in all the 'comedies' being played in the world.[11] Fried argues that in the mid eighteenth century taste rejected the decorative 'in the name of unity, the instantaneous and self-sufficiency and when that happened the concept of the *tableau* emerged with greatly enhanced significance'.[12] I am not entirely convinced by this argument about the tableau (which means a portable easel painting by this time), since most successful decorative schemes incorporating paintings fixed on ceilings and walls and above doors, including those by Boucher, embody concepts of unity and the instantaneous. Fried

also points to the rapprochement of aims in painting and drama in the later eighteenth century, citing various critics and theorists to prove his point.[13] Fried concludes that 'there can be no such thing as an absolutely anti-theatrical work of art – that any composition, by being placed in certain contexts or framed in certain ways, can be made to serve theatrical ends.'[14] This is fortunate, to say the least, for one of Fried's examples of absorption is David's *Belisarius* (1781) which many people would probably see as a perfect example of a staged theatrical *tableau* (plate 6).

Plate 6. J.-L. David, Belisarius Begging for Alms, *oil on canvas, 287.3 x 312.1 cm, 1781, Musée des Beaux-Arts, Lille; photo copyright R.M.N., P. Bernard.*

PAINTING, THEATRE, CINEMA

Roland Barthes' essay 'Diderot, Brecht, Eisenstein' opens up some useful ways of looking at subjectivity, spectatorship, the theatrical and the cinematic. Barthes points to the link between geometry and the

theatre – a very Cartesian comparison: 'The theatre is precisely that practice which calculates the place of things *as they are observed*: if I set the spectacle here, the spectator will see this; if I put it elsewhere, he will not and I can avail myself of this masking effect and play on the illusion it provides.'[15] He goes on to say that cinema is also expressed geometrically, cutting out segments in order to depict them, adding:

> to discourse... is simply 'to depict the tableau one has in one's mind'. The scene, the picture, the shot, the cut-out rectangle, here we have the very *condition* that allows us to conceive theatre, painting, cinema, literature, all those arts, that is, other than music and which could be called *dioptric arts*.[16]

The use of the term dioptric suggests an allusion to Descartes' work on dioptrics, concerned with sight but specifically that part of optics dealing with refraction. Barthes then discusses Diderot's remarks on the similarities between the painted *tableau* and the staged scene and notes Brecht's use of the *tableau* in his concept of epic theatre. However, with Brecht, the *tableau* is offered to the spectator for criticism, not acceptance. The fetishistic nature of the *tableau* is linked by Barthes to its 'cutting out' and extracting from a seamless totality some 'ideal' concept (such as Progress or Self-Sacrifice), but its *composition* is not fetishistic. Barthes also relates Brecht's concept of the 'gest' to the 'cutting-out' implicit in the creation of a *tableau* – a gesture, an action, which can sum up a whole social situation for the audience's critical awareness.[17] It is tempting to read the gestures in David's *Belisarius* in a partially Brechtian way, though clearly I do not want to push this ahistorical analogy very far. The woman giving the money to the beggars takes on a wider social significance. The staged scene is not just illusionistic history, but something of contemporary social relevance.[18] However, the 'gest' cannot have meaning in itself. It depends on being perceived as such from the spectator's position, says Barthes. He remarks: 'In the theatre, in the cinema, in traditional literature, things are always seen *from somewhere*. Here we have the geometrical foundation of representation: a fetishist subject is required to cut out the tableau.'[19]

In an interesting discussion of Japanese theatre and cinema, Noël Burch defines two different categories of theatre: the presentational and the representational. These are useful for our consideration of imagery and the viewing subject and the staged photograph in particular. In presentational theatre, the actor never looses his/her identity as an

actor. The audience never regards the character as 'real' but as a fictional person acted by an actor, for example, in Greek fifth-century theatre, Elizabethan theatre, or the work of the Soviet director Meyerhold. In representational theatre, every effort is made to 'suspend the disbelief' of the audience and convince spectators that the stage is a believable illusion and the actor a real person as in European mediaeval mystery plays and Greek theatre of the fourth and third centuries.[20] When we look at paintings, some of these ways of viewing presentational and representational theatrical scenes can apply, along with different implications for the subjectivity and (self-)consciousness of the spectator. However, they cannot be entirely transferred to the viewing of paintings, such as the *Belisarius*, for example, due to different contexts of spectatorship. The painting is viewed in light (usually), while the theatre and the cinema are dark (and therefore much more convincing metaphors for the interior of the brain, either as Cartesian theatre or camera obscura). Talking is permitted, though often strangely absent, during viewings of paintings in public, lit, spaces, while frowned on in the cinema and the theatre. The apparently communal and more social 'mass' spectatorship of film and stage is, in fact, rather a solitary one until the interval and after the 'show'.[21]

There are differences between the Brechtian and Cartesian theatres as metaphors for looking and self-consciousness. The Brechtian theatre disturbs illusion; it jolts the spectator's perception. If we use the Brechtian theatre as an analogy, it is what happens when the ideological illusion approaches the clarity of consciousness. We do not just experience subjectivity as we look, but an enhanced consciousness of our social positioning as viewing subjects.

While paintings can look staged, lens-based images are created not with paint but with light and the lack of it. Thus the staged photograph is of particular significance in a consideration of the theatrical in relation to the 'darkroom' of the mind's interior.

THE TABLEAU PHOTOGRAPH

The staged photograph has been an important development in art since the later 1970s. Sometimes called the photo-tableau, or the directorial mode, this type of photography usually accompanies the erosion of photographic realism.[22] Discussing the staged photographs of Rineke Dijsktra, Sarah Jones or Hannah Starkey, where nothing seems to happen, J.J. Charlesworth argues that something is *felt* to

be happening because of the assumption that 'the inner reality of the subject can be made manifest visually through gesture and expression.' So, paradoxically, if outwardly nothing much seems to be going on, then we assume that, in the hidden depths of these subjects, *something* must be going on! In a shrewd comment, Charlesworth remarks that:

In the present context, however, stripped of the political motivations that drove psychoanalytical criticism, contemporary photography retains a fascination with the theatre of psychological symbolism, the fragmentary narrative, the unexplained and the uncanny, as a space in which common assumptions about subjective reality can be rehearsed endlessly without ever being resolved.[23]

In an article published just a month before Charlesworth's piece, Alison Green also pondered on the 'directorial mode' of photography and its relation to film, theatre and fashion, rather than to previous photographic history: 'Like the self, pictures have a surface that both reveals and keeps things hidden.'[24]

The staged photographic tableau emphasises both the constructed nature of the photograph and also the difference between the painted and the photographed image. Contemporary photo-tableaux exploit saturated colours and almost tactile visuals, giving them an exaggeratedly sensual attraction for the viewer almost irrespective of subject matter (for example, in works by Rotimi Fani-Kayode, Tracey Moffat, Pierre et Gilles). At the same time, the staged photograph continues to mobilise traces and expectations of the real (Boris Mikhailov, Jeff Wall). The studio has been expanded to resemble a theatre, even in scenes constructed outdoors. Many of these images combine a mixture of 'straight' photography and digitally manipulated images.

The consciously artistic nature of many of these images, like the term *tableau*, connotes fine art, value and 'aura'. This kind of image makes *Art* of the most pitiful realities, as in the photographs of homeless people by Boris Mikhailov (colour plate 6).

Most photo-tableaux are produced in limited editions, like fine art objects rather than reproducible photographs.[25] Thus the concept of the photo-tableau facilitates the reading and consumption of these images as both high art and media culture. Museum curators can purchase them, yet audiences can relate to them using modes of spectatorship equally suited to advertising photography (for example, in works by Cindy Sherman and Sam Taylor-Wood).[26]

I want now to look at some of these issues in relation to a photograph

by Boris Mikhailov, which combines elements of the staged and the real, the photo-tableau and the documentary. Also in relation to this image we should ask who is staging the reality and for whom.

STAGING REALITY

Boris Mikhailov's photographs of homeless people in Kharkov in eastern Ukraine were the subject of an exhibition at the Photographer's Gallery, London in 2000 and also won the Citigroup Private Bank Photography Prize in 2001. The photographs, made in 1998, appeared in a publication the following year entitled *Case History*.[27] One photograph shows a young blonde man who looks towards the camera as he is supported by his companions, his arm dangling by his side, hand touching the snow-covered ground. The group recalls Christian imagery of the deposition from the cross. In another version of this (colour plate 6) the young man is without his coat, his upper body naked, looking even more vulnerable. We notice some tattoos on his lower arm and hand. The clothed version was used to publicise the private view of the 2002 Citibank prize competition in collaboration with *The Guardian*. Champagne and chocolate strawberries will be provided, read the announcement, courtesy of Nicholas Feuillatte and Godiva Chocolatier. No doubt the evening was very interesting, but it seems rather inappropriate to illustrate the event with a photograph of the penniless down-and-outs of the former Soviet Republic.

Boris Mikhailov has pointed out that at least three of the people were dead within months of being photographed. Maybe their bodies are the kind that end up being used for medical research, or become some of those with Cyrillic tattoos used by von Hagens for his plastination process. Mikhailov says he wanted to take photographs of the homeless while they were still more or less 'normal' and before they became hardened into the categories of 'outsider', or 'non-person'. Many of these homeless people were vermin-ridden, physically hurt (and probably mentally damaged as well), or addicted to alcohol or glue.[28] Numbers of homeless people, including many children, have increased since the collapse of the former Soviet Union and the reintroduction of unfettered capitalism into the economy.

Some of these photographs make very uncomfortable viewing and I am still not sure that they avoid being exploitative and voyeuristic. The most disturbing thing about them, for me, was not that they depicted poor, lumpenised and homeless people, but that the subjects are often

shown displaying their bodies, holding penises, or showing their backsides covered with scabs. A woman who looks as if she has had some sort of botched operation poses sideways displaying an awful protruding lump in her belly. These people who have no homes and few (perhaps no) rights, have little to sell any more except their bodies. They displayed themselves to Mikhailov for the fee of a month's pension, or the chance to clean up and use the bath in his rather humble flat. The subjectivity of these nameless people is reduced to their bodies. Mikhailov does give information which goes some way to explaining his intentions within the context of a disintegrating culture and the weight of Stalinism, which still hangs heavily over cultural life in the former Soviet Union.

Mikhailov was sacked from his job in 1966 when the KGB found nude photographs he had taken of his wife. This resulted in his decision to become a full-time photographer. Censorship under the Soviet bureaucracy meant that photographers could often be accused of spying, photographs were not permitted to bring the USSR into disrepute and nudity was prohibited.[29] In the 1930s, Soviet citizens were not permitted to have a camera at home and therefore very few family photos from that period survive.[30]

This is the historical context of photography in which Mikhailov displays the presence and suffering of the homeless in these images of people 'stripping'. He says that he wanted to show them 'with their things in hand like people going to the gas chambers. They agreed to pose for a so-called historical theme. They agreed that their photos would be published in magazines for others to learn about their lives.'[31] Mikhailov's sympathy for his models, however, does not guarantee that they will not be exploited. On the contrary, one of the photographer's aims was to demonstrate how new conditions in the former USSR mean that people can be increasingly manipulated with money. He comments on the 'submissiveness of the models'. Usually, he writes, models are posed to be beautiful or strong. 'Here the models didn't perform in such a theatre. At least, they were given the role of "who they are in reality".'[32]

These photographs of homeless people are not digitally manipulated and depict actual homeless people, but they are nevertheless staged in that Mikhailov has posed and photographed them. His studio has been moved outside, but it still functions as a studio. They are composed and arranged images, but without the prestige of classicism or the past to turn their representation into pathos or tragedy, as in David's

Belisarius, where the homeless pair of beggars elicit shock but not disgust or discomfort on the part of the spectator. David's use of the theatre of subjectivity enhances subjectivity, whereas few really want to be drawn into Mikhailov's work – it is too unpleasant. In an important sense, the preservation of our subjectivity depends on our viewing the homeless people in the images as objects apart from ourselves – a detached yet horrified voyeurism can result.

It is debatable whether the subjectivity denied these people in their everyday existence was restored to them in some degree by their public presence in Mikhailov's photographs (as compared to their neglect and avoidance by the 'normal' residents of Kharkov), or whether they look even more dehumanised without their filthy clothes. However, as Mikhailov himself points out, the photographer is not responsible for their plight. Ultimately, it is the economic forces of capitalism and the people who control them, embodied in organisations such as the Citibank (sponsor of the photographic prize won by Mikhailov), who continue to preside over the 'globalisation' of the so-called Third World and the Second World of the former Soviet Union. So, while we can say that Mikhailov has staged his real subjects for the photo-tableaux, the conditions for their reality have already been created for them by factors outside both their and the photographer's control. It is hard to represent people as subjects when they have already been turned into objects.

KAREN KNORR

I want to look now at a work by Karen Knorr which is a very different example of the staged photograph, but which also relates to the representation of subjectivity, interrogating the way in which the photographic apparatus uses light and shade. In this section and in the following one discussing Jeff Wall's lightboxes, I examine light in relation to representation and conscious subjectivity, leading on later to a discussion of the camera obscura as apparatus and metaphor linked to subjectivity and ideology.

Since the late 1970s the photographs of Karen Knorr have developed through six major series of works, mostly concerned with interrogating ideas of heritage and cultural values formulated in the Enlightenment period. Her use of the series is intended to undermine the emphasis on the individual art-photograph. Many of her works have accompanying titles and texts, designed to promote reflection on the part of the

spectator. Often these texts (either part of the photograph and printed on the photographic paper or on an accompanying brass plaque) allude to philosophical or other historical writings and are composed in a style which mimics conventions of the eighteenth century, or sometimes even advertising texts. Often the words – *légendes* as she likes to call them – are direct quotes. Black and white works were followed by series of cibachrome colour prints. This latter technique was selected due to its 'vulgar or commercial connotations', as compared to the notions of beauty and culture suggested by the fine-grain black and white art-photography prints.[33]

Karen Knorr studied at the Polytechnic of Central London at a time when photography students there were encouraged to engage with theory and this is apparent both in her photographic works and in her articulate comments. One of her intentions is to produce works which are not examples of 'reflective realism' but of realism with an edge to it. Her works are not incisively political, but more allusively allegorical or emblematic. They conjure up static images of a past which persists into the present – upper-class gentlemen in their clubs, stately homes filled with the objects beloved of high culture and the Grand Tour, prestigious houses and gardens of the elite. These images are posed, staged and sometimes also digitally constructed. She uses her locations as if in a studio, where poses and gestures are carefully planned. Classicism is a common element in all this and she enjoys introducing interlopers, or outsiders, whose (previously invisible) presence unsettles our assumptions – a black man strokes a white marble statue in a stately home, a woman in an eighteenth-century man's wig reclines in the grounds of a country estate. The enigmatic titles and texts are designed to question as much as describe these mysterious images and a sense of quiet and of time standing still pervades her work. This strangely 'frozen' history, that somehow does not go away, is also apparent in her works using museum locations, such as the Wallace Collection, London, or the Musée d'Orsay, Paris. David Campany has remarked on Knorr's interest in cultural heritage and the ways in which the culture and ideology of conservatism is defined: 'This is why the museum, which constructs a representation of the past from the ideological needs of the present, recurs throughout her work as a theatre for making photographs. Within this theatre she photographs, among other things, works of art.'[34]

Her work takes the theatre of the museum and utilises it alongside other constructed sites of spectacle, such as the anatomy theatre, or

the formal garden. Her own constructed images further develop the
idea of the (silent) theatre with their staged scenes which appear in
her work and have a strangely mesmerising, even dream-like, effect,
situated somewhere between memory and history, life and death,
animate and inanimate. Knorr herself likes to compare the ones with
figures to conversation pieces, a type of group portrait popular in
eighteenth-century English art. However, her portraits of gentlemen in
their exclusive Clubs, or the rich in their homes in Belgravia (a 'classy'
part of London), are not portraits of actual people:

These are 'portraits' which use images with text to refer to particular attitudes,
which are classed as much as they are sexed. It is not the individual that is the
focus, but rather the social group and its prejudices that are being parodied in
a highly artificial way. For this reason the images attempt to show, through the
mise-en-scène, a set of gestures in which a whole situation can be read. In a sense
it is using a Brechtian strategy, i.e. the concept of social gesture or action.[35]

 Despite Knorr's use of Brechtian theory, there is something about
the strangeness of her images that is not quite the same as the effects
of Brechtian 'making strange' and the shattering of theatrical illusion.
It is useful to speculate as to why this is. It has been suggested that it
is because Knorr herself is from a moneyed, upper-class background
and therefore can enter into the world of the bourgeoisie, albeit
uncomfortably. One writer finds her images not sufficiently critical to
be satisfying, seeing them less as a 'critique of established power than a
description of it through symbols'.[36] I feel that this is slightly harsh and
that Knorr's constructed scenes are much more than descriptions. She
is concerned with looking and representation and the ways in which
the spectator can construct meanings from the works. Admittedly, this
is not always straightforward and a degree of knowledge is required
to get the most out of these ambitious works. However, it is not her
intention to offer an easily digestible 'message' to a consuming subject.
Perhaps the key to the difference between Knorr's images and the
effects of Brecht's 'making strange' is in this staged, *tableau vivant*
and frozen atmosphere pervading the images. Everything is quiet and
still, alluring yet distant, addressing us as subjects, yet untouchably
other, objectified. The images are slightly disturbing, but not enough
to make us angry because they are so seductive. Intervention in these
situations is impossible, apparently. It is a world which we are shown,
but not invited to enter and therefore cannot change.[37]

In stills from Knorr's work from 1995, *Being for Another* (colour DVD, 10 minute loop, edition of three), we see the hand of a black man caressing a white marble statue posed lying front-down on a bed. The figure is somewhat ambiguous in terms of its gender, but probably female. The statue's eyes are closed, in contrast to the man, who carefully looks and touches. The contrast between the white marble and the black living skin is heightened. Shadows fall from his hand onto the glistening marble surface. The still images are accompanied by a quote from Hegel: 'Nothing has a Spirit that is ground within itself and dwells in it, but each has its being in something outside and alien to it' (Hegel, *The Phenomenology of the Spirit*).[38] The Hegelian tradition, developed by later philosophers such as Jean Paul Sartre, located subjectivity in a dialectical relationship between the self and the other, sometimes expressed in Hegel's thought as a master-slave relationship, where, according to Hegel, the slave needs the master in order to recognise himself, just as the master needs the slave's recognition in order to be a master. Hegel's view was that slavery was undesirable and should not exist in rational societies, yet he believed that Africans had not yet reached a sufficient degree of consciousness to be free subjects: 'the basic principle of all slavery is that man is not yet conscious of his freedom and consequently sinks to the level of a mere object or worthless article.'[39] The many attempts by slaves to escape and heroic rebellions throughout history from Spartacus to Toussaint l'Ouverture rather disprove this view, which underplays the use of brute force in keeping slaves docile and hardworking.

Knorr is interested in using writings from the Enlightenment period in her investigations of culture and taste in relation to prestige, power and subjectivity. Enlightenment subjectivity and active citizenship generally marginalises women, colonised people and, also, working-class men, who, as far as I am aware, do not make an appearance in Knorr's work.

In her image *Butades' Daughter* (1994; a framed cibachrome colour print, 101.5 x 101.5 cm, with brass plaque, edition of three, from the series *Academies*), Knorr stages the scene when, according to the classical writer Pliny's account, painting was invented. In the *Academies* series, Knorr constructs scenes relating to theories of the origins of art at a time when history painting was the preferred *genre* of the European Academies. In this particular image (colour plate 7 and cover), set in an interior with classical and neo-classical artworks, the photographer is shown kneeling on the ground tracing the outline of

a young woman's face cast in shadow on the wall. In another version of this, *The Pencil of Nature* (1994), a younger standing woman draws the outline. The title *Pencil of Nature* refers to the drawing of an image based on nature by the 'first' artist, but also to the book by Fox Talbot produced between 1843 and 1846, which was the first photographically illustrated book, publicising his invention of photography using the negative/positive process, which is the basis of all photography today. *Butades' Daughter* invites us to consider the parallel between the indexical nature of the photograph and the originally indexical nature of the portrait as a trace on a wall – a cast shadow. There is a physical link between the image and what it represents. However, the idea of copying from nature without the intervention of intellect and the transformation of nature into art was frowned on by Academic theorists. Towering above the two women is a classical nude male statue, its massive shadow cast on the wall. The women seem subordinate to its presence, but are nonetheless centre-stage. Light and shadow and the creation of photographic and artistic images are central concerns here and the women play the key roles as both models and makers.

The story of the origins of painting recounted by the classical author Pliny was a popular one in the later eighteenth century, the age of the Grand Tour and the classical revival among the elite of Europe. British artists often chose to depict it, following the story of how a Corinthian or Sicyonian maid, the daughter of Dibutades, with Cupid guiding her hand, traced the outline of her (male) lover's shadow on the wall the night before his departure for battle. (Note that Knorr uses two women in her images.) However, this feminine creator of painting caused problems for the predominantly male, eighteenth-century academic art milieu.

Discussing James Barry's treatment of this theme and also that of the birth of Pandora, John Barrell remarks that, for Academy purposes, as a myth of the origin of painting, 'Everything is wrong with it.'[40] It represents portraiture, not history painting, as the foundation of art; it shows copying and tracing, not invention and idealisation; it shows art in a domestic, not a public, space; art is associated with personal attachment, rather than noble abstract concepts. In short, 'Pliny's myth, in attributing the origin of painting to a woman, would have been interpreted in late eighteenth-century Britain as attributing a feminine function to the art.'[41] This, of course, is one of the central concerns of Knorr's work – the re-inscription of feminine subjectivity into the spaces of eighteenth-century high culture and the placing of different

actors into the theatre of consciousness, thereby undermining ideology and stimulating understanding.

LIGHT ON THE SUBJECT: THE WORK OF JEFF WALL

In the work of Canadian artist Jeff Wall we see examples of staged subjectivity in a way that is perhaps more clearly Brechtian than in the work of Karen Knorr. Wall's large-scale lightboxes engage more directly with issues of ideology and consciousness, self, history and society. Most of his scenes are staged in the present and the posed characters wear contemporary dress.

On holiday in Europe in 1977, Wall noticed an illuminated backlit sign: 'It was not photography, it was not cinema, it was not painting. It was not propaganda, but it has strong associations with them all.'[42] Although Wall has worked in black and white, it is the (mostly) cibachrome large transparencies behind a plane of Plexiglas in lightboxes, backlit by small daylight fluorescent lighting tubes, which have become most associated with him. This gives an almost magical look to his carefully staged tableaux photographic images, since they have an added dimension of depth and luminosity. Sometimes the compositions are meticulously staged and then photographed, using models and actors he scarcely knows. Sometimes he combines these images with digital manipulation. While Wall's art-historical training and theoretical sophistication give his compositions the aura of art, the materials he uses, for example industrial (factory) lighting, recall more banal, even tacky, advertising media.[43] Wall's use of lightboxes is also appropriate for his aim of illuminating the everyday, the banal and making the ordinary appear strange. The staged photograph does this in a particularly apt way and the lightbox format accentuates this. Wall himself refers to a fascination with the idea of a light source bringing an image to life – the mysterious genesis of representation: 'I think there's a basic fascination in technology which derives from the fact that there's always a hidden space – a control room, a projection booth, a source of light of some kind – from which the image comes.'[44] When an image is projected in the dark, as in the cinema, the light shines through the image and throws it onto the screen or the wall. In Jeff Wall's lightboxes, the light shines through from the back of the image and we view it in daylight, or even in artificial light in a gallery space. We see the image as a distinct kind of lightness from the light which surrounds it and this contributes to a different viewing experience from

cinematic projection, or seeing illuminated signs in the darkness. It is like comparing a camera lucida (light room) to a camera obscura (dark room). Of course when the electricity is not switched on, then the work remains in darkness, incomplete. Bryson sees an analogy between the transparencies and light used by Wall and the way in which the artist invites us to see *through* (unlike normal photographs which we look at in two dimensions) and thereby grasp a polemical intention of making social situations transparent to the viewer.[45] Wall is interested in the world outside the artwork and the fact that there is a past, present and future unfolding for the models and actors who come together briefly to pose for his works.

Wall's staged scenes are often compared to modernised history paintings of the later nineteenth century, such as those of the Parisian artist Eduard Manet. Wall consciously alludes to Manet's work and strategies in some of his works, such as *Picture for Women* (Pompidou Centre, Paris), which directly refers to Manet's *Bar at the Folies-Bergère* (1882; Courtauld Institute Galleries, London). Charles Baudelaire, poet and critic, had called for a 'painter of modern life' to fix the transient glimpse of modernity in capitalist urban society in images which linked it to the timeless element present in great art of the past.[46]

Wall's staged tableau-photographs – autonomous, discrete, large-scale images – can be compared not only with the work of Manet and modern-life painting, but also with earlier concepts of history painting. These images foreground composition, gesture and ideology. As in history paintings, gesture is important here for narrative and legibility. However, the gesture/gestus in contemporary capitalism has a different meaning from its existence in seventeenth or eighteenth-century academic history paintings. In 1984, Wall wrote about his understanding and use of gesture. As a sign, gesture was important for history paintings, making legible actions with an elevated moral content – patriotism, self-sacrifice etc. Nowadays, says Wall, gestures in modern life and art are different:

The contracted little actions, the involuntary expressive body movements which lend themselves so well to photography are what remains in everyday life of the older ideas of gesture as the bodily, pictorial form of historical consciousness...
Gesture creates truth in the dialectic of being for another – in pictures, its being for an eye. I imagine that eye as one which labours and which desires, simultaneously, to experience happiness and to know the truth about society.[47]

Discussing his tableau-photographs with T.J. Clark, Wall is asked whether his representations of these 'little' controlled actions visible in late capitalist society mean that he is still involved with the artist's control over things, that 'it opens itself up to a reading as your own puppet show and that you haven't actually exited from the transparencies.'[48] Wall replies that the issue here concerns a 'concept of truth guiding the *mise-en-scène*'.[49] Wall then discusses subjectivity, stating that the 'unified subject' has been replaced by 'an absolutization of the notion of the fragmented subject', which has resulted in an oscillation between the two concepts (unified vs. fragmented) within the same old discourse rather than a vision of a different kind of subject altogether.[50] This is a very interesting suggestion. Wall says his own aim is not to address a unitary subject or a fragmented one, but to 'create a sort of identity crisis with the viewer in some form, maybe even a subliminal one'.[51] He asks Clark: 'Don't you think it is rather unsatisfying to suggest that, because there is an ideological concept of the legal person – who is a legal possessor of property and derives personhood from that concept of property – that we should totalise that to the point where we can no longer accept any form of individuation as legitimate? Things are, of course, more complicated.'[52] The bourgeois notion of the so-called Cartesian subject is historical and contingent, not natural, and artistic and political critique can help us to evolve different notions of subjectivity which are, as yet, still in development. Political critiques of capitalism, its state apparatuses and legal systems, seem to me to be an essential factor in accompanying the emergence of more radical notions of subjectivity which value human beings above private property and encourage individuals to build supportive communal structures free from social and economic oppression. However, to attempt to define what subjectivity might be in the future would be prescriptive.

THE INVISIBLE SUBJECT

One of Wall's more recent lightbox works is *After Invisible Man by Ralph Ellison, the Preface* (1999–2001, transparency in lightbox, 220 x 290 cm; colour plate 8). This work deals with the denial of subjectivity through social oppression. The elaborately constructed image, a product of both straight and digital imaging, has a striking luminosity and presence, accentuated by the theme of the picture and by the hundreds of light bulbs suspended from the ceiling of the den, where

a black man sits with his back to us. Constructed around notions of dark and light, negative and positive, invisibility and visibility, Wall's inspiration came from the novel Ellison published in 1952, which deals with the experiences of an unnamed black male narrator experiencing racism in post-war America. He is invisible and unrecognised, without subjectivity, because people refuse to see him. Since he is invisible, he lives rent-free in a section of the basement of a building rented exclusively to whites. His 'hole' is full of light:

I doubt if there is a brighter spot in all New York than this hole of mine and I do not exclude Broadway. Or the Empire State Building on a photographer's dream night... Those two spots are among the darkest of our whole civilisation – pardon me our whole *culture*... I can now see the darkness of lightness. And I love light. Perhaps you'll think it strange that an invisible man should need light, desire light, love light. But maybe it is exactly because I *am* invisible. Light confirms my reality, gives birth to my form... That is why I fight my battle with Monopolated Light and Power. The deeper reason, I mean: It allows me to feel my vital aliveness. I also fight them for taking so much of my money before I learned to protect myself. In my hole in the basement there are exactly 1,369 light bulbs. I've wired the entire ceiling, every inch of it. And not with fluorescent bulbs, but with the older, more-expensive-to-operate kind, the filament type... The truth is the light and light is the truth.[53]

This scene is ideal for Wall, with its extended metaphor of light as life-giving and creative, and it also foregrounds the key role of light in the production of the photographic image. The light of truth and consciousness also pierces the murky depths of ideology. The invisible man has decided to opt out of the economics of capitalism, especially since its social system assigns him such an exploited and oppressed position. The image is at once totally seductive and yet, to a certain extent, strange and alienating. Using Fried's approach, we can see the figure seated and self-absorbed, but the whole tableau is presented as a self-contained scene into which we cannot enter. The enclosed space, which mimics the description of the 'hole' in the basement, is like an image of the dark chamber of the mind (as camera obscura) where light is brought in from outside. Subjectivity is not just a matter of visual perception and neural activity, but of understanding, of 'seeing the light'. Wall's lightboxes are embodied metaphors for the processes of photographic imaging and subjective consciousness. The tableau-photograph, with its combination of fabrication and vestiges of reality (after all, as Wall stresses, the photograph is basically the activity of

light on objects), also encompasses these elements of representation and consciousness – the outside and the inside. Wall succeeds in constructing images which function as pleasurable, even erotic, for the viewer. He has stated that 'you could even say that everything erotic is pictorial and everything pictorial is erotic.'[54] The eroticisation of the image in Wall's work results in photographs which give concrete form to the pleasures of 'seeing the light'.

THE CAMERA OBSCURA OF SUBJECTIVITY

At various points in this chapter, I have referred to the camera obscura and its use not just as a physical device linked to the development of later types of photographic apparatus, but also as a metaphor for seeing and understanding. Linked to the Cartesian theatre, a darkened space where a spectacle of 'illumination' can happen, the camera obscura is also a focus for the following investigation of subjectivity, ideology and representation, bringing together once more Marxist and psychoanalytic theories. Like the Cartesian theatre, the camera obscura, where light enters an enclosed space through a small aperture, is also a metaphor for subjectivity and consciousness associated with Descartes. In addition to its links with the later photographic camera, the camera obscura is thought to have been used by artists to trace compositional scenes from which to make paintings, although there is some argument about how influential this actually was on the works of major artists.[55] Within the field of cultural theory, the image of the camera obscura, its darkness and light, negative and positive, is encountered in the work of writers investigating subjectivity, desire and ideology.[56]

First of all, though, it is useful to say something briefly about the 'dark room'. The camera obscura was invented many centuries before the 'discovery' of photography.[57] The device was described in the ninth century by the Arab scholar Alhazen. This darkened box or larger space, sometimes a room, with a small hole on one side, allowed light to enter and project a reversed and inverted image on the opposite wall. Mirrors could be used to 'right' the image.

Descartes compared the workings of the eye to a camera obscura. Light entering the lens of the eye reflects a real image on the screen of the retina. As Richard Gregory puts it: 'in the eyes there are images of light, optically projected from the outside world onto the screens of the retinas.'[58] This image is reversed top to bottom and left to right. Leonardo had puzzled over this reversal, as did Descartes and Kepler

in the seventeenth century.[59] Was there somewhere in the brain that 'saw' the reversed images the right way up? The notion of the inner eye/the mind's eye is a mistaken one, however. The brain does not see retinal images, but relates signals from the eyes to objects in the world which are also known by the tactile experience of these objects.[60] The brain does not directly perceive the images nor does the light from the objects enter the brain, as Descartes seems to have thought. However, the notion of the conscious self whose mind functions like a camera obscura has persisted. Referring to Rodin's famous statue, *The Thinker*, Gilbert Ryle remarked: 'what are the mental processes like, which are going on in that Cartesian *camera obscura*?'[61] More recent writers have also linked the metaphor of the camera obscura to a Cartesian concept of the mind.[62] Jonathan Crary remarks that while Descartes compared the workings of the eye to the camera obscura, his concept of the mind also meant that one could not know the world only by eyesight. 'For Descartes, one knows the world "uniquely by perception of the mind" and the secure positioning of the self within an empty interior space is a precondition for knowing the outer world. The space of the camera obscura, its enclosedness, its darkness, its separation from an exterior, incarnate Descartes' "I will now shut my eyes, I shall stop my ears, I shall disregard my senses".'[63]

This metaphor of light entering the darkness of the mind's interior is one of considerably long standing. Before the discovery of the camera obscura, it occurred in Plato's *The Republic*. Plato (*c.*427–347 BC) uses the example of shadows in a cave to explain to his companion how men can be deceived into mistaking illusions for reality. Prisoners in the cave are tied so that they cannot look behind them and see only shadows of real people cast by the light of a fire. They mistake these shadows for reality. When a prisoner is freed, he experiences the daylight world, gradually becomes accustomed to natural light and the sun and able to discern the truth. In the physical world, there is a difference between things and their shadows which illustrates degrees of truth. For Plato, Good is linked to knowledge, light, vision and the sun. Opposed to this is darkness and lack of comprehension.[64]

The image of Plato's cave has been referred to often by writers on vision and photography. Richard Gregory likens the eye to 'Plato's cave with a lens, where images are projected from the outside world'.[65] Susan Sontag mentions it in the first sentence of *On Photography*.[66] More recently, writers on photography interested in postmodern theory have used the image of Plato's cave to discuss the concept of

the simulacrum, a copy of something of which there is no original, or something that looks like reality and truth but is not. The photographs of Cindy Sherman are often cited as an example of this development in postmodern photography. Her early black and white film stills professed to be from films which never existed.[67] The idea of the photographic simulacrum developed by writers influenced by the French philosophers Deleuze and Baudrillard, moves away from Plato's notion that men can progress to knowledge and understanding and even good government, through realising the difference between reality and illusion. Instead, the simulacrum is linked to theories which posit reality as ultimately unknowable. As Krauss puts it: 'We are surrounded, it is argued, not by reality but by the reality *effect*, the product of simulation and signs.'[68]

The camera obscura has an interesting history as a metaphor for the mind and for understanding and its close links with the development of photography also make it a useful concept through which to examine both the process of understanding and conscious subjectivity, and the representation of subjectivity by means of photography. The reversed and inverted image cast on the retina and inside the camera obscura, is further inverted in the photographic negative, where light and dark are transposed. This was not the case with early photographic images which produced positives, but were also unique and non-reproducible, for example, the Daguerreotype. Ironically therefore, the negative becomes more productive than the positive, reversing the usual ideological connotations of the light/dark binary opposition.

The symbolism of light and dark is a huge topic and beyond the immediate scope of this book. However, it is useful to refer to it briefly here. From Plato's cave to the 'Fiat Lux' ('Let there be light') detective agency of Nestor Burma in Léo Malet's wonderful French private eye novels, light is associated with discovery, comprehension and reason. Dark is its binary opposite, connoting evil, lack of understanding, fear and 'primitiveness'. A nineteenth-century manual for artists listed the oppositional values of black and white, concluding that: 'The battle between good and evil is symbolically expressed by the opposition of white and black.'[69] These oppositions were linked ideologically to racist ideas which valued whiteness over blackness, as Richard Dyer explains in his fascinating book on whiteness and light in photography and the cinema.[70] With the invention of electricity, light became even more symbolic of progress, industrialisation and modernity.[71]

IDEOLOGY

In *Techniques of the Observer*, Jonathan Crary argues that the camera obscura was a paradigm for a particular way of seeing by an observer endowed with authority and universality, detached from, and in control of, the material world 'outside' his inner subjectivity.[72] For scholars like Crary, it is therefore intimately linked with symbolic Cartesianism. Despite what one writer has called the 'technical determinism' of his approach, Crary's discussion of 'The Camera Obscura and its Subject' is an interesting one.[73] He refers in passing to a number of useful books which discuss the camera obscura and ideology, even though he himself is more comfortable with the notion of discourse.[74] He remarks that the camera obscura changed from being a metaphor for objectivity and knowledge in the early modern period and shows how, in later texts by Marx, Bergson and Freud, the camera obscura is seen as a 'model for procedures and forces that conceal, invert and mystify truth'.[75]

The most interesting reference is where Marx and Engels use the camera obscura as an analogy for the process of ideology and its relation to consciousness.[76] In their book *The German Ideology* (1845–1846), Marx and Engels argue that we need to focus on the material life of people in order to understand their ideas. Consciousness is conscious existence, not an abstract idea: 'If in all ideology men and their circumstances appear upside down as in a *camera obscura*, this phenomenon arises just as much from their historical life-process as the inversion of objects on the retina does from their physical life-process.'[77] This inversion of reality, as in the optical camera obscura, is an analogy for the way in which people misrepresent to themselves the true nature of society and the reasons why it functions as it does. Part of the solution to this process of misrepresentation, say Marx and Engels, is to see that consciousness is determined by life and not the other way around, as in idealist philosophies. The problem is, though, the image in the camera obscura looks so real and yet there is clearly something fundamentally wrong with it. Using a mirror can make things look right, but that merely changes things on the level of sight, not comprehension. For that you need to stand outside of the darkened box.

In his book on the concept of ideology and its history, Terry Eagleton discusses Marx's and Engels' models of ideology. The camera obscura analogy from the 1840s does not place enough emphasis on human consciousness as active, says Eagleton, as it implies that inversion is what is necessary – inverting the image in the camera, but also inverting

the explanatory significance of the material and the conceptual. However, when Marx discusses commodity fetishism in volume one of *Capital*, he argues that the commodity is not perceived primarily as a product of human labour for capitalism and appears to be endowed with a life of its own, and that to understand this we only have to look at religion. 'In that world, the productions of the human brain appear as independent beings endowed with life and entering into relations both with one another and with the human race'.[78] Eagleton points out that in this passage, published in the later 1860s, Marx has changed the concept of ideology and now it is less a matter of reality being inverted by modes of perception, than of the mind grasping a real inversion in the material world, i.e. things being endowed with a life of their own and valued over people.[79] Turning things on their heads again, instead of living with them upside down, is no longer sufficient, observes Eagleton. For Marx and Engels, subjectivity and class-consciousness are linked to the active changing of the world, not simply 'righting' a 'wrong' image in the mind.

In Sarah Kofman's stimulating book on ideology she examines how various thinkers have used the image of the camera obscura in their work. Starting with Marx and Engels, she also discusses Freud and Nietzsche, as well as Rousseau and Descartes. Thus we are invited to consider the links between the camera obscura, the darkened space of the mind, ideology and subjectivity and the strange paradox offered us by Rousseau, who writes that his personal 'confessions' are set down with the passive objectivity of the camera obscura, while being his personal portrait of himself.[80] After a fascinating philosophical discussion of the camera obscura and subjectivity, Kofman concludes that:

the use made of the camera obscura metaphor in the nineteenth century – as an image of the unconscious, of inversion, of perspectivism – is not a necessary consequence of the model itself. A metaphor such as this resists the evolution of science. That is, it operates above all through its mythical significations and through its impact on the unconscious.[81]

So the camera obscura *has* entered the brain after all. It is no accident that, through the image of the camera obscura, the two strands of my investigation throughout this book on subjectivity and representation – Marxism and psychoanalysis – come together once again. The mind and subjectivity are both individual and social, unconscious and conscious. Bringing subjectivity to light, representing and understanding it,

whether psychoanalytically, politically or photographically, means standing outside the camera obscura, whether as a Cartesian subject or as a conscious agent of a different sort.

I want now to conclude this discussion of photographic imagery and subjectivity by looking at two self-portrait photographs – one by Cecil Beaton and one by Mme Yevonde. These photographic self-portraits, made with light, but brought into being in a darkroom (or camera obscura?), are a site where private desire, fantasy and the unconscious meet the public concerns of economics, professional practice and published autobiographies. The subjectivities of Beaton and Mme Yevonde are both lived and constructed in the camera obscura of ideology.

CECIL BEATON

Cecil Beaton describes in his book *Photobiography* how he posed for a family portrait at the studio of Miss Lallie Charles, a portrait photographer specialising in pictures of 'stage goddesses' and Edwardian society beauties.[82] David Mellor has described Beaton's interest in collecting and making photographs as almost fetishistic.[83] Beaton was also interested in the theatre, took part in theatrical performances and arranged 'tableaux' of society beauties and debutantes in the bohemian and upper-class milieux he frequented.[84]

Within the world of photography, Beaton positioned himself as an amateur and a dandy, rather than as a practitioner. He emphasised the importance of breaking rules and compared his approach to that of a film director, creating a set and posing his cast.[85] Beaton's images in the inter-war period often attempted to recreate a pre-war utopia reviving Victorian and Edwardian styles with aristocratic connotations. His attitude to his photographic career in the world of fashion and commerce has been described by David Mellor as a lesson in 'how to be a dandy in the age of mass culture'.[86]

Beaton loved taking photographs – the feeling of transforming reality, of making the everyday theatrical: 'It is the theatre brought to everyday life; the ordinary routine of existence is broken and the tension is heightened.'[87] His concept of the theatrical is not Brechtian, however, being more akin to the theatricality of the baroque, where the spectacular is perceived and valued for its own sake more than for its relationship to reality. Beaton included glossy surfaces, photographs, mirrors and reflections in his images. He liked to stage himself, as well as others.[88]

By the 1930s, British studio photography was in decline. Department stores had began to offer mass-produced photos with, for example, eight small prints delivered in three minutes by the Photomaton in 1928 and then by the Polyfoto system (forty-eight negatives for 2/6d) in 1933.[89] Photographers like Beaton were obliged to align themselves with commerce, or develop original approaches, as Mme Yevonde was to do with colour portraiture of society women. Beaton once remarked that he would only occasionally take portrait photographs for $500 if he could think of something 'amusing' to do with the sitter.[90]

The frontispiece to his *Photobiography*, an account of his photographic career to 1951, written in a conversational, humorous, sometimes self-deprecating tone, was probably taken in the late 1940s (plate 7). In about 1947, Beaton bought Reddish House and there in the library all his photographs were kept in large red-leather-bound albums, more than forty or so at that time. Beaton has pictured himself in this room, perhaps looking at some of his own work by the light of a table lamp. This almost Baudelairean image shows the dandy as art lover intently scrutinising images, yet posing as a mere amateur. The use of light and shade is striking, dramatic yet intimate, even secretive. Beaton's library is like a scholar's study, but composed of images rather than words. He wrote: 'They reveal so many evanescent moods and modes, so many forgotten people – and the survivors have already undergone such startling changes – that the impression they create is that of a photographic mausoleum.'[91] Beaton's uneasy positioning of photography between stage and cinema, high and more popular art forms, is here situated more securely within the trappings of high culture: an eighteenth-century bust of a woman is placed behind his head. His interior life, about to be 'revealed' to us in his 'photobiography', is preceded by this self-created image of inwardness and self-absorption, rather than theatricality. Crary describes the spectator posited by the camera obscura as 'isolated, enclosed and auto-nomous within its dark confines', withdrawn from the world engaged in a 'metaphysic of interiority: it is a figure for both the observer who is nominally a free sovereign individual and a privatised subject confined in a quasi-domestic space, cut off from a public exterior world.'[92]

Yet Beaton was no autonomous, abstract individual but for all his pose of detachment, very much of his time and social milieu. For example, he disapproved of 'the new woman' with her profession or job. He preferred old notions of beauty and femininity, which were disappearing except in an increasingly restricted sphere of the old

aristocracy and royalty. More modern images of glamour were likely
to be constructed in fashion and the cinema. Beaton's condemnation of
the modern, working woman as a member of 'a race of Robot women,
uncaring and unreal' made his social views quite clear.[93] Beaton's
nostalgia for times past, where women were beautiful models for the
artist, meant that his study is represented as a refuge where images
could be lit up and become visible in the shadows. Karen Knorr's works,
on the other hand, show Enlightenment high culture, marble statues,
libraries and gentlemen's clubs as visually attractive, illuminated
and polished, but something to be viewed with a critical eye from
an 'estranged' perspective. Beaton's ideological view of culture and
women's place within it is embodied in his own private camera obscura
– a summation of his photographic life.

Plate 7. *Cecil Beaton,* Self Portrait, *frontispiece to Beaton's*
Photobiography, *1951, black and white photograph, courtesy Sotheby's
Picture Library.*

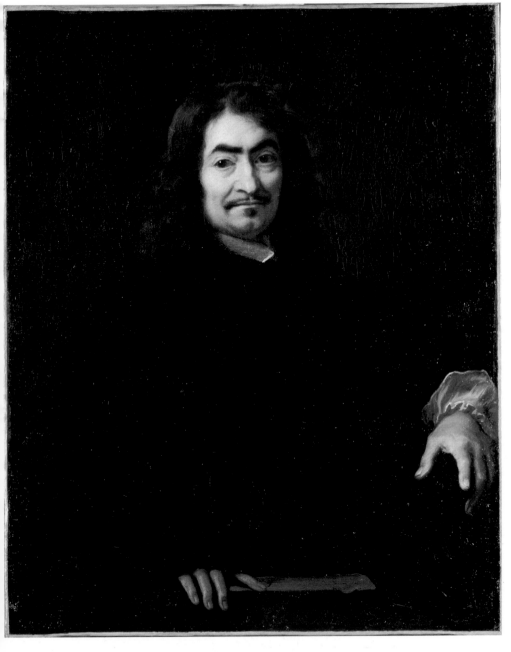

1. *Sébastien Bourdon (attributed to)*, Presumed Portrait of Descartes, *oil on canvas, 87 x 69 cm, late 1640s/early 1650s, Louvre, Paris, Photo copyright R.M.N., J.G. Berizzi.*

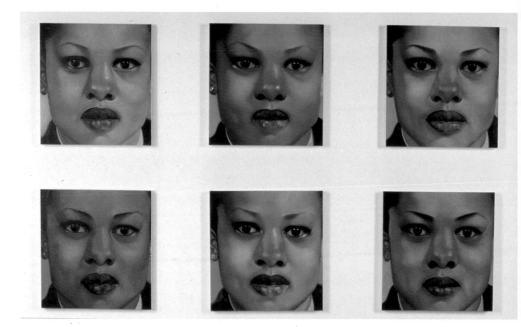

2. Eugene Palmer, Six of One, *oil on canvas, six paintings each 97 x 100 cm, 2000, courtesy of the artist.*

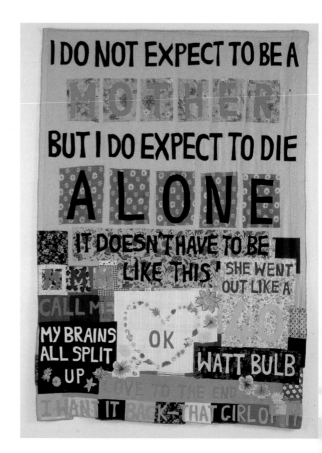

3. Tracey Emin, I do not expect to be a mother, but I do expect to die alone, appliqué blanket, 264 x 185 cm, 2002, copyright the artist, courtesy Jay Jopling/ White Cube (London), photo Stephen White.

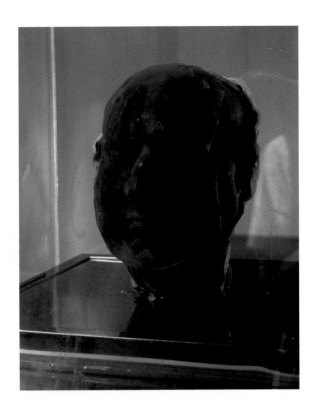

4. Marc Quinn, *Self*, blood, stainless steel, perspex and refrigeration equipment, 208 x 63 x 63 cm, 1991, copyright the artist, courtesy of Jay Jopling/White Cube, (London), photo Anthony Oliver.

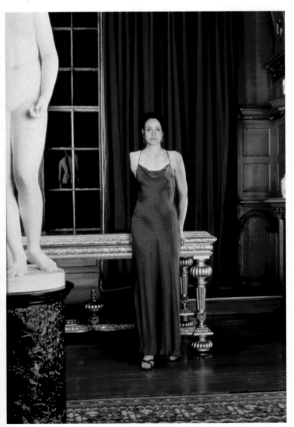

5. Alexa Wright, 'I' no.1, digitally manipulated photograph, 105 x 79 cm, 1998-9, reproduced courtesy of The Art Gallery and Museum, the Royal Pump Rooms, Leamington Spa, Warwick District Council, copyright the artist.

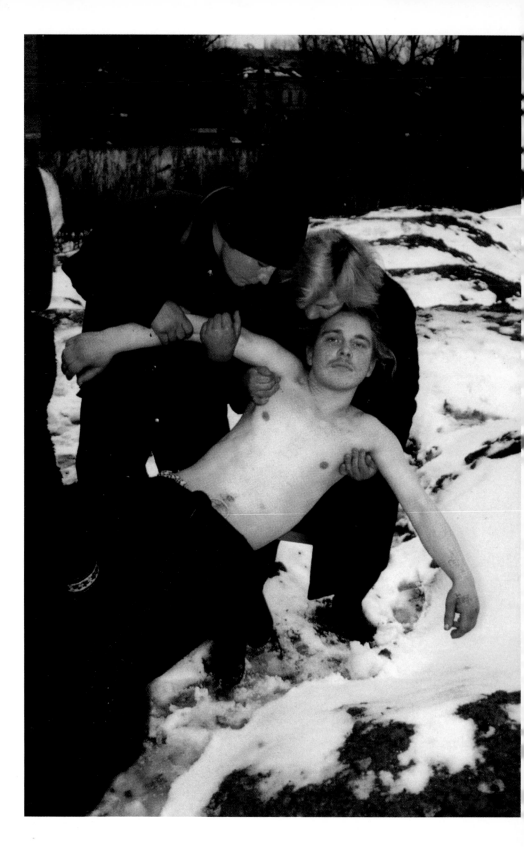

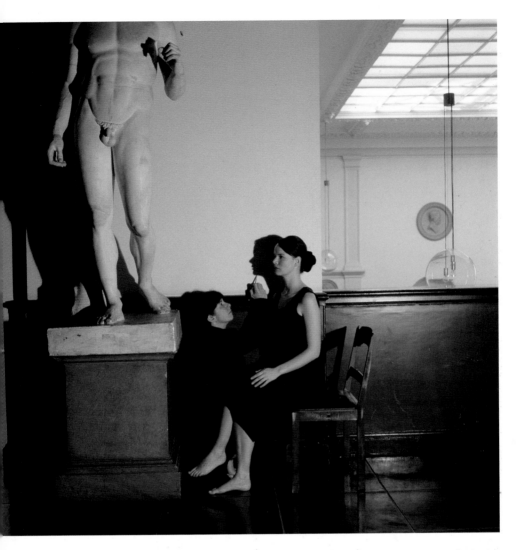

6. (opposite page) Boris Mikhailov, Untitled, *from 'Case History', Karkov, Ukraine, colour photograph, 127 x 187 cm (edition of 5) or 40 x 60 cm (edition of 10), 1997-8, courtesy of the artist.*

7. (above) Karen Knorr, Butades' Daughter *(from the series 'Academies'), framed cibachrome print, 101.5 x 101.5 cm, with brass plaque, edition of three, 1994, courtesy of the artist.*

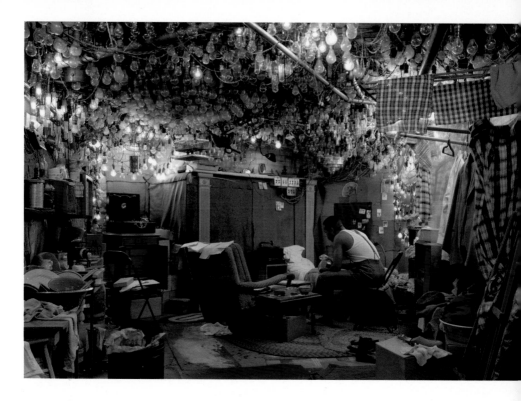

8. Jeff Wall, After Invisible Man by Ralph Ellison, the Preface, *transparency in lightbox, 220 x 290 cm, 1999-2001, courtesy of the artist.*

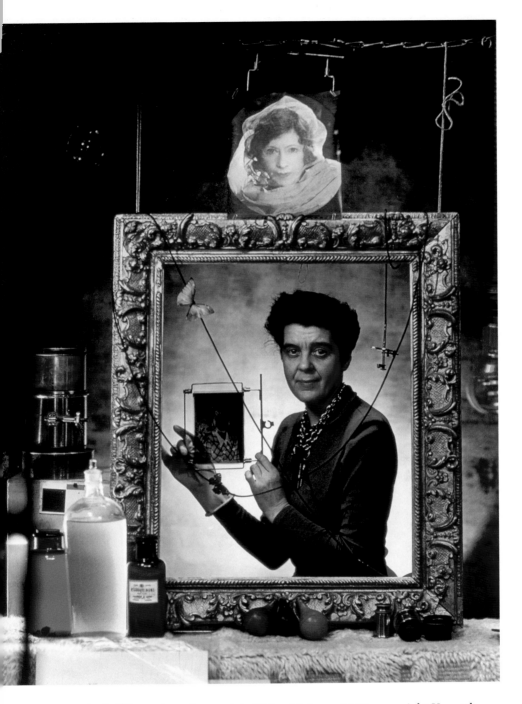

9. Mme Yevonde, Self Portrait, *colour print, 37.8 x 30.5 cm, 1940, copyright Yevonde Portrait Archive.*

10. Richard Pohle, Woman Begging on Euston Road, London, *colour photograph, published on the front page of* The Times, *9 March 2000, copyright NI Syndication,* The Times.

MME YEVONDE

The practice of photography was one area where subjects who were often relegated to the margins of cultural activity could come into their own. An example of such a female photographer was Beaton's contemporary, Mme Yevonde, a 'modern woman' with a profession. She was born in 1893 into a prosperous family in Streatham, South London.[94] Like Beaton she posed and staged her sitters and herself, but her work is significantly different from his in that she concentrated more on portraiture and she used colour photography in an innovative way. Like Beaton, too, she had passed through the studio of Lallie Charles, but as an apprentice rather than a sitter.

Mme Yevonde's autobiography, *In Camera*, published in 1940, is, in her own words, not 'the story of a woman's life but the story of a photographer who happens to be a woman'. She was 'no born genius', 'nor have I the astonishing facility for picture-making and social success of Cecil Beaton'.[95] The title of her book suggests not only the private chambers of a judge, but also, obviously, the camera obscura; the shortened version 'camera' referring to the apparatus where a film is exposed to light.

Mme Yevonde (or Yevonde Cumbers – the use of Madame for aspiring female photographers was not unusual and also suggests the use of Madame for French haute couture designers) – was educated in much the same way as many young women of her time and background, but became active in feminist and Suffragette politics for a time. She set up on her own as a photographer in 1914, her aim being to support herself financially as an independent woman. Thus she was one of the 'new women' frowned upon by the likes of Beaton, whose gender and class position allowed him to play the role of dandy and amateur in a way that Mme Yevonde consciously rejected. Though her Suffragette politics did not last, she became an important figure in the world of photography, giving public lectures (she was the first woman to lecture to the Royal Photographic Society) and in 1936 spoke at an international conference in Paris organised by the Business and Professional Women's Federation.[96]

Photography was a profession open to women, though many of the jobs in the industry were semi-skilled and low paid, for example in photographic or film laboratories. Mme Yevonde had to pay thirty guineas to be taken on by Lallie Charles for a three-year apprenticeship.[97] She herself charged up to £20 per portrait sitting

and more for advertising and commercial work. Her sumptuous colour portraits from the 1930s were expensive, more due to the process than anything else and one print cost £12/12/6.[98] Women could either be trained by a photographer in a studio, or take a college course, one of the recommended ones being at the Polytechnic of Regent St., London (later Central London Polytechnic).[99]

In 1920, Mme Yevonde married Edgar Middleton, a playwright who seems to have been rather difficult to live with and who died of cancer in 1939. In the final chapter of *In Camera*, she ponders on the conflicting needs of private emotional and sexual happiness as a wife and the fulfilling nature of a chosen career for women. 'If I had to choose between marriage and a career I would choose a career, but I would never give up being a woman.'[100] His death seems to have been a great blow to her, though he disappointed her by his lack of interest in having children. In his own autobiography, he never mentions his marriage and it includes chapters such as 'Why I hate women' and 'Women aren't wonderful'.[101]

In an article in 1924, Molly Durelle wrote: 'Photography is essentially a woman's employment. There is not a single branch of it in which she cannot compete equally with men and in some cases she is a much more artistic worker.'[102] Yet attitudes to women professionals were sometimes antagonistic and often patronising.

In her public lectures, Mme Yevonde sometimes used self-deprecatory humour referring to women's supposed frailties. Cecil Beaton's use of gentle self-mocking humour functioned to position him as an amateur, careless of money and fame. Mme Yevonde used similar tactics but in order to deflect antagonism directed towards a woman entering the ranks of a profession at a level where men predominated. At the same time, she mobilised notions of women's 'essential' female qualities to argue that women were best suited to portrait photography.[103] In another lecture delivered in 1933, described as 'a racy address', Mme Yevonde, a passionate advocate of colour photography, described woman as 'the more primitive sex' since she relied for seventy-five per cent of her sex appeal on colour, unlike men.[104] Presumably, this made women ideally suited to working with colour photography. In response to her talk, a discussion ensued in which one participant argued that love of colour was associated with primitive forms of society and black and white a sign of higher civilisation. Dr D.A. Spencer remarked that Madame Yevonde did not rely on colour for her charm, as she was wearing black and white and moreover her success could be attributed

to something she shared with men: 'she had intelligence!'[105] These remarks, no doubt well-meaning and intended to flatter a respected speaker and practitioner, have a rather patronising quality at times and betray something of the sexist attitudes Mme Yevonde and others like her must have encountered when trying to advance in their professions.

Mme Yevonde's advocacy of colour was partly based on the fact that she knew studio photography was under threat and she wanted to experiment with innovative forms of portraiture, making her works more like art. The Vivex colour process was a means of doing just this, especially when few other photographers wanted to go in this direction. The beautiful saturated colour created by the Vivex process was a result of its use of pigments, like paintings, rather than dyes.[106]

As mentioned above, however, colour was equated with the feminine and also with the primitive. This was not an isolated view, as another writer on photography notes in 1935:

Show a gaudy chocolate box to a child, a savage, or the unsophisticated and they will all be attracted and declare it beautiful. But we must not decry colour merely because it pleases the Philistines... In the writer's opinion, the only practical scope for colour lies in the film studios... Photography in colour is only in its infancy.[107]

The linking of colour to cinema film connoted spectacle, entertainment and mass audiences, not high culture. The Technicolor process used at this time used a three-colour subtractive system of colour negatives and prints, similar in principle to the procedure used by the laboratories processing Mme Yevonde's work. The lush and saturated colour was seductive and sensual. Mme Yevonde doubtless appreciated these aspects of colour, yet at the same time insisted that her work was artistic, rather than mass produced like department store photography.[108]

Steve Neale's excellent discussion of colour in the cinema includes quotes from the colour consultant for Technicolor, Natalie Kalmus, explaining in 1938 how colour had to be fitted to the emotion of the scene. She was particularly keen to stress that colour should not 'take over' from the narrative. Colour was effective and seductive, especially in highlighting the female star, but colour needed to be kept under control.[109] Max Factor developed special make-up for use with Technicolor film. Mme Yevonde's sitters also experienced problems with skin colour and make-up. All this, of course, was concerned with white skin, somehow normalised. White light and its breaking

down into colour was ultimately conceptualised, artistically and scientifically, around whiteness. Quoting Kristeva, Neale goes on to argue that colour is a potentially disruptive force. 'Because it touches so centrally on the drives and pressures of the psyche in general and the unconscious in particular, it is capable of shattering the rules and laws to which it may be subject in any particular pictorial or cultural system'. As Kristeva puts it, 'Colour is the shattering of unity.'[110]

Mme Yevonde and her advocacy of lush colour photography could have seemed threatening. However, as noted above, she was careful in her public pronouncements to perform her role as a professional woman in a particular way. Her self-portrait of 1940 (colour plate 9) gives us, in a visual form, an analogue for her public performances as a speaker. Her 'in camera' self-portrait, published in the same year as her autobiography, shows us a mature woman of forty-seven years old, with an interesting, but not conventionally beautiful, face. She wears a smart dress and holds up a negative of a female portrait, as she looks directly out at the viewer from an ornate frame of the kind used for oil paintings. Above this and slightly overlapping it is a print of Dorothy, Duchess of Wellington as Hecate, goddess of the night, from the *Goddesses* series. Shutter release chords are draped across the frame, along with a couple of butterflies, symbols of the soul.[111] Placed neatly outside the frame are pieces of photographic equipment, including a portrait lens. Although Mme Yevonde wears a smart dress, she has a heavy chain and keys around her neck and wears a plastic glove. The slightly surreal nature of the images alludes to contemporary avant-garde art practice and the whole image is heavily staged. Mme Yevonde may well be a spectacle in brilliant colour, but she is far from a passive object of the gaze, male or female.

If we compare this self-portrait with that of Beaton, there are a number of interesting contrasts. Beaton is self-absorbed, seated in his library surrounded by the trappings of high culture, represented in tasteful (and civilised) black and white. Mme Yevonde, on the other hand, is in an obviously artificial colour image, full of symbols and allegorical meanings, rather like a vanitas still life, hinting at the passing of time (the butterflies, shutter-release cable, the developing process of the photographic negatives) and the fading of youth. This was also the fading of Yevonde's career, to some extent. The Vivex laboratories closed soon after the start of the war and although she continued to practice as a photographer, she was never able to find a colour technique which suited her so well. Mme Yevonde's image emphasises the importance of

self-presentation for women in any sphere of photography, whether as professional maker, or model. Beaton is less concerned with returning the gaze in his self-image and his library recalls much more directly the notion of a 'camera obscura' of the self. Women looking, whether with glasses or through camera lenses become active subjects rather than objects, but this usually prevents them, in the ideology of mainstream culture, from being admired for their 'looks'. The active look implies knowledge and the desire to control, an intellect rather than beauty.[112] (Remember the comments from the audience about her intellect and the masculine after Mme Yevonde's lecture.)

In a now famous paper of 1929, the psychoanalyst Joan Rivière discusses the contemporary phenomenon of the woman in a 'man's' profession, in universities, business or in the sciences. These women who fulfil every criterion of feminine development, yet are as successful in their professions as any man, are puzzling to classify psychologically, says Rivière. She cites the example of a university lecturer who, in public lectures, is flippant and joking, wears particularly feminine clothes and treats 'the situation of displaying her masculinity to men as a "game", as something *not real*, as a "joke".'[113] These women 'who wish for masculinity may put on a mask of womanliness to avert anxiety and the retribution feared from men'.[114] Rivière concludes from this that there is no 'natural' femininity and that femininity is a masquerade which women act out in order to deflect the anger of men who may see them as a threat to their own spheres of power and influence and also, of course, economic security. Now I am not arguing here that Mme Yevonde is of the same psychological 'type' as the professional women discussed by Joan Rivière, but that the professional 'self' of women in largely male professions at this time often required a degree of acting, artifice, humour and perhaps even self-mockery in order to deflect the antagonism of men protecting 'their patch' from interlopers. Thus the staging of the self, for women, is not only a matter of appearing in staged images, but performing on a public stage and acting a part, both consciously and perhaps even unconsciously, as revealed by Rivière's analysis. This staging of the self, its placing in a 'theatre' of vision and consciousness, is historically and socially situated. In another kind of society, one not based on oppression and exploitation, women would not have to pose themselves, perform, or act out roles, self-deprecating or otherwise, for an audience. 'Being yourself' should hopefully one day dispense with the need for any kind of theatre of the self, whether Cartesian or Brechtian. But is 'being yourself' as natural

as it sounds (be natural, be yourself, listen to the 'smile please' of the photographer)? In what conditions can one 'be oneself'? What chance is there of really developing full self-potential for many people whose existence consists of a constant search for basic human needs such as housing, good health, food and clean water?[115]

CONCLUSIONS

In this chapter I have looked at the so-called Cartesian theatre and the camera obscura as metaphors related to subjectivity. Light and darkness have been culturally linked to concepts of knowledge and consciousness, or ignorance and incomprehension. But in a real, physical sense, the camera obscura, the photographic camera, the (enclosed) theatre and the cinema are actual spaces where the play of light and dark is utilised to create imagery in a different way from, say, drawing or painting. Through the image of the Cartesian theatre and the camera obscura, the presentation of imagery in these art media is intimately linked to models of subjectivity associated with European culture since the time of Descartes. The so-called Cartesian theatre and the mind as camera obscura thus incorporate both the viewing subject and the art object which is viewed within the same (self-)explanatory framework. However, as I have noted previously, it is all too easy to be seduced by abstract models of the mind, as well as by the sensual attractions of striking visual imagery without attending to gender or class, so crucial for an understanding of the self-representations of Cecil Beaton and Mme Yevonde. In the following chapter, I will look at some more modest, 'home-made' photographs related to the representation of my own self, situating those in relation to class and gender in post-war Britain. Specifically, in relation to a photograph taken by my mother, I will further develop aspects of light, shadow, photography and the conscious self.

Of the photographers discussed here, Mme Yevonde goes some way towards challenging the gender aspects of the camera obscura of ideology in her work. More recently, Karen Knorr and Jeff Wall attempt to go further in their staged photographic tableaux. Their works go beyond the categories employed by Michael Fried to understand eighteenth-century French painting, since they offer the viewing subject neither absorption nor theatricality but a modernised reinterpretation of Brechtian theatre which demands a changed consciousness and subjectivity during the viewing process. This changed and changing

self-consciousness and its representations are best understood, I would suggest, by the use of both Marxist and psychoanalytic theory.

I want to admire impressive and seductive photographs, while thinking about viewing the camera obscura of ideology from outside. I also want to ask how much it costs these days to buy a ticket for the Cartesian theatre and who can stand in the queue to enjoy the experience and spectacle of subjectivity.

CHAPTER 5

THE REAL ME

I am the person you have been reading so far, without really thinking about me, unless you happen to know me already. The narrative that begins this chapter is, as far as I can make it so, part of my true history. Photographs accompany this narrative, but they are not in themselves any guarantee of my accuracy or sincerity. My words are also required, in an attempt to assure you that this has not suddenly become a work of fiction, yet my writing is about to move into a different register which is not entirely academic. But first the narrative. Afterwards, I want to consider notions of truth, history, memory, selfhood and imagery as related to my own early life. I will be writing about myself, but while the language helps to represent and materialise aspects of my self, it does not constitute my subjectivity. Language is made socially and has a history, but I speak and write this language: it does not speak me.

Linda Rugg remarks that 'photographs and autobiographies work together as signs to tell us something about the self's desire for self-determination…'[1] However, this desire, while apparently an individual undertaking, takes place in a wider social and economic context, of which the self may often be quite unaware, especially in childhood and adolescence. So what happened to me? Or perhaps, what did I happen to?

NARRATIVE OF MY EARLY SELF

I was born in late October 1948, some time overdue and weighing about ten and a half pounds. My mother and father, although not particularly well off, had paid for the birth to take place in a private maternity hospital – the same one where my two brothers were to be born subsequently. Straight away, I entered the social and economic

milieu of the petty-bourgeoisie, constantly striving to better itself educationally and financially. I suspect this impetus originated more from my mother. She was a clever woman who had a plateful of chips on her shoulder since she had not been sent to university by her parents. Instead they decided she should become a post office clerk, while her younger brother and sister both became university graduates (the brother through an army engineering bursary, the sister paid for by the family). My father had been in the navy since before the Second World War, and had to buy himself out after it ended. He came from Lowestoft, a fishing town on the Suffolk coast, and had gone to sea with his father, the master of a drifter, who liked to drink and who wore a gold earring. I knew this because when I asked, as a teenager, to have my ears pierced, my father said that was fine because my Grandad Doy had an earring, so why not me? My father was good at drawing but weak at spelling, and felt that he had not been particularly successful during his time in school. This was not helped by my mother's family who were snobbish and proud to have worked themselves up from lowly origins to the position of shopkeepers. They wanted my mother to marry a minister or a doctor. I was grateful this plan failed, because I liked my father the way he was – tall, handsome, and with a voice unlike that of anyone else we knew. When he tried to read me Scottish comics, where characters said things like 'Watch oot Wullie! The polis is cumin!', the effect of his Suffolk accent was quite strange.

When I was born we lived in 'digs' (lodgings) in a house in a small village in central Scotland. The photo reproduced here as plate 8 shows me squinting into the sun pointing at my mother who is taking the photograph in the garden. Her shadow falls across my father, as she looks down into the camera she is holding. You can see something similar in photos of 'natives' taken by anthropologists, where the shadow of the scientific observer falls on the objects of study.[2] More of this later. Although in lodgings, I remember we had one of the first television sets in the village. I was allowed to watch if I had a nap in the afternoons. I never slept but just lay awake thinking till someone came to get me. I remember they seemed to show the same films and programmes over and over again.

My mother's father had a tobacconist's shop in Campbeltown, a small fishing town in Argyll, Scotland, situated at the head of a sea-loch. The shop was full of sweets in big glass bottles, smells of tobacco and snuff, and at the back of the shop there was a semicircular alcove which housed a lending library of crime novels, which I was later to

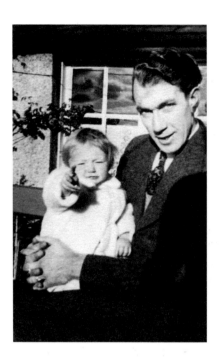

Plate 8. Margaret Doy (née Greig), photo of 'Guinevere' and her father, *Doune, Scotland, 1949, author's photo archive.*

enjoy. My grandpa Greig was the organist in one of the many churches in Campbeltown, and as a child I was forced to go to church in misery every Sunday morning after having spent a sleepless night with my long hair twisted up in pipe cleaners by my grandmother to make it curl. A girl with straight hair was considered unattractive. More interestingly though, my grandpa Greig had been the leader of a dance band, perhaps even a jazz band (plate 9). He is third from the right here. He was either quite young or a bit vain here, as he normally wore glasses as far as I remember, but I was not born when this photo was taken. My mother's uncle Jock is second from the right holding a trumpet, and my mum's auntie Bessie ('wee Bessie' who died of TB) is seated at the piano. My grandpa Greig had been a cinema pianist before he became a shopkeeper, but sound films finished that off.

He married Janet McDougall, sister of 'wee Bessie', Jock and various others. One of her brothers, Willie, was a post-office counter clerk who lived with his family in a prefab after the war. My grandmother was secretly very snobby about prefabs, as their own house was a big detached house with huge gardens and stained glass doors and windows. Plate 10 shows me wearing my cousin Ishbel's ballet clothes and shoes outside the prefab at Miller's Park and plate 11 is a photo of me and my grandpa Greig outside 'Thornhill'. This house had a

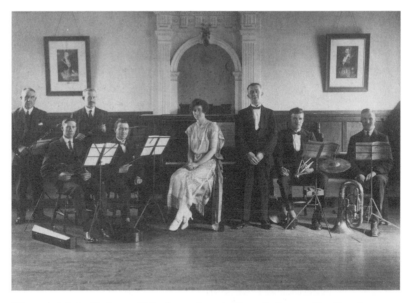

Plate 9. Adam Greig and his dance band, *Campbeltown, Scotland, 1920s, author's photo archive.*

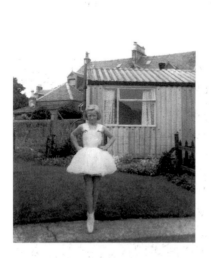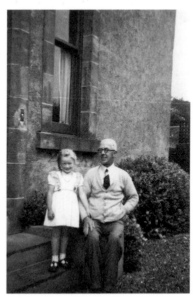

Plate 10. (left) 'Jennifer' wearing cousin's ballet clothes and shoes outside cousin's 'prefab', *Campbeltown, Scotland, 1950s.*
Plate 11. (right) 'Jennifer' with Grandfather Adam Greig outside his house, 'Thornhill', *Campbeltown, Scotland, 1950s.*
Both pictures from author's photo archive.

name, a self even, the prefab had no character and did not. One of my grandmother's sisters, Mamie, was a cinema usherette (again she later became a shopkeeper), and when I was young Mamie and her parents lived in a tiny cottage on Shore Street next to what seemed to me was a giant cinema, the Rex, built in art deco style. Unfortunately, it was demolished not too long ago. Along from it was another smaller cinema, The Picture House, 'the wee hoose', which fortunately survives and was still open for business the last time I was in Campbeltown a few years ago. The Rex cinema generator was right next to the cottage, and made it throb all the time.

My great grandad, Daniel McDougall, had been a carpenter, and now stayed mostly in a room at the back of the cottage, smoking a pipe, as far as I recall. He was a kind man, who made us wheelbarrows, a sledge and other toys and gave us lovely caramels with gold wrapping paper and different little icons on each one... a milk churn, a bottle of milk or a small cow. He didn't say much. My great-grandmother was pretty overbearing. As a child I was told never to beat her at cards or scrabble, or else I would risk her anger. My mother's side of the family was quite matriarchal, and I didn't take to that at all. This photo (plate 12) entitled *Four Generations* by my grandmother and mother seems to sum this up, showing all the female firstborn in the garden of the Shore Street cottage with Glen the dog, a domesticated male creature among us females.

Plate 12. 'The Four Generations' with 'Guinevere' as a baby, *Campbeltown, Scotland, 1949, author's photo archive.*

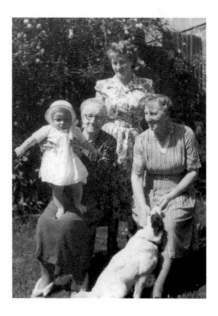

My father did a lot of housework, cooking, doing the fire, cleaning, as did my mother. They seemed to get on well enough, and he accepted that she was cleverer than he was. However, I discovered later that my mum's idea of cleverness was to amass a 'wealth of knowledge' (this phrase really sums up a petty-bourgeois notion of cleverness)... of grammar, of historical facts, dates and the like. Some of her terrible frustration eventually diminished when, aged about forty, she went to college and became a qualified teacher of music. We put her graduation photo on her coffin, feeling that it was something she had been particularly proud of.

I suspect it was my mother who named me Quinevere, but perhaps I'm wrong about this. My father's name was Roy Doy. I tried to distance myself from my first name at school, where the other children were called, for example, Jessie, Ena, Mary and Billy. Still, some of the Catholic girls were called more unusual names, especially those whose fathers were Polish and who had stayed in Scotland after the war 'to avoid communism'. I did not have a clue what this meant at the time. My own parents had met during the war when my father was stationed in Campbeltown with the navy. My name changed, sometimes at my instigation, sometimes due to the wishes of adults. It was changed to Jennifer (at school), Juniper (which I liked because my dad used it), Jen and eventually I chose my own: Gen. The captions of the photographs indicate this development. My father's form of affectionate address to me as 'my little English rose' was not terribly practical, unfortunately, especially since I wasn't even English. At the time its ideological implications passed me by.

Valerie Walkerdine has discussed her father's nickname for her – Tinky, short for Tinkerbell, the fairy in the Peter Pan story. Aged three, Walkerdine won a fancy dress competition (more of these later) and also 'won over' her father. She points out that her father did not invent this nickname, but selected it from 'available cultural fantasies'. Thus, argues Walkerdine, he negotiated his affection and fantasies about his daughter, and enjoyed his name for her, reciprocating her own desire. Walkerdine argues that this mutual desire is not 'about a minority of perverts... It is about massive fantasies carried in the culture, which are equally massively defended against by other cultural practices, in the form of the psycho-pedagogic and social welfare practices incorporating discourses of childhood innocence.'[3]

As well as struggling over a name, I realised I was also going to have to struggle, again with my mother, and her mother, with whom

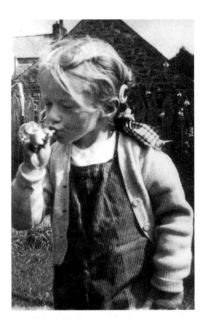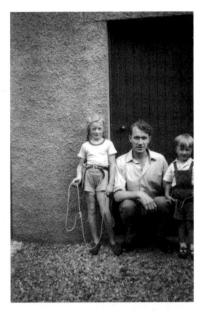

Plate 13. (left) 'Jennifer' on the way to becoming 'Gen', *Doune, Scotland, 1950s. Plate 14. (right)* 'Jennifer', almost 'Gen', outside the sorting-office door with father and younger brother, *Doune, Scotland, 1950s. Both pictures from author's photo archive.*

I stayed every summer, over my hair and my clothes. Whereas my father would have done anything to make me happy, my mother tried to encourage me to be a girl who would conform to her ideas of developing femininity. My childhood photographs show the contrast between a young person looking awkward in dresses and 'smart' clothes, and a person at ease in trousers, dungarees, or shorts (plates 13 and 14). I remember getting a hiding with the dog's lead from my mother because I played in the woods wearing a white sailor suit that she paid a dressmaker to sew for me. Another time I was looking in the mirror and she remarked to me how plain I was. I can never forget this, and decided I would never say that to my own children, even if they looked nothing special. It was always my father who made me feel valued and treated with respect. Yet both my parents were always generous in supporting me financially, and it was never even considered that I would be prevented from going to university because I was only a girl with two brothers. Yet I only really forgave my mother when I saw how she cared for my father when he was dying.

Different sorts of problems concerning self-determination arose later, when I realised that the few ideas I had about the world and how it worked were pretty awful. I was brought up with racist ideas, and fairly narrow-minded views about Britain's place in the world. In this photo of me in fancy dress devised by my mother, from Coronation Year, 1953, at the local gala day, I am 'British Maid' extolling the traditional values of British superiority in the spheres of industry, science, heritage and conquest (plate 15). This was in the post-war period, when, despite being on the 'winning' side, Britain's position within world imperialism had been seriously weakened. Direct control of important colonies such as India was a thing of the past. The USA was now the most powerful imperialist nation. The wartime destruction of Germany and Japan meant that these defeated countries now had a compliant workforce exhausted by privations, together with the opportunity to rebuild their economic capabilities with the latest in industrial technology, rather than updating obsolete capacity. In this situation after the war, to which the British petty-bourgeoisie were somewhat unaccustomed, my mother's patriotism (and my father's too, no doubt) focused on the individual acts of daring and heroism that helped define an ideology of 'Britishness'. On the standard I am holding in the photograph (I am Britannia) is a short text devised by my mother;

This standard held by BRITISH MAID

Tells of the Canberra's record flight;

Tells how men conquered Everest's might,

And raised to an immortal height

That standard which is BRITISH MADE.[4]

It was not until much later, at university, that I began to realise, sadly, that even my dad's ideas about politics were beginning to make me ashamed. But I don't entirely blame my parents for my ideas. I should have thought more about things. I was horrible to a tinker girl who used to come to our school occasionally as her family travelled around, and later on regretted my nasty behaviour. It is ironic to think I now give lectures criticising oppressive cultural practices, when I played a major part in making Helen Reid's short stays at school miserable. When my mother much later became a teacher, I was pleased that at last she'd been able to go to college, but saddened by her ideas about education. We had many arguments sparked off by her belief that people were

born either stupid or clever and teachers could not do much to change that. I used to wonder why she bothered.

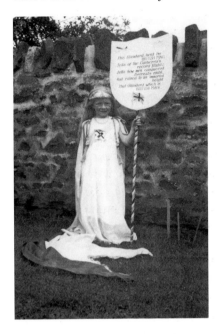

Plate 15. 'Quinevere' as Britannia/British Maid, Doune Gala Day, *1953, author's photo archive.*

Work is an important factor in the formation of selfhood and subjectivity. Not surprisingly for a petty-bourgeois family, there are no photos of work among our family photographs. The only trace of work in our photos is the location of many of the snapshots which are taken in front of the sorting-office door, at the back of my second home, the post office. (See, for example, plate 14 where I am holding a lasso.) It was a good plain background, and was painted green, or grey, at various times. My parents had a sub-post office that sold various other things, stationery, cigarettes, a few toys, and sweets. Up at the back of the garden was a small office where the mail was sorted by hand. The posties called my father Roy and poked fun at him a little, so luckily he was never much of a 'boss'. I really enjoyed the times when I could take a telegram with them or on my own, and, best of all, in the summer holidays or at Christmas I got a real paid job for a few weeks delivering mail. Sometimes I even got to take special items up to the railway station (now gone), like a basketful of homing pigeons which had to be sent off somewhere for the birds to be released. The money enabled me to choose my own clothes because I was paying for them myself.

My other source of income was 'tattie-howkin', or lifting potatoes. This was really hard, boring work. I know how all those people in Millet's peasant paintings feel! We were picked up early from the village and taken to a farm, where we joined up with a group of adult itinerant agricultural workers, who would, according to the season, do berry-picking or other kinds of work. You could see they were poor folk, with weather-beaten skin, and hardened to work. They made us kids from the village look pathetic. No one even thought of taking a photograph of this kind of activity where I lived.

My time as an adolescent was fraught with tensions, as I tried to assert myself against my mother and her expectations of femininity and attractiveness, and to draw strength from the support of my father, who was amazed that a child of his was so brainy at school because he himself had been made to believe he was intellectually dim. He would always remark, 'You must take after your mother.' I did not fit into expected categories very well at school either. I was clever but rude and disobedient, except with teachers I liked. One was a nice woman who was a good art teacher, although we didn't get much art in primary school. It turned out she was a lesbian, from what I later understood from the rather obscure comments made by people about her and her partner. Fortunately, I already liked her a lot by the time I understood the comments, and thought the remarks just vaguely interesting rather than off-putting.

I also loved sports and was good at them, and so I didn't conform to the mind vs. body categorisation which (wrongly) still pigeonholes many children. More struggles lay ahead when I tried to choose the subjects I wanted to concentrate on at school. My mother would not even let me do that for myself. However, this narrative of my activities and thoughts as I constructed myself in my early life has continued long enough. I'm sure you get the picture.

IN THE SHADOW OF MY MOTHER

The brownish, slightly sepia-tinted photograph of my father and myself was taken in the garden of our lodgings sometime in 1949, I suspect (plate 8). My father would then have been around thirty-one years old, my mother around twenty-six. My mother's shadow, as she looks down into the camera to take the picture, is visible on the right of the image. I point to her, no doubt in response to some question or prompting from one of my parents. My father is wearing a suit and tie, so I wonder whether

this is a Sunday, and he feels he needs to look smart. Later on in life, he dressed exactly the same on Sundays as on any other day.

For some women, the emergence of a sense of authentic self involves a conflict with the mother. For example, Annette Kuhn, in a discussion of some photographs of herself as a child, explains how the images, their interpretation, and their location in family history, became a site of antagonism between herself and her mother. This even involved the eventual assertion by the mother that Harry Kuhn, Annette's beloved father, was not her father at all. Kuhn writes perceptively:

There is a struggle over who is to have the last word – me; my father, the father who figures in my desire; my mother, the monstrous mother of my fantasy. With only one of the characters alive to tell the tale, there is unlikely ever to be a last word, as the struggle over the past continues in the present.[5]

I am now in a similar position. My mother and father are both dead, and I can only write about them and their images in the way I do, because I am no longer constrained by their presences, their sensibilities, or their disputing of my truths. Yet this freedom of the self is also a sense of loss in such situations.

It has been argued that the father is often the least visible in family photographs, for it is he who generally controls the camera. In my own family collection, however, it is clear that my mother often took the photographs, since my father appears in them on many occasions. However, the photograph album, the selection of images, the captions, the process of naming and displaying, was clearly my mother's. Patricia Holland has written that within women's domestic role, the album underlines the mother's commitment to organising the family and its history: 'it is largely they [women] who have become the historians, the guardians of memory, electing and preserving the family archive.'[6]

My own mother seemed to remember everything. She was often teased about this, and sometimes my father's banter had an edge to it, for my mother was 'the clever one' and her notion of intelligence was based on having 'a good memory' – a photographic memory, even. Whereas I cannot remember the day when the photograph was taken (plate 8), if my mother was alive I can guarantee she would recall it in great detail. The photographic album made by her to 'commemorate' my childhood comes to an abrupt stop when I am about three or four years old. At first all the photographs are carefully captioned in neat white writing on the black pages of the small A5 album, like a kind

of negative surrounding the photographic prints. Towards the end, there are mounted photos, but no captions. I don't know whether this coincided with my mother becoming pregnant with my first brother, and then being too tired or busy to spend time on the album. Perhaps the novelty of having children was wearing off. I am referred to in my mother's hand on the first page of the album as Quinevere. In plate 8, which is not from the album, my pointing finger and look, alongside that of my father, identifies her without naming her, since it is never the child's privilege to name the parent.

In Roland Barthes' famous meditation on photography and desire – *Camera Lucida* – the central image around which the whole book revolves is a photograph of his mother as a child in a Winter Garden. However, we never see this particular image, and thus its centrality, as an object of desire is made even more poignant.[7] In my childhood photograph, we also do not see my mother, although we both acknowledge her in our different ways. I recognise my mother, but I recognise that she is not me and, importantly, she is not 'me and my dad'. Unlike many images of infants which show them with mothers surrounded by a traditional, almost religious aura, my chosen image of my childhood self is different. Barthes comments that certain landscape photographs make him sure of having been there. He continues:

Now Freud says of the maternal body that 'there is no other place of which one can say with so much certainty that one has already been there'. Such then would be the essence of the landscape (chosen by desire): *heimlich*, awakening in me the Mother (and never the disturbing Mother).[8]

This 'homely' mother, who makes the child feel complete and fulfilled in its own bodily self, while paradoxically also united with the mother in plenitude, is lost for me. Her body is outside the image, already separated from me. It is a matter of some puzzlement, and indeed sadness to me, that, having become a mother myself, in contrast to my own mother I experienced feelings of total pleasure and happiness in contact with my children. Breastfeeding my boys was almost indescribably pleasurable for me, and it looked as if their feelings were similar. I suppose I was breastfed by my mother, since I later saw her feeding my two younger brothers. How is it, then, that this deep physical and emotional experience is completely gone from my memory? When I owe my mother so much, why did I feel so alien from her?

In his essay 'Mourning and Melancholia', Freud argues that the bereaved person's ego is absorbed in the work of mourning, but is gradually detached from the lost loved one, so that the person will continue with life, and eventually overcome the grief of bereavement or loss. For the person who becomes melancholic, things are more complicated. 'In melancholia, accordingly, countless separate struggles are carried on over the object, in which hate and love contend with each other; the one seeks to detach the libido from the object, the other to maintain this position of the libido against the assault.'[9] The melancholic's ego is impoverished and threatened with extinction, as s/he struggles with guilt and self-reproach following the death of the loved one and feelings of ambivalence, even hatred, towards the dead object. Until the bereaved person re-values his/her ego, normal psychic life will not progress. Thus Freud seeks to investigate how the self overcomes death and loss, in order to avoid being overwhelmed by the lost object. While I do not think I would describe my reaction to my mother's death as melancholic, I certainly experienced her loss very differently from that of my father.

I came to feel quite alienated from academic feminist writings, which give pride of place to the mother and her symbolic position in the formation of subjectivity. They make me feel very uncomfortable. Despite her financial help to me, my mother seemed a cold figure, and my recognition of my own subjectivity was not dependent on her affection for me, but rather manifested itself in my desire to become someone who would not be like her. When I read feminist eulogies of the maternal as a motor force of cultural radicalism, for example Griselda Pollock's emphasis on the relationship of the subject to the fantasy of the mother as a position from which to challenge 'the phallocentric symbolic', I feel depressed.[10] Of course, my personal experiences do not deny the existence of women's social oppression, nor the importance of motherhood, both of which I recognise. I just did not experience the empowerment of the maternal from my own early life. Ironically, my experience of the maternal from the other side of the mother/children relationship is very different. In a book which examines the work of a variety of both male and female artists, Pollock is quick to (spuriously) dismiss what she terms the 'narrow focus of Marxism' in favour of a search for

some way to acknowledge and speak of the maternal in all its ambivalence and structural centrality to the dramas of the subject... Without in any sense

privileging maternalism or motherhood, feminist theorisations of the feminine and analysis of representations made within its psychic economies have to rework and think through the mother...[11]

This focus on the mother as a means to understand the cultural productions of both male and female practitioners seems to be a highly partial view. Perhaps it is even a backward strategy, since, no matter how often we are told that the discussion is not literal but symbolic, the symbolism is ultimately connected to the lives of real women otherwise it would have no social meaning. Thus, ultimately, women are conflated with the maternal, whether symbolically or literally. Imagine, for example, that we investigated the production of culture using theories of labour and subjectivity, rather than the maternal body and subjectivity. We could still pay close attention to gender issues, but the feminine would not be tied inextricably to the maternal. I find it both intellectually and emotionally upsetting to read such glorifications of the maternal and culture when, to speak literally, my own mother wanted to prevent me from doing art at school ('clever people don't do art, it's only for people who can't do anything else') and she and my (university-educated) aunt convinced my (artistically talented) father that allowing me to go to art school would be 'a waste'.

THE PATERNAL BODY

I would like to take a little time here to discuss the notion of the paternal body, since it has been largely ignored both in psychoanalytical thought and in cultural theory.[12] Much emphasis in psychoanalysis centres around the mother and her relationship to the baby/child, probably because, in modern European culture, child-rearing was seen as a female task, whether carried out by the actual mother or by paid nurses, servants or childcare workers. In the last twenty-five years or so, there has been more attention paid to the relationship of the father and child, and the idea that fathers are good to have around.[13] In psychoanalytic theory, the father was largely ignored or seen negatively, as a possible source of violence or a competitor for the possession of women. In Freud's view, for example, the early stages of civilisation saw the banding together of young men to kill the violent primal father.[14] Now fathers are increasingly encouraged to participate in their children's upbringing (single-parent families headed by women are seen as more likely to produce 'delinquent' adolescents), and many more men are now

unemployed or part-time, casualised workers than previously. Formaini suggests that the time is ripe to examine the reasons for this absence of the father from psychoanalytic theory: 'My intuition suggests that the father's body, rarely known by the infant, might potentially hold the same physical and psychological significance as the mother's body.'[15]

As a shopkeeper, my father was not absent from my childhood, away at work, but just next door to our living room and kitchen. Also our mother worked in the shop and did more of the accounts. Unlike the abstract concept of the patriarch, this actual father was physically present and emotionally supportive to me. My own experience of my father was not as an oppressive, authoritarian figure, but as a reassuring and positive presence in my early life. I was carried around on his shoulders, though there are no photographs of us like this, since we were often out on our own. While women are undoubtedly socially oppressed, and I have absolutely no wish to underplay this, there is a need to look beyond abstractions about patriarchy and male power and look at specifics as well when we discuss the maternal and the paternal body. Personal circumstances modulate and engage with wider social structures; they do not simply mirror them. Furthermore, notions of the maternal and paternal body are not just to do with the body but also with a state of mind. The maternal body is embodied subjectivity, not just a physical thing, and so is the paternal body.

In her article, Formaini uses the Jungian notion of the 'shadow' to understand both the absence of the father from psychoanalytic theory, and also the repressed, less attractive aspects of the individual. She comments:

The term 'shadow' is used also in relation to an individual's least admirable aspects, or the ones least accepted. It is that part (or parts) in the personal unconscious which does not conform to the standards of so-called acceptable behaviour laid down in early life by those in authority. Given that it is unconscious, the shadow is projected on to other persons or objects who hold the projection until it is made conscious. The shadow is not 'bad' in itself; rather it is the attitude towards the qualities of the shadow that is difficult.

In this paper I am suggesting that the shadow of the father's body is the part of himself which he does not accept... Mothers traditionally have played the 'caring', intimate, relational role while fathers have maintained an emotional distance. Emotion in relation to offspring becomes part of the father's shadow. I also argue that the father's body casts a shadow on to the world, both the world of nature and the world of work, where men's minds make their impressions.[16]

In my development as a subject, the opposite took place. The photograph of my father and me in my mother's shadow (plate 8) perfectly pictures my relationship with them, literally and metaphorically. It was my mother who expressed no positive emotion towards me, not my father. Whatever she felt 'inside', I couldn't read it or feel it in her body. I wonder whether it was my mother's petty-bourgeois upbringing which made her so emotionally and physically remote towards me, or whether this (perpetuated) myth of the maternal actually obscured the fact that there were lots of families where fathers were far more caring. Perhaps more worrying is the fact that only a few writers and theorists, such as Walkerdine and Kuhn, for example, bother to try to bring a sense of class and gender to bear on their own experiences as subjects in order to question the denigration of the father (and actual fathers) within modern female scholarly activity.

MEMORIES ARE MADE OF THIS...

Sigmund Freud's comments on childhood memories and fantasies are, of course, significant in relation to photographs of ourselves when young. In 'Childhood Memories and Screen Memories', written in the first decade of the twentieth century, Freud attempts to understand the reasons why we remember certain things, forget others and, especially, why it is seemingly unimportant things that we recall. Our childhood memories often displace others, which are repressed through a process of 'screening'. The chronological sequence of the recalled incidents, and the displaced ones, is complex – sometimes, for example, the recalled incident can occur later than a repressed one, or vice versa. Freud recognised the power of distortion and displacement: 'Strong forces in later life have been at work on the capacity of childhood experiences for being remembered...'[17] Thus these memories are not genuine 'memory traces' but later revisions 'which may have been subjected to the influences of a variety of later psychical forces.'[18] They are like the myths that nations construct about their early development. Maybe they are like the ones I recount to you now.

Freud states that some people have visual memories, others auditive ones. However, he argues that everyone's childhood memories are visual, and uses his own as an example. In childhood memories, writes Freud, you see yourself as if in a stage setting. You look from the outside and see yourself there, as a child. However, as a adult, you do not picture yourself in the scene of your memories. This may

suggest why photographs of ourselves as children retain a powerful fascination for us. It is not just that that time has gone, for so have our experiences last week, but because the way the memory is presented to us may correspond to the way we visualised our sense of self as children – not through verbal description, nor through being absent physically from a remembered scene, but by being both in the scene and outside, recognising ourselves and at the same time *authenticating* the person as ourselves from an 'outside', surveying position of supposed neutrality. This is what we do when we look at photographs of ourselves when young. Perhaps this is, in part, a recurrence of the myth of the Cartesian subject. Patricia Holland puzzles over what happens when we gaze at layers of our past, as materialised in photographs. She comments, 'And we ask ourselves how our subjective memory can be aligned with the exterior image.'[19] I always find this very easy in childhood photographs. The problems for me come later, when what is inside my head seems to have nothing to do with a rather tired, unsmiling person seen in the mirror and in the few photographs which are now taken of me.

Not surprisingly, we learn that Freud believed that all childhood memories are really later revisions, and ultimately are all concerned with sex. In another essay, Freud begins by remarking that: 'The liberation of an individual, as he grows up, from the authority of his parents is one of the most necessary though one of the most painful results brought about by the course of his development.'[20] He argues that the young boy feels hostile towards his father, since the latter is a threat to his love for his mother. Freud remarks, 'In this respect the imagination of girls is apt to show itself much weaker.'

The rest of the essay continues as if Freud were speaking mainly of the male child, who, in cases of neurosis, imagines that his parents are not his true mother and father, and are replaced by others of better, more noble birth. This involves imagining his mother in sexual scenarios with upper class partners, thus engendering the 'family romance' in the child's fantasies. Again, the whole scenario here is based on the need for the child to go beyond, reject, and become independent from 'his' parents. Presumably, for Freud, female children do this without exercising their imaginations very much. However, if we look back at the case of Annette Kuhn's mother, and her comments on the family photos, we could read her comments as possible examples of 'family romances' as she wrote captions on the photos which conflicted with her daughter's experience, and also denied that Harry Kuhn was Annette's real father. Of course, we also have to consider Freud's view

of 'family romances' in the context of societies based on class privilege. You may want to reject your parents, but why replace them with upper class alternatives to boost your own youthful ego? The myth of Cartesian subjectivity only partially accounts for the positioning of the subject in relation to her/his own childhood and representations of it, for consciousness is only a part of our subjectivity and our understanding. I can only guess at the unconscious aspects of my subjectivity then and now – indeed I may never fully know them – but the model of so-called Cartesian subjectivity pays them very little attention.

MORE ON MY MOTHER'S SHADOW

In a catalogue essay on anthropological and ethnographic photographs, Christopher Pinney, Chris Wright and Roslyn Poignant describe how photography was linked to anthropology almost from its inception, only to lose its hold on the anthropological imagination during the later nineteenth and earlier twentieth centuries. The reason for this was that professional fieldwork, where the anthropologist is personally present within the society under scrutiny, became more important than the photographic archive.[21] The authors argue that during fieldwork the anthropologist became analogous to the sensitised photographic film or plate. S/he was 'exposed' during fieldwork to the daily life of the 'native' society, like a negative. Then a 'positive' was produced in the form of a scholarly ethnographic monograph. The information was now imprinted on a human mind and body.[22] In their exhibition catalogue, the authors illustrate a photograph taken in Kasai land in 1907–1909. The photograph is taken from above, looking down on a black figure bending down in front of the photographer. The shadow of the photographer wearing western clothes and hat falls on the ground and on the man's foot in the lower right of the picture. The fiction of the invisible, neutral observer is disturbed, as we see the sign of the photographer.

This photograph reminds me of the one of my childhood (plate 8). My mother took the photograph, but she became the living memory of our family, as everything was imprinted on her memory. The rest of us forgot things, she never did. When she gave up selecting and documenting the photographic archive of my childhood and her early years as a parent with my father, most things depended on her memory, and were, to a certain extent, under her control. And clearly, when she died, much of the family history disappeared. Without the photograph,

I would never know that this scene, with these people, ever existed. For my mother, remembering things was a sign of intelligence.

My mother's shadow is also an indexical sign, like the photograph, i.e. it is a sign that has a physical link with what it signifies. An index has the same characteristics as the shadow and the photograph 'because it is dynamically (and spatially) connected with both the individual object on the one hand and on the other with the senses or memory of the person to which it serves as a sign of the other'.[23] This perhaps explains something of the unsettling and surprising effect which the sight of the photographer's shadow has on the viewer of photographs. We expect it to be absent. When the shadow is there, the image seems addressed to, and works to include, the person taking the photograph, rather than just anyone who happens to view the photograph.

Stoichita, basing his findings on a study of the shadow in visual art, argues that the relationship of the self to a mirror reflection is a recognition of the self as 'sameness', whereas the recognition of one's shadow is a perception of the self as 'other', since shadows are often in profile.[24] Now, in this photo, my mother's shadow would not be in profile, as she is facing my father and me, as she looks down into the camera. Yet the shadow suggests ambiguity. We do not see her head in the image, yet we both acknowledge her as if she looks at, and speaks to, us. I am tempted to read this image in retrospect, as Freud suggests we read all childhood image memories, as a significant moment within a process of difficult self-recognition, when, secure within my father's grasp I look towards my mother as either my self-same or my self-other, or more likely both together in a troublesome dialectic.

WRITING AND THE SELF

Postmodern theorists often state that the self is constituted through language, and that 'language speaks the subject'. I would argue in opposition to this that it is the self who uses and negotiates the language that is given to him/her in social situations, in order to articulate and express concerns that are not 'always/already' present within language and writing. However, it is also the case that language can function in ideological ways, constraining and influencing the sense of self and agency of the writer/speaker of language.

When we consider the relationship of language and the self, it is useful to distinguish between several kinds of writing usually associated with self-expression or self-determination. Among them is the autobiography,

usually (though not always) devoted to a roughly chronological account of the life of celebrities of one sort or another (see, for example, the writings of Cecil Beaton and Mme Yevonde discussed in the previous chapter); then, the self-portrait, which involves non-chronological writing about the self (for example, the book *Roland Barthes by Roland Barthes*).[25] The third category is that of ego-documents, which can include the previous two, and also diaries, memoirs, and notebooks as well as visual images.[26] The autobiography and the self-portrait often include photographs, since they both have 'a supposedly referential character, a referentiality endorsed by the typical presence within them of photographs of their subject'.[27] Laura Marcus differentiates between auto-biographies and memoirs, arguing that the former are more significant in terms of agency and a desire on the part of the self for definition and determination: 'To stand as an I, or, more exactly, as an 'I'-saying person, over and against other persons and living beings and the things around us implies that we are aware of our independent existence.'[28] Indeed, Marcus convincingly points out that concepts of individuality and historical consciousness have to be in process of development, socially and culturally, for autobiography to even exist.[29]

Usually in autobiographies, the photographs of the author/ess are those taken by others, although the most obvious exception to this is the case of autobiographies written by professional photographers. In Cecil Beaton's *Photobiography*, for example, there is his frontispiece (plate 7). The photographs in autobiographies and self-portraits are chosen by the author, and taken with the subject's knowledge, since they can then trigger off more associations and memories, as s/he can recall who took the photograph, where and when. This process is less likely when we are confronted by an image of ourselves which was taken without our knowledge. It is not so much that we act differently when we are aware of the photographer, though this is a factor, but it is an issue of knowledge, or self-knowledge, which is linked to the situation of ourselves in history, which the recognition of the photographic moment anchors.

In comparing writing to imagery of the self in autobiographies and self-portraits, I want to dwell briefly on a few further points.[30] One thing that struck me in particular when thinking about writing (as a self) in relation to images (of the self) was the relative lack of evidence of passing time in the writing and speaking voice. In the images you are visibly 'dated' by appearance, clothing, the 'style' of the photograph and its technology, whether it has faded, and other considerations. When

you write about the self-images, it does not matter how you look, old, fat, skinny, injured, where you write or whatever, the 'voice' of the self seems to defy time in a way that the images do not. You can write yourself back into your childhood, but not visualise yourself back into your childhood photographs. However, the voice and writing of the self is not outside time and place – it is just that it can *appear* to be so.

As Liz Stanley has pointed out, 'A "voice" that speaks through representation in photographs is gendered as well as raced, classed; and "seers" of these representations are also gendered, raced and classed beings.'[31] I believe the same can be said for the voice that speaks through writing, not only in autobiographical writing but in other kinds of writing too. In relation to this book, for example, it seemed important to me to allow the personal to surface from within the supposedly neutral, objective and sometimes quite alienating discourse of academic writing with its apparatus of footnotes and references where the scholar (sometimes) displays his or her skills. Academic writing tries to distance itself from the personal and the spoken – academics teach their students not to write essays with 'don't' and 'won't', or even 'I'. Intentionally mixing the personal and the academic thus entails a stance against certain kinds of ideological notions of learning, scholarship and appropriate behaviour for professional academics. It is interesting to observe how academics such as Annette Kuhn, Eunice Lipton and others have felt impelled to speak of the personal in their work. Also in Eunice Lipton's book on Victorine Meurend, who modelled for Manet's painting *Olympia*, and in Carol Mavor's book on Victorian photography, *Pleasures Taken*, distinctive personal notes are evident.[32] The crucial element here is to get rid of the supposedly neutral, yet hugely ideological pronoun 'one', and replace it with 'I'. The abstract, vague and totalising 'one', whom no one can locate and thus criticise, is set aside by the personal and identifying 'I', replete with location, specificity and agency. It is interesting to me to see these scholars introduce the personal into their work. For Lipton it was a traumatic situation, and she explains in her book that it was part of her decision to give up being an academic art historian. The personal voice became the autobiographical, and eventually won out over the professional. The book was the history of her research and the final part of her career as an academic.

Less traumatic, perhaps, but just as serious, Angela Dimitrakaki's recent essay attempts to investigate and critique the processes by which feminist research is done on art in an inter-cultural context. She discusses how research is not some abstract, value-free process, but one

that '*involves "real" subjects*'.[33] Involved in exhibition and research
projects in Estonia and Greece, Dimitrakaki saw how encounters with
other cultures raised ideological issues which are usually suppressed in
scholarly writing. For example, British expectations of what feminist or
women's art should be about resulted in ideological value-judgements
about artists' works from other countries. Dimitrakaki argues that
considerations which relate to the 'reality' of the researching self's
situation and location, if they appear at all, are usually mentioned in
the introduction and not in the main body of research, which is seen
as more significant and separate from personal concerns of self and
agency. She adds:

Such observations are either seen as of a practical nature and too 'pragmatic',
or even trivial, to be taken seriously as an aspect of the always located practice
of history and theory, or they belong to an experience that the researcher
would rather forget – maybe they are reserved for the more private space of the
researcher's diary and they are to resurface later in the form of 'memoirs'. But
ideology resides typically in the trivial, the practical, the pragmatic and the
seemingly irrelevant: to exclude experiences by naming them 'irrelevant' implies
a form of repression.[34]

The self should not be ghettoised into the autobiographical or the
self-portrait. The self is present in all writing, and should be made
visible/audible. However, it is too simple to reiterate the old slogan
that 'the personal is political'. Only a self (of whatever gender) aware
and conscious of its ideological positioning can progress towards the
political, as Dimitrakaki implies.

AUTOBIOGRAPHY AND THE POSTMODERN SELF

I want now to look briefly at what writers on photography and
autobiography say about the self as single self, or multiple selves. The
main point of contention is whether there exists a self with agency
and consciousness, which changes through time but is essentially
an individual self, or whether the self as multiple, decentred and
fragmented, results not from human agency, but is constructed by social
discourses including, most importantly, language.

In one of the most famous photo-autobiographies, Jo Spence
examines conflicts between the fragments of the self/selves, but believes
that, through photo-therapy, a process she devised together with Rosy

Martin, the agency of the self can develop and become more conscious. Deconstruction of photographic images is not enough, writes Spence, we must have strategies to go forward. From where do these strategies come and how are they mobilised? From the self as agent. Speaking of her photo-therapy work, she writes: 'Out of the broken pieces of the self will come a subjectivity that acknowledges the fragmentation process, but which encompasses and embraces the parts and brings them into dialogue with each other.'[35] Thus the fragmentation of the self, and its alienation, can be superseded.

Liz Stanley, who devotes a chapter ('Auto/biography, photography and the common reader') to photography and autobiography, is not particularly sympathetic to postmodern theories of the subject, a position I share. She argues that in looking critically at 'personal' photographs, the viewer can situate them in history and 'enable more analytic purchase on them and on 'the self' as a socially located construct, rather than a psychoanalytic reduction'.[36] While I feel Stanley is mistaken in referring to psychoanalytic theories as necessarily entailing a reductive view of the self, she is correct in emphasising the self as socially constructed. Psychoanalytic theories themselves, as well as their objects of study, function and develop in a social context in any case. Stanley usefully distinguishes between postmodern theories and ideas, and postmodernity as a historical period.[37] The latter, she argues, does not exist, and in fact we are still within the modernist era. Stanley points, with justifiable anger, to the ways in which women and other socially oppressed people are dismissed by many postmodern theorists when they attempt to claim selfhood 'to protest at exclusion is to be treated as a native clinging to the wreckage of bourgeois humanist referential essentialism – "what, you want to claim a self, to speak your oppression, to name oppressors?" really, how primitive, how naive.'[38]

We might therefore ask whether a postmodern autobiography is something of a contradiction in terms. Not according to Hayden White, of the University of California, who has hailed *Roland Barthes by Roland Barthes* as 'a genuinely postmodern autobiography'.[39] Barthes' book is a series of discrete yet associated short sections, each with a heading. We assume they are all about him and written by him, but sometimes he uses the third person. For example, in the section '*Le Livre de Moi* – the book of the Self' he refers to (probably) himself in both the first and the third person, and tells the reader that 'All this must be considered as if spoken by a character in a novel – or rather by

several characters.' But, he adds, the book does not fit into any existing genre, as it is not quite a novel either:

His 'ideas' have some relation to modernity, i.e., with what is called the avant-garde (the subject, history, sex, language); but he resists his ideas; his 'self' or ego, a rational concretion, ceaselessly resists them. Though consisting apparently of a series of 'ideas', this book is not the book of his ideas; it is the book of the Self, the book of my resistances to my own ideas; it is a *recessive* book (which falls back, but which may also gain perspective thereby).[40]

Elsewhere, he wonderfully describes his book as a 'rhapsodic quilt'.[41] Yet he introduces a quote about the Enlightenment self, a quote he seems sympathetic to: 'Everything has happened in us because we are ourselves, always ourselves, and never one minute the same (Diderot, *Réfutation d'Helvétius*).'[42]

The inclusion of family photographs in the work also seems to strengthen the notion of an individual self, clearly the author, despite the different strategies which Barthes uses in the writing. Admittedly, the captions provided with the photos are not the usual kind which we would expect to find in a standard autobiography, yet we know they are of Barthes and his family, and he knows that we know. Rather than describe this work as a example of a pure postmodern autobiography, I would prefer to argue that it manifests and embodies contradictory notions of the self. The book falls much more into Laura Marcus' category of the 'self-portrait', i.e. a non-chronological piece of writing about the self, yet the photographs are in roughly chronological order (his grandparents, parents, himself as a child, adolescent, adult etc). Photographs can function either as autobiographical documents, or as aspects of a self-portrait, according to their use. In Barthes' book, I would argue that the writing (self-portrait mode) and the images (autobiographical mode) are being presented to us differently.

In a short but extremely interesting article on Barthes, Peter Collier suggests that in Barthes' later work we see the (re)emergence of a model of the subject which is a modernist one, such as can be found in the writings of Walter Benjamin. Collier suggests a comparison of the kind of free-flowing piecing together, or montage of thoughts and observations found in *Roland Barthes by Roland Barthes*, with the structure and approach of a work like Benjamin's 'Theses on the Philosophy of History' or, on a larger scale, the 'Arcades Project' devoted to nineteenth-century Paris. Collier argues that this kind of

'montage' writing works against an illusion of realism, 'so that the spectator cannot settle himself into a comforting illusionistic pact' and is forced to maintain a critical and analytical distance. The 'montage' principle, rather than encouraging a fragmented subject in pieces, 'both demands and creates the presence of a separate, critical, individual subject' both to produce it and to make sense of it.[43] So the fragmentary nature of the writing, interrogating the nature of the self, paradoxically depends on the presence of a critical self who is writing, and another who is reading (or viewing) the material. Collier concludes that what we see in Barthes' writing throughout his life is 'an elaboration of different aspects of a theory of the critical subject'.[44] When I read Barthes' book on himself, I was very taken by it, and toyed with the idea of using a similar approach in this chapter, while discussing my own childhood. But, as I made clear when introducing this chapter, I do not want this to be read as a work of fiction. It seemed very difficult to me to find a style of writing which would include the autobiographical, the historical, and the personal, avoid the purely academic, and yet allow some room for the imaginative. It also makes a difference if the self is a marketable commodity, of course, like the self of Roland Barthes. The self of Gen Doy is not quite in the same league. And, fortunately for me, my book is not posthumous.

The photographs in *Roland Barthes by Roland Barthes* are in monochrome, and probably are so in the originals, like most of my early family photographs. This almost always gives an impression of nostalgia, pastness, and, as Barthes and other photographic theorists have argued, of death.[45] Barthes, for example, writes of 'that rather terrible thing which is there in every photograph: the return of the dead'.[46] In an interesting comment on ethnographic photographs, many archival examples of which are not in colour, Elizabeth Edwards points to the dangers of viewing such images nostalgically:

However, to reduce photographs to ineffable nostalgia and pastness merely repeats oppositions of lost past and active present, links photographs to one past time only and restates the trope of the disappeared 'authentic'... Within the contexts of re-engagement and re-cognition photographs have the cultural potential for being about not Barthesian loss, but instead regain, empowerment, renewal and contestation...[47]

It is perhaps in order to deny the presentness and potential for life in photographs that Barthes rejects colour as an unnecessary addition

which mars the pure essence of the photographic image. In total contrast to the attitude of colour photographers such as Mme Yevonde, he writes:

I am not very fond of Color... I always feel... that in some way, color is a coating applied *later on* to the original truth of the black-and-white photograph. For me, color is an artifice, a cosmetic (like the kind used to paint corpses).[48]

For me, colour photography is associated with a later period in my life, when my parents no longer took photographs of me as an adolescent, and stopped using their old camera. Colour photography in my family coincided with my (semi-)independent subjecthood and eventual re-location outside the family home.

In an interesting section in his book on colour and our attitudes to it in art, David Batchelor discusses the film *The Wizard of Oz* (1939). Dorothy, scooped up by the tornado, is revealed later to be unconscious all the time that she 'leaves' the greyness of Kansas for the brilliant colour of the Land of Oz. 'In the end, Dorothy has to return from colour – to Home, Family, Childhood, Kansas and Grey.'[49] Batchelor cites many authors and critics whose chromophobia he links to a fear of contamination and almost a 'fall-from-grace'. Colour is a dangerous temptation: 'Sensuous, intoxicating, unstable, impermanent; loss of control, loss of focus, loss of self'.[50] The monochromatic is associated with the domestic, the known, the experienced, the safe. Lack of adventure is linked to lack of colour. Yet when I look at some of my childhood photographs, I bring elements of colour to them. I do not colour the whole image, but the memory of a particularly important item of clothing, usually one I liked, such as my red corduroy velvet trousers, is triggered by the photograph. The rest of the photograph remains black and white or sepia. Part of the problem is that family photographs in colour never look like developed Hollywood colour film, or Mme Yevonde's Vivex colour prints. Ordinary domestic colour prints do not possess that aura of 'out of the ordinary' colour that you find in Hitchcock's *Vertigo*, for example, or Cindy Sherman's cibachrome colour photographs. The monochrome prints seem to need the contribution of the self more, in order to explain their attraction, to provide additional details... to verify that they are really authentic even though they do not actually look realistic. The photograph needs a self, either as participant, or as viewer, in order to function as an ego-document – in order to bring it to life. Thus it may be true to say

that the photograph has connotations of death. However, it seems more fruitful to me to view photographic images as contradictory visual embodiments of reality that demand to be looked at dialectically. They are material realisations of the potential for both life and death, related to both their participants and their viewers.

EITHER SELF OR SELVES?

The issue of self/selves has sometimes been posed as a kind of binary opposition from which we have to choose one of the terms to the exclusion of the other. Laura Marcus writes: 'Either the autobiography serves to create the illusion of a unified self out of the fragments of identity, or the text reveals, in all its fissures, its doublings and incompleteness, the fragmentations of the subject and its lack of self-confidence.'[51] Similarly, Linda Rugg locates two different functions of photographs in autobiographies. The inclusion of a number of diverse photographs represents our multiple selves, as opposed to, say, a frontispiece showing *the* embodied self.[52] However, I would question whether it is correct to pose the problem in terms of this either/or opposition. What is missing from such conceptions of the self/selves is a dialectical view of the self, which conceptualises the contradictions and tensions both within wider social histories and the individual conscious and unconscious psyche. The opposition of the modernist (self) vs. postmodernist (selves) tends to result in circular arguments which make little progress. I am not claiming that this problem can be resolved by finding 'the correct answer', only that we can move it forward by understanding it differently.

Rugg touches on this when she discusses an essay by Walter Benjamin, 'Berlin Childhood', and argues that Benjamin 'forwards the argument that self-image is not constructed (or controlled) by the self alone, but by the state, society and the historical moment'.[53] This is a helpful comment. However, we need to envisage the tensions between the private and the social self not only within capitalism, but also within the self. The self is not a static entity, but, engaged with material life and experience, changes and develops, sometimes in a responsive way, at other times in a proactive manner. Within one physical body and psyche can exist seemingly contradictory traits. Also, the development of the self through time can result in dramatic changes. However, these tensions and conflicts are not simply random, but understandable in particular social contexts to which individuals

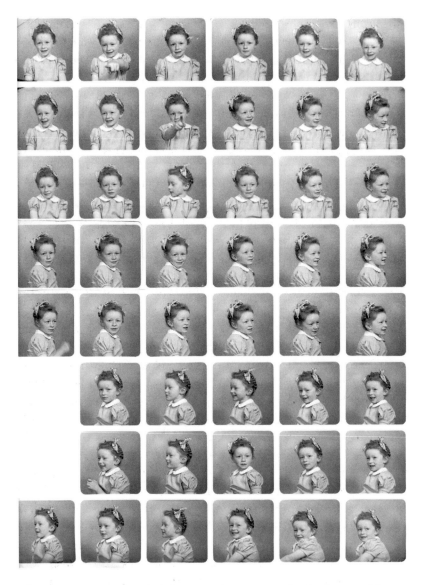

Plate 16. 'Guinevere' in Polyfotos, early 1950s, author's photo archive.

relate. I want to look at some of these points in relation to some images taken of me as a young girl, on a sheet of so-called Polyfotos (plate 16).[54] Two of the images have been cut out at some time in the past, probably to give to someone. These photographs are studio-based. The subjects are usually 'dressed-up' for the sitting, usually by the mother. In these photographs, I am wearing a dress with puffed sleeves, and

my hair is done in pigtails clipped round my head with hairpins and decorated with ribbons. I was no doubt encouraged to interact with the photographer and my mother (my father would have been working) in the studio. Afterwards, at home, the proud parents could look at the variety of poses and expression on the face of their child, perhaps feeling gratified at the many and varied facets of his/her character. Usually, one or both parents selected an image to be enlarged, thus choosing a picture which encapsulates the essential self of their child, one that really 'sums her up'. The photos show various versions of my public self at an early age, one which was largely in conflict with how I wanted to behave and dress. As noted above, I gradually became able to assert my own wishes, but the difficulties in doing this in a situation of dependency are obvious. Tensions within the self are embodied in these images, yet they are not necessarily indicated visually in the photographs. They need to be teased out and brought to the surface by a subject in a position of knowledge. This need not be the subject in the image herself, but could be a researcher or historian. The realist image is a very difficult surface within which to locate contradictions, because, by its very nature, it is designed to provide a static moment, a visual surface which is detailed and focused rather than blurred, and, usually, a commodity. I cannot find any enlargement of any of these photographs. I hope it was because my parents did not decide what my true 'self' was, because none of these images seemed to show it. I suspect it was more likely that they did not have the money at the time, despite the relative cheapness of the Polyfoto format.

Are so many images of me and my self simply self-indulgent? What might this mean? Laura Marcus observes that 'Even the best of confessional writers walk a fine line between self-analysis and self-indulgence... it also allows a lazy writer to indulge in "the kind of immodest self-revelation which ultimately hides more than it admits".'[55] When self-indulgence is mentioned, it suggests too much of forbidden pleasures such as sex, food, or buying things we don't need. It implies paying too much attention to the self in a bad way, for which we should feel guilty. After 'sinning', it was possible in the past to buy 'indulgences' from the Catholic Church to avoid God's punishment. At the other end of the scale of self and desire is self-sacrifice, where we give up our own individual desires and needs for a reason we feel to be more significant. In bourgeois democracy, the privileged notion of the self is a 'balanced' one – middle-of-the road – not too indulgent (but indulgent enough to purchase gratifying pleasures), and not too self-

sacrificing. It is interesting to note how many times arguments against communism take up the old refrain that it stifles individuality and subsumes the self in some amorphous collectivity. It is not an original observation for me to point out that the self is not an apolitical or ahistorical concept, but that specific models of the self/selves are valued and, indeed, actively fashioned by particular kinds of social formations according to a combination of 'race', gender, sexual identity, and class factors. Terry Eagleton has recently written of how postmodernism dismantled the 'robust human subject' and detached freedom 'from the dominative will and relocated [it] in the play of desire'.[56] However, will and agency survive, notably in recent times as evidenced by acts of terrorism, to which global capitalism has responded with another 'master narrative' of a war on terror. In the light of these developments, Eagleton feels that postmodernism has had its day.[57]

OWNERSHIP

Do I own myself and my image? This is ultimately an issue decided by the state, not by the individual self. There are several reasons to do with ownership why photographs of myself are in this book. Firstly, due to financial considerations, my books tend to have black and white images, because (with all due respect to my publishers!) I am not a bestselling author courted by relatively wealthy publishers who can pay for colour illustrations and/or large print runs to generate income.[58] Since my family photographs are already monochrome, they are ideal. No violence is done to them because they are not reproduced in colour. Secondly, again financial, I am not liable to pay copyright for reproducing these images, since they were all taken by one or other of my parents who are now dead and passed their property on to their children. However, it is not entirely clear that these photographs are mine, even though I am their subject. The photographs were left in the house of my parents, now lived in by one of my brothers and his family. I negotiated with my brother which ones I could take away from the house, and which ones to leave with the small family archive. The main criterion for deciding on this and my 'rights' in the matter (though this was never actually used in our friendly discussions) was that if I was the main person in the photos, then I could have them. If anyone else was included, then we should talk about it. My other brother was completely left out of all this, because he lives in Canada. It was nice to have a degree of control over the images, and to know that their

presence in this book would not depend on anyone else's permission. Yet, legally, the right to the photograph does not belong to the self represented in it but to the photographer. John Tagg has examined the development of photography in relation to capitalism, and, focusing on nineteenth-century France in particular, he uses the work of Bernard Edelman to argue that 'the founding moment of bourgeois law is the postulate that persons are naturally subjects in law, that is, potential owners, since it is of their essence to appropriate nature.'[59] The debates about photography and copyright protection in France meant that certain kinds of photographs were lifted 'from the level of the machine and brought... into the domain of the activity of the subject'.[60] Edelman argues, using the work of Hegel, Marx, Althusser and others, that the subject and products created by the subject are defined and constituted by 'the absolute subject', i.e. exchange value and capital:

in the sphere of circulation everything takes place (and does not take place) between subjects, who are also the subjects of capital, the great subject. And, furthermore, as circulation conjures away production (while revealing it), it can be said that all production is manifested as the production of a subject.[61]

Bourgeois society and its laws produce the subject in its most developed form, i.e. self-ownership, according to Edelman.[62] He has a harsh opinion of the bourgeois family and sees its main functions as 'hereditary transmission [of property] and constitution of the subject'.[63] I feel that this is somewhat one-sided, but nonetheless these two aspects of the family in capitalist society do contribute in great measure to the uneasy relationship I have with my mother, her memory and her legacy (emotional and financial).

Edelman shows how photographic images came to be defined as art in France, not principally due to aesthetic ideas, but due to legal definitions of the subject as self-possessing and therefore able to appropriate and possess nature. He gives a concise appraisal of the role of the photographer in bourgeois society: 'The photographer is a solitary man; his production is production of a subject.'[64] Perhaps family photographs do this more than most.

Now probably none of the images illustrated in this chapter would be defined as art by most critics and historians, and this has implications for the subjectivity and selfhood represented therein. The subject in a lowly, 'popular' visual medium is presented and perceived differently from one materialised in a statue of marble or bronze outside, say,

national government buildings. Fortunately, that location is not one I am interested in occupying in any shape or form.

CONCLUSIONS

Photographs of ourselves are significant ego-documents. They can help us situate ourselves in both the past and the present. Although themselves static images, they have a potential dynamic in that they embody tensions and contradictions both between individual selfhood and its social context, and within the individual subject. They raise issues of ownership of self-images, and control over these self-representations, both in the past and the present. In her essay on photography, childhood and place, Roberta McGrath proposes to utilise the child-psychology theories of D.W. Winnicott to understand the roles of photography. Transitional spaces or objects are crucial for the child in its development of subjectivity. The child is still attached to a transitional object when s/he has not yet become completely aware of the self as an independent entity. As McGrath puts it:

Transitional spaces are places between, and a transitional object is a kind of half-way house between subjective and objective where the perception of an object clearly differentiated from the subject has not been reached... Moreover, photographs are themselves rather like transitional objects; historically situated between painting and film, they function as particularly powerful intermediaries between an intensely internal subjective world and a shared external reality.[65]

I want to propose extending McGrath's suggestive view of the photograph as transitional object to a wider range of considerations. For example, rather than read the photograph as a moment of death, of stilled-life, we could read photographs of our dead relatives as transitional objects which, at one and the same time, show us both the presence and the absence of these people. In a similar way, photos of ourselves can be seen as instances of our objectification as subjects, whilst confirming our subjectivity and agency as we distance ourselves from that self-moment in the image, or perhaps even seek nostalgically to return to it. In either case, our own independent subjectivity must come into play as we seek, perhaps consciously, perhaps more intuitively, to write our own discourse of the self, rather than be written by it.

CHAPTER 6

SELF-DETERMINATIONS

The self does not exist as an abstract entity except in theory. In reality, the self exists in specific historical, cultural and economic contexts, and the same applies to theories of the self and subjectivity. So far, I have been discussing the legacy of the Cartesian self largely in relation to philosophy, the experiences of the situated embodied self and visual culture. The self also exists, however, in economic and legal frameworks, which can be empowering or oppressive, depending mainly on class but also on other factors such as gender, and/or 'race'.

We all currently exist as selves in capitalist societies (imperialist, semi-colonial, etc). Lest this appear natural or inevitable, more attention could be devoted to using critiques of capitalism to illuminate alternative ways of understanding subjectivity. Since the failure of radical social and political movements in the later 1960s and the changed situation of world politics (for example, May '68 in France, the demise of the women's liberation movement and radical black movements, the collapse of the post-capitalist bureaucratically state-planned economies in the former Soviet bloc), left politics and Marxism in particular have been increasingly on the defensive. The radical philosophers involved with May '68 in France either drifted out of politics or to the right, and postmodern theory, with its denigration and/or revision of Marxist concepts, became the dominant force in cultural studies. As Fine and Leopold point out, postmodern theories have eagerly focused on consumption, arguing that the Marxist emphasis on production is simply outdated and redundant in contemporary capitalist society: 'For consumption easily and positively places on the agenda those issues that have been an increasing focus of attention in the intellectual climate of postmodern times. Consumption, *par excellence*, concerns the position and activity of the individual in capitalist society.'[1] On

the contrary, argue Fine and Leopold, it is possible, and necessary, to link production and consumption in order to understand both, and they stress that Marx's writings have much to contribute on the topic of consumption.[2] What is significant, I feel, is not so much how but *why* we want to analyse consumption. For many influenced by postmodern theories, consumption is a liberating, almost playful, activity wherein subjectivity is both constructed and exercises agency.[3] In his critical analysis of the myth of consumerism, Lodziak points out that this myth 'ignores the fact that there are many sources of self-identity other than commodities, it ignores identity-needs and re-defines identity as image and style.'[4] Teresa Ebert also offers a sharp critique of postmodern theories in which the 'ludic [playful] valorization of consumption is the erasure of needs'.[5] Consumption is divorced from production, and from its economic and political context.

In turn, production as a term has been transformed from its Marxist or economic meaning, i.e. people making things out of materials, and in postmodern theory means something different. Following Foucault, cultural theorists now see knowledge as productive, power as productive, rather than oppressive, and human subjects as themselves 'produced' by social and cultural discourses. They are the produced, not the producers.

In this chapter, I want to look at questions of work and play, production and consumption, in relation to subjectivity and its representations. I will argue that work is just as important in determining and constructing selfhood as 'playful' consumption. I also want to consider representations of subjectivity in the case of people on the margins of capitalism, outside 'official' relations of production and consumption, such as beggars, and asylum seekers, who are not permitted to work legally.[6] How is their subjectivity supposed to relate to work and play/leisure, and in these cases who or what primarily defines subjectivity? In these contexts can we speak of self-determination or of being determined by others?

WORK AND THE SELF

At a time when class and class identities are perceived to be weakened, if not absent, individuals in the 'developed' world have a newly aligned sense of self. What they buy has become a more immediate aspect of their identities than what they make, according to a recent discussion of class.[7] Identities are now, apparently, seen by people not in terms of

social function, but as a reflection of 'the most irreducible elements of their being', for example, female, lesbian, black. Yet identity politics are readily recuperated by companies based in 'developed' countries, eager to get a share of the so-called Pink Pound, and its black equivalent.[8]

Companies strive to make workers identify with 'their' company and 'their' mission statement. They expect them to come to work in their 'leisure time', function as teams, and management and 'human resources' (personnel) departments stress the potential for self-realisation through work. However, this fails to totally convince even devoted employees. Despite changed forms of work and management strategies in so-called post-industrial and post-class societies, it is pretty clear from the interviews in Catherine Casey's study that employees' working lives have not qualitatively changed from previous forms of capitalist production. 'Sally' states:

I gave the very best of myself – *of myself* – for 23 years to this company, now I want something else in my life. I want a relationship with a man, and a good life outside of work... I still come in here by 7am every day. Some days I'll come in even earlier, like 6am. And I still come in most Saturdays, but not Sundays any more... You give 120 percent of yourself, and then one day eventually, you kind of wake up and you wonder about your life.[9]

In recent years, the kind of art which has hit the headlines has been installation pieces, bits of dead animals, or 'sexy' body art. Tracey Emin's *My Bed*, or even the (in)famous portrait of the murderess Myra Hindley by Marcus Harvey, made up of children's handprints, attracted controversy. This art, supported by Charles Saatchi in Britain and a few other key figures, almost became a part of popular culture. More traditional figurative painted images of workers or work seem very unfashionable, and artists who choose the subject of work and workers are relatively few. Andrew Tift, who paints detailed pictures on a variety of carefully chosen supports, concentrates on working lives and working people, from England to Japan. In the 'Body Shop', for example, autoworkers are pictured on a metal car door in painstaking detail so as to be 'objective, not subjective'.[10] Janice McNab's paintings are concerned with a Scottish factory whose women workers have used chemicals while making electronic equipment, and now suffer from various forms of cancer, miscarriages and reproductive ailments.[11] Probably the most painstakingly researched art focusing on work is produced by California-based Allan Sekula, an internationally acclaimed

photographer who has long been involved with projects concerning working people. His productions include the extensive project with images and text *Fish Story* (1990–1995), an outstanding, informative and moving body of work exhibited in 1995 and also at Documenta 11 in 2002.[12] In the past, representations of workers and their labours were at the heart of key moments of modern art, from the French artist Courbet's *The Stonebreakers* (1850) to the modernism of the Weimar Republic artists in Germany from 1919–1933 and beyond.[13]

Along with the rise of the myth of the 'classless' society, we have seen in older industrialised countries the decimation of traditional heavy industries such as coal-mining, ship and automobile building, and steel-making, whose predominantly male workforce suffered massive redundancies, changing the make-up of the contemporary labour force. The imagery of work in art often represented workers like these, whether in paintings, photographs or on trade union banners. In a related development, the demise of the USSR and its satellite states relegated the Stalinist imagery of heroic workers (whether male or female) in heavy manual jobs to the realm of theme park curiosities or kitsch.[14] However, in other industries, such as textile production in Britain, closures have hit women and Asian workers particularly hard. It is true that, in some senses, we have witnessed a move away from an emphasis on profit-making through production, and more expansion of the service and leisure industries. We now regularly see male checkout operators in supermarkets, and hear male voices in call-centres, a low-skilled exploitative employment where there is a huge turnover. However, even some of these low-paid jobs are being moved to call centres in India to generate super-profits. Previously such workers were mainly female, and these jobs seen as inferior to traditional male functions in the labour force. Now many women are their families' sole earners and men are often obliged to accept what they can get.

This has all taken place in a global context, where foreign coal can be produced more cheaply in poorer safety conditions, or workers in Asia can be super-exploited to undercut the wages of machinists in the US or Europe. Capital can easily cross national boundaries, while workers who travel, sometimes at great risk, to seek a better life are stigmatised as 'economic migrants'.

Often these traditional jobs were more than a way of making money. They allowed the worker, male or female, to belong to a group of colleagues, sometimes friends, become part of a community built up around a particular workplace, visit the local working men's club, go

for works outings and so on. Work can be exhausting, but at the same time it is a social part of people's lives and identities, and their sense of self, hence the huge personal problems caused by loss of employment, or even never having been employed at all.

Thus images of workers and their labour can be many different things. They can show workers as exploited victims, as heroic figures of monumentalised and allegorised toil, as happy and fulfilled at work, or as is sometimes the case with art works dealing with domestic labour, they can bring into view the overlooked, the marginalised or the 'previously invisible.[15] Images of the working self tended to be made in realistic or naturalistic modes, the argument being advanced by Courbet in particular, from the mid nineteenth century onwards, that (allegedly) this made them more accessible to ordinary viewers.[16] This also meant that figurative paintings, especially of workers, were looked down on by art historians and critics as marginal to the real development of (modernist) avant-garde art, and tarnished with the oppressive politics and physical repression of Stalinism or Nazism.[17] While, in the postmodern period, figuration has returned to painting in a big way, artists have often tended to use it in a playful, parodic manner, rather than in the engaged way it functioned to address the viewer in works by critical modernists such as George Grosz or Otto Dix, whose works were designed with a sharp polemical cutting edge. Also, while postmodernists tend to dismiss large 'master' or 'mistress' narratives of history in favour of the fragmented and the localised, many images of workers and their labour are determinedly focused on preserving and/or bringing to light something of the past, or inviting a critical appraisal of the present, for example Diego Rivera's frescoes of 1932–1933 on the topic of *Detroit Industry*, now in the Detroit Institute of Arts.[18] However, it is important not to fall into a kind of elegiac nostalgia for 'the good old days'. Some kinds of labour may be disappearing, or are already gone, but workers still exist, doing all kinds of labour. The contradictory nature of work is still present, as both enabling and exploitative, with all that this entails for the subjectivity of the worker, or indeed the unemployed person.[19] It is important to remember, however, that in a global context, many kinds of work done, particularly in poor countries, are almost totally dehumanising and even life-threatening.

It is also important to view the making of images as labour, rather than as some inspired activity which only special individuals can perform. Just as workers transform bits of metal into a car, artists

transform raw materials into something different and greater than the sum of the parts. As well as the physical labour of the artists, mental labour plays an important part, both in making the art and organising its appearance in public whether in exhibitions or publications. Though sold as a commodity, art can often be made as unalienated labour, where pleasure and satisfaction are experienced in the making process, and time is no longer measured or 'drags' but is forgotten. We should remember though that ideologies of art and the aesthetic colour the making subject's attitude to artwork and already carry the promise of discovery, fulfilment and heightened sensibility for the human subject during the making process. Mental labour has not been traditionally attractive as a theme to painters, despite the popularity of the 'scholar in his study' theme during the Renaissance period. Yet self-portrait images of artists are images of labour, and testify to this by their very existence. They, and the selves they portray, are the products of their makers.

PLAYFUL SUBJECTS?

While many academic disciplines have been influenced by postmodern theories in their critique of the so-called Cartesian or modernist subject, Roy Boyne has pointed out that there is an important exception. Economics is different, since the ideology of capitalist economics requires that the decision to work or to buy is a result of rational choice and agency, and therefore needs subjectivity.[20] While some scholars have been critical of the emphasis on consumerism as a site of agency and even of freedom, others are more enthusiastic. Daniel Miller, for example, sees shopping as 'the act of a home-making (as distinct from a homeless) mind', and consumption therefore becomes productive, cultural 'work'.[21] Miller's espousal of shopping as self-fashioning is very different from that typified by Conrad Lodziak, who argues that we are forced to consume because, with the hegemony of capitalism and generalisation of alienated labour, we can no longer produce to satisfy our own needs, so we have to buy things which previously were produced in the home or the locality.[22] Surely, socialised production is the answer, as it is hardly efficient or desirable to have millions of households each making their own food, clothing and furniture, or providing their own power supply.

Linked to consumerism is the concept of fashion, which is not applicable to clothes alone, but a whole gamut of lifestyle products and services. As Finkelstein puts it: 'Fashionability produces a sense

of self which is contingent, always in flux, an image that floats on the surface of life, that is constituted from a multiplicity of unconnected moments.'[23] This sense of self, however, gives a false sense of agency: 'being fashionable creates the illusion that one has a great deal of control and self-determinism.'[24]

This playful construction of the self, as opposed to the experience of the working self, is not merely a fabrication by cultural theorists, it relates to an important economic growth area where people pay to play, as James Woudhuysen has shown. Computer games, gambling, sport, performing arts, theme parks and adventure holidays are all big business. As Woudhuysen reminds us, though, in play there are usually losers as well as winners. (Less often there are draws!)[25] The marketisation of play means that it rarely provides spaces and moments of freedom, and in fact further erodes the 'active, conscious Subject'.[26]

Shopping has also been seen as a leisure activity where the subject can construct an identity, rather than a means of obtaining necessities. I recently received a glossy colour brochure publicising Nike sports clothes and shoes for women, inviting me, or perhaps commanding me: 'find yourself'. Conflicting fantasies of power and subjection are offered to the consuming self: next to a woman exercising we read 'in my kingdom would be law' but on the following page we are told 'skipping dance class would be criminal'.[27]

A number of artists have been interested in shopping as a theme and deal with it in their work. The Swiss artist Sylvie Fleury is perhaps the most uncritical, glorifying in a post-feminist designer paradise, which she creates in gallery and other spaces. Her work has involved installations of designer shoes, or carrier bags in 'classy' locations.[28] Anya Gallaccio is more troubled by her love of shopping:

To me that's a really important aspect of what I do. Maybe it's partly to do with being a woman, but I have a conflict with myself over consuming. I've been brought up to shop. I'm a fantastic shopper I love it. I have a problem with wanting to own things, and I find that interesting.[29]

This can be linked to the artist's use of ephemeral materials, and notions of pleasure, work, and possession. She attempts to (partly) evade commodification through dematerialisation. Few of Gallaccio's works survive, as the mutations of their components such as chocolate, wax, ice, vegetables and flowers cause them to degrade and decay.[30] For example, her piece *Flowers Behind Glass* requires the owner to

replace the dead flowers in order to maintain the artwork. One collector,
Duncan Cargill, accepts this and the artist has commented:

A buyer has to decide when to have my works installed. You can't just get them
out of the crate and put them on the wall. It requires effort. You have to make a
decision. You have to be active. You can still buy my work as an investment, but
you can't show it off without first doing something.[31]

Her works thus avoid the lure of passive consumption.

A recent major exhibition on shopping and art dealt with consumer
dreams and fantasies, window displays, shopping malls, and objects
of desire.[32] Clearly, this project was very much in tune with our
supposedly playful, leisured consumer activities. Of particular interest
to me was the material on early twentieth century shop window design.
Avant-garde designers utilised similarities between the stage and the
shop window in order to mobilise existing traditions of spectatorship
to attract the viewer. Designer Norman Bel Geddes likened stores to
'a stage on which the merchandise is presented as the actors', and L.
Frank Baum, writer, shop-owner, designer and author of *The Wonderful
Wizard of Oz* (1900) founded an influential magazine entitled *The Show
Window*.[33] Some theatre impresarios and stage designers made an easy
transition to shop window display. Fetishised commodities almost took
on a life of their own, as Marx suggested in his famous discussion of
'The fetishism of the commodity and its secret'.[34] Frederick Kiesler's
notes from the 1920s and 1930s for show windows in shops suggested
'a stage play where Mr Hat and Miss Glove are partners. The window a
veritable peepshow stage.' He wanted this staged 'play' in the window
to engage the passer-by and make her/him into an active viewer. The
boundaries between the display of goods and the street could thus
be broken down. The agency of the passer-by would be awakened,
the first stage in the decision to purchase.[35] In early shop window
displays, the invention of powerful new lighting methods meant that
the source of illumination could be moved inside the window, creating
stage settings similar to light-boxes. As the lighting was inside, this
avoided any reflection on the glass of the passer-by outside, 'enhancing
the illusion of there being no barrier between the consumer and the
desired goods'.[36] When the viewer is reflected on the window pane, a
more detached, self-aware approach as a subject is possible, though
this invitation to critically survey ourselves window-shopping is not
always consciously taken up.

Some, but not many, of the works in the *Shopping* exhibition offered a critical perspective on consumer culture.[37] One that did was a large photo-based work by Barbara Kruger, which I will discuss shortly (plate 17). Another was the wonderful *Le Bizarre Bazaar*, especially created for the exhibition by Fluxus artist Ben Vautier. This ramshackle construction was a shop (more of a shack) full of complete trash and oddities, a kind of mini-car-boot sale adorned with signs reminding us that 'the world is for sale' and that the KGB, CIA, and MI6 can get anything for money – oil, nuclear devices, cultural genocides, epidemics, viruses etc. This 'world art trade centre' is where 'the unsaleable can be sold'. As in capitalism, anything can be bought and sold here in this parody of designer goods and shopping experiences. A sign reading 'I don't buy therefore I am' was visible.[38]

A different strategy interrogating the construction of consumer subjectivity can be found in the work of Barbara Kruger. Kruger's early work was as a designer of book covers and magazine adverts. Her use of direct, aggressive forms of interpellation (address), the distinctively commercial typeface which she often uses (Futura Bold Italics), together with the scale and location of her works, partly engage with the terrain and modes of address as advertising images (plate 17). *Untitled (I shop therefore I am)*, of 1987, photographic screenprint on vinyl, 284.5 x 287 cm (private collection), has been produced in various versions and formats, including t-shirts and carrier bags. Ironically subverting Descartes' famous definition of conscious subjectivity, Kruger seems to suggest the *lack* of rational subjectivity required to engage in shopping as a means of self-fulfilment and human agency. A massive hand of indeterminate gender holds out a calling card towards the viewer, introducing the unknown person in the image as someone whose whole identity is fragmented, and defined by consumer activity. The red letters stand out against the grainy black and white image, echoed by the red enamelled frame. The use of pronouns such as 'I' and 'you' in Kruger's work, highlights the self/other relationship, modes of address and the subjectivising process in which contemporary advertising calls to its designated audience. The subject addressed is positioned in language, in culture and, usually, in economics. On the other hand, Kruger's works lack any conventional artistic signs of her own personal subjectivity – there are no traces of her touch – no thick paint which usually signals the expressive presence of the artist. Indeed, in commercial art, which Kruger mimics, the self of the author is usually anonymous and the brand name all-powerful. In her article

on Kruger's work, Nancy D. Campbell, following Craig Owens, argues
that Kruger's works are stagings of interpellation and subjection, and
thus critiques of ideological positionings of the subject. 'Kruger's
voice-texts comment most directly upon subject construction, not the
imposition of stereotypes. The stereotype does not produce subjection
and interpellation. Subjection and interpellation (and their basis in
ideological practices) produce the stereotpye.'[39]

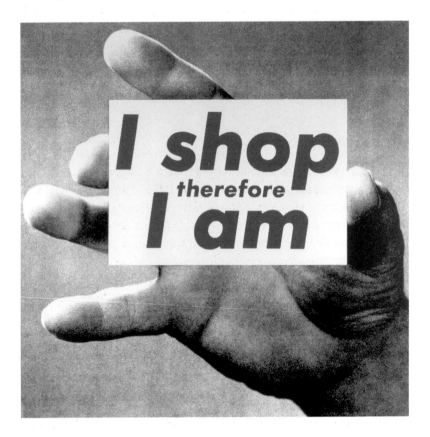

Plate 17. Barbara Kruger, Untitled (I shop therefore I am), *photographic
silkscreen on vinyl, 284.5 x 287 cm, 1987, private collection, courtesy
Thomas Ammann Fine Art, Zurich, copyright the artist.*

In her discussion of Kruger's strategies, Campbell turns to the
work of Michel Pêcheux, who uses the terms 'good subjects' and 'bad
subjects' to describe those who acquiesce to, and/or oppose, ideological
forms of address. He believes that subjects can refuse identification
with the prevailing practices of ideological subjection in a process

of 'disidentification' – of working against the dominant ideological form of interpellation. 'Disidentification is the "taking up of a non-subjective position", not the refusal or abolition of the subject but a "working (transformation-displacement)" of the subject.'[40] For Pêcheux, this process of interpellation is 'the theater of consciousness' which begins the subject's discourse.[41] While I accept that Kruger's works encourage a process of critique, or 'dis-identification', the result can sometimes be quite 'empty', since nothing else is proposed with which we can identify, having gone through the process of disengaging with the ideology of capitalism, sexism, racism, consumerism and so on. However, Kruger does sometimes offer the possibility of more active positions, for example in allowing her style to be used by a Pro-Choice Abortion Campaign.[42]

SUBJECTIVITY AND ADVERTISING

A series of television programmes broadcast on British television (BBC2, March 2002) examined the impact of Freud's psychoanalytic theories on the development of twentieth-century advertising. Freud's nephew, Edward Bernays, left Europe for New York and became the first PR agent. To Freud's horror, Bernays used his theories to promote commodities through crude, though effective, techniques, for example persuading more women to smoke. In this instance, cigarettes were conceived of as phallic symbols, replacing women's 'lack', and were now termed 'torches of freedom' for women.[43] Bernays also used his uncle's theories to help US government propaganda at home and abroad, and was active in supporting the US overthrow of the radical nationalist government of President Arbenz in Guatemala. The US bombed Guatemala into submission to regain economic control and continue to extract super-profits from the region, for example in the banana plantations which Arbenz had expropriated from the US United Fruit Company.[44]

Companies have been keen to utilise the theories and language of psychoanalysis to market their products. Addressing the customer in ways which engage her/him as a subject is an important part of this. For example, a recent advert for TAG Heuer 'alterego' watches for women, shows how different aspects of the self/subject can be expressed and satisfied through the wearing and possession of this expensive, jewel-encrusted watch. In this advert from 2001, we see a photographic image of which about two-thirds is composed of head and shoulders

(unclothed) images of the Spanish model and film star Ines Sastre (plate 18). The remaining third has a photograph of the watch and the TAG Heuer logo. The image is mostly monochrome, though Sastre's skin is a very dull, cloudy pink and her lips are also pink. In one pose, her head is slightly raised and her mouth marginally open as she looks in a 'sultry' way at the viewer. Leaning her body against the head and back of another version of herself, this time with her hair pulled back and looking down to the right of the image, she seems to invite us to contemplate the various sides of her personality, thoughtful, sexy, classy, glamorous, but especially young, attractive and ethnically ambiguous enough to appeal to a global consumer audience, though obviously a very well-off one! Indeed the advert is restrained and tasteful – more like a beauty-product advert than a watch promotion. In the image on the right where Sastre looks out at the viewer, we are invited to look and admire and she appears to acknowledge this. On the left, her pose is thoughtful and self-absorbed as she looks away from the camera. TAG Heuer's official website includes a more recent advert featuring Ines Sastre, 'Sorbonne graduate' and 'accomplished actress'. According to accompanying quotes from Sastre, these watches 'typify a modern woman's confidence and control'. Another personality appearing on the official website is Zhang Ziyi, star of the acclaimed film *Crouching Tiger Hidden Dragon*, 'confident', 'graceful' and 'sensual'.[45]

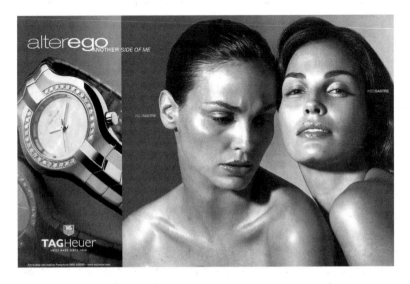

Plate 18. TAG Heuer, alterego, *watch advertisement, 2001, copyright Tag Heuer.*

The 'alterego' advert has Ines Sastre's name printed next to both photos of her, and the main text, next to the watch, reads 'alterego Another Side of Me'. The image, with its suggestions of 'doubling' and the uncanny, mobilises notions of narcissism, same-sex desire (as well as straight sexual desire), and commodity fetishism in that the inanimate watch, embodying the labour of those who provide its raw materials and assembly, plays an almost human role with its own life force. It *is* another side of the person, Ines Sastre, not just something to tell the time with, or to adorn the body. Without the watch, the 'me' of Ines Sastre will be without an important dimension of her selfhood.

CONSUMERISM AND SELF-EMPOWERMENT

The postmodern self can, we are told, be constructed through shopping and consumerism. We hear and see little, though, about the possibilities of self-construction through theft and shoplifting. While thousands of images urge us to buy, very few intentionally invite us to steal. For if the self is empowered and playfully constructed through the 'legitimate' purchasing of goods which enhance the subject's sense of self and identity, then what is wrong with applying the same arguments to theft? It seems to me this is a question well worth considering, and one which exposes the ideologically suspect premises of the positive postmodern view of shopping in relation to subject-construction.

A search for literature on shoplifting on the internet was instructive. A few books on shoplifting were mentioned (not very recent ones) but there was more material directed at management on how to prevent theft and swindling by store employees. It appears this is as big an issue as thefts by the public. Walsh's book, written in 1978, views shoplifting as a crime, not as a means of creating a self-image, nor as self-expression. It offers, however, a useful historical survey of shoplifting. In the nineteenth century and earlier, the poor and other potential thieves were simply prevented from entering shops by doormen stationed outside.[46] An Act of Parliament passed in Britain in 1698 approved the death penalty for shoplifting (122 years later this was changed to transportation for life).[47] In 1816, John Barney, aged nine, was judicially murdered for shoplifting fifty-pence-worth of goods.[48] By the 1950s, self-service shops had increased in number as a means of saving on staff wages, but this obviously made things easier for shoplifters. More recent work on shoplifting has looked at age, gender and 'race' factors in convictions for shoplifting. Not surprisingly, black

people were more likely to be charged when arrested, and homeless people were also more prone to being arrested for drunkenness and shoplifting than other offences.[49] A recent high-profile case showed the disparity in treatment and sentencing between the poor and the rich when it comes to shoplifting, like many other crimes. Film star Winona Ryder got off lightly (the prosecution was calling for probation or community service) after being convicted of shoplifting designer goods from Saks' Fifth Avenue Store in New York, her defence being that she was researching for a role in a forthcoming film. On the other hand, a poor Californian man, Leonardo Andrade was jailed for fifty years (under the 'three strikes' ruling) for stealing $154 dollars-worth of videos for his family to watch.[50]

Klemke is unusual in suggesting that there is a similarity between shoplifting and normal consumer behaviour, that we can perhaps view 'some shoplifters as frugal customers', and that shoplifting can also allow alienated individuals to express their creativity and individuality.[51] Not surprisingly, recent research has shown that shoplifting rises in line with unemployment and also during periods of high inflation and price rises.[52]

The idea that consumption has taken over from production, and that Marx had a one-sided model of capitalism, should be treated with some scepticism. In a really amusing, but important, discussion in *Theories of Surplus Value*, Marx argues that capitalism can turn anything into a way of making a profit, and also that any profession can result in productivity. He takes the example of the criminal 'who produces crimes'. The criminal produces criminal law, the professor who lectures on it 'and in addition to this the inevitable compendium in which this same professor throws his lectures', the police force, juries, hangmen, judges, torturers, prisons and prison officers, producers of penal codes, artists and writers whose works deal with crime (e.g. Schiller and Shakespeare). The criminal gives a spur to bourgeois society and economics. Security systems, locks and so on are devised and marketed, and sophisticated banknotes make things difficult for forgers. Marx also points to the crimes of nations in the development of the world market.[53]

A slightly less dialectical but nonetheless very interesting contribution on shoplifting can be found on an internet website, entitled 'Why I love shoplifting from big corporations'.[54] Indeed, if we follow the logic of postmodern thinking on consumerism and subjectivity, we could ask why those too poor to shop legally be denied subjectivity

and selfhood? If playful subjectivity is constructed through shopping, how much more so through the ingenuity of theft? The author of the article on this website encourages shoplifting as a form of 'refusal of the exchange economy' and a 'statement against the alienation of the modern consumer'. Stealing only from big corporations is a moral activity, and the shoplifter can also be sure that none of her cash will end up in the coffers of companies she disapproves of. This form of 'urban hunting and gathering' returns us to a means of survival predating capitalism and imperialism, argues the author. The final paragraph of this article is a telling alternative to the pro-capitalist consumerism that can be read between the lines of articles on the construction of the consuming subject:

Shoplifting divests commodities (and the marketplace in general) of the mythical power they seem to have to control the lives of consumers... when they are seized by force, they show themselves for what they are: merely resources that have been held by force by these corporations at the expense of everyone else. Shoplifting places us back in the physical world, where things are real, where things are nothing more than their physical characteristics (weight, taste, ease of acquisition) and are not invested with superstitious qualities such as 'market value' and 'profit margin'... .Perhaps shoplifting alone will not be able to overthrow industrial society or the capitalist system... but in the meantime it is one of the best forms of protest and self empowerment...[55]

Art has been analysed and produced in relation to its commodification and use within a capitalist economy and society, but there exists little in the way of fine art in modern times which deals with shoplifting or theft in general. I found this interesting, as there are many examples of literature (from Emile Zola to Raymond Chandler) and film (Jules Dassin's *Rififi* to Steven Sonderbergh's *Ocean's Eleven*, to name but two) in which robbery and thieves are central. Crime novels and films constitute important sub-genres of their respective media, yet are rare in fine art.[56] Artworks appear more often to be the objects of theft, rather than active attempts to engage with social and cultural notions of such crime. As far as consumerist constructions of subjectivity and fine art are concerned, it is the famous collector, such as Charles Saatchi, whose subjectivity is enhanced by his art collection, and not the thief who steals paintings from vulnerable art museums or stately homes. The iconoclast and the forger, on the other hand, do derive some celebrity and identity from their engagement with the values of commodified art. The petty thief who steals my car is a nobody, but

the robber who makes off with a Rembrandt or a Raphael has a few moments of fame.

SUBJECTIVITIES ON THE MARGINS

Many shoplifters are examples of marginalised subjects. These also include destitute people begging for money or food, and another increasingly important group of people who are without officially recognised rights or subject status in the sense of being citizens – namely refugees and asylum seekers.

Despite the prevalence of homelessness and destitution on a global scale, and its increase in developed imperialist countries in recent years, such topics do not often make an appearance in the realms of 'fine art'. There are notable exceptions, for example in the work of such artists as Martha Rosler in the mid seventies and more recently in Gavin Turk's *Nomad* 2002.[57] In terms of refugees and asylum seekers, the issue is so newsworthy in the UK that in the last few years more fine artists and film-makers are dealing with this issue in their work.[58]

Recently this omission of marginalised subjectivities was exposed by Berkeley-based US artist Jos Sances, who subverted the images of the biggest-selling living artist, Thomas Kinkade. Kinkade paints chocolate-boxy scenes of picturesque cottages with duck ponds, for 'family homes'. An actual village has been built by the firm Taylor Woodrow in conjunction with the artist, modelled on the homes in his pictures. Kinkade paints around a dozen new images a year, and these are digitally photographed and eventually transferred onto canvases. Hourly paid workers, mostly Latinos and Asians, then add dashes of colour and 'original' brushstrokes to make the works look authentic. Kinkade's company had revenues of $138 million dollars in 2000. Jos Sances' pastiches were not very subtle. In one, a homeless man stands outside a Kinkade house – 'Bush' is inscribed on the letterbox. Not surprisingly, Sances' exhibition caused a great deal of debate and controversy.[59]

Clearly, being destitute, homeless and reduced to begging, has a fairly major effect on people's sense of self. However, this can be quite complex. Having an identity without certification (paper proof), and feeling or appearing unclean, was found to have greatly affected a sense of self-esteem and personhood in a study of homeless women in 1993.[60] A study of homeless people in Toronto found that people's sense of identity was harmed and also that they were marginalised

and 'unrecognised' as subjects due to lack of a permanent address, identity and access to entitlements, rights and financial assistance.[61] The self became devalued, but many individuals interviewed in this study looked to the future and 'talked about a future self who was involved in meaningful work and further strengthened by the homeless experience'.[62]

How much, or how little, has the situation of homeless people and beggars changed since the nineteenth century? The legal framework used to harass and contain them has not altered significantly since the Vagrancy Act of 1824, cited by police to charge people in several English towns in recent years.[63] Police say they are responding to complaints by shoppers, visitors and traders. Consider the following:

MR EDITOR, – For some time past our main streets are haunted by swarms
of beggars, who try to awaken the pity of passers-by in a most shameless
and annoying manner, by exposing their tattered clothing, sickly aspect, and
disgusting wounds and deformities. I should think that when one not only
pays the poor-rate, but also contributes to the charitable institutions, one had
done enough to earn a right to be spared such disagreeable and impertinent
molestations. And why else do we pay such high rates for the maintenance of
the municipal police, if they do not even protect us so far as to make it possible
to go to or out of town in peace? I hope the publication of these lines in your
widely circulated paper may induce the authorities to remove this nuisance; and
I remain, – Your obedient servant.

A LADY.

This letter was actually written in 1844, but the sentiments it expresses seem very contemporary. It is quoted by Frederick Engels in his book published in 1845, *The Condition of the Working Class in England*.[64] With a few minor alterations, it could have been written yesterday. In Henry Mayhew's *London Labour and the London Poor*, based on his articles in *The Morning Chronicle* (1849–1850), the author voices his disapproval of the 'nomads' – beggars, prostitutes, sailors, street-performers – who do nothing productive but 'prey upon the earnings of the more industrious portions of the community'.[65] In 1914, J.A. Hobson took much the same view, linking beggars, 'gypsies', thieves and poachers as a group of vagabonds and parasites. Interestingly, though, he observed that the parasitic behaviour he discerned in this group of people mirrored that of the upper classes, who had also withdrawn from productive activity.[66] This is obviously very different from the

approach of Marx and Engels, which is far more sympathetic to beggars and destitute people, but also, as we noted above, sees how capitalism exploits the potential for productivity in any activity.

Many beggars see themselves as doing a job of work, rather than being parasites. In most cases, they spend long hours trying to get money, and construct an identity to help them achieve this.[67] A London beggar interviewed in the 1990s, Laurie McGlone, also felt he was doing a job and earning his money in an occupation that had no health and safety regulations: 'One day a tall, a very tall man comes down here and hit me right on the head with an umbrella. He got me right here, cut me, and called me a bastard. This is a dangerous, dangerous job.'[68]

Engels' text on working-class Britain resonates with anger at the appalling suffering of the poor in England in the mid nineteenth century. Those who beg, he writes, are those who cannot find work and who will not, or are not able to, rebel against the society which has reduced them to misery. In fact, as he points out, begging is less harmful to the state than many other possible responses to poverty and/or unemployment. Even in the late sixteenth century, before the damaging effects of the industrial and agricultural revolutions on the poor, the French writer and philosopher Michel de Montaigne wondered how beggars put up with their lot. In his essay of 1588, 'On Cannibals', he criticises French society by imagining a group of recently colonised people from the French New World dominions visiting France, and reacting in amazement at what they saw there:

> they had noticed among us some men gorged to the full with things of every sort while the other halves were beggars at their doors, emaciated with hunger and poverty. They found it strange that these poverty-stricken halves should suffer such injustice, and that they did not take the others by the throat or set fire to their houses.[69]

However, artists have not always shunned the subject of begging in their work, as in the example of David's *Belisarius* discussed earlier (plate 6). The French artist Géricault, visiting England in 1820-21, worked on a series of lithographs including scenes of the poor and destitute. One image, *Pity the sorrows of a poor old man!*, showed an old man begging outside a pastry shop.[70] Géricault was well aware of the lack of freedom, choice and potential for self-expression that beggars experienced. When offered the task of copying a religious painting for a provincial museum, he dismissed it with the words 'As I am receiving

encouragement, I'll send to the devil all those Sacred Hearts of Jesus [the topic of the work in question]. That's work for starving beggars.'[71] Clearly, Géricault believed the old adage that beggars can't be choosers, and he definitely wanted to be one of the latter. Freedom to choose his own subjects and execute original works was central to his concept of artistic subjectivity.

Artists such as Chardin, Brueghel, Rembrandt and Goya, all major figures, represented beggars in their works. Why were artists interested in beggars, and what did it mean to represent them and offer images of them for sale to middle or upper-class patrons, or even the state? Clearly lithographs and other prints could reach less affluent purchasers, but not if publishers turned them down. Images of beggars and their meanings differ according to their historical, social and economic contexts, so we have to be careful of generalisations. However, it is possible to make some suggestions. For artists, beggars as subject matter can function as cheap models, as examples of street life (I came across no domestic or interior scenes with beggars, presumably because no-one lets them into their homes), exemplars of the victims of modernity, participants in moral stories, or as vehicles for political criticism. The financial difficulties of many artists may also have made them aware of the possibility of one day being in the same position. In the past, artists often had to write pretty desperate letters begging for government commissions or other patronage, and it is not too far-fetched to compare the dire straits of some impoverished artworkers in times of crisis with the plight of those who had to hang about in the streets hoping for some financial help.[72] We have all seen pavement artists doing their chalk drawings and hoping for 'donations' from passers-by. Whether this is an example of taking art out of the museums and into the community, or begging, is open to debate.

AGGRESSIVE BEGGING

Perhaps the most famous example of a painting representing begging is David's *Belisarius, recognised by a soldier who had served under him, at the moment when a woman gives him alms* exhibited at the Salon of 1781 (plate 6). Inscribed on a block of stone on the right, in Latin, are the words 'Give an oble [ancient coin] to Belisarius', a rather more cultured version of the usual bits of paper used by today's beggars. Reduced to begging with the help of a young boy, Belisarius is shown as an example of the ingratitude of the powerful to those who serve

them, and parallels were drawn with the contemporary French military hero, Lally Tolendal, wrongly executed for treason and rehabilitated in the same year the painting was exhibited.[73] The painting thus links begging to political criticism.

Many readers will probably have noticed by now that this is an example of so-called 'aggressive begging' with a child, so much disapproved of in recent years by the British government and some sections of the press. While contemporary beggars with children are mainly female, this eighteenth-century example shows the woman as the giver of money, while the old patriarchal figure is reduced to blind helplessness. Actually, this painting, although addressing us in a visual register of classicism, nobility and elite cultural values, quite possibly shows a reasonably accurate picture of the types of beggar most commonly met with in eighteenth-century France. According to Olwen Hufton, in the 1770s most beggars were children, many of them abandoned by parents too poor to care for them. Along with children, the commonest beggars were aged ex-workers, male and female, with disabilities like arthritis or defective eyesight which prevented them from earning a living.[74] In the old regime before the Revolution of 1789, beggars could be branded, flogged, sent to the galleys, banished (a favourite way of disposing of the problem), or imprisoned in unsanitary conditions where many of them died.

Hugh Honour, discussing David's painting, has interpreted it as an example of 'helplessness', 'poignant lament', and of 'universal significance'. The hero bears his lot with 'moral heroism in adversity'. It has 'dignity of message', 'sobriety of handling', the 'gestures are restrained', and the 'colours are subdued'.[75] Honour reads the work as embodying these noble qualities. Passions are expressed in faces and bodily gestures, but in a controlled way. We should not get angry, because the painter is not angry and neither is Belisarius. Far from being so-called aggressive begging, this begging is largely passive. But then is contemporary begging really that aggressive? Chief Superintendent Steve Hotson of British Transport Police remarked that although he was not in favour of sending beggars to jail, passengers on the London Underground found the style of begging by East Europeans intimidating: 'They get close to you, or have a child with them, and British society doesn't cope well with that. That's why people find it intimidating and sometimes aggressive.'[76] Is begging with a child exploitative and aggressive in itself? Where would beggars leave their children anyway?

A slightly later French painting by Bonnemaison also depicts an example of 'aggressive begging' with a child (plate 19). The woman is dressed in black, while the child has a russet jacket, red waistcoat and dark green trousers. Like a large genre painting (it measures 150 x 118 cm) this work offers a certain intimate contact with the figures to the viewer, who is placed in the position of the passer-by accosted by the

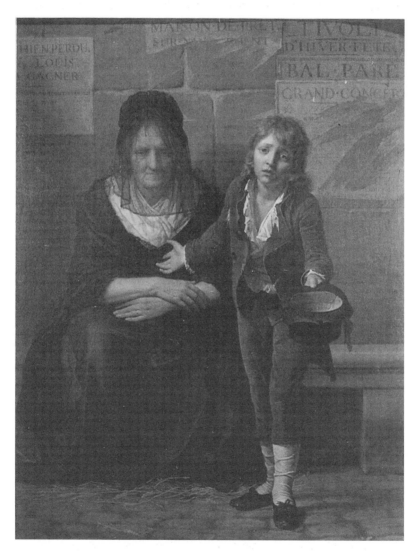

Plate 19. Féréol de Bonnemaison, La Rentière, *oil on canvas, 150 x 118 cm, exhibited at the Salon of 1800, Paris, private collection, England, with permission.*

young beggar-boy acting on behalf of the older woman, presumably his exhausted grandmother. Behind them, posters for balls and festivities, rewards for a lost dog, and a mortgage/pawnbroker's business highlight their plight in the midst of post-revolutionary social and economic upheaval. Very probably influenced by David's work, this shows two figures in contemporary dress and was exhibited in 1800 at the Salon as *La Rentière*. This term means a woman who lives from 'rents', money generated from capital invested in buildings, land, interest on loans to municipal councils, or stocks and shares. So the rentière probably never worked for a living. Various pointers are given to indicate her status as a widowed gentlewoman fallen on hard times, whose income has been drastically eroded by the rampant inflation caused, it is implied, by the economic chaos of the French Revolution and its aftermath.[77] Can this be the work of a painter exploiting a child to sell his work? Perhaps we have here an example of what I am tempted to call 'aggressive painting'. But perhaps this is the right kind of child and not one viewed as potentially aggressive? He is plaintive, beseeching, and touching – from a good family, ruined by factors outside his control.

This child was not like many other poor beggar children. I cannot resist giving details of an example of another young French beggar who had a run-in with the authorities some years later in 1828: 'A child of twelve or thirteen, Louis Brun, was arrested when soliciting charity from passers-by by showing off the tricks of a ferret... When the inspector arrested him, he let the ferret loose in his face and it bit him.'[78]

The painter of *La Rentière*, Bonnemaison, had been a refugee (émigré) or, in contemporary terminology, an asylum seeker in England in the first years of the Revolution, returning to France in 1796 after the most radical period of revolutionary activity had passed, so there is probably an undercurrent of hostility to the Revolution in his depiction of the rentière and her grandson. Under the restored monarchy he devoted himself to the conservation of royal and aristocratic art collections for which he received various medals and decorations.[79]

A more radical portrayal of marginalised subjects can be seen in the work by Gustave Courbet, *The Charity of a Beggar at Ornans* (plate 20). Signed and dated 1868 and exhibited that year in Paris and Le Havre, the work returned to an idea the artist had conceived fourteen years earlier, of painting a gypsy woman and her children by the roadside. This was to be another work in his series of 'road' paintings, according to the artist, which included his *Stonebreakers* and *Peasants of Flagey returning from the Fair*, both exhibited at the Salon of 1850–1851. The

work was generally badly received but Courbet was not to be put off and wrote in September 1868 that he still aimed to do more 'heartfelt and socialist paintings'.[80] Courbet wanted this work to embody a political and social message, but none of his contemporaries felt he had succeeded and neither did later art historians such as Benedict Nicolson or Jack Lindsay. The painting did not sell in Courbet's lifetime, and the last time I visited Glasgow's Kelvingrove Art Gallery it was not on public display.

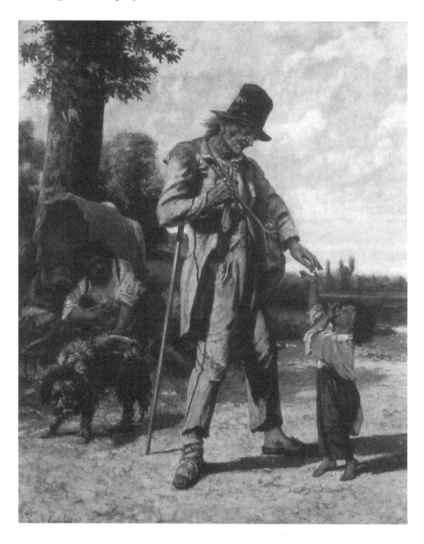

Plate 20. Gustave Courbet, The Charity of a Beggar at Ornans, *oil on canvas, 210 x 175 cm, 1868, Glasgow Museums, The Burrell Collection.*

Here we have some traditional ingredients of begging pictures, and also some more 'modern' signifiers of begging: poor, badly clothed, dark-skinned people, including children and a Romany woman. Various critics spoke of the figures as 'odious', 'horrible' and 'repulsive'. Even the left-wing Thoré wrote that:

His [Courbet's] friends are surprised that to personify generous poverty, the humanity that valiantly and sturdily survives despite the most extreme indigence, he has deliberately chosen such a horrible and repulsive figure.[81]

Benedict Nicolson commented:

One has only to turn to one of Van Gogh's potato-eaters to see how dignified abject poverty can be.[82]

Instead of picturesque gypsy costumes, attractive young women dancing round a campfire, and kind-faced, middle-class or petty-bourgeois benefactors, we are shown dismal-looking figures in dull browns, a rough paint surface, and expressions and gestures which are difficult to read. Unlike the legible facial expressions of feelings in history paintings, where the outside of the face mirrors the 'inside' of the mind, the charitable beggar looks threatening, not pitying. That's the whole issue really. This painting is about giving without pity, condescension or embarrassment.

What a contrast to the nobility and pathos of poor Belisarius! It appears that when beggars are lacking in dignity and nobility, they are alien to us, and therefore have no call on the human responses of non-beggars. It seems to me that the social and political meanings of Courbet's begging scene are rejected as unwelcome, or not even recognised, and that this is voiced in terms of the lack of aesthetic appeal of the painting, and condemnation of its ugly participants. The beggar is not portrayed as a victim, but as an active person. Normally, we would expect people from a more elevated social position to do this, but it is not the case here. Thus Courbet's work disturbs class relations and positions. Who has the right to be charitable and does charity merely keep its recipients in a subject position when bestowed by one's 'betters'?[83]

In return for the beggar's gift, the child appears to blow him a kiss of gratitude, since his 'wretched' appearance is largely a matter of subjective viewing. It is the poor who help the poor in Courbet's

picture, not the state or the rich. Engels remarked in *The Condition of the Working Class in England*, that the beggars he observed in the 1840s were to be found almost exclusively in working class districts, and received gifts mainly from the poor, who knew what it was to be cold and hungry.[84]

So, what of contemporary representations of beggars? A photograph printed on the front page of *The Times*, on 9 March 2000, could certainly qualify as a contemporary equivalent of one of Courbet's 'roadside' pictures related to current social and economic issues (colour plate 10). The colourfully dressed young woman stands holding a child in the road while she attempts to beg from drivers. The two beggars are the only note of colour in this otherwise drab scene. Judging by what we can see of the lorry driver in the wing mirror, he is ignoring her. Her behaviour is hardly aggressive. Clearly this is not safe for the mother and child, but it is relevant to consider what has forced her into such activities, rather than criminalise the woman for acting in an unsafe manner. Even supposedly left-wing politicians, such as the current Mayor of London, Ken Livingstone, have criticised these activities as for 'aggressive begging'. In an attempt to condemn the beggars, while maintaining an anti-racist stance, Livingstone tied himself in knots, arguing:

Every time the tabloid press launch one of their virulent campaigns – whether the target be immigrants, refugees or recently 'gypsies' – they encourage the kind of thugs who murdered Stephen Lawrence... Street crime should not be tolerated, and that includes any kind of aggressive begging.[85]

In fact, beggars are actually much more likely to be victims of an attack than the perpetrators.[86]

The coverage of begging at this time in *The Times*, however, dealt with issues similar to those which appeared in papers such as *The Sun*, but in more depth and written in longer sentences. The same front page on which the photograph was published carried articles on a crackdown on 'social security cheats and beggars', and the 'black economy'. The very language 'colours' the 'cheats' in a negative way. Under the photo, we read how a magistrate, Roger Davies, threatened to send women beggars to jail after fining a mother in court. Inside the paper are two facing pages (4 and 5) devoted to punishing benefit cheats and refugee beggars. A more sympathetic article at the foot of page five includes comments by Londoners on the beggars, which were not antagonistic at all, and did not really back up the magistrate's claim that 'the British people' were

losing patience with them. It is very likely that there are far bigger and richer tax dodgers and financial cheats who deserve punishment, but we would be more likely to see them behind a desk or in an exclusive club than standing in the middle of a busy road.

The connection between the riches of high finance and the destitution of begging is made in the series of large digitally manipulated photographs by John Goto entitled *Gilt City* (2003). These works, using central single figures posed by friends and acquaintances of the artist, show characters from modern street life placed in constructed settings using images of buildings from the City of London, London's main financial district. Reflected in the glass of the buildings we see workers, dealers and traders in the finance industry, walking along and contrasted with the static, emblematic or even allegorical-looking figures which include the beggar, the drunk, the worker, the tout, the dealer, the graffiti artist and the hustler.[87] Like Goto's other works, these images play off our expectations of documentary and staged photographs against one another, unsettling the viewer, as indeed the passer-by is often unsettled by the appearance of beggars and drunks on the streets in real life. We often do not know how to respond to these people who address us. Goto believes that the documentary approach of photographing poor people in the streets is now discredited as both exploitative and voyeuristic.[88]

Goto's approach is very different from the strategies used by Boris Mikhailov in his photographs of down-and-outs in the former Soviet Union. Goto also goes further in asking what now replaces documentary, which was based very much on an ideology of social criticism and left politics of one variety or another, from reformism to socialism. Goto remarks: 'The old documentary approach assumed an analysis based on class relations and the redistribution of wealth, which no longer finds political or popular support.'[89] Goto's image, *Beggar*, from this series, shows a kneeling young man wearing a camouflage jacket, posed as if praying to a holy figure in an altarpiece, but holding up in his hands a paper cup with a McDonalds logo. Reflected in a glass panel of the building behind him are figures of men wearing suits and ties, walking along in front of St Paul's Cathedral. Religious adoration is replaced by the worship of money, either from necessity or greed. Religious fetishism is superseded by commodity fetishism. Documentary is no longer sufficient to represent the politics of money, but neither is photomontage. Goto seeks to present us with a picture of reality which is 'true' but not quite 'real'; photographic, but staged.[90]

Begging has traditionally been perceived as more acceptable if performed with humility, for example, sitting quietly with downcast eyes while a written sign is displayed, and thus more active attempts by beggars to engage the attention of passers-by are frowned upon. An essay in *Begging Questions* on the global context of the increase in begging points to the collapse of the post-capitalist economies of the former Soviet bloc, the demise of older types of industry, consequent mass unemployment, the rising cost of housing and the abolition of benefits to young adults. Civil wars, massacres, famines and political persecution in many countries have increased the numbers of refugees and asylum seekers (who are not permitted to undertake paid or even voluntary work) on a global level.[91]

Refugees and asylum seekers do not just want a home and a job, they want to be a person, a self. The UK government stops them from working, not just to make sure they are isolated from any community who might come to support their right to citizenship, but to make their lives a misery, undermining any sense of self-worth. In articles investigating the appalling treatment of refugees in Britain, especially the case of pregnant women and women with children, Melanie McFadyean interviewed Paulette, a refugee who had suffered torture in Burundi. Her father was forced at gunpoint to rape her and then members of her family were killed. She lives in a damp room with her one-year-old child. She is not allowed to work. 'Even animals in the zoo, they treat them nicely. Who am I, what can I say, what can I do? Nothing. I am nothing, I count for nothing. I've got no family, I've got no history. This is not life.'[92] There is no chance for Paulette to interpret her situation as a potentially life-enhancing hybrid post-colonial experience of 'in-betweenness'. The very idea is ridiculous. What Paulette and thousands of others need is state recognition of her status and identity, her rights, her subjectivity, and her agency, for, in capitalist societies, the state ultimately decides who is a citizen, a human subject, and who is not.

Article Thirteen of the Universal Declaration of Human Rights states that anyone has the right to leave any country if they wish. However, it does not offer the right to enter any country other than as a refugee.[93] A recent book on international migration argued, convincingly in my view, that immigrants create far more economic wealth and cultural richness than they 'cost' their host country. While the jobs they do are visible, the jobs they create are not. They travel, eat and require housing, providing jobs for farmers, waiters, drivers and builders.[94] Many

are already trained professionals, and in Britain young immigrants could help to reinvigorate an ageing population and pay taxes and pension costs! But to do all this immigrants need passports and official recognition as citizens.[95]

THE SUBJECT OF PASSPORTS

In 1930, the Soviet poet and activist Mayakovsky committed suicide in the context of Stalinist repression in both political and cultural life. The previous year, he wrote 'My Soviet Passport', expressing his pride in being not a monarch's 'subject' but a citizen of the USSR. On his travels, he watches how the immigration bureaucrats treat different kinds of passport-holders, grovelling before the US passports, respecting the British ones and eager to 'crucify him on the spot' because he holds a Soviet passport.[96] Mayakovsky's pride in his Soviet passport and his anguish at Stalinist repression point to some of the contradictory meanings of passports, as we shall see.

Not long after the poet's death, the Stalinist authorities introduced a stringent internal passport regime in 1932, designed to intensify surveillance of political opponents and to discipline workers. Collective farmworkers were not even given the right to internal passports, thus confining them to their own locality. Genrikh Yagoda, the People's Commissar of Internal Affairs, in a top-secret speech to police chiefs in 1935, stated:

We need to create an atmosphere such that each citizen feels that without
a passport he will be unable to travel anywhere, that the single document
confirming his identity is the passport. The first question you must ask a detained
citizen is – show me your passport.[97]

In the years between about 1850 and the First World War, international travel throughout most of Europe was relatively easy, yet as one German historian has remarked, 'liberalism always stops at the gates of the lower classes.'[98] Dangerous immigrants were to be denied entry, while the industrious and honest poor were allowed in. Clearly, a passport, identity papers, proofs of nationality, 'belonging' to a particular country, and allegiance to its flag, vary in significance and purpose in differing historical, political and economic situations. Yet the passport and the identity that come with it are always contradictory and should be viewed dialectically – at once a sign of rights and

certain privileges, but also a means of surveillance, control and, in itself, a commodity purchased for a fee from the state in some way or another. Yet the granting of a passport depends upon more than just money – even the wealth of Mohammed Al-Fayed, owner of Harrods department store and a London football club, and father to Princess Diana's dead lover, cannot, so far, buy him a British passport, identity and subjecthood.

In recent decades, many black and Asian artists in Europe have produced works concerned with passports, identity documents, national flags and signs of national and international affiliation and belonging.[99] Yet suggestions by some critics and curators that this type of critical approach to subjectivity and identity has been superseded by 'post-black' art and culture are, I think, rather premature. In *Freestyle*, the catalogue of an exhibition at the Studio Museum Harlem (2001), curator Thelma Golden hailed new forms of post-black artistic expression within the 'economically induced interest in globalism in the latter part of the 90s', 'an overwhelming sense of individuality' and a 'relentless and unbridled expression of the self'.[100] However, I do not feel that, for the majority of people, the self is yet able to escape and transcend the effects of class, ethnicity, gender or sexuality as a free autonomous agent in the global art world. Rasheed Araeen, artist, curator and critic, who has maintained a consistently anti-imperialist standpoint since his arrival in Europe from Pakistan in the 1960s, is critical of many aspects of post-colonial, postmodern and post-black theories. He is highly suspicious of such buzzwords as hybridity, in-betweenness and the like. For example, the 'in-between' space of migrants and exiles, is, he writes:

a mythical space between the periphery and the centre through which the post-colonial artist must pass before he or she becomes a fully recognised historical subject... multiculturalism [is the means] by which the 'other' artist can be kept outside mainstream art history and at the same time promoted and celebrated on the basis of his or her cultural difference.[101]

Things are not particularly easy even for academics, artists and other professionals. Film-maker, lecturer and artist Isaac Julien has, I am reliably informed, experienced visa and entry problems travelling to and from the USA in the course of his work. At a conference in New York, where I recently presented a paper on this topic, delegates at one session were told how several speakers were unable to attend to present

their papers because they had been refused entry as they came from 'dangerous' countries where terrorists might be active, for example the Philippines, and China.[102] Apart from anything else, the refusal to let these speakers enter the USA ensured that the session organisers' aim of ensuring that views from parts of the world other than the USA and Europe were heard and seen was partially thwarted.

The passport or visa as an identity document within global capitalism is not merely a cultural sign in the work of artists and theorists, but often a matter of life and death and economic survival, for hundreds of thousands of refugees worldwide. I can only mention the British context briefly here. In the period from April to June 2002, the highest numbers of asylum seekers, according to Home Office figures, came from Iraq (3,240) and the next highest from Afghanistan (2,130). This is not surprising given the situation in the area.[103] People fleeing these countries, along with Somalia and Sri Lanka, regularly top the list of asylum seekers to the UK – all these groups are black and Asian.[104] Figures for the third quarter of 2003 are Somalia (1,440), China (965), Iran (860) and Zimbabwe (710).[105]

Yet within the national boundaries of Britain itself, the situation for black artists has definitely improved since the 1970s, when they and their cultural politics became more visible. Black and Asian artists are now more in the public eye, and a number have been nominated for as well as won major art prizes, including Anish Kapoor, Chris Ofili, Steve McQueen and Isaac Julien. More books and resources are available on their works. Thus the increased visibility and valuing of the work of these artists exists alongside government policies which bar large numbers of black and Asian people from Britain, and treat them extremely harshly if they do manage to enter. A number of artists have made powerful work on the subject of migration and forced exile, including Isaac Julien (*Paradise Omeros*, 2002) and Zarina Bhimji (*Out of Blue*, also 2002), the latter dealing with the trauma of the expulsion of Asians from Uganda in 1972. With a haunting soundtrack, this film shows images of desolate homes, graveyards, police cells, military barracks and airport buildings. Devoid of human presence, the film is powerfully poignant and moving, but at the same time contains a threatening and sinister meaning. With implications beyond the immediate context of Uganda, it succeeds in achieving the seemingly impossible by visualising 'disappearances' which regularly occur throughout the world under repressive political regimes and military death squads.

For the present, black is still black, rather than post-black, in the international economic and political context. As far as art is concerned, black and Asian artists may have more opportunities to explore wider aspects of subjectivity than previously, but this is largely in contrast to, rather than facilitated by, global developments in areas outside the cultural sphere.

CONCLUSIONS

The World Bank, World Trade Organisation, International Monetary Fund and the imperialist governments push free trade and trans-national capital flow as the way for poor nations to pull themselves up to 'our' levels. Increased globalisation, including the export of jobs to low-pay, non-union areas of the world economy, such as China or Mexico, has actually meant the increase of economic inequality. Imperialism's answer to this is that globalisation has not gone far enough: 'if inequality has increased in Africa, rural China and rural India they are victims of the lack of globalisation. It makes better sense to extend the scope of globalisation which means addressing the causes of their isolation.'[106] If globalisation is so good for everyone, and capital can travel across national boundaries, why don't people have the same rights? Are objects more free than subjects? It is true that we can communicate globally via the internet, but virtual transnational travel is not the same as actual reality. For many people in the world today, selfhood and subjectivity remain a site of struggle and contestation, rather than negotiation. Many individuals modulate and re-present the self in cultural, economic and social spheres, yet this always takes place in a framework which is ultimately determined by the state and its representatives, despite the ability (of many, not all, subjects) to vote every few years. Even that, at times, is fraught with difficulty in advanced capitalist societies, for example in the last elections in the USA where many black voters were disenfranchised and George Bush secured his victory in the courts, not the polling booths. Self-determination, rather than a Foucauldian focus on caring for the self, is still a crucial issue, individually, socially, and internationally.

CONCLUSION

Despite the recent vogue for some aspects of postmodern theory celebrating the death of the author, and/or the demise of the autonomous subject of modernity, a great deal of fine art and visual culture still depends on notions of the self and the subject. While less credence is given these days to the idea that artworks and images express the self of the person who made them, it is still true that art is generally linked to the notion of the individual maker. This is partly true for reasons of copyright, income and celebrity, and also for more academic reasons such as ease of researching a particular artist or designer.

The viewer's subjectivity is also significant, though increasingly conceived of in terms of modulations of 'the autonomous subject of modernity' by factors such as gender, 'race', sexuality and class. Both the production and consumption of aspects of visual culture in western societies are largely centred on, and addressed to, individuals, even when, as in advertising, the individuals are then expected to employ agency 'en masse' by purchasing commodities.

Thus we find a disjunction between the economic, the legal and the political, on the one hand, and the cultural on the other. Avant-garde cultural theory and practice explores many kinds of subjectivity, whereas in more fundamental spheres of social and economic life, the individual, property-owning, consuming and passport-holding self still holds sway. The state still defines who is a subject and who is not, who is or is not an author or a property owner, who is or is not a resident, even who has or has not rights over their own body.[1] In the cultural sphere, in theory and also in the practices of fine art, advertising, music videos and so on, fluid, hybrid, and playful subjects can enjoy new-found freedoms in postmodernity. On the internet and in cyberspace, subjects can migrate, change identities, and communicate

globally, so what does it matter if some of us cannot actually travel to the countries we want to visit, or live in, 'in real life'? Actually, it matters quite a lot.

Cultural material can move across national boundaries and, like capital, become part of a global super-identity. It was interestingly posed to me recently that perhaps we should not have a rigid, fixed notion of what constitutes citizenship (and I might add subjectivity) in the postmodern world.[2] Indeed, it is true to say that, for some people, negotiating notions of multiple possible subjectivities, citizenship and indeterminacy can be a fruitful experience, resulting in rethinking not only personal situations, but also larger issues of class and social struggle, even international conflicts.

I think perhaps we might distinguish between notions of subjectivity and citizenship on a state/government level, and on the level of the everyday experience of ordinary people, though of course the two overlap, especially in the case of, say, asylum seekers. Without suggest-ing some kind of rigid hierarchy, I would propose that ideologies and experiences of selfhood differ in different spheres of social existence. Art and culture have relative freedoms (not absolute freedoms) which are not applicable when, say, dealing with immigration authorities. In everyday life, for most people, consumerism of various kinds offers relative freedom within a restricted framework of economic means. 'Multiculturalism', for all the problems with the term and its lived realities, can allow subjects to escape what are perhaps restrictive religious, cultural and ethnic limitations. However, 'multiculturalism' can also strengthen the link between culture and religion, which is not necessarily a progressive development. Ways in which subjects modulate their experiences in particular situations can be fruitful, life enhancing and self-affirming.

We only have to look at some examples of works discussed in this book to see that the production of art and other objects attests to these positive effects of different, multiple potentialities for the self. But for many people, this is not the case. Perhaps one day our subjectivities and identities will be located within a different set of values, beyond patriotism, citizenship, the national, or even 'global' identities.

These desires and aspirations are important. But for the present, many marginalised subjects all over the world still do not have self-recognition and self-determination. This is why, although the Cartesian subject and its legacy should be critically interrogated, we should not relegate the subject/self to the dustbin of history just yet, if at all. Past,

present and probably future selves can be viewed as complex and contradictory agents, making, and interacting with, material and social reality. Visual culture is part of that making, part of that understanding, and an important part of many subjectivities.

NOTES

INTRODUCTION

1. R. Descartes, 'Discourse Four', in *Discourse on Method and the Meditations*, translated by F.E. Sutcliffe (Harmondsworth: Penguin, 1968), 53–4.

2. A. McRobbie, 'Feminism, Postmodernism and the "Real Me"', in McRobbie, *Postmodernism and Culture* (London: Routledge, 1985); reprinted in M.G. Durham and D.M. Kellner (eds), *Media and Cultural Studies: Key Works* (Oxford: Blackwell, 2001), 598–610, quotation 607.

3. T. Lubbock, 'Personal Worst', *The Independent Review*, 12 November 2002.

4. Descartes' legacy is still relevant to artists. For example, the recent Bill Viola exhibition at the National Gallery London (2003–2004) included slow-motion video works of human faces expressing passions. In a related publication, edited by Richard Meyer, *Representing the Passions: Histories, Bodies, Visions* (Los Angeles: Getty Research Institute, 2003), the opening essay (by David Summers) discusses Descartes' book on expressing the passions, and the book also includes photographs and notes by Viola. In a documentary on his recent 'passions' works directed by Mark Kidel, Viola states that passions involve the loss of the self and self-control, making their representation difficult.

5. See Descartes, *Discourse on Method and the Meditations*, 54.

6. Dalia Judovitz discusses how Descartes rejected previous baroque notions of embodied subjectivity, and, along with other thinkers, helped formulate a new disembodied subjectivity during the sixteenth to eighteenth centuries in Europe. She argues that twentieth-century thinkers such as Maurice Merleau-Ponty and Michel Foucault have returned to notions of embodied subjectivity. D. Judovitz, *The Culture of*

the Body: Genealogies of Modernity (Ann Arbor: University of Michigan Press, 2001).

7. See McRobbie, 'Feminism, Postmodernism and the "Real Me"'; and also S. Bordo, *The Flight to Objectivity: Essays on Cartesianism and Culture* (New York: State University of New York Press, 1987); D. Judovitz, *Subjectivity and Representation in Descartes: The Origins of Modernity* (Cambridge: Cambridge University Press, 1988); C.H. Cantrell, 'Analogy as Destiny: Cartesian Man and the Woman Reader', *Hypatia*, vol. 5, no. 2 (Summer 1990), 7–19; and, more recently, A.R. Damasio, *Descartes' Error: Emotion, Reason and the Human Brain* (London: Papermac, 1996).

8. There is a contradiction here in that such thinkers criticise the Cartesian subject for its dualism, yet also condemn it as unitary. There is a good discussion of postmodern thought and attacks on the 'modern' Cartesian/Enlightenment subject, reason and truth, in the very useful book by Alex Callinicos, *Against Postmodernism: A Marxist Critique*, (Cambridge: Polity Press, 1989).

9. K. Mercer, *Welcome to the Jungle: New Positions in Black Cultural Studies* (London and New York: Routledge, 1994); H.K. Bhaba, *The Location of Culture* (London and New York: Routledge, 1994); J. Butler, *Subjects of Desire: Hegelian Reflection in Twentieth-Century France* (New York: Columbia University Press, 1987) and *Bodies that Matter: On the Discursive Limits of 'Sex'* (London and New York: Routledge, 1993).

10. For more in-depth discussions of these issues, see the useful book by Caroline Williams, *Contemporary French Philosophy: Modernity and the Persistence of the Subject* (London and New York: Athlone Press, 2001), especially Chapter 5, 'The Discursive Construction of the Subject', where she analyses the work of Foucault and Butler; and Alain Renaut, *The Era of the Individual: A Contribution to a History of Subjectivity* (Princeton: Princeton University Press, 1997; first published in French, 1989). Also useful is P. Hodgkiss, *The Making of the Modern Mind: The Surfacing of Consciousness in Social Thought* (London and New York: Athlone Press, 2001), which, as the title suggests, discusses sociological and anthropological theorists as well as cultural theorists such as Michel Foucault.

11. See, for example, the various attempts to grapple with the problem of rethinking subjectivity in E. Cadava, P. Connor, J.-L. Nancy (eds), *Who Comes After the Subject?* (London: Routledge, 1991).

12. McRobbie, 'Feminism, Postmodernism and the "Real Me"', 607–8.

13. E. Shohat and R. Stam, 'The Politics of Multiculturalism in the Postmodern Age', *Art and Design* (July/August 1995), 10–16, 11.

14. K. Mercer, 'Busy In the Ruins of Wretched Phantasia', in *Mirage: Enigmas of Race, Difference and Desire* (London: Institute of Contemporary Arts/Institute of International Visual Arts, 1995), 14–55, 51.

15. For a more in-depth discussion of this, see Doy, *Black Visual Culture: Modernity and Postmodernity* (London and New York: I.B.Tauris, 2000), especially Chapter 2, 'Economics, Histories, Identities'. Attempts to relate psychoanalysis and Marxism to issues usually seen to be the province of postmodernism (queer theory, the postcolonial, subjectivity, gender and fantasy, to name but a few) can be found in the essays in *Psycho-Marxism: Marxism and Psychoanalysis Late in the Twentieth Century*, special issue, edited by R. Miklitsch, *South Atlantic Quarterly*, vol. 97, no. 2 (Spring 1998). See also the earlier book by E.V. Wolfenstein, *Psychoanalytic-Marxism: Groundwork* (London: Free Association Books, 1993).

16. D. Harvey, *The Condition of Postmodernity: An Enquiry into the Origins of Cultural Change* (Cambridge, Mass. and Oxford: Blackwell, 1994; originally published in 1990), 53. However, Harvey agrees with Fredric Jameson in believing that 'alienation of the subject is displaced by fragmentation of the subject' in postmodern aesthetics, 54. As we shall see, this is only partly true of contemporary visual culture.

17. For more on Marxism and postmodernism, see Doy, *Materializing Art History* (Oxford: Berg, 1998). See also the excellent work by M. Zavarzadeh, T. Ebert and D. Morton (eds), *Postality: Marxism and Postmodernism*, special issue of *Transformation: Marxist Boundary work in Theory, Economics, Politics and Culture*, no. 1 (Washington, DC: Maisonneuve Press, 1995), which includes the useful essay by Greg Dawes, 'A Marxist Critique of Post-Structuralist Notions of the Subject', 150–88. See also Teresa Ebert's incisive critique of postmodern feminism in her book *Ludic Feminism and After: Postmodernism, Desire, and Labor in Late Capitalism* (Ann Arbor: University of Michigan Press, 1996). Articles on Marxism and culture also appear in the journal *Historical Materialism: Research in Critical Marxist Theory*, published from 1997 onwards.

18. See, for example, C.O. Schrag, *The Self after Postmodernity* (New Haven and London: Yale University Press, 1997); L. McNay, *Gender and Agency: Reconfiguring the Subject in Feminist and Social Theory* (Cambridge: Polity Press, 2000); R.S. Perinbanayagam, *The Presence of Self* (Lanham, Boulder, New York, Oxford: Rowman and Littlefield, 2000); P. Hodgkiss, *The Making of the Modern Mind: The Surfacing of Consciousness in Social Thought* (London and New York: Athlone Press, 2001); and C. Anton, *Selfhood and Authenticity* (New York: State University of New York Press, 2001).

19. I do not see any reason why Marxism is incompatible with psychoanalytic theory per se. With care, an abstract, ahistorical use of psychoanalytic concepts can be avoided. For further discussion of this, see Doy, *Materializing Art History*, Chapter 4, 'How Is the Personal Political?'

Unfortunately, a good deal of postmodern usage of psychoanalytical work has been of this ahistorical and totally apolitical bent, facilitated by the overwhelming emphasis on the work of Jacques Lacan.

20. J. Seabrook, *The No-Nonsense Guide to Class, Caste and Hierarchies* (London: Verso/New Internationalist, 2002), 23.

21. On Emin as celebrity, see J.A. Walker, *Art and Celebrity* (London: Pluto Press, 2003), 248–56.

22. V. Descombes, 'Apropos of the "critique of the subject" and of the critique of this critique', in Cadava, Connor and Nancy (eds), *Who Comes After the Subject?*, 123, correctly points to the difference between the subject as understood in ordinary life, and the meaning of the subject in philosophy.

23. For example, there are many interesting essays in the book edited by David Michael Levin, *Modernity and the Hegemony of Vision* (Berkeley, Los Angeles and London: University of California Press, 1993), which thoughtfully question the prevailing postmodern view of Descartes as 'the father of modern mastering, objectifying and dehumanizing subjectivity' (from the essay by S. Houlgate, 'Vision, Reflection and Openness: The "Hegemony of Vision" from a Hegelian point of view', 87–123, 105). Yet rarely do these essays situate their often astute philosophical enquiries in a wider historical, social or political context.

24. For a useful short introduction to the terms self and subject/ivity, see the entries in T. Patin and J. McLerran, *Artworks: A Glossary of Contemporary Art Theory* (London: Fitzroy Dearborn Publishers, 1997); A. Edgar and P. Sedgwick (eds), *Key Concepts in Cultural Theory* (London and New York: Routledge, 1999); and the very useful entry on 'the subject' by E. Grosz in E. Wright (ed.), *Feminism and Psychoanalysis: A Critical Dictionary* (Oxford: Blackwell, 1992), 409–16.

25. W. Benjamin, 'The Work of Art in the Age of Mechanical Reproduction', in *Illuminations* (Fontana, 1973), extracts reprinted in F. Frascina and C. Harrison (eds), *Modern Art and Modernism: A Critical Anthology* (London: Harper and Row, 1982), 217–20.

26. Perhaps the first of these recent personalised contributions to art history was that of Eunice Lipton, whose book on Victorine Meurend, *Alias Olympia: A Woman's Search for Manet's Notorious Model and her own Desire* (Ithaca: Cornell University Press, 1999; originally published 1993) contained an account by the author of her feelings about the subject of her research and her ensuing decision to give up being an art historian. Carol Mavor has articulated a personal voice within her research on nineteenth-century British photography, for example in *Pleasures Taken: Performances of Sexuality and Loss in Victorian Photographs* (London and New York: I.B.Tauris, 1996); and Linda Nochlin discusses her self, her life, her art history and her poetry in Chapter 14 of A. D'Souza

(ed.), *Self and History: A Tribute to Linda Nochlin* (London: Thames and Hudson, 2001).

27. R. Gagnier, *Subjectivities: A History of Self-Representation in Britain, 1832–1920* (Oxford: Oxford University Press, 1991), 13.

28. Ibid. 10–11.

29. Doy, *Materializing Art History*, 109.

CHAPTER 1: I THINK THEREFORE I LOOK...

1. Descartes, 'Discourse 6', *Discourse on Method and the Meditations* (Harmondsworth: Penguin, 1968), 84.

2. See, for example, the extracts on the self/subject in Part 1, 'The subject of language, ideology and discourse', in P. du Gay, J. Evans and P. Redman (eds), *Identity: A Reader* (London: Sage/Open University, 2000), 7–118; Part 111, 'Looking and Subjectivity', in J. Evans and S. Hall (eds), *Visual Culture: The Reader* (London: Sage/Open University, 1999), 307–378; and N. Mirzoeff (ed.), *The Visual Culture Reader* (London and New York: Routledge, 1998), where Part One, 'A Genealogy of Visual Culture: From Art to Culture', opens with an extract from Descartes' writings on optics (60–5).

3. G. Steiner, 'The Historicity of Dreams' (1983), in *No Passion Spent: Essays 1978–1996* (London and Boston: Faber and Faber, 1996), 207–23, 215. See also J. Masten, 'The Interpretation of Dreams, circa 1610', in C. Mazzio and D. Trevor (eds), *Historicism, Psychoanalysis and Early Modern Culture* (London: Routledge, 2000). Also interesting with regard to Cartesianism is the fact that animals dream, despite the fact that they have no language and no subjectivity; see Steiner, 217. However, for the dream to be socially meaningful, it must be communicated.

4. Interestingly, Lacan claimed that psychoanalysis was built on the structure of Cartesian doubt, and without Descartes there could be no Freud. This is pointed out by C. Williams in her book *Contemporary French Philosophy: Modernity and the Persistence of the Subject* (London and New York: Athlone Press, 2001), 108. It is also possible to argue that Descartes' method of conceptualising the mind as distinct from the body, and consciousness as the self, prefigures Freud's primary focus on the mind and his characterisation of the ego as the 'controlling' consciousness.

5. See, for example, his correspondence with Princess Elizabeth of Bohemia in the mid 1640s, in John Cottingham, *Descartes* (London and New York: Routledge, 1999), 16. Kant's notion of the 'transcendental self' was distinguished by the German Enlightenment philosopher as distinct from the empirical self of which we seem to be aware in our day-to-day activities. 'Kant's subordination of the public, objective world of commonsense realism and the inner world of the Cartesian

self to the activity of a transcendental subject laid the basis of Hegel's absolute idealism.' A. Callinicos, *Marxism and Philosophy* (Oxford: Oxford University Press, 1983), 15.

6. Descartes, *Discourse on Method and the Meditations*, 28.

7. Ibid. 62.

8. Ibid. 98.

9. P. Dumont, *Descartes et l'esthétique: L'art d'émerveiller* (Paris: Presses Universitaires de France, 1997), 13.

10. Descartes, *Discourse on Method, Optics, Geometry and Meteorology*, translated by P.J. Olscamp (Indianapolis: Bobbs-Merrill, 1965), 90.

11. Dumont, *Descartes et l'esthétique*, 4–5. Kathleen Kirby recognises that this 'monadic' individual is a fiction, yet states that 'the monadic ideal of subjectivity still has power' as it is a *functional* fiction which grounds actions and produces effects. See K.M. Kirby, *Indifferent Boundaries: Spatial Concepts of Human Subjectivity* (New York and London: The Guildford Press, 1996), 39. Thanks to Marsha Meskimmon for this reference.

12. M. Jay, *Downcast Eyes: The Denigration of Vision in Twentieth-Century French Thought* (Berkeley and Los Angeles: University of California Press, 1994), 69–82. Robert D. Romanyshyn goes further, blaming Descartes for his part in the formation of modernity as 'ego-ocular-verbocentrism' (the separate individual, the despotic eye, the consciousness of the book); see his (contentious) essay, 'The Despotic Eye and its Shadow Media Image in the Age of Literacy', in D.M. Levin (ed.), *Modernity and the Hegemony of Vision* (Berkeley and Los Angeles: University of California Press, 1993), 339–60.

13. Jay, *Downcast Eyes*, 69–70.

14. Descartes, *Discourse on Method, Optics, Geometry and Meteorology*, 107–8: 'It is also obvious that shape is judged by the knowledge, or opinion, that we have of the position of various parts of the objects, and not by the resemblance of the pictures in the eye.'

15. Jay, *Downcast Eyes*, 81.

16. See L.B. Alberti, *On Painting and On Sculpture*, translated by C. Grayson (London: Phaidon, 1972), 41ff.

17. See J.F. Scott, *The Scientific Work of René Descartes (1596–1650)* (London: Taylor and Francis, 1952), 44, for reproduction of diagram.

18. As noted above, Descartes viewed images as signs (dots can represent battles or storms), not copies of three-dimensional bodies, so this view of Descartes' 'scopic regime' as totally ruled by maths and geometry is not the whole picture. I think there is a difference in Descartes' ideas between seeing as knowledge (geometry and so on) and seeing as pleasure (art images, for example). But I do not think the two can be totally separated because we can tell from his writings that for Descartes

knowledge and understanding are sources of pleasure, and are what make us fully human.

19. Jay, 'Scopic Regimes of Modernity', in H. Foster (ed.), *Vision and Visuality* (Seattle: Bay Press, 1988), 3–27.

20. The term is taken from S. Alpers, *The Art of Describing: Dutch Art in the Seventeenth Century* (Chicago: Chicago University Press, 1983). On baroque vision, see, for example, the works of Christine Buci-Glucksmann, *La Folie de Voir: De l'Esthétique Baroque* (Paris: Galilée, 1986), and *Baroque Reason: The Aesthetics of Modernity*, Introduction by B.S. Turner (London: Sage, 1994).

21. G. Doy, *Drapery: Classicism and Barbarism in Visual Culture* (London and New York: I.B.Tauris, 2002), 140–6.

22. Writing of the shift from a concept of the alienation of the subject to that of the fragmentation of the subject, Jameson commented: 'Such terms inevitably recall one of the more fashionable themes in contemporary theory – that of the 'death' of the subject itself – the end of the autonomous bourgeois monad or ego or individual – and the accompanying stress, whether as some new moral ideal or as empirical description, on the *decentring* of that formerly centred subject or psyche. Of the two possible formulations of this notion – the historicist one, that a once-existing centred subject, in the period of classical capitalism and the nuclear family, has today in the world of organizational bureaucracy dissolved; and the more radical poststructuralist position for which such a subject never existed in the first place but constituted something like an ideological mirage – I obviously incline towards the former.' F. Jameson, 'Postmodernism, or The Cultural Logic of Late Capitalism', *New Left Review*, no. 146, July/August 1984, 53–92, 63. His comments on the lack of any individual or collective political subject are from his later book *Postmodernism or the Cultural Logic of Late Capitalism* (London: Verso, 1991), 175.

23. J. Lacan, 'What is a Picture?', in *The Four Fundamental Concepts of Psycho-Analysis*, with an introduction by D. Macey (London and New York: Penguin Books, 1994), 105–19; see diagram, 106.

24. I will return to Lacan and visual images in the discussion of Holbein's *Ambassadors* in Chapter 2.

25. D. Judovitz, *Subjectivity and Representation in Descartes: The Origins of Modernity* (Cambridge: Cambridge University Press, 1988), 192.

26. J. Crary, *Techniques of the Observer: On Vision and Modernity in the Nineteenth Century* (Cambridge, Mass. and London: MIT Press, 1992), 6.

27. Ibid. 133.

28. G. Batchen, 'Seeing Things: Vision and Modernity', *Afterimage*, September 1991, 5–7.

29. H. Damisch, *The Origin of Perspective*, translated by J. Goodman (Cambridge, Mass.: MIT Press, 1995), 39, 45.

30. Perhaps the most extreme example of this I encountered is the (nonetheless interesting) article by William Dunning. Though the author tries to link the evolution of subjectivity to history, he is hampered by his conflation of different historical periods because of his neglect of the historical context in which Descartes' ideas existed. Also Dunning makes the odd remark that 'With their unified space and viewpoint, the self-centred painted illusions of the Italian Renaissance, the baroque and rococo periods, and the first half of the nineteenth-century, construct a Cartesian viewer.' The abstraction of Descartes' positions from the historical to the symbolic is here complete. Dunning then seems to imply that one-point perspective was natural (while at the same time criticising its constructedness) and hails the new (present-day) 'post-natural' epoch of pluralist realities and multiple points of view. Thus one point perspective is equated with modernist master-narratives, which are now discarded in a liberating shift to postmodern pluralism. There are lots of problems here. How can Cartesianism be the epitome of modernism, of capitalist masculine domination of the material world, of map-making and the scientific revolutions of the seventeenth century yet really have taken place in 1435 when Alberti wrote his description of perspective (as well as embodying the viewing practices of the baroque and the rococo)? See 'The Concept of Self and Postmodern Painting: Constructing a Post-Cartesian Viewer', *The Journal of Aesthetics and Art Criticism*, vol. 49, no. 4, Fall 1991, 331–6, 332. Dunning makes a similar point on page 333, describing Albertian perspective which he then claims constructs a Cartesian viewer, and on page 334 states: 'I contend the Albertian model logically constructs a Cartesian Viewer.'

31. See J. Swann, 'The State and Political Culture', in W. Doyle (ed.), *Old Regime France, 1648–1788* (Oxford: Oxford University Press, 2001), 146; and F.C. Green, *The Ancien Regime: A Manual of French Institutions and Social Classes* (Edinburgh: Edinburgh University Press, 1958), 23–5.

32. For an interesting discussion of Dutch culture and society at this period, see S. Schama, *The Embarrassment of Riches: An Interpretation of Dutch Culture in the Golden Age* (London: Collins/Fontana, 1988).

33. See E.J. Kearns, *Ideas in Seventeenth-Century France* (Manchester: Manchester University Press, 1979), 76; and J. Ree, *Descartes* (Harmondsworth: Allen Lane, 1974), 152. Biographical details are from these books, and also from T. Sorell, *Descartes: A Very Short Introduction* (Oxford: Oxford University Press, 1987); and John Cottingham, *Descartes* (London and New York: Routledge, 1999); and J.F. Scott, *The Scientific Work of René Descartes (1596–1650)* (London: Taylor and Francis, 1952). (My grateful thanks to Professor Tom Sorell for helping me with material

on Descartes.) However, despite attempts by the French authorities to stifle the influence of Cartesianism, the philosopher's works were available and discussed in the decades after his death; see the interesting article by R.M. Wilkin, 'Figuring the Dead Descartes: Claude Clerselier's *Homme de René Descartes* (1664)', in *Representations*, no. 83, Summer 2003, 38–66.

34.　F. Engels, *Socialism: Utopian and Scientific*, in K. Marx and F. Engels, *Selected Works* (London: Lawrence and Wishart, 1973), 383. In conjunction with the development of trade, geographical discoveries, transport and machines, scientific thought, increasingly freed from the restrictions of the Church, contributed to the destruction of feudal ideas of nature and human beings' relationship to the material world.

35.　For the founding of the Academy, the state of painting, and social and political context see the opening section of Tom Crow's excellent book *Painters and Public Life in Eighteenth-Century Paris* (New Haven and London: Yale University Press, 1985). See also the very useful historical material in I. Richefort, *Peintre à Paris au XVIIe Siècle* (Paris: Imago, 1998). The older book by D. Maland, *Culture and Society in Seventeeth-Century France* (London: Batsford, 1970), is useful for literature and philosophy, but does not have much on painting.

36.　There is an impressively detailed account of the Fronde in A. Lloyd Moote, *The Revolt of the Judges: The Parlement of Paris and the Fronde, 1643–1652* (Princeton: Princeton University Press, 1971).

37.　Indeed Kepler, studying the images of the camera obscura and those on the human retina, was not really concerned with the mechanisms by which the upside-down images were perceived correctly by the viewer. The mechanism of keeping the way we see 'the right way up' was dismissed through an analogy with law courts and magistrates, so the interior workings of eye and brain work like existing social institutions: 'I leave it to natural philosophers to discuss the way in which this image or picture (*pictura*) is put together by the spiritual principles of vision residing in the retina and in the nerves, and whether it is made to appear before the soul or the tribunal of the faculty of vision by a spirit within the cerebral cavities, or the faculty of vision, like a magistrate sent by the soul, goes out from the council chamber of the brain to meet this image in the optic nerves and retina, as it were descending to a lower court.' S. Alpers, *The Art of Describing: Dutch Art in the Seventeenth Century* (Harmondsworth: Penguin, 1989), 36.

38.　D. Judovitz, *Subjectivity and Representation in Descartes: The Origins of Modernity* (Cambridge: Cambridge University Press, 1988), 34.

39.　S. de Sacy, *Descartes* (Paris: Seuil, 1996), 127–39.

40.　A. Damasio, *Descartes' Error: Emotion, Reason and the Human Brain* (New York: Putnam, 1995); and *The Feeling of What Happens: Body, Emotion and the Making of Consciousness* (London: Vintage, 2000).

41. D. Dennett, *Consciousness Explained* (Harmondsworth: Penguin, 1991),
 111. I will return to the metaphor of the Cartesian theatre in Chapter 4.

42. Ibid. 297.

43. Rose, *The Conscious Brain* (Harmondsworth: Penguin, 1976), 177–8.
 Steven Rose's later books on this topic include *Not in our Genes: Biology,
 Ideology and Human Nature* (Harmondsworth: Penguin, 1984), and
 Rose (ed.), *From Brains to Consciousness? Essays on the New Sciences
 of the Mind* (London: Penguin, 1998).

44. Ibid. 181.

45. Ibid. 36.

46. My thanks to Kathy Fawcett for discussions on this topic. I am not
 sufficiently expert in theories of how the brain works to make a hard
 and fast decision about these various arguments, but I feel much more
 drawn to Rose's arguments, since he always attends to social factors
 and is an excellent communicator. The importance of attending to
 beneficial, not trivial, social outcomes can be seen in regard to recent
 research into how the brain works carried out by Paul Zak at the Centre
 for Neuro-economics, at Claremont Graduate University in California.
 The findings of brain scans are being used to predict why we make
 certain consumer choices and not others. Critics such as Paul Glimcher,
 Centre for Neuroscience, New York University, have pointed out that
 'It raises serious philosophical questions, because it reduces us to a
 machine, but there's also a huge moral issue.' See I. Sample and D.
 Adam, 'The Brain Can't Lie', *Guardian*, *Life* supplement, 20 November
 2003. Contemporary critics who castigate the 'mechanism' of Descartes
 could find more dangerous opponents to target.

47. Dunning, 'The Concept of Self and Postmodern Painting', 332.

48. In terms of pictures of Descartes himself, there are a few images of the
 philosopher, but the most commonly reproduced is a copy of a portrait
 by Frans Hals done in the late 1640s, now in the Louvre. Whether this
 is because Frans Hals is relatively famous, or the Louvre image is easily
 accessible and the reproduction fees are not extortionate, is not clear.
 See S. Slive, *Frans Hals*, 3 vols (London: Phaidon, 1970–1974), vol.
 1, 164–69; vol. 3, 89–91. See also the entry for the copy after Hals in
 Copenhagen in S. Slive (ed.), *Frans Hals* (Prestel: Royal Academy of Arts;
 Washington: National Gallery of Art; and Haarlem: Frans Halsmuseum,
 1989–1990), 314–6.

49. There are many examples in the book by Lorne Campbell, *Renaissance
 Portraits: European Portrait-Painting in the 14th, 15th and 16th
 Centuries* (New Haven and London: Yale University Press, 1990). See
 also Holbein's *Ambassadors*, illustrated here as plate 3. Joanna Woodall
 writes that this dualist division between the person as a living body
 and their real or true self is 'an opposition [which] means that a vivid

physiognomic likeness cannot represent the identity of the sitter in the satisfying way claimed by Aristotle and Alberti'. (She is referring to Aristotle's *Poetics*, iv3, iv8, xv8, and Alberti's *On Painting and Sculpture* of 1435). See J. Woodall (ed.), 'Introduction', in *Portraiture: Facing the Subject* (Manchester and New York: Manchester University Press, 1997), 9. Woodall points to the increasing economic and cultural power of non-noble elites valuing abstract, not 'blood' or inherited, qualities linked to the body. More valued for these groups were notions of talent, genius and self-improvement. Woodall adds that the dualist view of the self is linked by scholars such as Jakob Burkhardt in his study of the Renaissance to the rise of the bourgeoisie and that: 'The irreducible subjectivity produced by a fully fledged dualist view was aptly named the in-dividual', 15. She points out, however, that Alberti's view of the portrait is not dualist – he claims the portrait *can* show you the real character of the sitter, 17.

50. Or the specific could be generalised by a reference to mythology as in Bronzino's portrait of *Andrea Doria as Neptune* from the 1530s, oil on canvas, 115 x 53 cm, Pinacoteca di Brera, Milan, illustrated in Campbell, *Renaissance Portraits*, 3, fig. 8.

51. See H.W. van Helsdingen, 'Grégoire Huret's Optique de portraiture et peinture', in *Opstellen voor H. van de Waal* (Amsterdam: Scheltema and Holkema; Leiden: Universitaire Pers, 1970), 90–100, 93, note 16. There may, of course, be others whose references to Descartes are not yet known. Obviously, artists employed to illustrate his scientific works knew about his ideas, but at times it was difficult to find suitable illustrators. Florent Schuyl (1619–1669), a university philosopher who published an edition of Descartes' *De Homine* (*Concerning Man*) in 1662, provided his own, rather attractive, images. See R.M. Wilkin, 'Figuring the Dead Descartes', 44–9. The seventeenth-century images associated with Descartes' work are far more closely linked to traditions of scientific and anatomical illustration than to larger-scale fine art images in colour such as history paintings or portraits.

52. Much of this book is devoted to demonstrations of perspective for artists, with elaborate engravings to illustrate his points. These are sometimes very difficult to follow. There is a good deal of polemical writing criticising the approach to perspective of Abraham Bosse, who had been teaching perspective at the French Academy. Huret (and others) attacked Bosse for his doctrinaire approach to the rules of perspective as applied to teaching, and felt that artists needed to 'feel' what was best sometimes, rather than follow a rigid rule book. For a summary of the sometimes quite heated arguments, see M. Kemp, *The Science of Art: Optical Themes in Western Art from Brunelleschi to Seurat* (New Haven: Yale University Press, 1990), 122–34. For a study of Huret's career as an engraver and analysis of his

works, see E. Brugerolles and David Guillet, 'Grégoire Huret, dessinateur et graveur', *Revue de l'Art*, vol. 117, part 3 (1997), 9–35.

53. G. Huret, *Optique de Portraiture et peinture en deux parties* (Paris: C. de Sercy, 1670), vol. 2, 87: 'Qui est une des plus belles parties de ses Oeuvres, et qui luy a ouvert le chemin pour la demonstration de son Iris, ou Arc-en-Ciel, qui est une de ses plus belles découvertes.'

54. 'Pourquoy lors que les yeux d'une teste sont desseignez ou peints de sorte qu'ils regardent le Peintre qui les fait, regardent aussi de toutes parts chaques assistans qui seront devant le Tableau, et pourquoy le naturel ne le peut faire.' Ibid. 95.

55. For these points, see ibid. 96–99.

56. Among the more interesting are G. Clarke (ed.), *The Portrait in Photography* (London: Reaktion Books, 1992); and J. Woodall (ed.), *Portraiture: Facing the Subject* (Manchester: Manchester University Press, 1997). The frustrating book by Jacques Derrida, *Memoirs of the Blind: The Self-Portrait and other Ruins* (Chicago and London: University of Chicago Press, 1993), is worth a look, as is, for different reasons, the equally unsatisfactory D. McNeill, *The Face: A Natural History* (Boston, New York and London: Little, Brown and Co., 1998), which touches on many fascinating topics without really engaging with them in any depth. On the history of the portrait in the early modern period, I found the most useful book to be E. Pommier, *Théories du Portrait: De La Renaissance aux Lumières* (Paris: Gallimard, 1998).

57. E. van Alphen, 'The Portrait's Dispersal: Concepts of Representation and Subjectivity in Contemporary Portraiture', in Woodall (ed.), *Portraiture*, 239–256, 254. This volume is a stimulating collection of essays on different aspects of portraiture from the Renaissance to the present.

58. For example, Lomazzo in 1584, quoted by Pommier, *Théories du Portrait*, 132.

59. See Pommier, *Théories du Portrait*, 211.

60. Nanteuil was active in Paris from 1652 to 1678; see ibid. 278.

61. See Descartes, *The Passions of the Soul*, edited and translated by S. Voss (Hackett, Indianapolis and Cambridge: 1989; originally published 1649), article 113, 'About actions of the eyes and face', 79.

62. The best book on this topic remains J. Montagu, *The Expression of the Passions: The Origin and Influence of Charles Le Brun's Conférence sur l'expression générale et particulière* (New Haven and London: Yale University Press, 1994). While several scholars, including Jennifer Montagu, feel that Descartes' work (on the passions) definitely influenced Lebrun, the latter does not, apparently, acknowledge the philosopher.

63. J. Sawday, *The Body Emblazoned: Dissection and the Human Body in Renaissance Culture* (London and New York: Routledge, 1995), 148–59. Sawday points out that the man being dissected in the painting was

executed for stealing a coat in the 'tolerant' Dutch Republic. I am not very convinced by Sawday's argument about the stages of the dissection, but he is right to remind us that Descartes' work should be related to Dutch culture as well as to developments in France.

64.　Wolf sees the rooms and courtyards depicted in Dutch paintings like these as ordered, self-contained Cartesian spaces based on the principle of the camera obscura, and says of Netscher's *Lace Maker* (Wallace Collection, London): 'We inhabit the Cartesian ego here: an interior space set apart from *res extensa* [the material world], a place where the external realm is present only through its representations.' The figure of the lace-maker pictures what it is like in Descartes' head – she is, says Wolf, like 'Descartes in drag'. B.J. Wolf, *Vermeer and the Invention of Seeing* (Chicago and London: University of Chicago Press, 2001), 40. Wolf relates De Hooch's painted spaces to a society where commodity exchange prevails and thought is abstracted from the body and in danger of reification (84). Perhaps, but it is not clear to me why this is different from the economics prevailing in the nineteenth or the twentieth centuries. Wolf adds that De Hooch's work 'makes sense when we view it as an effort to legitimate the artist within the newly modern social spaces of Cartesianism' (85).

65.　J. Berger, *The Moment of Cubism and other essays* (London: Weidenfeld and Nicolson, 1969), 84; the quote is from V.I. Stoichita, *The Self-Aware Image: An Insight into Early Modern Meta-Painting* (Cambridge: Cambridge University Press, 1997), 156.

66.　Montagu, *The Expression of the Passions*, 17–19. Lebrun does not mention Descartes, however. It has been pointed out that Lebrun's approach was to codify the expression of the passions, to look for rules and precepts suitable to be taught to painters, which was not really Descartes' approach. Souchon argues that Descartes did not claim that the facial movements and changes 'expressed' interior passions but that they were 'external signs' of feelings and 'accompanied' them. There was not therefore a direct and unproblematic link. Also, as noted above, Descartes felt that responses to art were subjective and could not be codified, so there was always room for ambiguity, both on the painted faces and in the mind of the spectator. H. Souchon, 'Descartes et le Brun: Etude comparée de la notion cartésienne des "signes extérieures" et de la théorie de l'Expression de Charles Le Brun', *Les Etudes Philosophiques*, no. 1 (1980), 427–58. It has also been noted that Lebrun's concept of the soul differed from that of Descartes. Lebrun conceived of a pre-Cartesian soul with levels and divisions within it, but the Cartesian subject is unified, without divisions and conceived as different from the body. The Cartesian view is that the body reacts independently to the stimulus it receives from the senses and then the self or 'soul' relays instructions

to the body as to how to respond. See H.W. van Helsdingen, 'Body and
Soul in French Art Theory of the Seventeenth Century after Descartes,
Simiolus, vol. XI (1980), 14–22.

67. Despite this, Norman Bryson wrote that 'The voice behind this whole
[Lebrun's] generation of painters is that of Descartes.' Bryson, *Word and
Image: French Painting of the Ancien Régime* (Cambridge: Cambridge
University Press, 1981), 51.

68. T.P. Olson, *Poussin and France: Painting, Humanism and the Politics of
Style* (New Haven and London: Yale University Press, 2002), argues that
Poussin's work was patronized and appreciated by members of the Robe
nobility and supporters of the Parlementaire side in the revolt against
the French Monarchy during the Fronde, and that the painter was not
a politically neutral exile in Rome. David Packwood, in a review of
Olson's book, feels that the case is not quite proven. See D. Packwood,
'Border Crossings: French Painting and the Public', *The Art Book*, vol.
10, issue 2 (March 2003), 18–21.

69. I. Richefort, *Peintre à Paris au XV11e Siècle* (Paris: Imago, 1998), 156.
Richefort notes, however, that after the death of owners and sitters, most
portraits tended to lose value (64). Presumably portraits of kings and
really famous individuals were different. A vast number of paintings
have probably disappeared, however. Mérot estimates that four or five
million paintings were executed in France during the seventeenth
century, of which about four per cent are extant. A. Mérot, *French
Painting in the Seventeenth Century* (New Haven and London: Yale
University Press, 1995), 19. We know that the artist Sophie Chéron
(1648–1711), whose self-portrait in the Louvre dates from 1672,
produced a large number of important portraits of other people, all of
which are lost. She was received as an academician in 1672 (supported
by Lebrun) and was the first French artist to have been honoured by
a monograph on her career. See *Visages du Grand Siècle; Le Portrait
français sous le règne de Louis XIV 1660–1715* (Musée des Beaux-Arts
Nantes and Musée des Augustins Toulouse, 1997), 16–17, 200. Most of
the material on French portraits concentrates on this later period and
the first part of the seventeenth century is less well covered. See, for
example, A. Schnapper, 'Le Portrait à l'académie au Temps de Louis
XIV', *XVIIe Siècle* (January–March 1983), no. 138, 97–123.

70. The work was a portrait of a man by Titian, see *Images du Grand
Siècle*, 42. For a good discussion of the academy and its theories in
the seventeenth century, see P. Duro, *The Academy and the Limits
of Painting in Seventeenth-Century France* (Cambridge: Cambridge
University Press, 1997).

71. The current information exhibited with the painting in the Musée du
Louvre says the portrait may be of Descartes, possibly posthumous,

or perhaps done during a short visit by Descartes to Paris in the later 1640s and gives the work to Sébastien Bourdon. However, the recent catalogue of Bourdon's work by Jacques Thuillier doubts the attribution to Bourdon, and also doubts whether the work represents Descartes. See *Sébastien Bourdon, 1616–1671: Catalogue critique et chronologique de l'oeuvre complet* (Paris: Réunion des Musées Nationaux, 2000), 489, cat. no. 150. Descartes died in Stockholm on 11 February 1650 and Bourdon arrived there in mid October 1652. The cataloguer is of the opinion that the work is a fine example of French portraiture from the period 1645–1650, but that is as much as he is willing to say given the present state of information about the work. I think it could well be by Bourdon for stylistic reasons.

72. P. Barlow, 'Facing the Past and Present: The National Portrait Gallery and the Search for "Authentic" Portraiture', in Woodall (ed.), *Portraiture*, 219–38.

73. Ibid. 229, fig. 76 caption.

74. Ibid. 228.

75. Mérot, *French Painting in the Seventeenth Century*, 16.

76. Formerly said to be a portrait of Robert Arnaud d'Andilly, this is now rejected. Bernard Dorival proposed an identification of Charles Coiffier, based on facial resemblance to an engraved portrait. See B. Dorival, *Philippe de Champaigne, 1602–1674: La Vie, l'oeuvre, et le catalogue raisonné de l'oeuvre*, 2 vols (Paris: Léonce Laget, 1976), vol. 2, cat. no. 161, 91. This has recently been rejected by L. Pericolo; see *Philippe de Champaigne* (Paris: La Renaissance du Livre, 2002), 191. Unfortunately, Dorival's work has a number of errors and care must be taken when using these volumes. See the detailed review by Anne Sutherland Harris, in *Art Bulletin* (June 1979), 319–22. An interesting, more thought-provoking approach to Champaigne's work than that of Dorival can be found in L. Marin, *Philippe de Champaigne ou la présence cachée* (Paris: Hazan, 1995).

77. It is tempting to relate this image to Descartes' second meditation, 'Of the nature of the Human Mind; and that it is Easier to know than the Body' (1641), where he discusses the certainty of the knowledge of the mind, compared to the changing and uncertain phenomena of the natural world, e.g. a piece of wax melted by a flame. 'If I chance to look out of a window on to men passing in the street, I do not fail to say, on seeing them, that I see men, just as I say that I see the wax; and yet, what do I see from this window, other than hats and cloaks, which can cover ghosts or dummies who move only by means of springs? But I judge them to be really men, and thus I understand, by the sole power of judgement which resides in my mind, what I believed I saw with my eyes.' (*Discourse on Method and the Meditations*, 110) However, I do not

think that this is a direct influence of Descartes' thought on Champaigne. J. Bernstein, in his essay 'Wax, Brick and Bread: Apotheosis of Matter and Meaning in Seventeenth-Century Philosophy and Painting', in D. Arnold and M. Iversen (eds), *Art and Thought* (Oxford: Blackwell, 2003), 28–50, opposes Descartes' 'distrust' of matter and the senses, to the realistic depiction of matter in Dutch painting.

78. C. Gottlieb in his book *The Window in Art: From the Window of God to the Vanity of Man* (New York: Abaris Books, 1981), discusses how the window originally had more of a religious symbolism (e.g. divine illumination as the light comes through the window) and gradually changed to convey other meanings, such as the window as symbolism of the senses. By the seventeenth century, the Christian meanings were gradually giving way to more secular connotations (274). The use of the window or parapet in portraiture originated in the north of Europe, according to Lorne Campbell, and then became popular in Italy, see Campbell, *Renaissance Portraits*, 69.

79. L.B. Alberti, *On Painting and On Sculpture* (London: Phaidon, 1972), Book 1, 55.

80. Duro, *The Academy*, p132. Champaigne actually had a well-stocked library with books on a variety of subjects, so it was certainly not the case that his art was anti-intellectual and based simply on copying. See Richefort, *Peintre à Paris au XVIIe Siècle*, 80–95 for levels of knowledge and libraries of painters in Paris in the seventeenth century.

81. See, for example, Titian's *The Man with the Blue Sleeve*, oil on canvas, 81.2 x 66.3 cm, National Gallery, London, dated around 1511–12? Illustrated in Campbell, *Renaissance Portraits*, 70, fig. 77. See also Pierre Mignard's portrait of *Man in a Fur Hat* (1654), National Gallery, Prague, where a young man holding gloves and resting his hand on a parapet in an outdoor setting looks reminiscent of Netherlandish Renaissance works, illustrated in Mérot, *French Painting in the Seventeenth Century*, 196.

82. Pommier, *Théories du Portrait*, 348. In her recent book, *The Modern Portrait in Nineteenth-Century France* (Cambridge: Cambridge University Press, 2001), H. McPherson states: 'The modern, secular, painted portrait, which appeared during the Renaissance, is commonly associated with humanism, the rise of individualism, and the development of biography and autobiography', adding that 'its basic premises remained remarkably constant until the nineteenth century' (4). I tend to agree that portraits did not change much. This relatively unchanging nature of portraiture should not be interpreted, however, as support for the 'Cartesian perspectivalism' thesis, since influential portrait types were developed before Descartes.

83. For the Jansenists and Port Royal, see Chapter 6 of D. Maland, *Culture and Society in Seventeenth-Century France* (London: Batsford, 1970);

for Pascal and Port Royal, see Ben Rogers, *Pascal* (London and New York: Routledge, 1997), and the introduction by A.J. Krailsheimer to Pascal's *Pensées* (Harmondsworth: Penguin, 1995). The asceticism of Port Royal and the rejection of sensual pleasure of any kind made the community reluctant even to have portraits of their founders, but exceptions were made if the individuals portrayed had contributed to the glory of God.

84. Pascal, *Pensées* (Harmondsworth: Penguin, 1995), 201–2.

85. Ibid. 217–8.

CHAPTER 2: SUBJECTS AND PICTURES

1. We cannot be entirely sure of this, for the painting is first referred to in an inventory of 1589, but it is very likely that Jean de Dinteville, who commissioned the painting, had it taken back from London to his home at the Château de Polisy in France in the autumn of 1533. See S. Foister, A. Roy and M. Wyld, *Holbein's Ambassadors: Making and Meaning* (London: The National Gallery and Yale University Press, 1997), 87.

2. Interview with the author.

3. I note here an important point. While I have taken care to motivate my selection of examples, these are clearly not the only ones which could make the points I argue for in this chapter. These are not particularly bizarre or unrepresentative images, though clearly they are unique in their own ways. Many other examples would have served a similar purpose, though I have chosen ones which I find most interesting and where there is adequate information available to make informed observations rather than mere speculations.

4. See the discussion in D. Aers, 'A Whisper in the Ear of Early Modernists; or, Reflections on Literary Critics Writing the "History of the Subject"', in D. Aers (ed.), *Culture and History, 1350–1600: Essays on English Communities, Identities and Writing* (New York: Harvester Wheatsheaf, 1992), 177–202.

5. Aers, 'A Whisper in the Ear of Early Modernists', 191. He is referring to Greenblatt's book, *Renaissance Self-Fashioning* (Chicago: Chicago University Press, 1980).

6. C. Belsey, *The Subject of Tragedy* (London: Methuen, 1985), 18.

7. Aers, 'A Whisper in the Ear of Early Modernists', 180.

8. Similarly, socialist/Marxist art history has tended to focus on later periods, for example the works of T.J. Clark on French nineteenth-century art, *Image of the People: Gustave Courbet and the 1848 Revolution* (London: Thames and Hudson, 1973) or *The Painting of Modern Life: Paris in the Art of Manet and his Followers* (London:

Thames and Hudson, 1985). Attempts to apply Marxist analysis to pre-modern periods (such as Meyer Schapiro's writings on mediaeval art) are less developed than Clark's. See Chapters 2 and 3 of Doy, *Materializing Art History* (Oxford and New York: Berg, 1998).

9. For example, by voting or participating in political demonstrations, though in the recent example in the UK of mass demonstrations against the war against Iraq, the limits of self-representation within the boundaries set by bourgeois democracy were apparent, as the British government dismissed the protests.

10. P. Burke, 'Representions of the Self from Petrarch to Descartes', in R. Porter (ed.), *Rewriting the Self: Histories from the Renaissance to the Present* (London and New York: Routledge), Chapter 1, 25–6.

11. Ibid. 28.

12. This and other information on the painting is taken from the well-researched book by S. Foister, A. Roy and M. Wyld, *Holbein's Ambassadors: Making and Meaning* (London: National Gallery and Yale University Press, 1997).

13. D. Hillman, 'The Inside Story', in C. Mazzio and D. Trevor (eds), *Historicism, Psychoanalysis and Early Modern Culture* (London and New York: Routledge, 2000), 299.

14. Ibid. 300.

15. Ibid.

16. Allan Stewart, *Close Readers: Humanism and Sodomy in Early Modern England* (Princeton: Princeton University Press, 1997), referred to by Hillman, 309.

17. For the portraits by Holbein representing Erasmus and Pieter Gillis in their respective studies, sent to their friend Sir Thomas More in 1517, see figs 178 and 179, in L. Campbell, *Renaissance Portraits: European Portrait-Painting in the 14th, 15th and 16th Centuries* (New Haven and London: Yale University Press, 1990), 165.

18. Foister et al., *Holbein's Ambassadors*, 14–16, 42.

19. Foister et al. mention other double portraits of men, but stress that this is especially unusual for Northern Europe (18). For an example of a double male portrait specifically referring to male friendship, see Pontormo's *Portrait of Two Friends*, c.1522, oil on wood, Cini Collection, Venice. The two men are shown in three-quarter length and one holds a copy of an essay by Cicero on friendship. Illustrated as plate X6 in S. S. Nigro, *Pontormo: Paintings and Frescoes* (New York: Abrams, 1994). See also Raphael's so-called *Raphael and his fencing master*, Louvre, Paris, illustrated as fig. 116 in Campbell, *Renaissance Portraits*, 100, and believed to date from about 1519.

20. P. Simons, in her essay 'Homosociality and erotics in Italian Renaissance portraiture', in J. Woodall (ed.), *Portraiture: Facing the Subject*

(Manchester and New York: Manchester University Press, 1997), 29–51, argues that homosociality, i.e. the 'bonding between men through social and emotive ties' (29) did not always overlap with homoeroticism, especially in courtly settings which allowed 'a refined elegance and homosocial bodily contact between men that was not automatically coded as abnormal or sinful' (32).

21. Ibid. 14, 87.

22. Details can be found in E.A.R. Brown, 'Sodomy, Treason, Exile and Intrigue: Four Documents Concerning the Dinteville Affair (1537–8)', in *Sociétés et Idéologies des Temps modernes. Hommage à Arlette Jouanna* (Montpellier, 1996), 512–32.

23. J.M. Saslow, 'Homosexuality in the Renaissance: Behaviour, Identity and Artistic Expression', in M.B. Duberman, M. Vicinus and G. Chauncey Jr. (eds), *Hidden from History: Reclaiming the Gay and Lesbian Past* (Harmondsworth: Penguin, 1989), 90–105, 96.

24. Ibid. 94.

25. McRobbie, 'Feminism, Postmodernism and the "Real Me"', in M.G. Durham and D.M. Kellner (eds), *Media and Cultural Studies: Key Works* (Oxford: Blackwell, 2001), 607.

26. Simons, 'Homosociality and erotics in Italian Renaissance portraiture', 29, 47. We should take care, however, that notions of 'homosociality' do not result in the disappearance of homosexuality from history altogether. John d'Emilio, revising a talk he first gave in 1979 and 1980, discusses how many in the Lesbian and Gay Liberation movements of the 1970s sought to reclaim a Lesbian and Gay History from earlier times, arguing that sexualities other than heterosexual had always existed. D'Emilio now believes that, in a different political context, this 'myth' has trapped the Gay and Lesbian community into particular forms of struggle. Now the building of 'an affectional community' is as important as campaigns for civil rights. Developed capitalism with its commodification of labour power, urbanisation and the (partial) destruction of the family unit helped create a context where Lesbians and Gays could meet, self-fashion identities and lifestyles, and organise politically from the later nineteenth-century onwards. Developments within capitalism have also led to the separation of sexuality from procreation, as medical and technological advances are marketed on a mass scale. J. d'Emilio, 'Capitalism and Gay Identity', in D. Morton (ed.), *The Material Queer: A LesBiGay Cultural Studies Reader* (Boulder, Colorado and Oxford: Westview Press, 1996), 263–71.

27. M. Roskill and J.O. Hands (eds), *Hans Holbein. Paintings, Prints and Reception* (Washington: National Gallery of Art; New Haven and London: Yale University Press, 2001), 238, mentioning Ruskin, 1876, and Curt Seckel, 1951.

28. See A. Callinicos, 'The Aporias of Poststructuralism', in Callinicos, *Against Postmodernism: A Marxist Critique* (Cambridge: Polity Press, 1989); and Caroline Williams, *Contemporary French Philosophy: Modernity and the Persistence of the Subject* (London and New York: Athlone Press, 2001), Chapters 3 and 4.

29. J. Lacan, *The Four Fundamental Concepts of Psychoanalysis* (Harmondsworth: Penguin, 1994), 86.

30. For Lacan, the Other refers to the symbolic order of language and speech into which people are born and become subjectified. The other (small o) refers to the specular other, the image through which the child relates to her/himself as if to an objectified other. Or this can mean other people to whom the child relates, and thus the ego is structured through inter-action or even agreement and recognition. See the entry 'Other/other' by M.-C. Boons-Grafé in E. Wright (ed.), *Feminism and Psychoanalysis: A Critical Dictionary* (Oxford: Blackwell, 1992), 296–9.

31. Ibid. 106.

32. Ibid. 100–1.

33. Ibid. 101, 109.

34. See diagram and comments in Lacan, 106.

35. Ibid. 82–3.

36. Ibid. 88–9.

37. Ibid. 88.

38. There is now a considerable body of literature on Claude Cahun, since her rediscovery in the last fifteen years or so. See especially the section on Cahun, her photographic work and politics in the chapter 'How is the Personal Political?', in Doy, *Materializing Art History* (Oxford: Berg, 1998), 105–37. Also useful are *Claude Cahun Photographe*, exhibition catalogue (Paris: Musée d'Art Moderne de la Ville de Paris, Paris Musées/ JeanMichel Place, 1995); and F. Leperlier, *Claude Cahun: L'Ecart et la Métamorphose* (Paris: JeanMichel Place, 1992).

39. See, for example, R. Krauss, *Cindy Sherman: 1975–1993* (New York; Rizzoli, 1993); and Laura Mulvey, 'A Phantasmagoria of the Female Body: The Work of Cindy Sherman', *New Left Review*, no. 188 (July/ August 1991), 136–50; and, more recently, the chapter on 'Abstract Machines of Facility: The Dramaturgical Identities of Cindy Sherman' by Robert A. Sobieszek, in *Ghost in the Shell: Photography and the Human Soul, 1850–2000, Essays on Camera Portraiture* (Los Angeles: MIT Press and Los Angeles Country Museum of Art, 1999), 170–229. Of course, in actual practice, Cindy Sherman is the author and copyright owner of her work, despite these theoretical subtleties. Sherman, the author/agent who makes the work, is quoted in a discussion of her work by F.A. Mighetti, *Identita Mutanti dalla piega alla piaga: esseri delle contaminazioni contemporanei* (Genoa, 1997), 44–8, as saying: 'to

escape from one's own identity means to work things in such a way that the distinction between *I* and the *others* can be modified by myself... I don't do self-portraits. I try to keep me away from myself when I'm taking my pictures.' Thanks to Laura Saraceni for this reference.

40. See, for example, Katy Kline, 'In or Out of the Picture: Claude Cahun and Cindy Sherman', in W. Chadwick (ed.), *Mirror Images: Women, Surrealism, and Self-Representation* (Cambridge, Mass. and London: MIT Press, 1998), 66–81; and S. Rice (ed.), *Inverted Odysseys: Claude Cahun, Maya Deren, Cindy Sherman* (Cambridge, Massachusetts and London: MIT Press, 1999).

41. A. Solomon-Godeau, 'The equivocal "I": Claude Cahun as Lesbian Subject', in S. Rice (ed.), *Inverted Odysseys*, 110–25, 114. For my situation of Cahun's work in the context of radical culture and politics in 1930s France, see Chapter Four of *Materializing Art History*, referred to above. Solomon-Godeau goes on to discuss questions of lesbian identity and self-representation in Cahun's photographs drawing on the views of Judith Butler, especially from her book *Bodies that Matter: On the Discursive Limits of Sex* (London and New York: Routledge, 1993), and an earlier article, 'Imitation and Gender Insubordination' in D. Fuss (ed.), *Inside/Out: Lesbian Theories, Gay Theories* (London and New York: Routledge, 1991), where Butler argues that there is no 'I' which precedes and performs gender (either masculine or feminine) and that '*gender is a kind of imitation for which there is no original*', italics in original, quoted by Solomon-Godeau, 122. However Solomon-Godeau warns against turning Cahun into a postmodernist (or even a post-feminist?) *avant la lettre.*

42. See catalogue nos 45–47, in *Claude Cahun Photographe*, 141.

43. E. Cowie, *Representing the Woman: Cinema and Psychoanalysis* (Basingstoke: Macmillan, 1997), 90. Cowie's book is an excellent text on psychoanalytic theory, subjectivity, gender and imagery, which I highly recommend. The mirror-phase is also discussed in David Macey's introduction to Lacan, *Four Fundamental Concepts of Psycho-Analysis*, xvii-xix, and Lacan's essay 'The Mirror Stage as Formative of the Function of the I as revealed in the Psychoanalytic Experience' is reprinted in Lacan, *Ecrits: A Selection* (London: Tavistock, 1997), 1–7.

44. S. Freud, *On Metapsychology: The Theory of Psychoanalysis* (Harmondsworth: Penguin, 1991), 81.

45. E. Grosz, *Jacques Lacan: A Feminist Introduction* (London: Routledge, 1990), 31. See also the entry on 'Narcissism' by E. Ragland-Sullivan in E. Wright (ed.), *Feminism and Psychoanalysis: A Critical Dictionary* (Oxford: Blackwell, 1996), 271–4; and Jeremy Holmes, *Narcissism*, in the useful series 'Ideas in Psychoanalysis' (Cambridge: Icon Books/Totem Books, 2001.

46. See my *Materializing Art History*, 120.

47. S.R. Munt, 'The Personal, Experience and the Self', in A. Medhurst and S.R. Munt (eds), *Lesbian and Gay Studies: A Critical Introduction* (London: Cassell, 1997), 186–97.

48. Ibid. 191.

49. V. Slater, 'Negotiating Genres', in P. Horne and R. Lewis (eds), *Outlooks: Lesbian and Gay Sexualities and Visual Cultures* (London and New York: Routledge, 1996), 126–31, 127.

50. Some painters were sons of glassblowers, and even made and sold mirrors themselves. The Spanish painter Velasquez's inventory listed more than ten mirrors in his possession when he died. S. Melchior-Bonnet, *The Mirror: A History* (London: Routledge, 2002), 28–9, 168; and M. Pendergrast, *Mirror Mirror: A History of the Human Love Affair with Reflection* (New York: Basic Books, 2003).

51. R. Gregory, *Mirrors in Mind* (Oxford, New York, Heidelberg: W.H. Freeman/Spektrum, 1997), 174.

52. On real and virtual images, see ibid. 79, 237–8.

53. Ibid. 174.

54. L. Rideal with W. Chadwick and F. Borzello, *Mirror Mirror: Self-Portraits by Women Artists* (London: National Portrait Gallery, 2001). See also the catalogue *In the Looking Glass: An Exhibition of Contemporary Self-Portraits by Women Artists* (Lincoln: Usher Gallery, 1996), curated by Janita Elton, and the chapter entitled 'Beyond the Mirror: Women's Self Portraits' by Felicity Edholm in F. Bonner, L. Goodman et al. (eds), *Imagining Women* (Polity Press/Open University, 1992), 154–72.

55. See the well-known argument in Berger et al., *Ways of Seeing* (Harmondsworth: BBC and Penguin books, 1976; first published 1972), Chapter 3, especially 50–1.

56. Quoted by W. Chadwick, 'How do I look?', in *Mirror Mirror*, 8–21, 9.

57. Ibid. 12.

58. M. Meskimmon, *The Art of Reflexion: Women Artists' Self-Portraiture in the Twentieth Century* (Scarlet Press, 1996), 196–9, for a discussion of Helen Chadwick's *Vanity 2* (1986); and *Mirror Mirror*, 100–1. Chadwick's circular photograph shows her as Vanitas looking at a mirror which reflects the artist's installation *On Mutability* at the ICA, London.

59. S. Hall (ed.), *Representation: Cultural Representations and Signifying Practices* (London: Sage/Open University, 1997), 55–6.

60. Hartsock, 'Foucault on Power: A Theory for Women?', in L. Nicholson (ed.), *Feminism/Postmodernism*, (New York and London: Routledge, 1989), 157–75, 163–4, cited in T. Ebert, *Ludic Feminism and After: Postmodernism, Desire and Labor in Late Capitalism* (Ann Arbor: University of Michigan Press, 1996), 251–2.

61. A. de Souza and S. Merali (eds), *Crossing Black Waters*, exhibition catalogue (Leicester: City Gallery and London: Panchayat, 1992), 7.

62. Recent developments have seen a move away from the more extreme interpretations of theories of authorial death; see S. Burke, *The Death and Return of the Author: Criticism and Subjectivity in Barthes, Foucault and Derrida*, 2nd edition (Edinburgh: Edinburgh University Press, 1998).

63. Doy, *Black Visual Culture: Modernity and Postmodernity* (London: I.B.Tauris, 2000).

64. I discuss these issues with reference to both Eugene Palmer's work and that of Barbara Walker in my article, 'The Subject of painting: Works by Barbara Walker and Eugene Palmer', *Visual Communication*, vol. 1, no. 1 (February 2002), 41–58.

65. See the comments by Isaac Julien and Kobena Mercer in 'De Margin and De Centre', in D. Morley and K.-H. Chen (eds), *Stuart Hall: Critical Dialogues in Cultural Studies* (London and New York: Routledge, 1996), 450–64.

66. Unless otherwise stated, all information on Palmer's views is from interviews with the author. I am very grateful to Eugene Palmer for his help and friendly hospitality. I should point out that the wider interpretations of the artist's work are my own, and may not necessarily coincide with all of the artist's aims.

67. This is discussed in my article 'The Subject of Painting', where it is reproduced in black and white. A colour reproduction is on page 31 of the exhibition catalogue, *Transforming the Crown: African, Asian and Caribbean Artists in Britain, 1966–1996* (New York: The Franklin H. Williams Caribbean Cultural Center/African Diaspora Institute, 1998).

68. Interview with the author in the artist's studio.

69. H. Foster, 'The Expressive Fallacy', in *Recodings: Art, Spectacle, Cultural Politics* (Washington: Bay Press, 1985), 59–78, 73.

70. Ibid. 62.

71. See Atkinson's article 'Phantoms of the Studio', in *Oxford Art Journal*, vol. 13, no. 1 (1990), 49–61.

72. D. Green, 'Refiguring Identity, Retouching History, Revisioning Art', in *Circumstantial Evidence: Terry Atkinson, Willie Doherty, John Goto*, exhibition catalogue (Brighton: University of Brighton, 1996), 5–23, 9; Atkinson's works are illustrated in this catalogue on 28 and 29.

73. For Walter Benjamin's discussion of the artwork and its 'aura', see his previously cited essay 'The Work of Art in the Age of Mechanical Reproduction', in F. Frascina and C. Harrison (eds), *Modern Art and Modernism: A Critical Anthology* (London: Harper and Row, 1982), 217–20. Benjamin's essay dates from 1936.

74. *Foil*, exhibition catalogue (London: Gallery Westland Place, 2000), with essays by Michael Phillipson and Jim Mooney.

75. On Palmer and painting, see the essay by Eddie Chambers, *Eugene Palmer: Recent Paintings* (Nottingham: The Bonnington Gallery, Nottingham Trent University, April–May 1999), 2–3.

76. See the essentials of this argument in L. Althusser, 'Ideology interpellates individuals as Subjects', in P. du Gay, J. Evans and P. Redman (eds), *Identity: A Reader* (London: Sage, 2000), 31–8. In contrast to this view, Marx and Engels had argued that ideology functions in societies based on private property and exploitation, and therefore ideology is not universal and timeless.

77. Ibid. 33.

78. See Judith Williamson, *Decoding Advertisements: Ideology and Meaning in Advertising* (London: Marion Boyars, 1978). I will return to the concept of interpellation later in this book in a discussion of consumption and subjectivity.

79. Interview with the author, 2001.

80. See, for example, the contributions by Stuart Hall and Homi K. Bhabha to the symposium at the Institute of Contemporary Art, in A. Read (ed.), *The Fact of Blackness: Frantz Fanon and Visual Representation* (London and Seattle: ICA/Bay Press, 1996).

81. Fanon, *Black Skin, White Masks* (London: Pluto Press, 1993; originally published 1952), 109.

82. Ibid. 231.

83. Interview with Jagjit Chuhan in *In the Looking Glass: An exhibition of Contemporary Self-Portraits by Women Artists* (Lincoln: Usher Gallery, 1996), 72. It is also worth considering the dual subjectivity/ split subjectivity which women experience during pregnancy, which is never experienced in the same way by men, and the implications of this for the notion of autonomous, unitary subjectivity. Clearly there are a number of issues raised by this, among those being the question of the equality of subjectivities of mother and foetus, which is often discussed in debates over abortion and women's rights to terminate unwanted pregnancies. On subjectivity and pregnancy, see Iris Marion Young, 'Pregnant Embodiment: Subjectivity and Alienation', *The Journal of Medicine and Philosophy*, no. 9 (1984), 45–62.

84. For a discussion of the self/other master/slave model and the legacy of slavery, see M. Bull, 'Slavery and the Multiple Self', *New Left Review* (September/October 1998), no. 231, 94–131.

85. S. Boyce and M. Diawara, 'The Art of Identity: A Conversation', in H.A. Baker Jr., M. Diawara and R.H. Lindeborg (eds), *Black British Cultural Studies: A Reader* (Chicago: Chicago University Press, 1996), 306–13, 308–9.

CHAPTER 3: BODIES AND SELVES

1. I freely confess that I have not read all of them. However, from my research I think that among the best are I. Burkitt, *Social Selves: Theories of the Social Formation of Personality* (London: Sage, 1991); see also Burkitt's article, 'The Shifting Concept of the Self', in *History of the Human Sciences*, vol. 7, no. 2 (1994), 7–28; and A. Elliott, *Social Theory and Psychoanalysis in Transition: Self and Society from Freud to Kristeva*, second edition (London and New York: Free Association Books, 1999). This last is an excellent critical account of key twentieth-century theorists of the self, which locates and analyses the weaknesses of postmodern theories, while also criticising the ideological premises of the notion of the unitary subject. Also thought provoking is the chapter on 'Subjects' in Terry Eagleton, *The Illusions of Postmodernism* (Oxford: Blackwell, 1996). Other left/Marxist approaches to the topic of subjectivity can be found in the excellent T. Ebert, *Ludic Feminism and After: Postmodernism, Desire, and Labor in Late Capitalism* (Ann Arbor: University of Michigan Press, 1996); and G. Dawes, 'A Marxist Critique of Post-Structuralist Notions of the Subject', in M. Zavarzadeh (ed.), *Post-ality: Marxism and Postmodernism, Transformation 1* (Washington, DC: Maisonneuve Press, 1995), 150–88. In addition to the books on subjectivity already mentioned in previous chapters, see, on feminist theory and the self, M. Griffiths, *Feminisms and the Self: The Web of Identity* (London and New York: Routledge, 1995); M.A. Mahoney and B. Yngvesson, 'The Construction of Subjectivity and the Paradox of Resistance: Reintegrating Feminist Anthropology and Psychology', in R.-E.B. Joeres, B. Laslett (eds), *The Second Signs Reader, Feminist Scholarship, 1983–1996* (Chicago and London: University of Chicago Press, 1996), 245–74. Other general works on subjectivity and the self are D. Bakhurst and C. Sypnowich (eds), *The Social Self* (London: Sage, 1995), which has a useful chapter by D. Coole, 'The Gendered Self', 123–39; R. Stevens (ed.), *Understanding the Self* (London: Sage/Open University, 1996); F. Geyer, *Alienation, Ethnicity and Postmodernism* (Westport, Connecticut, London: Greenwood Press, 1996), a useful book which argues for a materialist reconceptualization of the self, rather than a development of more theories of subjectivity – thanks to Andrew Kennedy for pointing this book out to me; A. Giddens, *Modernity and Self-Identity: Self and Society in the late Modern Age* (Cambridge: Polity Press, 1991); E. Cadava, P. Connor, J.-L. Nancy (eds), *Who Comes After the Subject?* (London and New York: Routledge, 1991); M. Brewster Smith, 'Selfhood at Risk: Postmodern Perils and the Perils of Postmodernism', *American Psychologist* (May 1994), 405–11. An idiosyncratic defence of aspects of the Cartesian subject can be found in

S. Zizek, *The Ticklish Subject: The Absent Centre of Political Ontology* (London and New York: Verso, 1999), though, despite its title, this is not a very political book. Older works still relevant are J. Henriques et al. (eds), *Changing the Subject: Psychology, Social Regulation and Subjectivity* (London: Methuen, 1984); John M. Broughton, 'The Psychology, History and Ideology of the Self', in K.S. Larsen (ed.), *Dialectics and Ideology in Psychology* (New Jersey: Amblex, 1986), 128–64; E. Guibert-Sledziewski and J.-L. Vieillard-Baron (eds), *Penser le Sujet aujourd'hui* (Paris: Meridiens Klincksieck, 1988); P. Smith, *Discerning the Subject* (Minneapolis: University of Minnesota Press, 1988); C. Taylor, *Sources of the Self: The Making of the Modern Identity* (Cambridge: Cambridge University Press, 1989). 'Uncovering the Self' is a special issue of *The Philosophers' Magazine*, issue 12 (Autumn 2000).

2. N. Mansfield, *Subjectivity: Theories of the Self from Freud to Haraway* (London: Allen and Unwin, 2000), 178.

3. For example, the exhibitions *Zelfbeschikking/Self-Determination*, Museum voor Moderne Kunst, Arnhem, 1995 (my grateful thanks to Joke Louwrink for a copy of this catalogue); and *'Insertion': Self and Other*, curated by Salah Hassan for Apexart, New York, 2000. The temporary exhibition *The Museum of Me*, at the Bargehouse, London in 1999 was a more light-hearted approach to the issue of subjectivity and identity; see review by Brian Durrans, 'Making an Exhibition of Yourself', in *Museums Journal*, vol. 99. no. 7 (July 1999), 17.

4. For example, a collection of essays dedicated to the contribution of Professor Linda Nochlin to the discipline of art history was marketed under the title *Self and History: A Tribute to Linda Nochlin*, edited by A. D'Souza (London: Thames and Hudson, 2001). A recent book by sociologist Roy Boyne, *Subject, Society and Culture* (London: Sage, 2001), includes a section on the self and the visual arts, focusing on Barnet Newman, Francis Bacon and Georg Baselitz. The recently published *Tactics of the Ego* (Manchester: Kerber Verlag/Cornerhouse Publications, 2003), 'demonstrates how contemporary artists respond to psychological, social, emotional and politically motivated transformations of the "ego".' (Quote from blurb on book.) Earlier publications of interest include the papers of talks given at the ICA, *ICA Documents 6: The Real Me: Postmodernism and the Question of Identity* (London: Institute of Contemporary Arts, 1987); and M. Yaari, 'What is the subject? Representations of self in late twentieth-century French art', *Word and Image*, vol. 16, no. 4 (October–December 2000), 363–77.

5. Boyne, *Subject, Society and Culture*, 167.

6. M. Sladen, 'The Body in Question', *Art Monthly*, no. 191 (November 1995), 3–5, 5.

7. R.A. Dermer, 'Joel-Peter Witkin and Dr Stanley B. Burns: A Language of Body Parts', *History of Photography*, vol. 23, no. 3 (Autumn 1999), 245–53, 247.

8. Martin Kemp and Marina Wallace, *Spectacular Bodies: The Art and Science of the Human Body from Leonardo to Now*, Hayward Gallery catalogue (Berkeley, Los Angeles, London: University of California Press, 2000).

9. Adrian Searle, 'From the Cradle to the Grave', *The Guardian*, 21 October 2000, 'Saturday Review', 5.

10. John Ezard, 'Alarm at modern art's atrocity exhibition', *The Guardian*, 17 January 2001, 5, discussing a talk by Tessa Adams of Goldsmith's College, London, given to an audience of artists, market researchers, arts bureaucrats and business people.

11. *Make: The Magazine of Women's Art*, no. 74 (February/March 1997), 6.

12. See, for example, S. Lalvani, *Photography, Vision, and the Production of Modern Bodies* (New York: State University of New York, 1996), which is informed throughout by Foucault's theories of the body.

13. See J. Kristeva, *Powers of Horror: An Essay on Abjection* (New York: Columbia University Press, 1982), quoted in N. Mansfield, *Subjectivity: Theories of the Self from Freud to Haraway* (London: Allen and Unwin, 2000), 89. See also K. Oliver, 'The Flesh Become Word: The Body in Kristeva's Theory', in D. Welton (ed.), *The Body: Classic and Contemporary Readings* (Oxford: Blackwell, 1999), 341–52. Rosemary Betterton's book *An Intimate Distance: Women Artists and the Body* (London and New York: Routledge, 1996), has a very useful discussion of how Kristeva's theories can be related to the visceral qualities of some contemporary works by women artists; see Chapter 6, 'Body Horror? Food (and sex and death) in women's art'.

14. Eagleton, *The Illusions of Postmodernism*, 69, 71.

15. B.H.D. Buchloh, 'Residual Resemblance: Three Notes on the ends of Portraiture', in M.E. Feldman, *Face-Off: The Portrait in Recent Art* (Philadelphia: Institute of Contemporary Art, University of Pennsylvania, 1994–1995), 53–69, 54–5.

16. See Helen Carter, 'Body Parts thief displays his art', *The Guardian*, 14 February 2000.

17. See the Channel 4 UK television programme on Von Hagens, 'The Anatomists', 26 March 2002.

18. N. Scheper-Hughes, 'The New Cannibalism', *New Internationalist* (April 1998), 14–17.

19. See 'Art Show in Siberian Corpse Inquiry', *The Guardian*, 12 April 2001; and 'Pathologist charged in Plastination case', *The Guardian*, 17 October 2002.

20. S. Jeffries, 'The Naked and the Dead', *The Guardian*, 19 March 2002, 'G2', 2–3.

21. A. Smith, in *The Guardian*, 24 October 2002, G2, 15.

22. D. Anzieu, *The Skin Ego: A Psychoanalytic Approach to the Self* (New Haven and London: Yale University Press, 1989). Recent articles on tattoos do not utilise Anzieu's ideas so much as those of Foucault, Derrida, Freud and Irigaray. The same theorists seem to crop up no matter what the topic of enquiry is. See, for example, M. Hardin, 'Mar(k)ing the Objected Body: A Reading of Contemporary Female Tattooing', *Fashion Theory*, vol. 3, issue 1 (1999), 81–108; and K. MacKendrick, 'Technoflesh, or "Didn't that Hurt?"', *Fashion Theory*, vol. 2, issue 1 (1998), 3–24. A writer on skin and its meanings, who does utilise a wider range of sources, including Anzieu's work, is Steven Connor; see S. Connor, *Skin: An Historical Poetics* (London: Reaktion Books, 2003) and his website at http://www.bbk.ac.uk/eh/skc.

23. See the useful discussion of this in relation to women and clothing in Francette Pacteau, *The Sympton of Beauty* (London: Reaktion Books, 1994), 152–3.

24. See S. Ahmed and J. Stacey, 'Introduction: Dermographies', in S. Ahmed and J. Stacey (eds), *Thinking Through the Skin* (London and New York: Routledge, 2001), 7.

25. Anzieu, *The Skin Ego*, 63, quoted in Ahmed and Stacey, 'Introduction: Dermographies', 82, note 4.

26. Ahmed and Stacey, 'Introduction: Dermographies', 9.

27. The artist Shani Rhys James makes some interesting comments on her painted self-portraits, comparing the paint surface to skin and speaking of her desire to get under this to an interior self: 'Unconsciously and intuitively I started to use the paint as a substitute for skin', and 'to get beyond the stage of external appearance and to get behind the skin of the figure.' See *In the Looking Glass: An Exhibition of Contemporary Self-Portraits by Women Artists* (Lincoln: Usher Gallery, 1996), 63–4. In *An Intimate Distance*, Betterton discusses works by Eve Muske and Laura Godfrey-Isaacs, for example, the latter's painting *Pink Skin* (1992) where the pinkness and malleability of the paint surface mimic the 'signs of the female body within the symbolic order' of a patriarchal society (96) and suggest the revulsion occasioned by encounters with the abject, which Kristeva likens in one passage of her writings to the sensation experienced when the lips touch the skin on the surface of milk (144).

28. S. Benson, 'Inscriptions of the Self: Reflections on Tattooing and Piercing in Contemporary Euro-America', in J. Caplan (ed.), *Written on the Body: The Tattoo in European and American History* (London: Reaktion Books, 2000), 234–54, 237.

29. Ibid. 244.

30. Ibid. 245.

31. Ibid.

32. Ibid. 252.

33. J. Jones, 'Take the ego out of art', *The Guardian*, 26 August 2002.

34. M. Glover, 'Review of Tracey Emin exhibition', *The Independent*, 15 May 2001.

35. Emin is one of the artists discussed in J.A. Walker, *Art and Celebrity* (London: Pluto Press, 2003), see especially 248–56.

36. Linda S. Klinger, 'Where's the Artist? Feminist Practice and Poststructural Theories of Authorship', *Art Journal* (Summer 1991), 39–47, 46.

37. See the frustrated address to Emin by Adrian Searle at the time of the 1999 Turner Prize exhibition: 'This tortured nonsense can't go on. It isn't my job to criticise you as a person, but to comment on the art you make. But you leave no space for that.' A. Searle, 'Tracey's pants but McQueen's the real pyjamas', *The Guardian*, 20 October 1999. Compare Michael Corris's comments in 'Tracey Emin', *Artforum* (February 1995), 84: 'Given long-standing cultural prejudices, it is easy to fail to draw the necessary distinction between "self-expression" and using one's "self" as a source of expression.'

38. *On the Ropes*, BBC Radio 4, 24 July 2001.

39. See Aurora Gunn's film on Emin for London Weekend Television, broadcast on *The South Bank Show*, 19 August 2001.

40. See her voiceover on the video *Why I never became a dancer* (1995) and her comments on the *South Bank Show* programme.

41. S. Morgan, 'The Story of I', *Frieze*, no. 34 (May 1997); and A. Searle, 'Me, me, me, me, me', *The Guardian*, 22 April 1997.

42. Interview by Jean Wainwright with Tracey Emin in M. Merck and C. Townsend (eds), *The Art of Tracey Emin* (London: Thames and Hudson, 2002), 195–209, 198. The installation piece was entitled *Exorcism of the Last Painting I ever Made* (also known as *The Swedish Room*).

43. For this, see the frontispiece in Merck and Townsend (eds), *The Art of Tracey Emin*, and Emin's quote is from the essay in the same volume by Deborah Cherry, 'On the Move: *My Bed*, 1998 to 1999', 134–54, 146.

44. J. Jopling, *Tracey Emin*, texts by Neal Brown, Sarah Kent and Matthew Collings (Jay Jopling, 1998), 34.

45. Interview with Jean Wainwright, in Merck and Townsend (eds), *The Art of Tracey Emin*, 205. Emin is discussing why she didn't actually 'do a poo' and bury it on the beach, though she thought it was a good idea.

46. Jopling is an old boy of Eton College, and son of Margaret Thatcher's first Chief Whip, Michael Jopling, now a life peer and gentleman farmer. Emin admires her dealer, despite her oft-expressed scorn for Thatcher's politics. See Tim Adams, 'The Observer Profile: The Master of Arts',

The Observer, 24 October 1999, text obtained from *Guardian Unlimited*, http://www.guardian.co.uk/turner/story.

47. J. Beckett, 'History (Maybe)', in *History: The Mag Collection – Image-Based Art in Britain in the late Twentieth Century* (Kingston upon Hull City Museums, Art Galleries and Archives, 1997), 133–41, 136, where Beckett also mentions Jay Jopling as a dealer who approves of the visual arts working hand in hand with media, film and rock music. See Rosemary Betterton, 'Why is my art not as good as me? Femininity, Feminism and "Life-Drawing" in Tracey Emin's Art', in Merck and Townsend (eds), *The Art of Tracey Emin*, 23–38, where she quotes Beckett on page 37.

48. Val Richards, 'Introduction', in V. Richards with G. Wilce (eds), *The Person Who Is Me: Contemporary Perspectives on the True and False Self* (London: Karnac Books, 1996), 2.

49. Winnicott, 'Transitional Objects and Transitional Phenomena' (1951), in *Through Paediatrics to Psychoanalysis* (London: Hogarth Press, 1975), 233, quoted by K. Cameron, 'Winnicott and Lacan: Selfhood versus Subjecthood', in Richards and Wilce (eds), *The Person Who Is Me*, 37–45, 42.

50. See Lynn Barber, 'Show and Tell', *Observer Magazine*, 22 April 2001, 8–12, 12.

51. Emin in the interview for *The South Bank Show*.

52. S. Matthews and L. Wexler, *Pregnant Pictures* (London and New York: Routledge, 2000), xi.

53. Ibid. 13, from the chapter on subjectivity and the pregnant woman.

54. I.M. Yopung, *Throwing like a Girl and other Essays in Feminist Philosophy and Social Theory* (Bloomington and Indianapolis: Indiana University Press, 1990), 160, from the chapter 'Pregnant Embodiment: Subjectivity and Alienation'.

55. See the extracts from Maurice Merleau-Ponty's works in D. Welton (ed.), *The Body* (Oxford: Blackwell, 1999), 150–77; and the extensive discussion of the body (especially Part One: The Body) in M. Merleau-Ponty, *Phenomenology of Perception*, translated by Colin Smith (London: Routledge and New Jersey: The Humanities Press, 1994; first published in French, 1962).

56. 'Show and Tell', *Observer Magazine*, 22 April 2001, 12.

57. Richard Cork, 'Tracey Thinks Twice', *Art Review* (November 2002), 58–61, 61. See also Merck and Townsend (eds), *The Art of Tracey Emin*, 200–1 on her spelling and how correcting it 'throws the whole sentence out of balance' once it has been arranged on the blanket. Also crossing things out is 'visually satisfying'. Lacan's famous 'crossing out' sign (the word woman with a line drawn through it = not the woman) was seen as semiotically and intellectually interesting, so why should we

not view Emin's crossings out as something more than a messy use of language?

58.　In an unpublished paper, 'Only over her living body – On the work of Tracey Emin', Kerstin Mey discusses Emin's use of 'I' in her work and public pronouncements, remarking 'The "I" offers – more or less convincingly – a whole repertoire of public and private shades and variations of the self.' Many thanks to Kerstin Mey for allowing me to read her paper, which enabled me to think in new ways about Emin's writing.

59.　See the section headed 'Masculinity' in Tracey Emin, *This is another place* (Oxford: Modern Art Oxford, 2002), no pagination.

60.　See the excellent entry by E. Guild on 'écriture féminine' in E. Wright (ed.), *Feminism and Psychoanalysis: A Critical Dictionary* (Oxford: Blackwell, 1992), 74–6, 75.

61.　H. Cixous, 'The Laugh of the Medusa', in E. Marks and I. de Courtivron (eds), *New French Feminisms: An Anthology* (New York: Schocken Books, 1981), 245–64, 246.

62.　Merck and Townsend (eds), *The Art of Tracey Emin*, 200.

63.　For examples, see K. MacKendrick, 'Technoflesh, or "Didn't that Hurt?"', *Fashion Theory*, vol. 2, issue 1 (1998), 12, fig. 3, 15, fig. 9.

64.　Searle, 'Ouch! Tracey Emin's new show is full of angst and trauma. But there's much more to art than pain', *The Guardian*, 12 November 2002, G2, 12–13, 12. In an earlier review of the artist's work he had berated her ('I wish you'd learn how to spell – or is it more authentic to get things wrong?'), in *The Guardian*, 20 October 1999, G2, 12, on the Turner Prize exhibits.

65.　H. Cixous, 'The Laugh of the Medusa', 250.

66.　Although Emin says she does not mind this, the difference is significant between well-known artists at the same stages of their careers. *My Bed* was bought by Charles Saatchi for £150,000, while the same collector paid £1,000,000 for Hirst's *Hymn* and £500,000 for the Chapman Brothers' *Hell*. See Rose Aidin, 'Visual Art: The Business of being Tracey Emin. Does she embroider her own blankets? What is the price of her work?', *The Independent*, 22 April 2001. Text from Proquest.

67.　From Marc Quinn interview with Sarah Whitfield in *Marc Quinn* (Liverpool: Tate Liverpool, 2002), purple page section, no pagination.

68.　Illustrated in ibid. and now in the Prada collection.

69.　The work is illustrated and discussed in D. Leader, 'Sculpture between the Living and the Dead', in *Marc Quinn* (Milan: Fondazione Prada, 2000), 14–15.

70.　Interview with Germano Celant, ibid. 59.

71.　The blood heads require fairly expensive and elaborate technology, as Quinn's dealer, Jay Jopling, has pointed out. 'The Blood Head is a very

fragile sculpture and requires quite a degree of commitment on the part of the collector.' Quote from a 1994 interview between Jay Jopling and Steve Rushton, http://www.backspace.org/everything/e/hard/text/jopling.html, 2.

72. Interview with Germano Celant, in *Marc Quinn* (Milan: Fondazione Prada, 2000), 59.

73. J. Stallabrass, 'Token Images: A User's Guide', in *Third Text*, no. 52 (Autumn 2000), 91–4, 91.

74. *Marc Quinn* (Liverpool: Tate Liverpool), red pages at back of book, no pagination.

75. J. Kristeva, 'Approaching Abjection', in *Powers of Horror: An Essay on Abjection* (New York: Columbia University Press, 1982), 1–31.

76. Peter Weiermair, 'Reflections on Blood in Contemporary Art', in J.M. Bradburne (ed.), *Blood: Art, Power, Politics and Pathology* (Munich, London, New York: Prestel, 2001), 205–16.

77. Ibid. 231.

78. Quinn talking with Germano Celant, in *Marc Quinn* (Milan: Fondazione Prada, 2000), 61.

79. There are two marbles of Alison Lapper, one is *Alison Lapper (8 Months)*, 2000, showing the model heavily pregnant, 83 x 40 x 65 cm, Mugrabi Collection, and *Alison Lapper and Parys*, 2000, 83 x 43 x 62 cms, Mugrabi Collection, both illustrated in *Marc Quinn* (Liverpool: Tate Liverpool, 2002).

80. M. Kennedy, 'Pregnant and proud: statue of artist wins place in Trafalgar Square', *The Guardian*, 16 March 2004; and H. Freeman, 'Why shouldn't my body be art?', *The Guardian*, 17 March 2004, G2, 6–7.

81. See S. Morris, 'Thatcher accused says: "I'm no criminal"', *The Guardian*, 5 July 2002.

82. S. Hoggart, 'We are a statue! And larger than life!', *The Guardian*, 22 May 2002.

83. 'Heads they lose…', *The Guardian*, 4 July 2002.

84. G. Younge, 'Premature Adulation', *The Guardian*, 8 July 2002.

85. On iconoclastic acts and their meanings, see D. Gamboni, *The Destruction of Art: Iconoclasm and Vandalism since the French Revolution* (London: Reaktion Books, 1997).

86. Jessica Evans, in an excellent essay, has pointed out how a historical shift occurred in the late nineteenth century from the exhibiting of disabled people as freaks to that of medicalised, scientific objects for research. See J. Evans, 'Feeble Monsters: Making up Disabled People', in J. Evans and S. Hall (eds), *Visual Culture: The Reader* (London: Sage/Open University, 1999), 274–88, 277.

87. Both quotes from the leaflet accompanying the exhibition of '*I*' at Loughborough University Art Gallery, 2001.

88. Back page of exhibition leaflet, Loughborough University Art Gallery.
89. See Hannah McGill, 'Body Politic', *Sunday Herald*, 24 October 1999, magazine section, 15–17.
90. Back of exhibition leaflet, Loughborough University Art Gallery.
91. See A. Wright, 'Partial Bodies: Re-establishing boundaries, medical and virtual', in Cutting Edge: The Women's Research Group (ed.), *Desire by Design: Body, Territories and New Technologies* (London and New York: I.B.Tauris, 1999), 21–7, 26.
92. S. Penny, Ars Electronic Information website, quoted in Alexa Wright, 'Partial Bodies', 27. I feel there is a problem here, for if the Enlightenment, or modern, view of the self is one that splits mind from body, how then is it also the Enlightenment/modern view that exterior appearance mirrors the interior mind and intellect? A less monolithic and more dialectical view of Enlightenment thought is necessary, I think.
93. M. Eagle, 'The Invisible Force', *The Guardian*, 27 November 2002, Society, 119.
94. J. Evans, 'Feeble Monsters', 285.
95. C. Davies and L. Crow, *A Sense of Self* (London: Camerawork, 1988), 44.
96. Ibid. from the statement by Chris Davies, 14–15.
97. Alexa Wright leaflet, Loughborough University Art Gallery.
98. C. Davies and L. Crow, *A Sense of Self*, 44.

CHAPTER 4: FOCUSING ON THE SELF

1. A. Damasio, 'Mind over Matter', *The Guardian*, 10 May 2003, Review, article on Spinoza, 4–6, 4.
2. D.C. Dennett, *Consciousness Explained* (Harmondsworth: Penguin, 1991), 39.
3. Ibid. 227.
4. A. Damasio, *Descartes' Error: Emotion, Reason and the Human Brain* (London: Papermac, 1996), 94. Damasio also states: 'I must immediately say that the self is a repeatedly reconstructed biological state; it is *not* a little person, the infamous homunculus, inside your brain contemplating what is going on... I must point out also that having a self, a single self, is quite compatible with Dennett's notion that we have no Cartesian theater in some parts of our brains' (227). Descartes himself argues that the brain interprets images, not the eyes (which can deceive us), and that there is no final set of surveying, spectatorial eyes hidden within: 'Now although this picture, in being so transmitted into our head, always retains some resemblance to the objects from which it proceeds, nevertheless, as I have already shown, we must not hold that it is by means of this resemblance that the picture causes us to perceive the objects, *as if there were yet other eyes in our brain with*

which we could apprehend it...' [my emphasis]; R. Descartes, *Discourse on Method, Optics, Geometry and Meteorology*, translated P.J. Olscamp (Indianapolis: Bobbs-Merrill, 1965), 101. So the Cartesian theatre is a metaphor created by later thinkers, not Descartes himself.

5. Damasio, *Descartes' Error*, 99–100.

6. F.A. Yates, *The Art of Memory* (London: Pimlico, 1992), 161.

7. Quote from Viglius' letter, ibid. 136–7.

8. There is a detailed diagram of the theatre taken from a publication of 1550 reproduced at the end of Yates' book. The idea of the enclosed and darkened theatre where memories which are at once part of, yet distanced from, the contemporary self is a continuing one: see, for example, Raphael Samuel, *Theatres of Memory: Past and Present in Contemporary Culture* (London: Verso, 1994).

9. M. Fried, *Absorption and Theatricality: Painting and Beholder in the Age of Diderot* (Berkeley: University of California Press, 1980).

10. Ibid. 60–1.

11. Descartes, *Discourse on Method and the Meditations*, 50–1.

12. Fried, *Absorption and Theatricality*, 89.

13. Ibid. 77.

14. Ibid. 173.

15. R. Barthes, 'Diderot, Brecht, Eisenstein', in *Image-Music-Text* (Glasgow: Fontana/Collins, 1977), 69–78, 69.

16. Ibid. 70.

17. Brecht's concept of 'Gestus' (or gest, as John Willett has translated it) means both gist and gesture – 'an attitude or a single aspect of an attitude, expressible in words or actions'. The gest is a 'socially significant gest, not illustrative or expressive gest'. See J. Willett (ed. and trans.), *Brecht on Theatre* (London: Eyre Methuen, 1974), 42 and 86. The 'story' fits together all the gestic incidents, and 'Each single incident has its basic gest... The grouping of the characters on the stage and the movements of the groups must be such that the necessary beauty is attained above all by the elegance with which the material conveying that gest is set out and laid bare to the understanding of the audience' (200–1).

18. The figure of Belisarius was intended as a historical parallel to the contemporary French general, Lally-Tolendal, executed for treason after having been defeated in India in 1766. For details, see *Tradition and Revolution in French Art 1700–1880: Paintings and Drawings from Lille* (London: National Gallery Publications, 1993), cat. no. 35, 109–10. Of course the similarity is also due to the idea of selecting a key moment (pregnant moment, as Barthes calls it) which is also a technique of French classical drama, for example in Racine's plays.

19. Ibid. 77. I am not convinced that this is a fetishistic activity on the spectator's part, unless Barthes is (possibly) suggesting that by cutting

out the tableau from the totality the spectator is investing the discrete image with desire and possession to compensate in some way for a lack of understanding and belonging (alienation?) in relation to the wider totality of cultural and social experience.

20. N. Burch, *To the Distant Observer: Form and Meaning in the Japanese Cinema* (London: Scholar Press, 1979, 69–70. Many thanks to Val Hill for this reference.

21. This is less the case in multiplex cinemas where spectators talk more and even use mobile phones.

22. See, for example, Arthur Tress, *The Theater of the Mind* (New York: Morgan, 1976), where the artist's work is referred to as the directorial mode, in which events are 'deliberately staged for the express purpose of making photographs thereof' (Introduction by A.D. Coleman, 1). See also M. Köhler (ed.), *Constructed Realities: The Art of Staged Photography* (Zurich: Edition Stemmle, 1989). This erosion concerns both eroticisation and undermining of the 'reality' of the photographic image. I owe this observation to discussions with the late Professor Nicholas Zurbrugg.

23. Charlesworth's perceptive article 'Reality Check' is in *Art Monthly*, no. 247 (June 2001), 7. Lucy Souter has similar concerns: 'many art writers assume offhandedly that if a photograph appears to show fantasy, obsession, voyeurism, masochism, sadism or misogyny, it is in fact a critical commentary.' 'Dial "P" for Panties: Narrative Photography in the 1990s', *Afterimage*, (January/February 2000), 9–12, 11.

24. A. Green, 'Photography', *Art Monthly*, no. 246 (May 2001), 3. Douglas Crimp's article, 'Pictures', discusses staged photographs, the theatrical and the temporal, emphasising the 'psychologised' aspect of these images. See D. Crimp, 'Pictures', in B. Wallis (ed.), *Art after Modernism: Rethinking Representation* (New York: New Museum of Contemporary Art, 1984), 175–87.

25. Köhler, *Constructed Realities*, 36, points out that most of the works he discusses in *Constructed Realities* are produced in editions numbering 1–15.

26. H. Visser discusses 'photographs labelled "tableau" according to a newly developed theory' and museum collecting and exhibiting strategies in 'What are Museums making of Photography?', in E. Janus (ed.), *Veronica's Revenge: Contemporary Perspectives on Photography* (Zurich, Berlin, New York: Scalo, 1998), 225–33, 26.

27. *Boris Mikhailov: Case History* (Zurich: Scalo, 1999).

28. For information on *Case History*, see the publication mentioned above. On Mikhailov's work, see also G. Williams, *Boris Mikhailov* (London: Phaidon, 2001). This book also has illustrations of some of Mikhailov's staged self-portraits, for example, *I am not I* (1992), and this is also

discussed in A. Efimova, 'Photographic Ethics in the work of Boris Mikhailov', *Art Journal*, vol. 53, no. 2 (Summer 1994), 63–9.

29. *Case History*, 7.

30. G. Williams, *Boris Mikhailov*, 15.

31. *Case History*, 5–6.

32. Ibid. 9.

33. Interview with Karen Knorr, in K. Knorr, *Marks of Distinction*, introduction by P. Mauriès (London: Thames and Hudson, 1991), 124–31, 125.

34. D. Campany, 'Museum and Medium: The Time of Karen Knorr's Imagery', in *Genii Loci: The Photographic Work of Karen Knorr* (London: Black Dog Publishing, 2002), 114–23, 116.

35. Knorr, *Marks of Distinction*, 130. Knorr then goes on to discuss what Barthes says about Brecht and the social gesture in his essay mentioned above, 'Diderot, Brecht, Eisenstein'.

36. See John Taylor, 'The Order of Things', *Afterimage* (September 1991), 12–14, 13.

37. Clearly there is a difference between tableaux 'made strange' in the theatre by living actors, and photographic *tableaux* (even as series) comparable to film stills.

38. See page 18 of *Genii Loci*.

39. See M. Bull, 'Slavery and the multiple Self', *New Left Review*, no. 231 (September/October 1998), 94–131, 107, citing G.W.F. Hegel, *Lectures on the Philosophy of World History*, translated by H.B. Nisbet (Cambridge, 1975), 183.

40. J. Barrell, *The Birth of Pandora and the Division of Knowledge* (Basingstoke and London: Macmillan, 1992), Chapter 7, 162.

41. Ibid. 162. Barrell goes on to explain how James Barry in his painting *The Birth of Pandora*, completed 1804, attempted to renegotiate the feminisation of art, by showing Pandora being educated by Minerva how to paint in tapestry, as Barry put it. This was, unlike painting, 'truly feminine work' in Barry's view (180).

42. Jeff Wall, quoted in R. Lauter (ed.), *Jeff Wall: Figures and Places – Selected Works from 1978–2000* (Prestel, 2001), 20–1.

43. Norman Bryson draws the comparison with factory lighting in 'Enlightenment Boxes: Jeff Wall', in *Art+Text*, no. 56 (1997), 56–61, 59.

44. Wall, quoted in R. Lauter (ed.), 20.

45. Bryson, 'Enlightenment Boxes', 61.

46. Hence the title of T.J. Clark's book: *The Painting of Modern Life: Paris in the art of Manet and his Followers* (New Haven and London, 1985). Clark is one of a group of people who discuss modern life, history, critical image-making and theory in a very useful interview conducted

with Wall in 1990, in T. de Duve, A. Pelenc, B. Groys, *Jeff Wall* (London: Phaidon, 1998), 1112ff. See also the revised and expanded edition of this book by T. de Duve, A. Pelenc, B. Groys, J.-F. Chevrier, *Jeff Wall*, revised and expanded edition (London: Phaidon, 2002).

47. 'Gestus' (1984), in T. de Duve et al., *Jeff Wall*, 76.

48. Ibid. 114.

49. Ibid. 115.

50. Ibid. 117.

51. Ibid. 118.

52. Ibid. 122.

53. R. Ellison, *Invisible Man* (London: Penguin Books, 2001; 1952), 6–7.

54. T. de Duve et al., *Jeff Wall*, revised edition, 137.

55. Among the latest contributions to this literature is the book by David Hockney, *Secret Knowledge: Rediscovering the Lost Techniques of the Old Masters* (London: Thames and Hudson, 2001), which argues that artists used optical devices of many kinds much more than is commonly supposed.

56. To cite just a couple of examples, the psyche has been seen as both light and dark, see C. Bollas, *The Shadow of the Object: Psychoanalysis of the Unthought Known* (London: Free Association Books, 1987) emphasises the darkness of the mind. S. Tisseron, *Le Mystère de la Chambre Claire: Photographie et Inconscient* ['The Mystery of the Light Room: Photography and Unconscious'] (Les Belles Lettres/Archimbaud, 1996), stresses light. The title of Roland Barthes' famous book on desire and photography, *Camera Lucida* (London: Vintage, 1993; first published 1980), refers not to a light room but to a device invented in 1806 by William Woollaston. This was a tool for artists, and consisted of a small prism supported over the drawing paper which reflected an image for the viewer to trace. The eye has to be placed so that half the pupil receives the scene through the prism while the other half views the paper directly. This differs from the camera obscura as it gives not a real image but a virtual image, depending on an observing eye or lens. See J.H. Hammond and J. Austin, *The Camera Lucida in Art and Science* (Bristol: Adam Hilger, 1987). Barthes specifically refuses 'the dark side' of photography: 'It is a mistake to associate Photography... with the notion of a dark passage (*camera obscura*)'. Barthes, *Camera Lucida*, 106.

57. See J.H. Hammond, *The Camera Obscura: A Chronicle* (Bristol: Adam Hilger, 1981); H. Gernsheim, *The Origins of Photography* (London: Thames and Hudson, 1982); and the useful book by Steve Neale, *Cinema and Technology: Image, Sound, Colour* (London and Basingstoke: Macmillan, 1995).

58. R.L. Gregory, *Eye and Brain: The Psychology of Seeing*, fifth edition (Oxford: Oxford University Press, 1998), 1.

59. Ibid. 52.

60. Ibid. 52–3; and also R.L. Gregory, *Mirrors in Mind* (Oxford, New York and Heidelberg: W.H. Freeman/Spektrum, 1997), 7, 208.

61. From his book *On Thinking* (Totowa, New Jersey: Rowman and Littlefield, 1979), 65, quoted in D. Dennett, *Consciousness Explained*, 223.

62. 'Both Descartes and the *philosophes* influenced by Locke remained beholden to a concept of the mind as a camera obscura.' See M. Jay, *Downcast Eyes: The Denigration of Vision in Twentieth-Century French Thought* (Berkeley, Los Angeles, London: University of California Press, 1994), 85.

63. J. Crary, *Techniques of the Observer: On Vision and Modernity in the Nineteenth Century* (Cambridge, Mass. and London: MIT Press, 1996), 43. Crary exaggerates here. Descartes does not ignore the senses but says they cannot be totally trusted, and that reason is superior and central to human consciousness. Crary also discusses John Locke's metaphor of the mind as a dark room where the light of understanding enters, from the *Essay Concerning Human Understanding* (1690), and Newton's *Opticks* (1704), 40–43. See also Chapter One, 'Inside the Camera Obscura', in B.J. Wolf, *Vermeer and the Invention of Seeing* (Chicago and London: University of Chicago Press, 2001).

64. Plato, *The Republic* (Harmondsworth: Penguin, 1972), 265–86. The editor and translator of this edition, H. Lee, suggests we should follow the advice of a previous editor, Cornford, in replacing the vision of Plato's cave with that of a projection in the cinema, as a more modern version of the scene.

65. R.L. Gregory, *Eye and Brain*, 1.

66. S. Sontag, *On Photography* (Harmondsworth: Penguin, 1977), 3: 'Humankind lingers unregenerately in Plato's cave, still reveling, its age-old habit, in mere images of the truth.'

67. See R. Krauss, 'A note on photography and the simulacral', in C. Squiers (ed.), *The Critical Image. Essays on Contemporary Photography* (London: Lawrence and Wishart, 1991), 15–27.

68. Ibid. 24.

69. See A. Boime, *The Art of Exclusion: Representing Blacks in the Nineteenth Century* (London: Thames and Hudson, 1990), Chapter 1, 'The Art of Darkness', 2, quoting J.M. Paillot de Montabert writing in 1838.

70. R. Dyer, *White* (London and New York: Routledge, 1997).

71. See A. Blühm and L. Pippincott, *Light! The Industrial Age 1750–1900: Art and Science, Technology and Society* (London: Thames and Hudson, 2000).

72. Crary, *Techniques of the Observer: On Vision and Modernity in the Nineteenth Century* (Cambridge, Mass.: MIT Press, 1996).

73. See G. Batchen, 'Seeing Things. Vision and Modernity', *Afterimage* (September 1991), 5–7.

74. Ideology retains its Marxist meaning of false consciousness, which obscures the real meanings of their situation and actions from many people living under capitalism. What seems to them as 'natural' is actually historically contingent and can be changed. Discourse is a far less political term and describes ways in which language or other sign systems position people in social relations. It can be seen as more class-neutral, in contrast to ideology, though Foucault linked discourse to the exercise of a rather abstract notion of omnipresent power.

75. Crary, *Techniques of the Observer*, 29; for references to the texts of these writers, see Crary's note 3.

76. Slavoj Žižek, *Tarrying with the Negative: Kant, Hegel, and the Critique of Ideology* (Durham: Duke University Press, 1993), takes up the positive/negative symbolism in the title.

77. Quoted in T. Eagleton (ed.), *Ideology* (London and New York: Longman, 1994), 24. Also very useful on the topic of ideology is D. Hawkes, *Ideology* (London and New York: Routledge, 1996).

78. Eagleton, *Ideology: An Introduction* (London and New York: Verso, 1991), 84, quoting Karl Marx.

79. Ibid. 85–7.

80. S. Kofman, *The Camera Obscura of Ideology* (London: Athlone Press, 1998; first published 1973), 37. Kofman points out that the camera obscura image is not mentioned in the Confessions themselves but only in J.-J. Rousseau's *Ebauche des Confessions*, vol. 1 (Paris: Pléiade, 1969), 1154.

81. Kofman, *The Camera Obscura of Ideology*, 53.

82. C. Beaton, *Photobiography* (London: Odhams Press, 1951), 14.

83. P. Garner and D.A. Mellor, *Cecil Beaton* (London: Jonathan Cape, 1994), 11, for the photograph of Beaton by Paul Tanqueray of 1937 which shows Beaton in a dramatically lit pose with photographic prints adhering to his clothes.

84. D. Mellor, Introduction, *Modern British Photography 1919–39* (London: Arts Council of Great Britain, 1980), 22.

85. Beaton, *Photobiography*, 180–1.

86. Mellor uses Susan Sontag's phrase; see *Modern British Photography*, 24.

87. Beaton, *Photobiography*, 181.

88. See, for example, the self-portrait photograph of *c*.1938, plate 73 in R.A. Sobieszek and D. Irmas, *The Camera i: Photographic Portraits from the Audrey and Sydney Irmas Collection* (New York: Los Angeles Country Museum of Art and Abrams, 1994). For other examples of staged self-portraits, see J. Lingwood (ed.), *Staging the Self: Self Portrait Photography 1840s–1980s* (London: National Portrait Gallery, 1986).

89. *Modern British Photography*, 14.

90. Garner and Mellor, *Cecil Beaton*, 34.

91. Beaton, *Photobiography*, 180.

92. Crary, *Techniques of the Observer*, 39.

93. Garner and Mellor, *Cecil Beaton*, 51.

94. Though her birth and marriage certificates give her name as Yevonde Cumbers, she is also referred to as Edith Plummer, as noted in Brett Rogers, 'Be Original or Die – Yevonde's Life of Colour', in *Madame Yevonde: Be Original or Die* (London: British Council, 1998), 9–21, 9.

95. Mme Yevonde, *In Camera* (London: John Gifford Ltd., 1940), 283.

96. See *Madame Yevonde: Be Original or Die*, 15. For other sources of information on Mme Yevonde, see *In Camera*; also L. Rideal, *Mirror Mirror: Self-Portraits by Women Artists* (London: National Portrait Gallery, 2001), 78; and the excellent exhibition catalogue by R. Gibson and P. Roberts, *Mme Yevonde: Colour, Fantasy and Myth* (London: National Portrait Gallery, 1990). Val Williams, *Women Photographers: The Other Observers 1900 to the Present* (London: Virago Press, 1986), discusses Mme Yevonde and other women photographers of her era; and D. Mellor, *Modern British Photography 1919–39* (London: Arts Council of Great Britain, 1980), has an excellent essay on photography of the period contextualising the work of Mme Yevonde.

97. Gibson and Roberts, *Mme Yevonde*, 9.

98. Ibid. 16.

99. See Williams, *Women Photographers*, 90, for quotes from newspapers in the 1920s giving advice on photography training for young women. It is interesting that later generations of influential women photographers, including Jo Spence and Karen Knorr, studied photography at Central London Polytechnic.

100. Mme Yevonde, *In Camera*, 284.

101. *Mme Yevonde* (London: British Council, 1998), 15.

102. Williams, *Women Photographers*, 142, quoting an article in *Women's Employment*.

103. See her lecture of 1921, 'Photographic Portraiture from a Woman's Point of View', where she states that tact, sympathy and the 'quickness of a woman's brain' are useful for dealing with awkward situations, especially those involving children, though 'scientists tell us that it tires more easily than a man's'. *British Journal of Photography*, 29 April 1921, 251–4, signed Philonie Yevonde.

104. The exceptions were soldiers, mayors, sportsmen and higher officers of the Church. 'Why Colour?', *The Photographic Journal* (March 1933), 116–120.

105. Ibid. 119.

106. For a good description of the Vivex process, patented in the later 1920s and which Mme Yevonde used from 1932 onwards, see Pam Roberts,

'Yevonde and the Techniques of Colour Photography', in Gibson and Roberts, *Mme Yevonde*, 25–30. Early photographic and film colour techniques are discussed in S. Neale, *Cinema and Technology: Image, Sound, Colour* (Basingstoke: Macmillan, 1985), 109–44. Only a few of Yevonde's original colour prints exist, the others having been recreated by computer technology producing colour dye transfer prints, like the example of her work illustrated here.

107. Gibson and Roberts, *Mme Yevonde*, 29, quoting D.M. Cuthbertson, 'Colour in Photography: A Help to Artistic Expression', *British Journal of Photography*, 1 November 1935, 692–3.

108. *Gone with the Wind* (1939) is a good example of Technicolor sophistication at the time. Mme Yevonde's portrait of Vivien Leigh, female lead in the film, from 1936 is on page 83 of *Mme Yevonde* (London: British Council, 1998). Her famous 'Goddesses' series was a tongue-in-cheek look at high-society beauties, including the wife of fascist leader Moseley as Venus, but referenced such previous examples as Sir Joshua Reynolds' eighteenth-century grand manner portraits of society ladies as mythological characters.

109. Neale, *Cinema and Technology*, 150.

110. Ibid. 158, quoting Julia Kristeva, *Desire in Language* (New York: Columbia University Press, 1908), 158. Neale's discussion anticipates some of the points made at greater length in the book by David Batchelor, *Chromophobia* (London: Reaktion Books, 2000), where colour is discussed as a threat to the self, associated with the other, and dangerous as compared to the dull and the homely. Grégoire Huret, remember, did not mention Descartes' philosophical ideas, but hailed his work on the rainbow as 'one of his most beautiful discoveries', see *Optique de Portraiture et de Peinture* (1640), 87.

111. Psyche is also a kind of day-flying moth, as well as the English word for spirit, soul or mind – from the Greek *psukhé*, meaning breath, life, soul.

112. When Bette Davis is transformed from a dowdy spinster to a beautiful, poised woman in the film *Now Voyager*, one of the first things to go is her set of spectacles. Many thanks to Christine Boydell for this observation.

113. J. Rivière, 'Womanliness as a Masquerade', in V. Burgin, J. Donald, C. Kaplan (eds), *Formations of Fantasy* (London and New York: Routledge, 1986), 35–44, 39.

114. Ibid. 35.

115. In Chapter Six, I will look more at issues of subjectivity and representation in relation to poverty and homelessness.

CHAPTER 5: THE REAL ME

1.　L.H. Rugg, *Picturing Ourselves: Photography and Autobiography* (Chicago and London: University of Chicago Press, 1997), 9.

2.　See, for example, Emil Torday and M.W. Hilton-Simpson, *The Photographer's Shadow in Kasai Land* (Royal Anthropological Institute, 1907–1909), illustrated on page 13 of the catalogue *The Impossible Science of Being: Dialogues between Anthropology and Photography* (London: The Photographer's Gallery, 1995).

3.　V. Walkerdine, *Daddy's Girl: Young Girls and Popular Culture* (London: Macmillan, 1997), 181–2; and V. Walkerdine, 'Dreams from an ordinary childhood', in L. Heron (ed.), *Truth, Dare or Promise: Girls Growing Up in the Fifties* (London: Virago, 1985), 63–77. In this essay, Walkerdine illustrates a photograph of herself in fancy dress as a 'bluebell fairy' aged three in 1950 (67). In 1975, she visited her father's grave to tell him she had managed to get her Ph.D. I wish I could tell mine I am a professor, but I know he won't hear me.

4.　In Annette Kuhn's excellent book, which I read after writing the first draft of this chapter, she also illustrates a photograph of herself in fancy dress, devised and made by her mother. She is dressed as 'Cinema Litter' with empty cartons and sweet wrappers attached to her clothing. See Kuhn, *Family Secrets: Acts of Memory and Imagination* (London and New York, 1995), 54. Fancy dress costumes for galas seem to have been quite popular after the war, with mothers more involved than fathers. Like Annette Kuhn's mother, mine prided herself on her 'original' ideas for costumes, rather than just selecting obvious ones like the nurse, Snow White, a princess etc. One of my brothers had to dress up (embarrassingly) one year in a bath towel and mob-cap as 'The Order of the Bath'. These costume events in the post-war period were not like carnivals, since there was no idea of 'turning-things on their head', of mocking the dominant social order, as Bahktin describes it in his book on Rabelais and carnivalesque humour. Kuhn's excellent book also situates the Coronation of 1953 in the context of post-war Britain gradually emerging from austerity, hoping for an affluent future.

5.　A. Kuhn, 'Remembrance', in J. Spence and P. Holland (eds), *Family Snaps: The Meanings of Domestic Photography* (London: Virago, 1991), 22. This essay also appears in *Family Secrets*, which Annette Kuhn dedicates to her late father, Henry Philip Kuhn.

6.　Spence and Holland (eds), *Family Snaps*, Introduction, 9.

7.　R. Barthes, *Camera Lucida* (London: Vintage, 1993).

8.　Ibid. 40.

9.　S. Freud, 'Mourning and Melancholia' (1917), in *On Metapsychology*,

Penguin Freud Library, vol. 11 (Harmondsworth: Penguin, 1991), 245–68, 66.

10. G. Pollock, *Differencing the Canon: Feminist Desire and the Writing of Art's Histories* (London and New York: Routledge, 1999), 229. Others who see the female body as the foundation of subjectivity and creativity opposed to the phallocentric symbolic order include Bracha Lichtenberg Ettinger. See her essay 'The With-In-Visible Screen', in M.C. de Zegher (ed.), *Inside the Visible: An Elliptical Traverse of 20th Century Art in, of, and from the Feminine* (Cambridge, Mass. and London: MIT Press, 1996), 88–113.

11. Pollock, *Differencing the Canon*, 35; the reference to Marxism is from page 12.

12. Exceptions are Tabitha Freeman who is researching a Ph.D. on 'Discourses of Fatherhood: Silences and Contradictions' at the University of Essex; a paper by Elsbeth Kneuper and Michael Ensslen (Heidelberg) given at Mekrijärvi, Finland in 2002: 'A Topological Approach to the Paternal Body – A Contribution to the Cultural Construction of Intersubjectivity', available on the web at http://medanthro.kaapeli.fi/nordic2002/papers/Documents; and the useful article by Heather Formaini, 'Some ideas about the father's body in psychoanalytic thought', at http://www.cgjungpage.org/articles/formiani1.html. I am much indebted to Formiani's piece.

13. See Formaini, 'Some ideas about the father's body in psychoanalytic thought', 12–13.

14. 'We need only assume that the group of brothers banded together were dominated by the same contradictory feelings towards the father which we can demonstrate as the content of ambivalence of the father complex in all our children and in neurotics. They hated the father who stood so powerfully in the way of their sexual demands and their desire for power, but they also loved and admired him.' S. Freud, *Totem and Taboo: Resemblances Between the Psychic Lives of Savages and Neurotics* (Harmondsworth: Penguin, 1938; first published 1919), 218–19.

15. Formaini, 'Some ideas about the father's body in psychoanalytic thought', 3.

16. Ibid. 4.

17. Freud, 'Childhood Memories and Screen Memories', in *The Psychopathology of Everyday Life*, Penguin Freud Library, vol. 5 (Harmondsworth: Penguin, 1975), Chapter IV, 83–93, 87.

18. Ibid. 88.

19. Spence and Holland (eds), *Family Snaps*, 2.

20. Freud, 'Family Romances' (1909), in *On Sexuality*, Penguin Freud Library, vol. 7 (Harmondsworth: Penguin, 1991), 221.

21. C. Pinney, C. Wright and R. Poignant, *The Impossible Science of Being: Dialogues between Anthropology and Photography*, exhibition catalogue (London: The Photographer's Gallery, 1995), 7.

22. Ibid. 8.

23. C.S. Pierce, quoted by V.I. Stoichita, *A Short History of the Shadow* (London: Reaktion Books, 1997), 113. For another, less wide-reaching discussion of shadow as lack of light in the Enlightenment period, see M. Baxandall, *Shadows and Enlightenment* (New Haven and London: Yale University Press, 1995).

24. Ibid. 35, 41, 221: 'We should bear in mind that the whole dialectic of Western representation has taught us that frontality – and the mirror – constitutes the symbolic form of the relationship between the self and the same, whereas the profile – and the shadow – constitutes the symbolic form of the relationship between the self and the other.'

25. The distinction between the autobiography and the self-portrait is usefully made by Laura Marcus, *Auto/biographical Discourses: Theory, Criticism, Practice* (Manchester and New York: Manchester University Press, 1994), 203. *Roland Barthes by Roland Barthes* is published by the University of California Press (Berkeley and Los Angeles, 1994).

26. I have tried to do something different here by incorporating elements of all three. Sometimes I write myself into the childhood and adolescent material, sometimes I stand outside it, attempting to theorise it. I am not taking a detached, controlling 'Cartesian' position, but nevertheless have perspectives on what I present.

27. L. Stanley, *The Auto/biographical I: The Theory and Practice of Feminist Auto/biography* (Manchester: Manchester University Press, 1992), 18. Stanley is referring specifically to autobiography here, though I think this should also include self-portrait writing.

28. Marcus, *Auto/biographical Discourses*, 151.

29. Ibid. 155.

30. I would recommend here the book by L.H. Rugg, *Picturing Ourselves: Photography and Autobiography* (Chicago and London: University of Chicago Press, 1997).

31. Stanley, *The Auto/biographical I*, 20.

32. E. Lipton, *Alias Olympia: A Woman's Search for Manet's Notorious Model and Her Own Desire* (Ithaca, New York: Cornell University Press, 1999; originally published 1993); and C. Mavor, *Pleasures Taken: Performances of Sexuality and Loss in Victorian Photographs* (London and New York: I.B.Tauris, 1996).

33. A. Dimitrakaki, 'Researching Culture/s and the Omitted Footnote: Questions on the Practice of Feminist Art History', in B. Biggs, A. Dimitrakaki, J. Lamba (eds), *Independent Practices: Representation, Location and History in Contemporary Visual Art* (Liverpool: Bluecoat

Arts Centre, Liverpool School of Art and Design, Liverpool John Moores University, Saffron Books, 2000), 91.

34. Dimitrakaki, 'Researching Culture/s and the Omitted Footnote', 92.

35. J. Spence, *Putting Myself in the Picture: A Political, Personal and Photographic Autobiography* (Seattle: The Real Comet Press, 1988), 198.

36. L. Stanley, *The Auto/biographical I*, 45.

37. Ibid. 5–6.

38. Ibid. 16.

39. *Roland Barthes by Roland Barthes*, blurb on back cover of the University of California edition.

40. *Roland Barthes by Roland Barthes*, 119.

41. Ibid. 142.

42. Ibid. 144.

43. P. Collier, 'Roland Barthes: The Critical Subject (an idea for research)', *Paragraph*, vol. 11 (1988), 175–80, 177.

44. Ibid. 177.

45. I have discussed this elsewhere, in relation to Barthes, Susan Sontag and Christian Metz. See my book *Drapery: Classicism and Barbarism in Visual Culture*, Chapter 6, note 39.

46. Barthes, *Camera Lucida*, 9.

47. E. Edwards, *Raw Histories: Photographs, Anthropology and Museums* (Oxford: Berg Publishers, 2001), 11.

48. Barthes, *Camera Lucida*, 81.

49. D. Batchelor, *Chromophobia* (London: Reaktion Books, 2000), 41.

50. Ibid. 31.

51. Marcus, *Auto/biographical Discourses*, 218.

52. Rugg, *Picturing Ourselves*, 13.

53. Ibid. 175.

54. Polyfoto used a glass negative 13 x 18 cm., on which to take forty-eight separate little negatives which were then supplied in a slightly enlarged proof, each measuring one and a quarter inches square. Each exposure was one twenty-fifth of a second, and in 1933 the cost of posing and a sheet of proofs was 2/6d. The whole process took about one minute and small studios with the special cameras were situated in large shops such as department stores. See 'Polyfoto – the new portrait photography', *British Journal of Photography*, 21 July 1933, 421–2. My Polyfotos are covered by a transparent sheet which, among other things, claims that 'Polyfoto is the only system of photography giving natural and truly characteristic portraits, since the sitter can move and converse freely.' Thanks to Trish Doy, my sister-in-law, for sending me a copy of the text.

55. Marcus, *Auto/biographical Discourses*, 173. Quote within quotes from C. Lasch, *The Culture of Narcissism* (London: Abacus, 1980), as used by Marcus.

56. Eagleton, *After Theory* (London: Allen Lane, 2003), 219.

57. Ibid. 221.

58. This is the first of my books to have colour reproductions, courtesy of a very welcome grant from the Arts and Humanities Research Board of the UK.

59. J. Tagg, *The Burden of Representation: Essays on Photographies and Histories* (London: Macmillan, 1988), 106. Tagg is following B. Edelman, *Ownership of the Image: Elements for a Marxist Theory of Law* (London: Routledge and Kegan Paul, 1979).

60. Ibid. 113.

61. Edelman, *Ownership of the Image*, 97.

62. Ibid. 107.

63. Ibid. 187.

64. Ibid. 52.

65. L. Wells, K. Newton, C. Fehily, *Shifting Horizons: Women's Landscape Photography Now* (London: I.B.Tauris, 2000), 32.

CHAPTER 6: SELF-DETERMINATIONS

1. B. Fine and E. Leopold, *The World of Consumption* (London and New York: Routledge, 1993), 254. See also J.-C. Agnew, 'Coming up for Air: Consumer Culture in Historical Perspective', in J. Brewer and R. Porter (eds), *Consumption and the World of Goods* (London and New York: Routledge, 1993), 19–39, who notes the gradual marginalisation of labour and production in many recent cultural studies. 'What began after 1968 as a legitimate effort to correct the labour metaphysic of classical and Marxist political economy and to restore the symbolic dimension of consumption has given way to a blanket dismissal of such categories as subsistence, use-value and labour.'(30)

2. In her book *The Fashioned Body: Fashion, Dress and Modern Social Theory* (Cambridge: Polity Press, 2000), Joanne Entwistle argues that to understand both the pleasures and the exploitation of fashion we need to attend to both consumption and production and the ways in which the two are linked; see especially Chapter 7, 'The Fashion Industry'.

3. See, for example, Angela Partington's essay, 'Perfume: Pleasure, Packaging and Postmodernity', in P. Kirkham (ed.), *The Gendered Object* (Manchester: Manchester University Press, 1996), Chapter 19; and R. Shields (ed.), *Lifestyle Shopping: The Subject of Consumption* (London and New York: Routledge, 1992).

4. C. Lodziak, *The Myth of Consumerism* (London: Pluto Press, 2002), 5.

5. T. Ebert, *Ludic Feminism and After: Postmodernism, Desire, and Labor in Late Capitalism* (Ann Arbor: University of Michigan Press, 1996), 137.

6. Many, however, work illegally in low-skilled, low-paid jobs. See the excellent feature on immigration and asylum by Libby Brooks, '5 tough questions about asylum', *The Guardian*, 1 May 2003, G2, 2–9. Many of these low-paid jobs are in cleaning, catering and hospitality (9). Such workers are the dramatic leads in the feature film *Dirty Pretty Things* (dir. Stephen Frears, 2002), which, unusually, does not take a documentary approach to the issue.

7. J. Seabrook, *Class, Caste and Hierarchies* (London: New Internationalist/ Verso, 2002), 67. For a selection of texts on class and a useful introduction, see P. Joyce (ed.), *Class* (Oxford: Oxford University Press, 1995).

8. 'Ethnic and gender categories, long fought for, were almost instantly converted into target markets during the mid-Nineties. Watch MTV or go to Benetton; their diversity of musicians and models, which once seemed pretty admirable, now looks like nothing more than globalised sales talk.' A. Beckett, 'Backlash against the Brand', review of N. Klein, *No Logo*, *The Guardian*, 15 January 2000, Saturday Review, 8. Companies are also prepared to recognise and reward the talents of socially oppressed groups, not only out of morality or legal obligation, but for commercial benefit: 'The problem is not getting women and "ethnic minorities" in at the entry level; the problem is making better use of their potential at every level, especially in middle-management and leadership positions. This is no longer a question of common decency, it is a question of business survival.' R. Roosevelt Thomas, 'From affirmative action to affirming diversity', *Harvard Business Review* (March–April 1990), 107–17, 108, cited by C. Lury, *Prosthetic Culture: Photography, Memory and Identity* (London and New York: Routledge, 1998), 25.

9. C. Casey, *Work, Self and Society After Industrialism* (London and New York: Routledge, 1995), 155–6. Casey's very interesting book is based on fieldwork in a large Northern American company (which for obvious reasons is not identified) and contains many revealing interviews as well as discussions of theories of the self and their relation to work and society.

10. Quote from the artist in a talk at the City Gallery Leicester, September 2000.

11. Catalogue of the exhibition *Janice McNab*, Doggerfish, Edinburgh, and Tramway, Glasgow, 2001–2002.

12. See the exhibition catalogue *Allan Sekula: Fish Story*, Catalogue of the exhibition at Witte de With, Rotterdam, Richter Verlag, Dusseldorf (1995) and the catalogue of Documenta 11 Platform 5, *Catalogue*, 2002, Hatje Cantz Verlag, Ostfildern (2002).

13. See W.L. Guttsman, *Art for the Workers: Ideology and the Visual Arts in Weimar Germany* (Manchester: Manchester University Press, 1997).

For other examples, see G. Pollock and V. Mainz (eds), *Work and the Image*, 2 vols (Aldershot: Ashgate, 2002).

14. See, for example, the various images and objects illustrated in the many colour reproductions in A. Michaelis, *DDR Souvenirs* (Cologne: Benedikt Taschen, 1994).

15. For a very interesting discussion of representations of women workers, see Kristina Huneault, *Difficult Subjects: Working Women and Visual Culture, Britain 1880–1914* (Aldershot: Ashgate, 2002).

16. See the excellent essay by John Roberts in the catalogue *Renegotiations: Class, Modernity and Photography*, exhibition catalogue (Norfolk Institute of Art and Design: Norwich Gallery, 1993).

17. For really excellent discussions of realism, its complex cultural ideologies and its audiences in the twentieth century, see P. Wood, 'Realisms and Realities' in B. Fer, D. Batchelor, P. Wood, *Realism, Rationalism, Surrealism: Art between the Wars* (New Haven and London: Yale University Press and Open University, 1993), 250–331.

18. Illustrated in colour in ibid. 250.

19. For a fascinating testimony relating to subjectivity and work as punishment in the 1960s in the USA by an anonymous African-American prisoner, see K. Thomas (ed.), *The Oxford Book of Work* (Oxford: Oxford University Press, 1999), 157–9. The former prisoner describes how singing enabled the gang to work in unison, whereas without singing, the group becomes a number of uncoordinated individuals: 'every man has probably got his lip stuck out 'cause he's got time to think.' (158) Or else 'they all daydreamin': they drivin' the Cadillacs and sleepin' on the silk sheets, you know. Living a fictitious life and daydreaming.' (159)

20. R. Boyne, *Subject, Society, and Culture* (London: Sage, 2001), 45.

21. See the comments on Miller's work by J.-C. Agnew in 'Coming up for Air: Consumer Culture in Historical Perspective', 19–39, 30; see also D. Miller, *A Theory of Shopping* (Cambridge: Polity Press, 1998).

22. Lodziak, *The Myth of Consumerism*.

23. J. Finkelstein, *The Fashioned Self* (Cambridge: Polity Press, 1991), 151.

24. Ibid. 147.

25. 'Play as the Main event in International and UK Culture', *Cultural Trends*, issues 43 and 44 (2003), 95–145.

26. Ibid. 139.

27. Brochure from JD Sports shops.

28. Fleury has said, 'I'm quite against feminism. I read all women's magazines – or at least I try to. For me that's a full-time job and it inspires my work. And this is the answer to those women who think that they cannot afford to do a thing like that.' From A. Shelton (ed.),

Fetishism: Visualising Power and Desire (London: South Bank Centre in association with Lund Humphries, 1995), 92.

29. Quoted in J. Beckett, 'History (Maybe)', in *History: The Mag Collection: Image-Based Art in Britain in the Late Twentieth Century* (Kingston upon Hull: Ferens Art Gallery, 1997), 133–43, 138.

30. Her Turner Prize entry for 2003 includes a bronze cast of an apple tree bearing real apples, *Because I could not stop* (2002).

31. Richard Johnson, 'Gather ye Rosebuds', originally published in *The Observer*, available on http://www.rjsj.demon.co.uk/pieces/gather.htm, quote from p. 3.

32. See the exhibition catalogue by C. Grunenberg and M. Hollein (eds), *Shopping: A Century of Art and Consumer Culture*, Shirn Kunsthalle Frankfurt and Tate Liverpool, 2002–3 (Hatje Cantz Publishers, 2002).

33. Ibid. 22.

34. K. Marx, *Capital*, vol. 1 (Harmondsworth: Penguin, 1976), Chapter 4, 163–77.

35. See E.C. Kraus, 'Contemporary Art applied to the Store and its Display: Thoughts on Frederick Kiesler's Show Windows', in Grunenberg and Hollein (eds), *Shopping*, 124–9, 125.

36. C. Grunenberg, 'Wonderland: Spectacles of Display from the Bon Marché to Prada', in Grunenberg and Hollein (eds), *Shopping*, 17–37, 25.

37. The same could be said for the essays. One of the most interesting was by Julian Stallabrass, critic and historian of the 'young British artists', 'Shop until you Stop', 222–30.

38. See Grunenberg and Hollein (eds), *Shopping*, 196–7.

39. See N.D. Campbell, 'The Oscillating Embrace: Subjection and Interpellation in Barbara Kruger's Art', *Genders*, no. 1 (Spring 1988), 57–74, 65. On Kruger, see also B. Kruger, *Love for Sale: The Words and Pictures of Barbara Kruger* (New York: Abrams, 1990); and B. Kruger, *Thinking of You* (Los Angeles: Museum of Contemporary Art and New York: Whitney Museum of American Art and MIT Press, 1999).

40. Campbell, 'The Oscillating Embrace', 62, quoting Pêcheux, *Language, Semantics and Ideology. Stating the Obvious* (London: Macmillan, 1982), 158.

41. Ibid. 64.

42. B. Kruger, *Thinking of You*, 172.

43. Programme 1, 17 March 2002.

44. Programme 2, 24 March 2002.

45. http://www.tagheuer.com; I am very grateful indeed to James Hughes at TAG Heuer (UK) for his generous help with adverts featuring Ines Sastre.

46. D.P. Walsh, *Shoplifting: Controlling a Major Crime* (London: Macmillan, 1978), 4–5.

47. Ibid. 23.

48. Ibid. 114.

49. L.W. Klemke, *The Sociology of Shoplifting: Boosters and Snitches Today* (Westport, Connecticut and London: Praeger, 1992), 51, 63. 'Boosters' steal to sell, and 'snitches' steal for their own use.

50. D. Campbell, 'Show Trial', *The Guardian*, 8 November 2002, G2, 2–4.

51. Ibid. 78, 79, 92.

52. B. Zalud, 'Stress, Feeling Unfairness Encourage Shoplifting', on the website of *Security Magazine*, http://www.securitymagazine.com, posted on 14 February 2002.

53. Marx, 'On the productivity of all professions', from *Theories of Surplus Value*, extract in M. Solomon (ed.), *Marxism and Art: Essays Classic and Contemporary* (Brighton: Harvester, 1979), 37–8. Marx acknowledges that Mandeville in his *Fable of the Bees* (1705) had already pointed out the productivity of all occupations.

54. http://www.crimethinc.com.

55. http://www.crimethinc.com/library/shoplifting.html, 3.

56. For a thoughtful discussion of the crime novel, see E. Mandel, *Delightful Murder: A Social History of the Crime Story* (London and Sydney: Pluto Press, 1984).

57. In Martha Rosler's text and photographic series *The Bowery in Two Inadequate Systems* (1974–1975), the artist documented the homeless, marginalised, and largely alcohol-dependent people living on the streets in New York's Bowery district. They are absent from the images, but signified by empty bottles and street corners, so as to avoid a voyeuristic picturing of their condition. In Turk's *Nomad*, a life-size painted bronze sculpture represents a recumbent figure totally hidden in a sleeping bag. Turk had placed this piece in various doorways around the Charing Cross area of London before its exhibition in galleries. One writer has remarked: 'The focus is the strategy of survival that urban nomads currently utilize – anonymous, unnoticed, covert and passed by.' See Fred James, 'Broken Toes', *Kultureflash*, no. 10, 13 August 2002, from the website http://www.kultureflash.net.archive/10/piece.html. ('Broken Toes' refers to what hostile passers-by might get if they kicked Turk's statue thinking it was a sleeping person.) The work is now on show in the Saatchi Gallery, County Hall, London. Turk has also produced a waxwork sculpture of himself as a tramp accosting passers-by, *Bum*, 1998, illustrated as plate 73 in Julian Stallabrass, *High Art Lite: British Art in the 1990s* (London and New York: Verso, 1999), 283. Discussing Turk's pieces on pages 285–6, Stallabrass remarks: 'but in Turk's pieces, homelessness is not seen as a misfortune that happens to individuals but is used to stand in for the artist's alienation.'

58. For example, the series of related exhibitions in Kent in autumn 2003, see M. Belléguic, M. Rossi, J. Stewart (eds), *Strangers to Ourselves*, catalogue (Hastings: Hastings Museum and Art Gallery, 2003), and the international conference organised by the British Council in Cardiff 2003, *A Sense of Place*, which brought together artists, curators, journalists, policy-makers, and educators (many of those speaking were, or had been, refugees) to discuss the role of the arts and media in reshaping societies and identities in Europe. See also S. McGlashan and S. Pacitti (eds), *Sanctuary: Contemporary Art and Human Rights*, exhibition catalogue (Glasgow: Glasgow Museums, 2003).

59. D. Campbell, 'Land of the Twee', in *The Guardian*, 8 July 2002, G2, 12–14.

60. K.M. Boydell, P. Goering, T.L. Morrell-Bellai, 'Narratives of Identity: Re-presentation of Self in People who are Homeless', *Qualitative Health Research*, vol. 10, no. 1 (January 2000), 26–38.

61. Ibid. 30.

62. Ibid. 36.

63. See, for example, S. Morris, 'Beggars feel Dickensian chill', *The Guardian*, 24 February 2003, discussing recent arrests and fines in Cambridge.

64. Engels, *The Condition of the Working Class in England* (Harmondsworth: Penguin, 1987), 277.

65. Quoted from *London Labour and the London Poor: A Cyclopedia of the Condition and Earnings of those that will work, those that cannot work, and those that will not work*, vol. 1 (London, 1861 edition), 2–3, in C. Gallagher, 'The Body versus the Social Body in the works of Thomas Malthus and Henry Mayhew', in C. Gallagher and T. Laqueur (eds), *The Making of the Modern Body: Sexuality and Society in the Nineteenth Century* (Berkeley, Los Angeles and London: University of California Press, 1987), 90.

66. J.A. Hobson, *Work and Wealth* (1914), extract from K. Thomas (ed.), *The Oxford Book of Work* (Oxford: Oxford University Press, 1999), 54–5.

67. See, for example, the essay by A. Travers, 'The face that begs: street begging scenes and selves' identity work', in H. Dean (ed.), *Begging Questions: Street-level Economic Activity and Social Policy Failure* (Bristol: Policy Press, 1999). This is a very interesting and well-researched book which gave me insights into begging as an economic activity and the lives of people who beg.

68. A. O'Hagan, 'Down and out in London', *World Press Review*, vol. 41, no. 3 (March 1994), 46 (3), downloaded from infotrac. The journalist O'Hagan posed as a beggar to interview people about their experiences and also describes how he was treated with contempt by non-beggars.

69. Quoted from the Penguin edition of Montaigne's *Essays*, translated by J.M. Cohen (1957), 119, by John Forrester in 'A brief history of the subject', in *ICA Documents 6. The Real Me: Postmodernism and the Question of Identity* (London: ICA, 1987), 13–16, 14.

70. For illustrations and information, see K.H. Spencer, *The Graphic Art of Géricault* (New Haven: Yale University Art Gallery, 1969), and L. Eitner, *Géricault: His Life and Work* (London: Orbisk, 1983), 228ff.

71. He passed the commission on to his friend Delacroix, see Eitner, *Géricault*, 216.

72. T.J. Clark mentions that artists wrote letters to the Bureau des Beaux-Arts asking for help after the 1848 Revolution in France: 'The dossiers of the Bureau des Beaux-Arts filled with pleas for help', *The Absolute Bourgeois: Artists and Politics in France. 1848–1851* (London: Thames and Hudson, 1988; first published 1973), 49.

73. Information from the exhibition catalogue *De David à Delacroix: La Peinture française de 1774 à 1830* (Grand Palais, Paris: Editions des Musées Nationaux, 1974), cat. no. 30, 364–5. There is also an English version of this catalogue.

74. O. Hufton, *The Poor of Eighteenth-Century France, 1750–1789* (Oxford: Clarendon Press, 1974), Chapter IV; beggars were commonly seen outside churches (112). Perhaps this could be compared with what appears to be a classical temple in David's painting. See also J. Cubero, *Histoire du Vagabondage du Moyen Age à nos Jours* (Paris: Imago, 1998).

75. H. Honour, *Neoclassicism* (Harmondsworth: Penguin, 1968), 34.

76. Quoted in an article by V. Dodd, *The Guardian*, 10 March 2000. So-called aggressive begging is not a new phenomenon, and is described when non-beggars are unable to cope with the situation the beggars find themselves in, and therefore experience it as threatening and upsetting. Engels describes large groups of unemployed men begging in the early 1840s: 'they begged, not cringing like ordinary beggars, but threatening by their numbers, their gestures, and their words'; Engels, *The Condition of the Working Class in England*, 121. Of course, it is quite possible to feel threatened by a group of people, especially in an isolated spot, and it is not my view that beggars are all wonderful people. However, it is important to point to a systematic representation of beggars in the media and in visual culture as somehow 'not people like us'.

77. This work was bought in Paris by an English industrialist from the area around Ironbridge, and taken back to a private collection in the UK. Perhaps the hints of sentimentality ensured a purchaser. The print of the painting was inscribed 'the most touching in the Salon of year 9 addressed to sensitive souls' (actually the Salon was year 8 that year). See the entry on this painting in the catalogue *La revolution Française*

et l'Europe, vol. 11 (Grand Palais, Paris: Editions des Musées Nationaux, 1989), 615–16.

78. From the *Journal des Débats*, 8 October 1828, quoted by Louis Chevalier in *Labouring Classes and Dangerous Classes in Paris during the First Half of the Nineteenth Century* (London: Routledge and Kegan Paul, 1973), 470, note 20.

79. See the entry on the Chevalier Féréol de Bonnemaison in *De David à Delacroix*, 329.

80. See B. Nicolson, 'Courbet's *L'Aumône d'un Mendiant*', *Burlington Magazine*, vol. CIV (January 1962), 73–5; and J. Lindsay, *Gustave Courbet: His Life and Art* (Bath: Adams and Dart, 1973), 114, 227–8.

81. Lindsay, *Gustave Courbet*, 227.

82. Nicolson, 'Courbet's *L'Aumône d'un Mendiant*', 74.

83. I was prompted to think about charity and this painting in a discussion following the presentation of this material at a public lecture at Kingston University.

84. Engels, *The Condition of the Working Class in England*, 120.

85. *The Independent*, 15 March, 2000. Stephen Lawrence was a young black student murdered by racists in South London in 1993. Due to police incompetence at the scene and during the inquiry, allegedly because of racism, his murderers have never been convicted.

86. See R.H. Burke, 'Tolerance or intolerance? The policing of begging in the urban context', Chapter 13, in H. Dean (ed.), *Begging Questions*, 222.

87. For illustrations of this series, see the book which accompanied the exhibition *Ukadia: John Goto* (Nottingham: Djanogly Art Gallery, University of Nottingham, 2003).

88. Communication from John Goto to the author, October 2003.

89. Communication to author, October 2003. Perhaps it is more accurate to say that this approach is not supported by any of the larger political parties. However, it is the case that left political artists, such as the film-maker Ken Loach, for example, tend to rely very much on a strongly realist and/or documentary approach.

90. I think the photograph in the series which is most like John Heartfield's work is the least successful, though politically I had no disagreements with it at all. See *Living Sculpture*, 79 x 74 cm, where a statue of 'Blair of Baghdad' stands over a bleeding-heart liberal to whom he pays no attention.

91. See the essays in H. Dean (ed.), *Begging Questions*, especially Chapter 4 by B. Jordan, 'Begging: The global context and international comparisons'.

92. Melanie McFadyean, 'Hard Labour', *The Guardian*, 14 September 2002, *Guardian Weekend*, 45–7, 121–25, 125. Another excellent investigation by McFadyean, on Iraqi refugees in Britain, was published in *Guardian*

Weekend on 22 March 2003. See also C. Harvey and M. Ward (eds), *No Welcome Here? Asylum Seekers and Refugees in Ireland and Britain*, Democratic Dialogue Report 14 (Belfast, 2001); and Jenny McLeish, *Mothers in Exile: Maternity Experiences of Asylum Seekers in England* (London: Maternity Alliance, 2002).

93. P. Stalker, *The No-Nonsense Guide to International Migration* (London: Verso and New Internationalist, 2001), 42.

94. Ibid. 65.

95. For more on immigration and refugees, see T. Hayter, *Open Borders: The Case Against Immigration Controls* (London and Sterling, Virginia: Pluto Press, 2000); *Index on Censorship*, vol. 32, no. 2 (April 2003), issue 207, 'Double Crossings: Migration Now'; and *Listen to the Refugee's Story: How UK Foreign Investment Creates Refugees and Asylum Seekers*, co-published by Ilisu Dam Campaign Refugees Project, The Corner House and Peace in Kurdistan (2003).

96. H. Marshall (ed. and trans.), *Mayakovsky* (London: Dennis Dobson, 1965), 387–9.

97. Quoted in M. Garcelon, 'Colonising the Subject: The Genealogy and Legacy of the Soviet Internal Passport', in J. Caplan and J. Torpey (eds), *Documenting Individual Identity: The Development of State Practices in the Modern World* (Princeton: Princeton University Press, 2001), Chapter 2, 89.

98. Hans-Ulrich Wehler, quoted on p. 253 of *Documenting Individual Identity*, in the essay by L. Lucassen, 'A Many-Headed Monster: The Evolution of the Passport System in the Netherlands and Germany in the Long Nineteenth Century', Chapter 13.

99. For example, works by Said Adrus, Dave Lewis, Baljit Balrow and Juginder Lamba. See *'Let the Canvas come to light with dark Faces'*, exhibition catalogue, curated by Eddie Chambers, Herbert Art Gallery and Museum (1990); on Juginder Lamba, see Doy, *Black Visual Culture: Modernity and Postmodernity* (London and New York: I.B.Tauris, 2000), 228–32. More recently, Mark Sealy and Stuart Hall's *Different* (London: Phaidon, 2001) illustrates works dealing with national symbols of identity on 165–6.

100. *Freestyle* exhibition catalogue (Harlem: Studio Museum, 2001), 14–15.

101. Araeen in C. King (ed.), *Views of Difference: Different Views of Art* (New Haven and London: Yale University Press and Open University, 1999), 233.

102. At the College Art Association of America Conference 2003. The speakers had been due to present papers in the session on *Differencing the Feminist Canon: Power, Politics, and International Discourses*.

103. *The Guardian*, 31 August 2002.

104. *The Guardian*, 24 May 2002.

105. See A. Travis, 'More legal aid cuts planned in asylum cases', *The Guardian*, 28 November 2003. This article juxtaposed images of the British Home Secretary, David Blunkett, and an engraving of King Herod, who ordered the (probably mythical) 'slaughter of the innocents' recounted in the Bible. This refers to Blunkett's latest plan to take the children of asylum seekers away from their parents if they refuse deportation.

106. *The Economist*, 28 April 2001, quoted by K. Harvey, 'Is globalisation good for you?', *Workers Power*, Global Supplement (July 2001), 11.

CONCLUSION

1. The French artist Orlan, whose work has involved operations altering her facial appearance, has decided to test the legal limitations of identity change as an 'author' and a citizen when her series of operations is completed. 'I will solicit an advertising agency to come up with a name, a first name, and an artist's name; next, I will contract a lawyer to petition the [French] republic to accept my new identities with my new face.' R.A. Sobieszek, *Ghost in the Shell: Photography and the Human Soul, 1850–2000 – Essays on Camera Portraiture*, exhibition book (Cambridge, Mass. and London: Los Angeles County Museum of Art and MIT Press, 1999), 280.

2. My thanks to Jeff Rosen, University of Chicago, who was a stimulating and thoughtful discussant at the College Art Association of America in 2003, for posing some searching questions. I would also like to thank Jennifer Way, University of North Texas, for inviting me to give a paper at the conference, and the British Academy and De Montfort University whose (combined) generosity enabled me to attend the conference. I had no problems with immigration.

SELECT BIBLIOGRAPHY

Aers, D., 'A Whisper in the Ear of Early Modernists: or, Reflections on Literary Critics Writing the "History of the Subject"', in D. Aers (ed.), *Culture and History, 1350–1600: Essays on English Communities, Identities and Writing* (New York: Harvester Wheatsheaf, 1992), 177–202

Ahmed, S., and J. Stacey (eds), *Thinking Through the Skin* (London and New York: Routledge, 2001)

Alphen, E. van, 'The Portrait's Dispersal: Concepts of Representation and Subjectivity in Contemporary Portraiture', in J. Woodall (ed.), *Portraiture: Facing the Subject* (Manchester and New York: Manchester University Press, 1997), 239–56

Althusser, L., 'Ideology Interpellates Individuals as Subjects', in P. du Gay, J. Evans and P. Redman (eds), *Identity: A Reader* (London: Sage, 2000), 31–8

Anon, 'Why I love shoplifting from big corporations', http://www.crimethinc.com

Anzieu, D., *The Skin Ego: A Psychoanalytic Approach to the Self* (New Haven and London: Yale University Press, 1989)

Atkinson, T., 'Phantoms of the Studio', *Oxford Art Journal*, vol. 13, no. 1 (1990), 49–61

Barlow, P., 'Facing the Past and Present: The National Portrait Gallery and the Search for "Authentic" Portraiture', in J. Woodall (ed.), *Portraiture: Facing the Subject* (Manchester and New York: Manchester University Press, 1997), 219–38

Barthes, R., 'Diderot, Brecht, Eisenstein', in *Image-Music-Text* (Glasgow: Fontana/Collins, 1977), 69–78

Barthes, R., *Camera Lucida: Reflections on Photography* (London: Vintage, 1993)

Barthes, R., *Roland Barthes by Roland Barthes*, translated by R. Howard (Berkeley and Los Angeles: University of California Press, 1994)

Batchen, G., 'Seeing Things: Vision and Modernity', *Afterimage* (September 1991), 5–7

Beaton, C., *Photobiography* (London: Odhams Press, 1951)

Benson, S., 'Inscriptions of the Self: Reflections on Tattooing and Piercing in Contemporary Euro-America', in J. Caplan (ed.), *Written on the Body: The Tattoo in European and American History* (London: Reaktion Books, 2000), 234–54

Betterton, R., 'Why Is My Art Not As Good As Me? Femininity, Feminism and "Life-Drawing" in Tracey Emin's Art', in M. Merck and C. Townsend (eds), *The Art of Tracey Emin* (London: Thames and Hudson, 2002), 23–38

Boydell, K.M., P. Goering and T.L. Morrell-Bellai, 'Narratives of Identity: Representation of Self in People Who Are Homeless', *Qualitative Health Research*, vol. 10, no. 1 (January 2000), 26–38

Bull, M., 'Slavery and the Multiple Self', *New Left Review*, no. 231, (September– October 1998), 94–131

Burkitt, I., 'The Shifting Concept of the Self', *History of the Human Sciences*, vol. 7, no. 2 (1994), 7–28

Callinicos, A., *Against Postmodernism: A Marxist Critique* (Cambridge: Polity Press, 1989)

Campbell, L., *Renaissance Portraits: European Portrait-Painting in the 14th, 15th, and 16th Centuries* (New Haven and London: Yale University Press, 1990)

Campbell, N.D., 'The Oscillating Embrace: Subjection and Interpellation in Barbara Kruger's Art', *Genders*, no. 1 (Spring 1988), 57–74

Caplan, J., and J. Torpey (eds), *Documenting Individual Identity: The Development of State Practices in the Modern World* (Princeton: Princeton University Press, 2001)

Casey, C., *Work, Self and Society after Industrialism* (London and New York: Routledge, 1995)

Charlesworth, J.J., 'Reality Check', *Art Monthly*, no. 247 (June 2001), 1–5

Cottingham, J., *Descartes* (London and New York: Routledge, 1999)

Crary, J., *Techniques of the Observer: On Vision and Modernity in the Nineteenth Century* (Cambridge, Mass. and London: MIT Press, 1992)

Damasio, A.R., *Descartes' Error: Emotion, Reason and the Human Brain* (London: Papermac, 1996)

Davies, C., and L. Crow, *A Sense of Self* (London: Camerawork, 1988)

Dawes, G., 'A Marxist Critique of Post-Structuralist Notions of the Subject', in M. Zavarzadeh, T. Ebert and D. Morton (eds), *Post-ality: Marxism and Postmodernism*, special issue of *Transformation: Marxist Boundary Work in Theory, Economics, Politics and Culture*, no. 1 (Washington, DC: Maisonneuve Press, 1995), 150–88

Dean, H. (ed.), *Begging Questions: Street-Level Economic Activity and Social Policy Failure* (Bristol: Policy Press, 1999)

Dennett, D., *Consciousness Explained* (Harmondsworth: Penguin, 1991)

Descartes, R., *Discourse on Method and the Meditations*, translated F.E. Sutcliffe (Harmondsworth: Penguin, 1968)

Descartes, R., *Discourse on Method, Optics, Geometry and Meteorology*, translated by P.J. Olscamp (Indianapolis: Bobbs-Merrill, 1965)

Descartes, R., *The Passions of the Soul* (Indianapolis and Cambridge: Hackett, 1989)

Doy, G., *Materializing Art History* (Oxford: Berg, 1998)

Doy, G., *Black Visual Culture: Modernity and Postmodernity* (London and New York: I.B.Tauris, 2000)

Doy, G., *Drapery: Classicism and Barbarism in Visual Culture* (London and New York: I.B.Tauris, 2002)

Doy, G., 'The Subject of Painting: Works by Barbara Walker and Eugene Palmer', *Visual Communication*, vol. 1, no. 1 (February 2002), 41–58

Dunning, W., 'The Concept of Self and Postmodern Painting: Constructing a Post-Cartesian Viewer', *The Journal of Aesthetics and Art Criticism*, vol. 49, no. 4 (Fall 1991), 331–6

Duve, T. de, A. Pelenc, B. Groys and J.-F. Chevrier, *Jeff Wall*, revised and expanded edition (London: Phaidon, 2002)

Eagleton, T., *The Illusions of Postmodernism* (Oxford: Blackwell, 1996)

Ebert, T., *Ludic Feminism and After: Postmodernism, Desire and Labor in late Capitalism* (Ann Arbor: University of Michigan Press, 1996)

Elliott, A., *Social Theory and Psychoanalysis in Transition: Self and Society from Freud to Kristeva*, second edition (London and New York: Free Association Books, 1999)

Evans, J., 'Feeble Monsters: Making Up Disabled People' in J. Evans and S. Hall (eds), *Visual Culture: The Reader* (London: Sage/Open University Press, 1999), 274–88

Foister, S., A. Roy and M. Wyld, *Holbein's Ambassadors: Making and Meaning* (New Haven and London: Yale University Press and The National Gallery, 1997)

Formaini, H., 'Some ideas about the father's body in psychoanalytic thought', http://www.cgjungpage.org/articles/formaini.html

Foster, H., 'The Expressive Fallacy', in H. Foster, *Recodings: Art, Spectacle, Cultural Politics* (Washington, DC: Bay Press, 1985)

Freud, S., 'Childhood Memories and Screen Memories', in *The Psychopathology of Everyday Life* (Harmondsworth: Penguin, 1975), 83–93

Freud, S., 'Mourning and Melancholia', in *The Theory of Psychoanalysis* (Harmondsworth: Penguin, 1991), 245–68

Fried, M., *Absorption and Theatricality: Painting and Beholder in the Age of Diderot* (Berkeley: University of California Press, 1980)

Gagnier, R., *Subjectivities: A History of Self-Representation in Britain, 1832–1920* (Oxford: Oxford University Press, 1991)

Gibson, R., and P. Roberts, *Mme Yevonde: Colour, Fantasy and Myth* (London: National Portrait Gallery, 1990)

Gregory, R.L., *Mirrors in Mind* (Oxford, New York and Heidelberg: W.H. Freeman/Spektrum, 1997)

Gregory, R.L., *Eye and Brain: The Psychology of Seeing*, 5th edition (Oxford: Oxford University Press, 1998)

Grunenberg, C. (ed.), *Marc Quinn* (Liverpool: Tate Liverpool, 2002)

Grunenberg, C., and M. Hollein (eds), *Shopping: A Century of Art and Consumer Culture* (Frankfurt and Liverpool: Shirn Kunsthalle Frankfurt and Tate Liverpool, 2002–2003, Hatje Cantz Publishers, 2002)

Helsdingen, H.W. van, 'Body and Soul in French Art Theory of the Seventeenth Century After Descartes', *Simiolus*, vol. XI (1980), 14–22

Hodgkiss, P., *The Making of the Modern Mind: The Surfacing of Consciousness in Social Thought* (London and New York: Athlone Press, 2001)

Huret, G., *Optique de Portraiture et Peinture en Deux Parties* (Paris: C. de Sercy, 1670)

ICA Documents 6: The Real Me: Postmodernism and the Question of Identity (London: Institute of Contemporary Arts, 1987)

Jay, M., 'Scopic Regimes of Modernity', in H. Foster (ed.), *Vision and Visuality* (Seattle: Bay Press, 1988), 3–27

Jay, M., *Downcast Eyes: The Denigration of Vision in Twentieth-Century French Thought* (Berkeley and Los Angeles: University of California Press, 1994)

Judovitz, D., *Subjectivity and Representation in Descartes: The Origins of Modernity* (Cambridge: Cambridge University Press, 1988)

Klemke, L.W., *The Sociology of Shoplifting: Boosters and Snitches Today* (Westport, Connecticut and London: Praeger, 1992)

Knorr, K., *Genii Loci: The Photographic Work of Karen Knorr* (London: Black Dog Publishing, 2002)

Kofman, S., *The Camera Obscura of Ideology* (London: Athlone Press, 1998)

Kristeva, J., 'Approaching Abjection', in *Powers of Horror: An Essay on Abjection* (New York: Columbia University Press, 1982), 1–31

Kuhn, A., *Family Secrets: Acts of Memory and Imagination* (London and New York: Verso, 1995)

Lacan, J., *The Four Fundamental Concepts of Psycho-Analysis*, Introduction by D. Macey (London and New York: Penguin, 1994)

Lodziak, C., *The Myth of Consumerism* (London: Pluto Press, 2002)

Mansfield, N., *Subjectivity: Theories of the Self from Freud to Haraway* (London: Allen and Unwin, 2000)

Marcus, L., *Auto/biographical Discourses: Theory, Criticism, Practice* (Manchester and New York: Manchester University Press, 1994)

McNay, L., *Gender and Agency: Reconfiguring the Subject in Feminist and Social Theory* (Cambridge: Polity Press, 2000)

McRobbie, A., 'Feminism, Postmodernism and the "Real Me"', in M.G. Durham and D.M. Kellner (eds), *Media and Cultural Studies: Key Works* (Oxford: Blackwell, 2001), 598–610

Mérot, A., *French Painting in the Seventeenth Century* (New Haven and London: Yale University Press, 1995)

Munt, S.R., 'The Personal Experience and the Self', in A. Medhurst and S.R. Munt (eds), *Lesbian and Gay Studies: A Critical Introduction* (London: Cassell, 1997)

Neale, S., *Cinema and Technology: Image, Sound, Colour* (London and Basingstoke: Macmillan, 1995)

Pommier, E., *Théories du Portrait: De la Renaissance aux Lumières* (Paris: Gallimard, 1998)

Renault, A., *The Era of the Individual: A Contribution to the History of Subjectivity* (Princeton: Princeton University Press, 1997)

Richards, V., with G. Wilce (eds), *The Person Who Is Me: Contemporary Perspectives on the True and False Self* (London: Karnac Books, 1996)

Richefort, I., *Peintre à Paris au XVIIe Siècle* (Paris: Imago, 1998)

Rivière, J., 'Womanliness as a Masquerade', in V. Burgin, J. Donald, C. Kaplan (eds), *Formations of Fantasy* (London and New York: Routledge, 1986), 35–44

Rose, S. (ed.), *From Brains to Consciousness? Essays on the New Sciences of the Mind* (London: Allen Lane/Penguin, 1998)

Rugg, L.H., *Picturing Ourselves: Photography and Autobiography* (Chicago and London: University of Chicago Press, 1997)

Saslow, J.M. 'Homosexuality in the Renaissance: Behaviour, Identity and Artistic Expression', in M.B. Duberman, M. Vicinus and G. Chauncey Jr. (eds), *Hidden from History: Reclaiming the Gay and Lesbian Past* (Harmondsworth: Penguin, 1989), 90–105

Scheper-Hughes, N., 'The New Cannibalism', *New Internationalist* (April 1998), 14–17

Schrag, C.O., *The Self after Postmodernity* (New Haven and London: Yale University Press, 1997)

Simons, P., 'Homosexuality and Erotics in Italian Renaissance Portraiture', in J. Woodall (ed.), *Portraiture: Facing the Subject* (Manchester and New York: Manchester University Press, 1997), 29–51

Solomon-Godeau, A., 'The Equivocal "I": Claude Cahun as Lesbian Subject', in S. Rice (ed.), *Inverted Odysseys: Claude Cahun, Maya Deren, Cindy Sherman* (Cambridge, Mass. and London: MIT Press, 1999), 110–25

Stalker, P., *The No-Nonsense Guide to International Migration* (London: Verso and New Internationalist, 2001)

Stanley, L., *The Auto/biographical I: The Theory and Practice of Feminist Auto/biography* (Manchester: Manchester University Press, 1992)

Stoichita, V.I., *A Short History of the Shadow* (London: Reaktion Books, 1997)

Taylor, C., *Sources of the Self: The Making of Modern Identity* (Cambridge: Cambridge University Press, 1989)

Walker, J.A., *Art and Celebrity* (London: Pluto Press, 2003)

Weiermair, P., 'Reflections on Blood in Contemporary Art', in J.M. Bradburne (ed.), *Blood: Art, Power, Politics and Pathology* (Munich, London, New York: Prestel, 2001), 205–16

Williams, C., *Contemporary French Philosophy: Modernity and the Persistence of the Subject* (London and New York: Athlone Press, 2001)

Wolf, B.J., *Vermeer and the Invention of Seeing* (Chicago and London: University of Chicago Press, 2001)

Wright, A., 'Partial Bodies: Re-establishing Boundaries, Medical, and Virtual', in Cutting Edge: The Women's Research Group (ed.), *Desire by Design: Body, Territories and New Technologies* (London and New York: I.B.Tauris, 1999), 21–7

Yates, F.A., *The Art of Memory* (London: Pimlico, 1992)

Yevonde, Mme Philonie, 'Photographic Portraiture from a Woman's Point of View', *British Journal of Photography*, 29 April 1921, 251–4

Yevonde, Mme, *In Camera* (London: John Gifford Ltd., 1940)

INDEX